The Kinetoscope:
A British History

This book is dedicated to the memory of Ray Phillips (1920–2017) whose unique work in documenting and replicating the Edison Kinetoscope has contributed greatly to our understanding of the earliest years of the moving image.

The Kinetoscope: A British History

Richard Brown and
Barry Anthony

with an additional chapter by Michael Harvey

Foreword by
Charles Musser

British Library Cataloguing in Publication Data

The Kinetoscope: A British History

A catalogue entry for this book is available from the British Library

ISBN: 0 86196 730 8 (Paperback)
ISBN: 0 86196 931 9 (Ebook)

Front cover: A reproduction kinetoscope constructed in 2015 by Suphachai Worthong, and exhibited at the Thai Film archive.

The right of Richard Brown to be identified as author of Chapters Two to Six of this work has been asserted in accordance with the Copyright, Designs and Patents Act 1988.

The right of Barry Anthony to be identified as author of Chapter One, and Chapters Seven to Thirteen of this work has been asserted in accordance with the Copyright, Designs and Patents Act 1988.

The right of Michael Harvey to be identified as author of Chapter Fourteen of this work has been asserted in accordance with the Copyright, Designs and Patents Act 1988.

Published by
John Libbey Publishing Ltd, 205 Crescent Road, East Barnet, Herts EN4 8SB,
United Kingdom e-mail: john.libbey@orange.fr; web site: www.johnlibbey.com

Distributed Worldwide by
Indiana University Press, Herman B Wells Library—350, 1320 E. 10th St., Bloomington,
IN 47405, USA. www.iupress.indiana.edu

Printed and bound in the United Kingdom..

Contents

Acknowledgements

First and foremost, the authors wish to thank David Robinson for his invaluable help and encouragement during the early stage of this project. We would also like to acknowledge the assistance of the late Frank Andrews, Jean Anthony, the late John Barnes, Stephen Bottomore, Adam Carter, Reference and Information Librarian, Bury Library; Richard Crangle, Associate Research Fellow, University of Exeter; Bryony Dixon, British Film Institute; the late Geoffrey Donaldson; Frank Gray, Director of Screen Archive South East, University of Brighton; Paul Israel, Director and General Editor of the Thomas A. Edison Papers at Rutgers University; Elizabeth MacKinney; Luke McKernan, Head Curator, News and Moving Image, British Library; Charles Musser, Professor of American Studies, Film and Media Studies and Theatre Studies, Yale University; Simon Popple, Deputy Head, School of Media and Communication, University of Leeds: Deac Rossell, Lecturer in European Studies, Goldsmith's College, University of London; Irfan Shah; Paul C. Spehr, former Assistant Chief of the Motion Picture, Broadcasting and Recorded Sound Division, Library of Congress; and Madeleine Stannell.

For the final chapter, Michael Harvey would like to thank former colleague, Toni Booth, at the National Science and Media Museum, Bradford for her help in accessing the Science Museum registry files and her patience in dealing with various enquiries and requests. The quotations from the Science Museum registry files are by kind permission of the Trustees of the Science Museum. Grateful thanks go to the late Ray Phillips and his family for their kindness in allowing quotes from his letters, and to Jeff Oliphant who gave invaluable assistance and insights into American Edison collectors. Thanks also to Stephen Herbert for so generously sharing information and to Gordon Trewinnard for his kind co-operation.

Finally, our gratitude to Le Giornate del Cinema Muto for making the publication of this book possible.

Foreword

Charles Musser

Richard Brown and Barry Anthony have been long-standing contributors to the intellectual formation focused on the study of early cinema, which emerged as a dynamic field of investigation around the time of the 1978 FIAF Conference in Brighton England and continues to this day.[1] While each have produced significant work in their own right, they may be best known for their previous joint effort, *A Victorian Film Enterprise; The History of the British Mutoscope and Biograph Company* (1999), which detailed the efforts of a turn-of-the century motion picture syndicate that dominated the high end of film production and exhibition in turn of the century England. Since the publication of this important study, the field of film history has been transformed in at least two respects, both of which are very much on display in their latest undertaking, *The Kinetoscope: A British History*. First, the digitization of newspapers and other paper documentation has become so extensive that access to potentially relevant data has multiplied exponentially. It is now possible to locate not just one factual needle in the proverbial haystack of printed ephemera but many isolated facts scattered across many such haystacks. As with their current achievement, this enables a more fine-grained sense of the epoch; but it also means scholars can (and must) ask new questions while looking for new and more specific answers to old ones. Second, film history is increasingly practiced under the rubric of media history. More specifically, the history of early cinema – particularly the history of motion pictures in the late nineteenth century – increasingly falls under the rubric of media archeology.[2]

Edison's peephole Kinetoscope dominated the field of motion pictures for less than two years (1894–95). The several books that have been written on the subject have focused on the United States and concentrated in large part on motion picture production.[3] Its history in Britain has previously received only the most perfunctory of attention. Using the tools of digital and traditional scholarship, Brown and Anthony show how the Kinetoscope provided a crucial basis for later motion picture developments, not only in Great Britain but in the US and internationally. Edison and his long-standing business associates were frankly

inept when it came to effectively exploiting the Kinetoscope in England. By the time that Franck Maguire and Joseph Baucus had taken over, any possibility of a cohesive marketing plan was lost. Maguire & Baucus made credible efforts, but what soon occurred was a disorganized free-for-all. Local entrepreneurs – most notably R. W. Paul – began to make knock-off Kinetoscopes and often sold them using Edison's name. While some dealers made illegal dupes of Edison films, Birt Acres and Paul produced an array of innovative short films that could be used in Edison's (and Paul's) Kinetoscopes and featured British and European subject matter. In short Brown and Anthony show how a fledgling infrastructure developed using the Edison film gauge as a standard; and it was this standard that would ultimately prevail worldwide, in part because it flourished outside Edison's control. In other parts of the world, competing motion picture systems often used a different format and/or a different sized film gauge. In the United States, this included Charles Chinnock with his own version of the Kinetoscope, the Lathams with their Eidoloscope system, the Veriscope, and the American Mutoscope Company with its large format cameras and Biograph projectors. In France, the Lumières, Léon Gaumont, Henri Joly and others also employed different film formats. The English, in contrast, pursued extensions of the Edison system and this provided the basis for what ultimately prevailed worldwide.

Given the various British challenges to his Kinetoscope business, we should not be surprised that Thomas A. Edison and his associates were deeply concerned about the imminent invasion of British projectors and films as the new era of projection began. Consider the opening night programme of Edison's Vitascope at Koster & Bial's Music Hall on 23 April 1896. Three films by Birt Acres were listed on the programme though only one of them was shown. They screened five others, all of which were made by the Edison Manufacturing Company. The unfamiliar British films would have received a warm reception; instead, the Vitascope people attacked their country of origin. The first film to be projected was a tinted print of *Umbrella Dance*, with the Leigh sisters. Dance films had been a popular Kinetoscope genre, and the Vitascope programme began by reprising it by featuring two American ladies. Next came Acres' *Rough Sea at Dover* – an English film which seemed to wash away the lovely dancers and threaten the spectators in the front rows. This inundation produced a fight, for it was followed by *Walton and Slavin*: a burlesque boxing bout between the long and the short of it – the short one being a stand-in for John Bull (England) and his rival evoking Uncle Sam (the US). Next came the *Finale of 1st Act of Hoyt's "Milk White Flag"* (not listed in the programme), in which a large number of Americans in uniform march to band music – as if off to war. This was followed by *The Monroe Doctrine*. Made in preparation for the Vitascope debut, *The Monroe Doctrine* offered a new type of subject matter, a comic allegory that was overtly political. As described by the *New York Herald*, "At first John Bull was shown bombarding a South American shore, supposed to represent Venezuela. John was getting the better of the argument when the tall, lank figure of Uncle Sam emerged from the back of the picture. He grasped John Bull by the neck, forced him to his knees and made him take off his hat to Venezuela. This delighted the audience."[4] With John Bull

put in his place, the final picture of a skirt dance appeared – a return to the kind of familiar, pleasurable American subject matter that was meant to delight the Music Hall's largely male patrons. American order and American dominance had been restored – at least on the screen. This opening night allegory is worth recalling occasionally while reading Brown and Anthony's fascinating history of the Kinetoscope in Britain.

In the past, when examining the introduction of projected motion pictures in the United States, we have tended to pit the Edison Vitascope against the Lumière Cinématographe. Yet Edison and his associates were initially much more concerned about the British threat. Perhaps they were right, for Brown and Anthony provide considerable evidence that the fledgling British film industry had a longer-term impact on the motion picture field than the Lumières. *The Kinetoscope: A British History* does more than fill in a blank space in the historical record: it changes how we think about motion picture practices of the 1890s. Certainly the authors provide us with a sharper appreciation of the international nature of the global film industry. The British must have felt that the initial appearance of motion pictures only furthered the invasion of Americans working in the emergent communication industries. As the authors reveal, the kinetoscope was first introduced in Europe and possibly in England by U.S. citizens of Greek background: George A. Georgiades, George John Tragidis, Demetrius Anastas Georgiades, and Themistocles John Tragidis. Moreover, Franck Maguire and Joseph Baucus were American as were their associates Charles Urban and the wealthy Irving Bush. So too was Birt Acres. This was, of course, balanced by a strong British presence in the early American film industry: W. K. L. Dickson, Albert E. Smith, J. Stuart Blackton, William T. Rock and others.

This rich and detailed history, largely made possible by new research methods, further illuminates one of the characteristic ways in which labor was organized in the nineteenth and early twentieth centuries: partnership. Collaborative partnerships were crucial to the various processes of invention and innovation in the motion picture field. Thomas A. Edison and W. K. L. Dickson invented the first motion picture system. They were followed by the two Lumière brothers in France. In the United States, the introduction of the essential intermittent mechanism for motion picture projection was invented and patented by Thomas Armat and C. Francis Jenkins. In England, this pattern had its counterpart in the Birt Acres-R. W. Paul partnership. Moreover, very much like Edison-Dickson and Armat-Jenkins, their partnership soured soon after they achieved notable successes. Each partner subsequently claimed that he was the one who deserved the lion's share of the credit for the relevant invention. Each has also had his scholarly supporters. In this study Brown and Anthony provide considerable evidence to support their advocacy of Birt Acres, but it will be interesting to see how Ian Christie, who is working on an extensive biography of R. W. Paul, will assess similar evidence. However, it is the recurrent nature of these fraught partnerships that fascinates me. Not only do Brown and Anthony illuminate the ways that partnerships such as Maguire & Baucus were important factors on the

business side, they themselves have forged a successful scholarly partnership that spans two decades. Partnerships often combine complementary skills and resources as the making and the subject of this book so eloquently reveal.

A "media archeology" frame of reference is a useful way to approach *The Kinetoscope: A British History*, in part because some of its leading advocates strongly valorize the investigation of marginal technologies that were quickly forgotten.[5] Such "dead media" offer evidence of different possible media futures even as they proved to be tangential to the major thrusts of technological industrial achievement. When it came to the exploitation of peep-hole motion pictures, the Kinetoscope was soon surpassed by the Mutoscope, while the film industry's commercial and artistic future was in the projected image rather than the peep-show. In this respect, the Kinetoscope's uncertain status is an interesting one. In *The Beginnings of the Cinema in England*, John Barnes asserts that cinema originated with the invention of Edison's Kinetograph camera and the Kinetoscope, a peep-hole viewing device that could show about 20 seconds of film. Cinema thus began in England with the opening of Maguire & Baucus' peep-hole kinetoscope parlor in London on 18 October 1894 – some six months after the first Kinetoscope parlor opened its doors in New York City on 14 April. Not everyone would agree with his declaration. For many scholars (including myself), cinema began with projection. For this achievement, Louis and Auguste Lumière and their Cinématographe system are generally awarded credit. Although such claims to priority require significant caveats, the Cinématographe's commercial debut in Paris on 26 December 1895 was a major milestone that signaled the opening up of a new creative field. Although Edison's initial motion picture system may not qualify as cinema, and the Kinetoscope was soon thrown on the trash heap of forgotten technologies (as Michael Harvey explicates in this book's final chapter), its long-term impact was significant. The very ambiguity of its status makes the Kinetoscope an ideal occasion for the study of ephemeral media technologies.

As a technology, the Kinetoscope was so provisional that it cannot really be said to constitute a discrete, coherent practice. Rather it functioned within a series of overlapping genre categories. It was a novelty in a world where novelties could be exploited for financial gain by savvy showmen. It operated within a tentative world of new communication technologies along with the phonograph and telephone (which the English tended to view as an Edison invention). It thus also functioned within the world of nascent audio-visual reproducibility that eventually became the modern entertainment industry. Not surprisingly many entrepreneurs interested in the Kinetoscope had prior experience with the phonograph. If the Kinetoscope was at the origins of a new kind of communication, it was also functioned within the well-established tradition of optical and peep-hole entertainment that flourished in the late nineteenth century. Many of these elements had come together two years earlier when Ottomar Anschütz's Electrical Schnellseher (or rapid viewer) exhibited commercially in London (see page 16). Yet as Brown and Anthony point out, the phonograph and Kinetoscope

also had affinities with the bicycle for they were often marketed by owners of bicycle shops. Modernity and the ability to change our experience of space and time were one of their shared characteristics. The Kinetoscope was a highly peculiar, fascinating system for creating and reproducing short space-time fragments. Now its history in Great Britain can finally be told, and Richard Brown and Barry Anthony do a brilliant job of exactly that.

Charles Musser
New Haven, CT

Notes

1. What precisely constitutes "early cinema" remains a topic of some debate. Certainly, it refers to motion picture history before the formation of the Classical Hollywood Studio system ca. 1920. In some contexts, it can focus on the "pre-Griffith" cinema, before 1908 when cinema became a form of mass culture and mass entertainment – at least in the United States and parts of Europe.

2. Thomas Elsaesser, *Film History as Media Archaeology* (Amsterdam University Press, 2016), esp. 351–387.

3. Gordon Hendricks, *The Kinetoscope; America's first commercially successful motion picture exhibitor* (New York, Beginnings of the American Film, 1966); Ray Phillips, *Edison's Kinetoscope and Its Films: A History to 1896* (Westport, CT: Greenwood Press, 1997). Of course, the first such history was W.K.L. Dickson and Antonia Dickson, *History of the Kinetograph, Kinetoscope and Kineto-Phonograph* (New York, Albert Bunn, 1895).

4. "Wonderful is the Vitascope", *New York Herald*, 24 April 1896, 11.

5. Erkki Huhtamo and Jussi Parikka, eds., *Media Archaeology: Approaches, Applications, and Implications* (Berkeley: University of California Press, 2010); Siegfried Zielinski, *Deep Time of the Media: Toward an Archeology of Hearing and Seeing by Technical Means*. Translated by Gloria Custance (Cambridge, MA: MIT Press, 2006), 101–157.

Charles Musser teaches Film and Media Studies at Yale University and has written extensively on early cinema. His most recent book, *Politicking and Emergent Media: US Presidential Elections of the 1890s* was published by University of California Press in 2016. His documentary feature *Errol Morris: A Lightning Sketch* premiered in 2014.

Chapter One

The Kinetoscope: An International Perspective

Inventions multiply with increasing rapidity, and discoveries flash as lightning over the land. We cannot, if we would, shut our eyes to the results. J. B. McClure, *Edison and his Inventions*, 1889.[1]

T he world's first practical devices for taking and viewing motion pictures were developed in the United States during the early 1890s. Thomas Alva Edison, the 'Wizard of Menlo Park', had been prompted to begin experiments after a meeting with the celebrated chronophotographer Eadweard Muybridge in 1888. During their conversation, it was suggested that they should combine the phonograph and the Zoopraxiscope projector to create sound-accompanied, motion pictures of famous actors and singers. The limitations of Muybridge's machine made such a scheme impracticable, but Edison, in collaboration with his employees William Kennedy Laurie Dickson and William Heise, started to work on a system which 'does for the eye what the phonograph does for the voice'.[2]

By 1892 the Edison Laboratory had constructed an electrically driven movie camera, employing a 35mm film format that was to become the international standard for many years to come. It did not take long before Edison was predicting the imminent arrival of full-length reproductions of plays and operas, projected life size onto a screen with closely synchronised sound. But prophecy was replaced by pragmatism when the prototype 'Kinetoscope' was publicly unveiled at the Brooklyn Institute on 9 May 1893. The device proved to be an unassuming cabinet peepshow delivering a tiny moving image that lasted for just 20–30 seconds. A 40-foot celluloid band ran continuously (not intermittently) over rollers and was viewed by electric light through a revolving shutter. Financial considerations based on the exploitation of the phonograph had caused Edison to reject the uncertain profitability of projection for the assured income of coin-operated devices. Since the late 1880s he had witnessed the rapid spread of

1

automatic vending machines, at first providing simple items such as sweets and matches and later offering an extended range of products and services. In a flourishing network of 'nickel-in-the-slot' phonograph parlours across the United States, Edison had ready-made exhibition venues for his invention.

The Birth of Commercial Films

Following the construction of a studio, nicknamed 'The Black Maria' after a supposed resemblance to a police arrest vehicle, commercial production of films started on 6 March 1894. The choice of the first subject demonstrated an attachment to celebrity that had been present at the earlier meeting of Muybridge and Edison. Back in 1888 it was proposed that images of renowned Shakespearian actor Edwin Booth were married to phonograph recordings of his voice, now, in March 1894, the internationally famous strongman Eugene Sandow was asked to flex his impressive muscles for public admiration. With the heavy, studio-bound Kinetograph camera and a restricted stage area, performers from the theatre, music hall and circus proved dependable participants in the first films. As Charles Musser observes 'Dickson and Heise kinetographed over seventy-five motion pictures in 1894, and virtually everyone drew on some type of popular commercial amusement'.[3] Although at first attractive, such predictable content was eventually to become a key factor in the kinetoscope's decline.

The Edison Manufacturing Company assumed responsibility for producing the motion picture hardware, whilst marketing was put in the hands of the Kinetoscope Company, a consortium that included Alfred O. Tate (Edison's former business manager); Norman C. Raff; Frank R. Gammon and the Canadian entrepreneur Andrew M. Holland. Already leading exponents of Edison's phonograph, the brothers Andrew and George Holland became the first commercial exhibitors of motion pictures. Ten kinetoscopes were put on display at 1155 Broadway, New York, on 14 April 1894, followed by the same number at a Masonic Temple, Chicago on 17 May. By the end of the year the proliferation of machines throughout the United States had provided a substantial boost to Edison's fortunes. But, following an extremely lucrative financial year (April 1894 – February 1895), sales of film-related business fell away dramatically, giving a clear indication that, in its current form, the kinetoscope had a limited future. In April 1895 Edison attempted to revive public interest by coupling the phonograph and kinetoscope to create the kinetophone, but the lack of genuine synchronisation between sound and image meant that the device received an unenthusiastic reception. The same month saw the multi-talented Dickson leaving Edison's employment to concentrate on developing projected motion pictures.

The story so far will be familiar to students of early film history. Edison's archives and those of Raff and Gammon have provided generations of scholars with a rich source of primary evidence to be interpreted and re-interpreted. Historians such as Terry Ramsaye, Gordon Hendricks, Charles Musser, David Robinson,

Ray Phillips and Paul Spehr have differed on important aspects of emphasis and attribution, but all have agreed on the position occupied by the kinetoscope as

the earliest practical means of motion picture exhibition. In the rest of the world the lack of similar archives and sometimes, it seems, a reluctance to accept the kinetoscope as anything more than a historical curiosity, have largely impeded research. It was not until widespread digitalisation of original material that it became possible to construct a detailed account of the kinetoscope's British, and to a lesser extent, international development.

★ ★ ★

Continental Commerce

Edison's kinescope was shown, at a private preview, in London on 17 October 1894. The device's debut, and consequently the birth of moving pictures in Britain, would probably have taken place around two months earlier had the master plan of Colonel George Edward Gouraud, late of the 3rd New York Cavalry, come to fruition. As Edison's European agent for many years, Gouraud (1842–1912) had been responsible for the exploitation of the new 'Perfected' phonograph since 1888. With a close relationship to Edison and a network of technically minded associates it came as no surprise when, on 17 May 1894, he agreed to pay $20,000 for 100 kinetoscopes. But the colonel's suitability for exploiting the new form of entertainment was open to question. Some felt that he had mishandled Edison's earlier invention in Britain and Europe, continuing to promote the phonograph as an isolated scientific novelty at the time it was rapidly becoming a popular form of recreation in the United States. Whether he sensed he was not the right man for the new venture or whether the large financial outlay proved beyond his means, he was happy to step away from the deal when two fellow Americans made their bid to become Edison's kinetoscope agents in territories beyond the United States and Canada. On 12 August 1894 Franck Zevely Maguire (1859–1910) and Joseph Deyhoe Baucus (1864–1928) were granted the concession for the kinetoscope in South America, the West Indies, Australia and Mexico. Within a month, on 3 September, they obtained sole European rights, an agreement that was extended on 30 October to cover Africa and Asia. To consolidate their international campaign Maguire and Baucus joined with Irving Ter Bush (1869–1948) to found the Continental Commerce Company on 12 September 1894.

The triumvirate seemed well-suited to introduce the kinetoscope to the world. Although he was the youngest of the three, Bush had already travelled widely, circumnavigating the globe on a sailing ship in 1888. On the death of his oil tycoon father in 1890 he became a millionaire, although he continued to work as a clerk for the Standard Oil Company. Franck Maguire was an entrepreneur who had promoted the Edison phonograph and other inventions during the 1880s. A colleague, Charles Urban, remembered that 'he dressed well, was bright and convincing in his arguments and inspired confidence'.[4] As the son of a respected Democrat politician, Baucus had received a good education, attending Princeton University and Columbia Law School before becoming an attorney in a Wall Street law firm. He recovered from a railway accident that killed his wife on their honeymoon to become an urbane pleasure-seeker with a fondness for Paris. The

three men were keen to impress Edison with their energy and business acumen, hoping to establish centres throughout Europe from which they could promote all his inventions.

Earliest European Exhibitions

The introduction of the kinetoscope into Europe had already been widely anticipated in the scientific and popular press and several machines had made their way across the Atlantic by the summer and early autumn of 1894. Colonel Gourard had acquired a sample kinetoscope which he returned to Edison by November 1894, while Irving Bush probably arrived in London by August 1894, ordering ten kinetoscopes and five films.[5] Early in 1895 it was reported that six kinetoscopes sent by Edison to 'a friend on the Continent' had been seized by foreign customs authorities and sold.[6] But the first exhibition of an Edison kinetoscope in Europe was arranged by a group who were outside the inventor's circle of associates. In July 1894, a kinetoscope, owned by American entrepreneurs and purchased in the United States was shown in Paris to Henri Flamans, the editor the periodical *Le Magazine Pittoresque*.[7] Two films were demonstrated, a Spanish Dance (presumably *Carmencita*) and, one of the most popular early kinetoscope subjects, the 1893 version of *Barber Shop Scene*. Falsely claiming to have worked as an electrical engineer in Edison's laboratory for nearly two years, the owner of the device identified himself as Monsieur Georgiadeo.

On 16 July 1894, the same (or perhaps a companion) machine gave the first public display of motion pictures in Europe. The venue, on one of Paris' four grand boulevards, was appropriate for the unveiling of a new entertainment technology. Opened in June 1891, the Salle des Dépêches of the popular weekly newspaper *Le Petit Parisien* provided Parisians with instant news updates, relaying parliamentary debates, stock market details and sporting commentary via a series of telegraph printers. Situated at 20 Boulevard Montmartre, the establishment was redolent of the *Belle époque*, standing out from the busy pavement cafes and up-market shops with an ornate glass and cast-iron entrance canopy. Inside, original designs for some of Paris' most famous illustrated periodicals and a selection of theatrical memorabilia adorned the walls. On its installation, the kinetoscope attracted a rush of curious visitors, including the famed chronophotographer Étienne-Jules Marey. An account of the show published in *Le Petit Parisien* on 18 July 1895 provided a detailed description of the device, although just how the august analyst of human and animal locomotion reacted to the slapstick antics of *Barber Shop Scene* was not recorded.[8] The initiators of this historic exhibition can be identified as 'the Greeks', a partnership of hitherto obscure merchants who have been likened by Deac Rossell to 'fast-disappearing quarks influencing the chain reaction in a laboratory and then vanishing forever'.[9]

Although previously recorded as consisting of only two individuals, the alliance formed to promote the kinetoscope in Europe appears to have been four, possibly five-sided. Until now the only background details concerning the Greeks have been passing references by Frederick A. Talbot and Terry Ramsaye. The former,

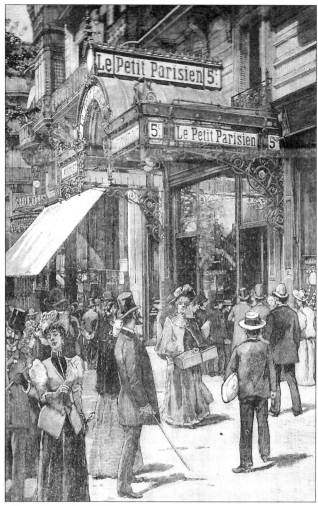

Fig. 1. Venue for the first commercially exhibited films in Europe, the Petit Parisien's *Salle des Dépêches*, 20 Boulevard Montmartre.

in 1912, wrote that they were 'a greengrocer; the other was a toymaker',[10] whilst the latter, in 1926, reported that 'according to tradition, they had been candy merchants or green grocers'.[11] Both sources agree that they had been based in London and had travelled to the United States where they came across the kinetoscope. In fact, they had not made the journey from London or any other European city, but were already ensconced in New York as members of the large Greek immigrant community. Research has established that the men were naturalised Americans, originating in Turkey, but of Greek extraction. George A. Georgiades, who was born in Smyrna in 1859, left Turkey in 1877 and became an American citizen in 1883. On his passport application of 9 November 1893

5

(witnessed by George Tragidis) he described himself as a cabinet maker. Demetrius Anastas Georgiades (1860-?) had left Smyrna in 1875, settling in New York and applying for naturalisation in 1885. When he witnessed George Tragidis' naturalisation application in 1888 he gave his occupation as engineer. George John Tragidis (1867–1923) had arrived in America from Turkey in 1882 and in 1888 was recorded as a salesman. His younger brother, Themistocles John Tragidis (1873–?), might also have been involved with the group. An older man, George Malamakis or Malamackis (1849–1927), may have provided funds for the enterprise. Born in Constantinople, he was variously described as a manufacturer, merchant and, at the time he made his historic trip to France, a confectioner.[12]

By 1894 Demetrius Georgiades and George Tragidis were trading as florists from premises at 1 Columbus Avenue.[13] As New Yorkers they would have been well placed to witness the first kinetoscope exhibitions and, with their business partners, to purchase some of the earliest machines. They chose not, however, to exploit the kinetoscope in their adopted homeland, but instead displayed considerable business acumen by taking it to Paris and London. Following their brief, controversial motion picture venture the partners appear to have gone their separate ways. Although nothing further is known about either of the Georgiades, Tragidis returned to New York where, in 1896, his company was involved in a major fraud case.[14] While continuing to work as a florist, and later a cigarette manufacturer, he became bankrupt at least twice, ending his days as a fruit stand operator. The eldest of the four men, George Malamakis, returned to the US, from England, early in 1896. By 1900 he had found his way to Corunna, Michigan, with a candy store business that added an element of accuracy to Ramsaye's otherwise confusing statement. However ill-remembered and transient their appearance in cinema pre-history, the Greeks were on the scene for long enough in France and England to become a major threat to Maguire's and Baucus' supposed monopoly and a causal factor in the development of motion pictures.

Having agreed to sell 13 kinetoscopes a week for six months and eight machines a week thereafter, the newly founded Continental Commerce Company placed its first order with the Edison Manufacturing Company on 3 September 1894. Fifty individually numbered kinetoscopes were shipped from New York between 13 September and 21 November 1894. Initially two consignments of 10 were sent to Bush and Maguire in London on 13 and 21 September (nos. 118–127, 141–150), followed by a further three to the Continental Commerce Company on 21 November (nos. 307–309). One kinetoscope was sent to John A. Kondylis, Liverpool (no. 179) on 18 October; two to G. E. Tewksbury, Blackpool (nos. 209 and 217) on 24 and 29 October; two to H. Wyndham at an unknown destination (nos. 258–257) on 7 November; three to W. Dower, London (nos. 294–296) on 15 November; two to the General Electric Company, London (nos. 302–303) on 16 November; and three to the Continental Commerce Company, London (nos. 307–309) on 21 November.[15]

Ten machines were publicly exhibited at the company's London headquarters, 70 Oxford Street, from 18 October 1894, with, perhaps, a similar number at their

second showroom at 432 Strand, London, from 9 November 1894. Considering the company's ambitions a surprisingly small number of kinetoscopes were despatched to other European locations. In October two machines were sent to Italy, one to a James P. Milworth (no. 194) and another to G. Bicciulli, care of Questra and Co., 6 Pelioro Grande, Naples (no. 218).[16] Although Mr Milworth's identity and location in Italy remain a mystery, the ordering of the Naples kinetoscope appears to have been arranged by an Italian inventor well known to Edison. Italian expatriate and New York socialite Gianni Bettini (1860–1938) had patented several sophisticated improvements to Edison's phonograph before devising his own remarkable movie camera, but his name on a communication relating to the Naples order is the first sign of an interest in cinematography. Four machines were despatched to P. Soht, Copenhagen (Nos. 211–213 on 26 October; no. 280 on 7 November), presumably connected with the kinetoscope's first Danish exhibition at Vilhelm Pacht's Panoptikon amusement arcade in Radhusplasden, Copenhagen, on 16 December 1894.

Of the Continental Commerce Company's first order for 50 machines 11 were sent to Paris. The Edison Manufacturing Company's shipment record for five (nos. 297–301) sent to a 'Homes Agnew' on 15 November appears to bear mute testimony to an extraordinary human interest story. [John] *Holmes* Agnew (born. c. 1865) was an archetypal black sheep, shaming an old and respected American family as he squandered fortunes on wine, women and flamboyant acts of generosity. To the embarrassment of his uncle, a doctor who had attended President Garfield, and his mother, an eminent writer on religion and history, he was often arrested for drunken exploits which frequently involved molesting young women and assaulting police officers. When his brother, a restraining influence, died in April 1894, a group of friends arranged for Agnew to make a recuperative and constructive new start in a different country. Unfortunately presenting him with $30,000 dollars and sending him to Paris was not a sound business plan. Variously described as a venture to 'introduce a certain well-known commodity'[17] or 'to handle an electrical patent'[18] the scheme held little interest for the dissolute Agnew. Consignments from the United States were left un-opened as he unsteadily worked his way through his windfall. Following this short episode, presumably involving the kinetoscope, he spent some time in England before returning to America. His wild behaviour, frequent arrests, confinement in mental institutions and frequent episodes of begging were regu-larly reported in the popular press, along with the accidental death of his mother Mary Platt Parmele, who left him another fortune in 1911.

Of an altogether more sober and industrious disposition, the brothers Michel and Eugène Werner were already exhibiting kinetoscopes in Paris when they were sent six machines on 9 November (nos. 229–234).[19] After seeing the Geor-giades/Tragidis exhibition they had opened kinetoscope parlour on 1 October at 20 Boulevard Poissonière. A second establishment was opened at 6-8 Place de l'Opera on 5 December 1894, both parlours running in conjunction with their Edison phonograph shop at 85 Rue de Richelieu. Also in October, Shepherd's

7

European Agency advertised in the British press that it was selling Edison kinetoscopes 'with full rights to exhibit in Great Britain' from its headquarters at 41 Rue Lafayette, Rouen. The kinetoscope exhibition at the Salle des Dépêches continued into January 1895[20] with the supervising presence of George Malamakis confirming an ongoing Greek connection.[21]

Contracts with France and Germany

At the close of 1894 and beginning of 1895 the Continental Commerce Company significantly improved its sales figures by negotiating two contracts which parcelled out a large area of Western Europe. On 14 December 1894, an interim agreement was struck with Henry de Fleurigny to exploit the kinetoscope in France.[22] A well-known writer and poet, de Fleurigny (also known as Henri Micard) agreed to buy 300 machines at $305 each; the first 100 to be delivered as quickly as possible with the purchase of the remainder to be set at 15 a month. As with all Continental Commerce Company contracts the purchaser was also committed to take Edison films, an expensive but unavoidable option as no alternatives were available. About a month later de Fleurigny ceded his exclusive rights to the kinetoscope in exchange for a large shareholding in Edison's Kinétoscope Française, a new company set up in Brussels with a founding capital of one million Belgian francs.

The Werner brothers also appear to have been associated with Edison's Kinétoscope Française, advertising on 10 February 1895 that they had the sole rights to sell Kinetoscopes in France. On 1 April 1895, they signed over the lease of their establishment at 20 Boulevard Poissonière to M. De La Valette, director of Edison's Kinétoscope Française, but by April 1896 the company had gone into liquidation, selling off its stock of kinetoscopes for knock-down prices. Despite a gradual decline in trade, Michel and Eugène Werner proved resilient and ingenious operators. With the occasional assistance of their father Alexis and a female backer Adrienne Charbonnel, they organised several companies to promote the kinetoscope, also taking out a French patent for a device that was almost identical to Edison's machine. In May 1895, they negotiated with the American inventor Charles Edward Chinnock for the delivery of a movie camera (see Chapter Three) and by July 1895 Eugène was marketing Edison's fusion of phonograph and kinetoscope as 'le Kinetophonograh'. Eugène maintained an interest in synchronised sound films, advertising the 'Phonothêatroscope' projector in February 1896.[23]

The Continental Commerce Company's second major contract was with Deutsche-österreichische-Edison-Kinetoskop-Gesellschaft, signed on 9 April 1895 and negotiated by the attorney Carl Wilhelm Spitta.[24] Kinetoscopes had recently arrived in Germany, having been exhibited the previous month at the Centralhof Concert Hall, Munster, and at Castan's Panopticum, Berlin. Partly financed by the chocolate manufacturer Ludwig Stollwerck (1857–1922), the new German company was assigned the rights for Germany and Austria-Hungary for three years. Having already purchased five kinetoscopes, the company agreed to take another 45 at once and 250 more to be delivered and paid for at the rate of one a

month starting from 1 July 1895. Standard machines were to cost $300 each and were to be delivered 'immediately or as soon as the same can be obtained from the Edison Manufacturing Company'. Within a few weeks Stollwerck attempted to provide kinetoscope subjects with more regional relevance by inviting Birt Acres to take films of the opening of the Kiel Canal and other German events (see Chapter Eleven). Despite such attempts to boost the kinetoscope's popularity sales declined, forcing the Continental Commerce Company to reduce its prices several times. By February 1896 they were selling machines to the German company for $136, a sum that included a $36 commission to Carl Spitta.

Further Expansion

Outside Britain, France and Germany the progress of the kinetoscope was erratic. After the two machines purchased for Italy in October 1894 there appears to have been little activity until kinetoscope exhibitions opened in via Roma, Turin on 21 April 1895 and in Milan (by 27 April 1895), followed by shows in Messina, Bologna and Palermo. By January 1896, the Continental Phonograph Kinetoscope Company was active in Milan. The first kinetoscope seen in Portugal was exhibited from 6 March 1895 at the Tabacaria Neves, Lisbon, by George Georgiades who had dissolved his partnership with Tragidis just three weeks earlier. In Spain, the device did not appear until 5 May 1895 when it was introduced in a bar at Plaça de la Catalunya, Barcelona. As with France, Belgium's initial sight of the kinetoscope took place under the auspices of a newspaper, *La Chronique* claiming exclusive exhibition rights when it presented a machine at its pressroom in March 1895.[25] In the Netherlands, the presence of an Englishman, Jonathan Lewis Young (1859-1940), provided the Continental Commerce Company with an ongoing cause of irritation. Since leaving Colonel Gouraud's Edison United Phonograph Company, where he had been employed as General Manager, Young had exploited the famous inventor's lucrative name by marketing the 'Edison Commercial Mimeograph' (a duplicating machine) and establishing the 'Edison Phonograph Company'. After losing a long-running legal battle with the Edison-Bell Phonograph Corporation Ltd over the infringement of patents in 1894, he established businesses in Paris and Amsterdam where he continued to trade with impunity. By the summer of 1895 Young was selling kinetoscopes alongside phonographs, trading from 140 Rokin, Amsterdam as The World's Phonograph Company. The first public show in the Netherlands was organised by Karel van Egmond and H. F. Degens who, trading as Edison's Kinetoscope Association, had installed a machine at Reguliersbreestraat 48, Amsterdam, by 27 December 1894.

By the time the kinetoscope reached many areas of the world its popularity in North America and Western Europe had already started to recede. Five machines were sent by Maguire and Baucus from London to Sydney, Australia, where they were first publicly shown on 30 November 1894, but, audiences in New Zealand had to wait until 29 November of the following year to see A. H. Whitehouse's kinetoscope at Bartlett's Studios in Auckland. In South Africa, the kinetoscope was demonstrated to a small group of literary and scientific gentleman in a small

room at the Grand National Hotel, Johannesburg, on 4 April 1895. Fifteen days later its owners, Franks and Stephens, presented it to the public at Henwood's Arcade in the same city. It was not until the winter of winter of 1895/96 that a machine reached Calcutta in India, while the first exhibition in Japan was given in Kobe for the benefit of Crown Prince Yoshihito on 17 November 1896.

The First European Films

Within a few months of the kinetoscope's first exhibition concerns were being expressed about the content of its films. Truncated views of music-hall acts and comic scenes of American life soon lost their novelty, resulting in British and European customers calling for subjects with greater variety and more local interest. Initially it was only Edison who could supply such material and he was uncharacteristically tardy in addressing the demand. As early as 9 November 1894 Maguire and Baucus had asked him to send a Kinetograph camera to Britain, stating that they had already received many requests for scenes taken in Europe. By 9 January 1895 Maguire's frustration over the lack of a European camera caused him to write to Henry de Fleurigny suggesting that he might be forced to travel to the United States to persuade Edison to supply a camera. Edison's delay in sending a Kinetograph had a severe, but in some respects liberating, effect on European exhibitors.

By late July 1895, when Edison's cameraman arrived in Europe, film-making was already a reality. Birt Acres had started filming in England four months earlier, while in June 1895 he had been engaged by Stollwerck to make films in Germany. In London in April 1895 'Up-to-Date English and Continental Films' were offered by Jonathan Lewis Young's newly founded Kinetoscope and Film Company (a mystery, as it is unclear who was able to furnish non-American or non-British subjects at such an early period). In Paris, the Werners, either separately or together, actively sought an alternative to Edison films. A deal was struck with the inventor Charles Chinnock to supply a movie camera and five of his own 'kinetoscopes' by 20 May 1895 (see Chapter 3) and although it is unclear whether the devices ever reached Paris, an advertisement published on 1 June suggests that some form of moving pictures may have been taken. The American Anemoscope, said to be an 'improved kinetoscope', at 16, rue Saint-Marc, reportedly presented: 'scènes animées de la vie parisienne prises sur le vif' ('animated scenes of Parisian life taken on the spot').[26] And before Edison's representative had returned to the United States, Charles Pathé had commissioned Henri Joly to devise a movie camera.[27] By the autumn of 1895 such predictably Gallic subjects as *Le Bain d'une mondaine* were produced using Joly's camera. Of even greater significance was the work of the Lumière brothers who, inspired by a piece of kinetoscope film, had taken their first moving picture on 19 March 1895.

Negative Factors

Viewing kinetoscope films was not an entirely satisfactory experience. An account published in the *Journal of the Photographic Society of India* in July 1896 stressed the brevity and artificiality of the process:

I had an opportunity last cold weather [perhaps in 1895] of viewing Edison's Kinetoscope in Calcutta. It was certainly extraordinary because it depicted what I had just been describing. But the pictures are too small and the duration of the scene too short, to altogether satisfy me. Looking through an object glass into a breast-high box one was first conscious of a whirring sound, then a sparkling light, and presently a picture about 2 in. square appeared. It was a supposed scene at a fire: a fireman in glistening helmet climbs up a very short ladder, and limp female forms appear above him and are handed down over his shoulder one after the other with a rapidity only more startling than the decorous adjustment of their garments. Having caught the hang of it, I was about to settle down comfortably to a good view when the whirring suddenly ceased, out went the lamp as I appealed to the showman. There's nothing wrong – that's all he said. Oh! That's all is it – It looks very indistinct, and the movements are too rapid to be grasped with advantage. Mayn't I have it all over again – The operator was very obliging, and I had a second performance. When I had taken breath I began to ask questions. There was an absence of smoke, bustle, crowd, &, about the fire which was more suggestive of a carefully planned performance in a well-lighted studio than a scene taken at a real fire – and then I bethought me of a description I had read of Edison's works where there was a studio for acting of these pieces.[28]

In Nottingham, England, Sydney Race first encountered the kinetoscope in February 1895:

During this month Edison's last greatest invention – the Kinetoscope showing living figures – has been on exhibition in a shop on the Long Row. The figures were contained in a big box and one looked down through a glass and saw them within.

I saw at different times a dancer and a barbers shop the latter with several figures and everything was true to life. The figures appear a brilliant white in outline on a black background but in the barber shop it was possible to distinguish a negro from the white man. The figures have been photographed continuously and two or three thousand of them are whirled before your eyes by Electricity in less than a minute.[29]

On first seeing projected films Race commented 'the pictures lasted about a minute and unlike the kinetoscope did not seem to disappear almost as soon as they appear'.[30]

The kinetoscope lacked the physical and economic flexibility of its older sibling, the phonograph. The latter device was often cheaper, more portable, could be exhibited to several people at one time, was able to draw on a large repertoire of commercial cylinders and could even manufacture its own recordings. During 1895 there were several attempts to provide the kinetoscope with added novelty value. But, despite the introduction of an enlarged machine for showing prize-fights, hand-applied colour, sound accompaniment via phonograph cylinders and the advent of films depicting European subjects there was a falling off in interest that led to drastically reduced sales. It was a situation that largely mirrored developments in the American market. There were elements that detracted from the profitability of the device both in large towns and cities and in less heavily populated areas. Throughout Europe peripatetic showmen could utilise a network of fairs and festivals that attracted high concentrations of visitors. However,

the wear and tear of constant travelling and the need to frequently replace electric batteries made touring exhibition an expensive business. While the urban kinetoscope show had the benefit of large numbers of potential customers, its static nature meant that to avoid staleness film subjects needed to be changed on a more regular basis. Even when cheaper, British-made kinetoscopes were available running costs were substantial.

Perhaps the greatest factor influencing sales was that the kinetoscope had been pronounced obsolescent before it was launched. When audiences examined the device's diminutive pictures, they were already looking forward to seeing large-scale motion pictures projected onto a screen. Edison, a 'machine man', had put his financial faith in the kinetoscope, but even he was compelled to acknowledge the attraction of the projected image. In a widely-syndicated interview published in April 1894 (the same month as the the first commercial exhibition of the kinetoscope) he explained how he had already experimented with projection and foresaw 'throwing scenes from the Kinetoscope on a large screen by means of a stereopticon'. For a hard-headed scientist, he displayed a distinctly emotional response, enthusing 'You should see the figures on the screen'.[31]

The public were familiar with various kinds of projected images. As Charles Musser reflected 'the idea of adapting Edison's moving pictures to the magic lantern or stereopticon was so simple and straightforward that it undoubtedly occurred to hundreds, probably thousands, of people who peered into the kinetoscope'.[32] For more than a century magic lantern showmen had utilised slides, dissolves and ratchets to achieve a limited illusion of movement, while in more recent years short sequences of photographs had been projected by the chronophotographers Eadweard Muybridge and Ottomar Anschütz. From 1892, the Musée Grevin in Boulevard Montmartre, Paris (close to the scene of the first public kinetoscope exhibition), presented Emile Reynaud's *Pantomimes Lumineuses*, a projected series of animated painted images. At their parlours in the United States in 1894, Gray and Otway Latham pushed at the technical boundaries of the kinetoscope by installing devices specially enlarged to show boxing matches. Intent on achieving projection, they collaborated with their father Woodville Latham and W. K. L. Dickson to produce the Panoptikon which gave the first public screening of movies on 20 May 1895. In the same month Birt Acres patented a movie camera that was also intended to function as a projector.

A strip of kinetoscope film provided the direct inspiration for the first projected European films. In the summer of 1894 Antoine Lumière returned to his successful photographic paper and plate factory in Lyon from Paris carrying with him a fraction of *The Barber's Shop* that he had obtained from an unnamed kinetoscope showman. Given that the only kinetoscope show operating in Paris at the time was that of Georgiades and Tragidis it must be assumed that the influence of the 'fast-disappearing quarks' was once more in evidence. The Lumière Company's chief mechanic, Charles Moisson (1863–1943), later recalled how Antoine explained the financial significance of the piece of film. Addressing those present in his office he suggested, 'this is what you have to make, because Edison sells

this at insane prices and the agents are trying to make films in France so they can get them cheaper'.[33]

Antoine's economic prescience was soon acted upon by his sons Auguste and Louis. Within a few months, assisted by Moisson, they had constructed a movie camera which also acted as a film printer and projector. The first public display of their Cinématographe took place on 22 March 1895, the single subject projected showing a stream of employees pouring out of the gates of the Lumière works. Several more scenes were obtained near the Lumière homes and factory, supplying the programmes for several trial exhibitions that were given during the year. After an extended period of planning the Lumière Cinématographe was first presented to a paying public at the Grande Café, boulevard des Capucines, Paris, on 28 December 1895. In marked contract to Edison's dilatory approach the Lumières went about the exploitation of the Cinématographe in a premeditated and highly organised way. Before the first public show an order for 25 machines had already been placed (soon followed by another for 200) and the brothers had initiated the recruitment and training of a small army of camera operators. As a lightweight, versatile machine the Cinématographe conferred on its user both freedom of movement and accessibility, providing the means to record scenes of everyday life and major state occasions. During 1896–1897 Lumière cameramen roamed the world, filming subjects which were shown locally and then added to a growing catalogue of international views. By 1896 Charles Moisson, the unknown mechanic from a provincial factory, had became Charles Moisson, famed international cameraman, capturing subjects in Germany, Austria-Hungary, the United Kingdom, Italy and Russia.

When the kinetoscope was first exhibited in Europe its arrival had been long anticipated. During the first half of the 1890s the commercial success of the phonograph and other mechanical forms of entertainment had inspired inventors across the world to intensify their attempts to create 'animated photographs'. Various exhibition possibilities were envisaged, ranging from individually viewed domestic or public devices to small or large scale projected displays. Although it was not clear which form would predominate, a multiplicity of showman and entrepreneurs closely monitored international developments whilst waiting their chance to exploit the latest scientific wonder. In the United Kingdom, the kinetoscope was quickly absorbed into the various fields that constituted popular entertainment, with its short American films and their more innovative British counterparts providing a tantalising glimpse of what motion pictures might one day become.

Notes

1. J. B. McClure, *Edison and his Inventions* (Chicago: Rhodes and McClure Publishing Company 1889), 18.

2. Edison patent caveat, 8 October 1888, Thomas A. Edison Papers Digital Edition PTO31AAA (10 February 2017) http://edison.rutgers.edu.

3. *Musser, The Emergence of Cinema*, 78.

4. Urban, *A Yank in Britain. The Lost Memoirs of Charles Urban*, 43.

5. Shipping order, 11 August 1894, TAED D9428AAA (10 February 2017).

6. *Greenock Telegraph and Clyde Shipping Gazette* (18 February 1895): 4.

7. *Le Magazine Pittoresque* (July 1894): 247–248.

8. *Le Petit Parisien*, no. 6473 (18 July 1894): 2.

9. Herbert and McKernan (eds.), *Who's Who of Victorian Cinema*, 57.

10. Talbot, *Motion Pictures* (1912), 33.

11. Ramsaye, *A Million and One Nights*, 138. It is likely that both Talbot and Ramsaye received their information about the Greeks from R. W. Paul. If this was the case one wonders if the British film pioneer had an ulterior motive in suggesting that they came from London, rather than New York.

12. Cleveland Street Directory 1895 lists George Malamakis and Constantine Cheronis as confectioners at 350 Erie.

13. Ramsaye records the delivery of kinetoscope to George Georgiades and Tragidis at 1 Columbus Avenue in August 1894.

14. Having offered to sell goods such as eggs, poultry, glassware, cigars and bicycles on commission George J. Tragidis and Co. vanished from their New York address owing an estimated $15,000. They appear to have been involved in a wider criminal conspiracy. See *New York Herald* (16 August 1896): 4.

15. Shipping account, 21 November 1894, TAED D9428AAL (10 February 2017).

16. Maguire and Baucus to Edison Manufacturing Company, 3 October 1894, TAED D9428AAH5, and TAED D9428AAH4 (10 February 2017).

17. [New York] *Evening Telegram* (23 March 1899): 1

18. *New York Press* (12 August 1897): 7.

19. Maguire and Baucus to Edison Manufacturing Company, 9 November 1894, TAED D9428AAJ2 (10 February 2017).

20. *Le Petit Parisien* (30 January 1895): 4.

21. *L'Univers Illustré* (15 December 1894): 790. George Malamakis was issued with an American passport on 16 June 1894, witnessed by George Georgiades, 1 Columbus Avenue, New York.

22. Contract, 14 December 1894, TAEB HX94121 (10 February 2017).

23. *Le Petit Parisien*, No. 12115 (26 February 1895).

24. Contract, 9 April 1895, TAED HX95131 (10 February 2017)

25. See Convents, Guido, 'Edison's Kinetoscope in Belgium, or, Scientists. Admirers, Businessmen, Industrialists and Crooks', in Claire Duprié la Tour, André Gaudreault and Roberta Pearson (eds), *Cinema at the Turn of the Century* (Lausanne: Payot, 1999): 249–258.

26. *Le Petit Parisien* (1 June 1895): 4.

27. Patented 26 August 1895.

28. *Journal of the Photographic Society of India* (July 1896): 110–111.

29. Race, *The Journals of Sydney Race 1892-1900*, 50.

30. Ibid., p. 79.

31. *St Paul's Daily Globe* (8 April 1894): 18.

32. Musser, *Emergence of Cinema*, 91.

33. Charles Moisson quoted in Rossell, *Living Pictures*, 128.

Chapter Two

The Arrival of the Kinetoscope in Britain and Early Developments

The earliest references to Thomas Edison's *ideas* (not actual accomplishments) concerning film production and exhibition procedure were published in Britain in February and March 1890.[1] All originated from a report in the *New York Herald*, 'To Catch a Speaker's Gestures', published in the issue for 2 February. Claims were made in this article for successful simultaneous sound and film recording, with the results 'projected by a magic lantern to the size of life'. A film exposure rate of from eight to twenty pictures per second was given, which was far less than Edison's later, and much repeated, figure of 46 fps. The impact made by these early and isolated notices should not be over-emphasised. While of considerable interest to film historians, no contemporary evidence has been located that subsequent British comment resulted, and indeed this is perhaps not surprising, for unsubstantiated claims for various innovations made by Edison were of quite frequent occurrence.

However, the *Photographic News* report of 7 February appears to have been read by the persistent British opportunist William Friese Greene, who wrote to Edison three days later.[2] He then arranged for the *Photographic News* to print a description of his 'Machine Camera' in their issue for 28 February probably in the hope of interesting Edison and obtaining a job from him. Indulging in Edison-style exaggeration, Friese Greene promoted the impression – with the inclusion of the caveat 'hopes' – that his interests were similar to those that had been reported of Edison's, and speculated that:

> By an improvement upon that lantern, now in course of manufacture, Mr. Greene hopes to be able to reproduce upon the screen, by means of photographs taken with his machine camera, street scenes full of life and motion; also to represent a man making a speech, with all the changes in his countenance, and, at the same time, to give the speech itself in the actual tones of the man's voice by means of a loud-speaking phonograph.[3]

By the time that a second batch of early notices were published in Britain in May 1891, Edison's purely visionary claims had been replaced with a modicum of actual accomplishment. Once again, the source was second-hand, this time the Dalziel news agency, whose reporter had been shown a prototype 'Kinetoscope' viewing cabinet, and a length of film taken on a horizontal-feed camera. A report was published in *The Times*, which had a link-up with the Dalziel agency and the same source was credited by *The Photographic News*.[4] A search has not revealed any further notices published by the photographic press.

A development of more substance was the appearance in Britain of the 'Schnell-seher' (Rapid Viewer) promoted under the title of 'The Electrical Wonder' This coin-operated peep show viewer which used glass plates rather than celluloid film was developed by the German photographer Ottomar Anschütz, a specialist in 'instantaneous' photography, and was built for him by the Siemens company. An exhibition featuring twelve of these machines opened in a shop on the Strand, opposite Charing Cross Station in December 1892. Short, 20 second views of dancing girls, marching soldiers, gymnasts, and performing dogs were shown stroboscopically illuminated. A second exhibition was opened at the Crystal Palace, and initially both flourished, but business levels were not maintained, and by the summer of 1893 business at the Crystal Palace show was moribund, and the Strand exhibition also failed to maintain public interest and was closed in December 1893.[5] The chronology of its commercial history was strikingly similar to the later trajectory of the kinetoscope.

The world's first kinetoscope 'parlor', or shop presenting a film exhibition, opened in Broadway, New York, on 14 April 1894. A month later, in conversation with Edison, Colonel George Gouraud his British Agent for the phonograph, expressed an interest in acquiring a sole foreign sales concession.[6] Gouraud's apparently voluntary offer was that he would order 25 kinetoscopes a week for a year – a total of 1300 machines. Not surprisingly Edison agreed to this proposal, although with an understandably cautious caveat – 'if I can deliver at that rate'. He required Gouraud to place his orders in batches of 200 at a time, and agreed to supply each machine – minus batteries and films – for $200, with an enforced selling price of $300. Gouraud's initial investment was set at $20,000, or 50% of the total of the first order. Significantly for Gouraud's chance of future success in the venture, Edison insisted that no company could be formed 'employing the name of "Edison" either directly or indirectly ...'[7] Gouraud accepted these terms on 17 May and confirmed his first order for 100 (rather than 200) kinetoscopes.[8]

It was perhaps after receiving negative responses from potential investors that Gouraud realised that Edison's close involvement was essential for future success. He therefore attempted to manoeuvre himself into a better position, proposing to Edison on 6 July – only seven weeks after agreeing to terms – that Edison should in fact agree to link himself to a 'corporation for the promulgation of his kinetoscope business' and that he should also agree to send William Dickson to London to assist in setting-up and exhibiting the first ten machines, evidence in itself of a significant scaling-down of his original intention to take 25 machines

every week. Edison rejected both proposals without contacting Gouraud personally and left it to his General Manager W. E. Gilmore to draft a negative reply.[9] It was apparent by early July 1894 that his agreement with Gouraud was impractical.[10] In the meantime, potential revenue was being lost, and it was evident that an alternative marketing arrangement, especially for the important British and European territories would have to be made without delay.

An alternative to Gouraud was soon found. By the time that he became involved in the kinetoscope business, Franck Maguire had accumulated a varied commercial career – which often intersected with Edison interests – including involvement in journalism, office equipment supply through a 'concession' for the Edison mimeograph, and a phonograph agency in Philadelphia. He later worked at the Edison General Electric company, and, when General Electric was reorganised in 1892, applied unsuccessfully for a job at the Edison laboratories in Orange, New Jersey. The following year he was working for the Eastern Rubber company in New Jersey, and then returned to the phonograph business. In common with other restless opportunists, Maguire became interested in the commercial potential of the kinetoscope. Just two days before the first commercial exhibition opened in New York in April, he had enquired about kinetoscope prices, and by July had, probably for financial reasons, formed an association with Joseph Baucus, a New York lawyer, and opened a kinetoscope exhibition in Brooklyn.[11]

No doubt by making use of Baucus' Wall Street contacts, the partners were able to locate and interest a young multi-millionaire, Irving Bush (1869–1948) in their future Edison-linked plans. Now adequately financed, their business was of interest to Edison, and on 12 August 1894 he awarded them kinetoscope distribution rights for the secondary territories of Mexico, South America, the West Indies, and Australia. Although territorial remoteness and language were presumably problematic, Maguire and Baucus produced good results in the circumstances, purchasing over $16,000 of goods from the Edison Manufacturing Company between July and October 1894.[12]

On 30 August, only just over two weeks after receiving their first territorial concession, Maguire and Baucus wrote to Edison to ask him to award them the potentially valuable British and European agency. This is a most interesting letter for its disclosure that the partners – and especially Bush – intended to use the film exhibition business merely as an introduction to a much more ambitious involvement with a range of Edison products. It was the prospect of a long-term commercial relationship with Edison in the industrial area – Bush already had substantial investments in industrial manufacturing and transportation – rather than film-exhibition, that Bush wanted to gain access to, as Maguire and Baucus made clear in their letter:

> ... his purpose in coming into this business with us is not merely to form a connection for the purpose of selling Kinetoscopes, but to establish agencies in the various European countries which will enable us to market your new inventions as they are brought out; and with him back of us we will be in shape to put in any reasonable

amount of money that is necessary to insure the proper handling of that part of the business.

We tell you this in order that you may see that we are going into this thing, not alone for what money we may make out of the Kinetoscope, but with an idea of establishing here a permanent business and permanent agencies in all of the important foreign centres, and be thus enabled in future to further your interests as well as our own. We intend to so handle the Kinetoscope business, if it is placed in our hands, that you will not hesitate to allow us to market all your future inventions that you may put out ...[13]

This letter challenges early film historians to abandon a retrospective view of film history based on film's later commercial and cultural importance, and to accept instead the validity of a contemporary perspective which could assign films to a secondary, rather than an inevitably central position and did not necessarily consider them as having either a long-term or important future. It was the kinetoscope *machine*, 'branded' with Edison's name that was regarded as of most importance in attracting purchasers, and this will become especially apparent when British promotional advertising is described. In the present case, the kinetoscope business as a whole was itself secondary to its assigned role of a strategic ploy to be used to achieve an intended wide-ranging future distributive and agency relationship with Edison and his world-wide business activities.

Engaging with this situation suggests that it may be productive to briefly examine – from an empirical position – a perspective of early film history which has not been considered adequately in the past. It is a main theme of this book to describe various forms of market mechanisms that were created to deal with different aspects of the kinetoscope business, and thereby to define the level of commercial sophistication present. In doing this it becomes clear that there were complex motivational factors present which influenced both decision-making and subsequent actions.

Accepting that, in the present case, objectives unrelated to the kinetoscope business nevertheless affected the character of decisions taken by Maguire and his partners, a couple of examples can be selected to demonstrate this effect. First the question of kinetoscope profit and return-on-capital can be examined. Were results in this case 'negotiable' to a lower level, as an acceptable price to pay to keep alive the prospect of a *future* greater prosperity gained by distributing an increased range of Edison products? Was the partners' later involvement in an English legal case – to be described – less concerned with protecting their own position against fraud, and more as a practical demonstration of the extent of support they were willing to give to Edison to show that they were worthy of his future patronage?

In outlining their marketing plans for the kinetoscope, and confirming their perception of the business, Maguire and Baucus told Edison what he wanted to hear – that it was the sale of machines on which they intended to concentrate:

We propose putting in at least $20,000 now, and propose establishing agencies in London, Paris, Berlin, and Vienna as quickly as the machines can be furnished...We

do not intend to make the exhibition of the machines our chief source of revenue, but on the contrary merely as a method of advertising the machines, and in that way selling larger numbers than could otherwise be done. In other words, we intend to make the selling of machines our chief business ...[14]

Why this 'introductory' letter was written is not clear, since it is evident that two days earlier Edison had already discussed European distribution matters with the partnership and had come to a decision to allow them to replace the failing Gouraud. On 28 August Edison cabled Gouraud 'Parties here want to buy some or all your machines will relieve you at cost whole thing'. Gouraud agreed on the same day to 'cancel everything', no doubt grateful for his release from an untenable agreement of his own making, and the prospect of being sued by Edison for breach of contract.[15]

On 3 September Edison confirmed his agreement to Maguire and Baucus having 'the sole right to sell and exhibit my Kinetoscope in Europe'.[16] Purchasing terms were notably more realistic than the levels that had been suggested by Gouraud, and it is possible that Edison may have based the targets he set for Maguire and Baucus on the kinetoscope production capacity of his manufacturing company since he would have had no information available of likely demand in either Britain or Europe. An initial order for 50 machines was to be followed by orders for 13 machines a week for the first six months of the agreement, which then reduced to eight machines thereafter. In terms of the first year's British and European operation, Edison therefore expected to supply 596 machines at $200 each ($119,200). He stipulated that the kinetoscopes were to be sold for $300. In fact, in Britain Maguire's price was £70, which, at the prevailing exchange rate of just under $5 to the pound, meant that Maguire had increased his margin per machine by approximately 15% from the figure set by Edison.

Maguire and Baucus paid Edison an initial deposit of $5,000, on 5 September (25% of their alleged liquid capital) which represented 50% of their initial order total.[17] No target was set for films, which were priced, as they had been to Gouraud, at $10 each. Once again Maguire inflated the price he charged when he arrived in England, from an intended £2 to an actual £3. The initial films order placed by Maguire and Baucus for the British and European market was 100 prints featuring a wide selection of subjects which are noted and discussed in Chapter Seven.[18] In the event Maguire and Baucus' total purchases from the Edison Manufacturing company fell substantially below the figure that Edison had set. For the full year from October 1894 to September 1895, they spent $85,697 (and this included films, batteries and additional machine items) a shortfall from the kinetoscope-only required purchasing target of 28.1%.[19]

Unlike the Gouraud arrangement, there is no suggestion in surviving documents that Edison's agreement with Maguire and Baucus included a prohibition against forming a national company to promote the kinetoscope. Britain would have been an obvious place to do this, but in fact nothing of this kind occurred, which indicates that there was in fact an 'understanding' on the part of Maguire and Baucus that they were not allowed to follow this procedure. This interdiction is

understandable if considered solely from Edison's perspective of wishing to retain control over the activities of his concessionaires, and preventing his name becoming involved in any commercial or financial scandal that they might create. But at the same time, it narrowed the sales base of potential kinetoscope customers considerably. Investing in an Edison kinetoscope in Britain could now only be done directly – by buying a machine, personally exhibiting it, and then relying for return on capital from the chance level of receipts obtained. Had the alternative, of equity investment through the formation of a joint-stock, limited liability company existed, third party investment could have been accessed and this would have enabled accelerated growth to occur. A regionally- based structure of kinetoscope companies, each with a stipulated number of machines contracted for – like the arrangement actually created three years later by the British Mutoscope and Biograph Company – would certainly have benefitted Maguire and Baucus' stated intention of creating profit primarily by the sale of kinetoscopes.[20]

Franck Maguire and his wife Maud, travelling as first-class 'Saloon' passengers, sailed to England from New York on board the *Trave*, arriving at Southampton on 23 September 1894.[21] In London Maguire linked up with Irving Bush who had probably arrived in England before him. Arrangements were made during the next three weeks to prepare the shop at 70 Oxford Street (a main London retail street with a high customer flow) for the opening on 18 October, and to arrange for a prior press reception to launch 'Edison's Latest Wonder'.

Although the film exhibition at 70 Oxford street is undoubtedly the first in Britain *for which positive documentation exists*, there must be considerable doubt about its precedence. Maguire himself informed Edison in a letter written on 9 November 1894, that 'There are at present in London about five kinetoscope exhibitions ...'.[22] and it seems unlikely that all these shows had appeared between 18 October and 9 November. George Tragidis, an American-Greek showman who has an important part in the British kinetoscope story, is known to have arrived at Southampton from New York on 12 September, and so it is quite possible that he, or his associates, may have established a show at Queen Street before 18 October. Notwithstanding Maguire and Baucus' 'sole' selling agreement for Britain, the British market appears to have been regarded as an unrestricted 'open' territory for kinetoscope dealers at the time they arrived in London. The following advertisement for example appeared in *The Era* on 10 November 1894:

EDISON KINETOSCOPES
ON SALE.

With Full Rights to Exhibition in Great Britain.
At Shepherd's European Agency France.
41, Rue Lafayette (Saint Sever) Rouen France.
Wonders of the Kinetoscope.
M. Edison is the miracle worker of the modern world.
The newest of his inventions is now on sale at Shepherd's European Agency, 41, Rue Lafayette, Rouen. [23]

Fig. 2. Oxford Street Parlour, *Westminster Budget* (26 October 1894).

The internal appearance of the London Oxford Street shop is shown in a sketch published in *The Westminster Budget* journal a week after opening.[24] Similarities with the New York 'parlor' opened six months earlier, show that the London shop design had been modelled on it.[25] Both venues arranged their ten kinetoscopes in two back-to-back rows of five machines. A surviving machine used in the London presentation had metal struts and protruding bolts and nuts fixed to its wooden case in order that it and the other machines could be locked together on the shop floor.[26]

The use of potted palms as decoration functioned as a reassuring visual indication to patrons of social respectability, and this 'message' would certainly have been recognised, especially by middle and upper- middle class patrons who decorated the reception rooms of their own houses in a similar way. Some shows, such as the one held in Newcastle on Tyne in January 1895, made a point of emphasising in newspaper advertising that their kinetoscope exhibition was suitable entertainment for a family visit.

'The International Kinetoscope Company' established at 83, Regent Street in London, included this explicit statement in the advertising leaflet they produced.

Fig. 3. Family orientated advertising for an exhibition at Mawson, Swan and Morgan's store, Newcastle, January 1895.

TO THE LADIES

Ladies are specially invited to these exhibitions. Ladies without escorts need not feel any timidity or restraint about attending, for these exhibitions are in charge of ladies and gentlemen, and the surroundings will be found all that a refined, or even fastidious person could desire.[27]

A few days after the opening of the Oxford Street shop a reporter from the London *Evening News and Post* went to see the exhibition:

I directed my steps to the shop and looked in at the window. This was the sight that met my gaze. Ten box-like arrangements, half table, half cupboard, a respectable-looking gentleman in a top-hat peering into the top of each, and occasionally giving vent to a chuckle, a paybox with a beautiful young lady in it in the corner, a gentleman inside the two rows of boxes explaining the show, Mr. George Grossmith awaiting his turn at the end of a row. Determined to know all about it I went in and asked for the manager, introduced myself, inquired the wherefore of the top-hats and boxes. "Don't you know?" he replied, "Why, this is Edison's Kinetoscope. We opened here just four days ago, and you can see how the people are flocking in".[28]

About 50 press notices related to the opening of 70 Oxford Street have been examined, and, while it is true, as Maguire reported to Edison, that many are positive in tone, not all were. It is also evident from the extent of repetition – sometimes word-for-word – shared between a number of unrelated newspaper titles, that some reviews were copied either from a pre-prepared press release, or from an information sheet written by Maguire. *The British Journal of Photography* remarked rather sourly:

What we of the photographic world are possibly more immediately concerned in

is to know how much of the Kinetoscope, which is just now being so seriously boomed, is due to the "inventive genius" of Edison? A significant feature of the boom is that the photographic press has not been invited to "do" the Kinetoscope. On the whole, perhaps the omission is a wise one.[29]

The Westminster Budget also had some reservations, considering that:

> The present exhibition ... suffers by the smallness of the pictures and the want of clearly defined light and shade, as well as by the inconvenience of looking down into the instrument. The inventor intends in future developments to throw moving pictures of life-size figures on the screen[30]

More serious from the point of view of the claimed 'novelty' of Edison's invention were three rebuttal letters published in the leading British newspaper *The Times*, suggesting that the kinetoscope was nothing new because of its similarity to small optical toys like the zoetrope which had been known for many years. Maguire was evidently concerned about the effect these criticisms might have on investors, because he wrote to the editor in a letter published on 6 November:

> As Mr. Edison's representative and in justice to him, I desire to state that he frankly acknowledges, in a letter published in the June issue of the *Century* Magazine, that the fundamental principle of the kinetoscope is a perfection of the crude idea of the zoetrope of ancient origin... In the kinetoscope are exhibited from 760 to 2,600 pictures at each view. The record of the scene is absolute, and thousands of people who have seen the invention since it has been on exhibition in London will verify this statement. All pronounce it marvellous and I simply write this note for the benefit of those who may be led astray by correspondence from persons who know nothing about the present invention. Mr. Edison's name is a guarantee in itself to the public.[31]

Maguire wrote to Edison in early November, stressing the prestigious reception the kinetoscope had received, and of course the care and attention that was being given to its promotion in England:

> The newspapers have treated the invention in the most friendly and enthusiastic way ... We have in London the handsomest and most complete Kinetoscope exhibition in the world ... This exhibition has averaged between £17 and £18 per day since opened ... we are getting all the swells, and in fact, I never before have seen such a fashionable crowd in a Kinetoscope exhibition. I received a note from the Secretary of the Prince of Wales, and expect shortly to have a private exhibition before him.[32]

Ignoring the 'social recognition' assertions designed to impress Edison, attention can be focussed instead on the money-taking claim which it is possible to test for credibility to gain an idea of what level of patronage the exhibition was likely to be attracting. Two price levels were charged when the Oxford Street shop opened, five 'views' for a shilling, (12d) and all ten views for one shilling and sixpence. (18d).[33] Thus a single machine average was either 2.4d or 1.8d, with a united mean paid of 2.1d. £18 equals 4320 pennies – if divided by ten, an average daily 'take' per machine of £1 16s. Therefore, at an average paid of 2d, it would require 216 customers per machine per day to reach this total.

There is fortunately an American equivalent available for comparison. Gross

receipts produced by the New York Kinetoscope Company exhibition of ten machines in one year from April 1894 to March 1895, amounted to $16,171, or approximately £3234 at the prevailing exchange rate of nearly five dollars to the pound.[34] On the assumption that New York ran a six-day operation (i.e. closed on Sundays) gross daily receipts were just short of £11 a day, or 39% less than the claimed London level. Even when an allowance is made for the fact that the New York figure covers a full year, during which demand would naturally be expected to be less than the levels of initial enthusiasm being experienced during the kinetoscope's first three weeks' exhibition in London, the difference is so great that it reinforces the impression that Maguire had moved from exaggeration to deception in his claim for the London daily revenue he made to Edison.

It will be recalled that Maguire and Baucus had assured Edison that their 'chief source of revenue' would come from the sale of machines rather than from the receipts generated from exhibiting films, but initial experience in London attempting to sell kinetoscopes was evidently not encouraging, and, as Maguire admitted to Edison, he and Bush had found that genuine customers were rather hard to find:

> From time to time we have had numerous promoters and other individuals in with offers to take a very large number of machines. ... all want to get into the business without putting up any cash ... One party ... wanted to get a number of Kinetoscopes by the payment of One Pound deposit on each machine.[35]

A breakdown of the destination of the initial 50 kinetoscopes ordered shows that in the period from 13 September to 21 November, 23 (46%) were sent to Maguire and Baucus in London. Since ten of these machines were on permanent display at the exhibition in Oxford Street, and at least another six must have been on show at the Strand exhibition that opened on 9 November, Maguire could not have sold more than seven kinetoscopes in the first month after his arrival. This was not a good result, especially when facing imminent competition.

When the advertising campaign is discussed, it will be seen that the solution chosen to counter the evident problem – existing it should be emphasised from the very beginning in Britain – of selling expensive goods, was not to highlight quality or 'novelty', or even to promote endorsements from satisfied customers, but to again make exaggerated claims for the level of return which could be expected from an investment in a kinetoscope. The advertising that Maguire and Baucus placed on a regular basis in *The Times* and in provincial cities such as Birmingham and Leeds always included the line 'Machines earning 1,000 per cent on investment'.

The Greeks

According to the deposition statements made by George Tragidis and Demetrius Georgiades in the Continental Commerce Company 'passing off' case, they had purchased three kinetoscopes directly from Edison [Edison Manufacturing Company?] in, or before, June 1894.[36] On 14 June George Georgiades witnessed George Malamakis' passport application, suggesting that both men may then

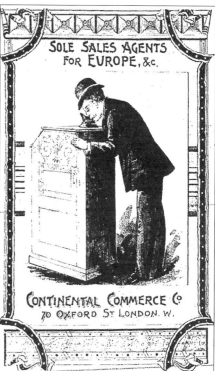

Fig. 4. Front and back cover of a Continental Commerce Company advertising leaflet, c. 1894.

have travelled to Paris to demonstrate the kinetoscope to the press in July and to open an exhibition at the *Petit Parisien's* Salle des Dépéche, 20 Boulevard Montmartre, in the same month.[37] Further kinetoscopes, films and machine parts appear to have been purchased in August and delivered to the Georgiades/Tragidis premises at 1 Columbus Avenue.[38] George Georgiades left France at the end of August, sailing from Le Havre to New York on the *La Bretagne* as a steerage passenger (the cheapest form of accommodation available). He gave his age as 34 and his occupation as 'traveller', i.e. salesman.[39] Arriving in New York on 3 September, he probably collected further kinetoscopes and films from Holland Brothers. The Kinetoscope Company's account with Holland Brothers records three payments amounting to $940 (excluding an 'express' payment of $2.25) made between 11–14 September 1894 for order number four, one of which was a cheque for $497.50 from George Tragidis.[40] The cheque must have been delivered earlier or by another person for 'George Tragidas', giving his age as 25 and his occupation as 'merchant', arrived in Southampton from New York on the *City of Paris* on 12 September.[41]

The English show, under the business title of 'The American Kinetoscope Company' was established at 95 Queen Street, on the corner of Cheapside, with

a sign reading 'Edison's Marvellous Kinetoscope' in the window and the claim, in a small advertising brochure, that 'Nothing like it ever before seen in England'. Situated a door away, at numbers 92-93 Queen Street, the City of London Electric Lighting Company had showrooms which proudly displayed the latest advance in electric lighting and cookery. Although located close to the Mansion House, Stock Exchange and the Bank of England, the Queen Street show kept a low publicity profile and does not appear to have advertised in any London newspaper. In fact, the only published notice of it that has been located appeared in an electrical journal *Lightning* in December 1894:

> For sometime past Edison's Kinetoscope has been on view in Queen St, almost next door to the electric cooking exhibition. Passing there the other day, I went in to see it, and strongly advise everyone who has the chance to do the same. Of course one has heard how life-like the movements are, and is prepared for a very literally "living picture" but, until seen one hardly realises the perfection of the illusion. The only drawback is that the whole thing lasts for so few seconds – one wants to have an encore.[42]

When – and under what circumstances – did the Greek kinetoscope- exhibitors become involved with Robert Paul in the plan to produce copies of Edison's kinetoscope? According to Ramsaye, in an account obtained from Paul (who must in turn have incorporated details received from Henry Short), it was a chance circumstance that was involved:

> Georgiades and Trajedis fancied a certain brand of Turkish in their cigarettes, which made them familiars in the cigarette establishment of John Melachrino ... Melachrino in turn recalled an English customer for that same fragrant blending of the weed, one Henry Short. Now Short had gossiped over the counter of the skill of his old friend Robert W Paul, maker of scientific instruments of precision. At Melachrino's the Greeks waited for Short and he took them to Paul with their mechanical problem.[43]

The 'mechanical problem' was a request by the Greeks to Paul that he should manufacture facsimile copies of the Edison machine for them, correct in every detail, even to the incorporation of the carved floral design on the wooden case. Plagiarism and deception were clearly involved, and it is certainly not credible to suppose that anyone in Paul's situation should have failed to realise that a dishonest motive was involved in the proposed scheme he entered. Paul's earliest apologist, Frederick Talbot, the author of *Moving Pictures* (1912), while quite willing to excoriate the Greeks – 'not animated by very lofty ideas of business integrity' – yet passes no criticism on Paul's own willing involvement in the scheme, suggesting instead (and did this suggestion originate with Paul?) that since Edison had not applied for a British patent for the machine, Paul was therefore 'at liberty to build as many machines as he desired'.[44] As Birt Acres remarked on reading this passage, 'What is the difference between the Greeks actions and that [of Paul] described.[45] In his later accounts Paul never disclosed the date when he first met the Greeks, nor when production of the 'bogus' machines – as Edison and Maguire named them – began. However, he did state

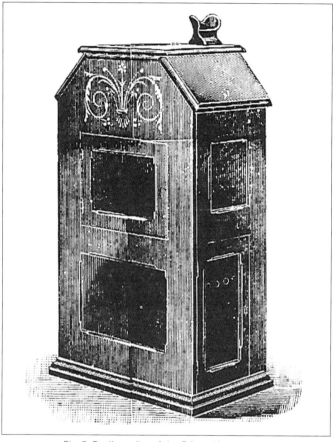

Fig. 5. Paul's replica of the Edison kinetoscope.

in a 1936 account that he had completed six by December 1894, and, if an allowance of two months is made for the sourcing of parts and assembly work, a date sometime in October is likely, with the intriguing possibility that manufacture might have commenced *before* Maguire opened the 'official' exhibition in Oxford Street.

Although Paul later claimed that *he* 'made' these copied machines, it is improbable that this was literally the case, and more likely instead that Paul acted as a facilitator or 'middle-man' supervising their construction. He had established his own company in November 1891 in the specialised area of electrical instrument production. How would it be possible for a business of this type to adapt quickly to the manufacture of kinetoscopes? The fact that Paul's name appeared on some later models is only an indication that he marketed them and not that he had any part in their construction. Most the component production work, such as the fabrication of the wooden cases and the moulding of cast-iron parts, must

necessarily have had to be contracted out, while other items such as lenses and locks would have been provided by specialised suppliers. While the assembly work could have been done at Paul's workshop, it is inherently unlikely that he would have been willing to divert skilled staff in his own business to semi-skilled work with which they were not familiar. Considering that in the circumstances both speed and secrecy were required, it seems likely that these kinetoscopes were produced and assembled at one of the many mechanical engineering workshops in London.

How successful was Paul in selling his 'bogus' machines throughout 1895? According to Terry Ramsaye, there was initially very substantial interest in them:

> The fame of Paul and the Kinetoscope spread, and a large demand arose in Great Britain and extended over to the Continent. Orders for the machines came from all directions. Edison had not only overlooked foreign patents but the whole foreign market as well. When Paul and his assistants appeared at his shop in the mornings they found the stairways lined with waiting customers, some asleep on the steps after a night long vigil there in Hatton Garden holding their places to book orders for Kinetoscopes.[46]

Whether this account is the result of Ramsaye's imagination, or is based on a Paul memory, it does not match the information about machine sales given by Paul in his 1936 BKS/SMPTE article. In this account, he claimed that he had 'made about 60 Kinetoscopes in 1895'. Unfortunately for determining the historical record with certainty, this statement is both ambiguous (note that Paul does not say that he *sold* 60 machines although this is implied) and contradictory if compared with a contemporary notice he issued in which he states that a total of 200 machines were manufactured. It seems unlikely that Paul would have forgotten in 1936 how many machines had actually been manufactured.

If it is assumed that only 60 machines were 'made', a similar picture of lack of success emerges. By his own account, Paul used 15 (a contemporary advertisement claims 16) models at the 'Empire of India' exhibition held at Earls Court between May and October of that year. Even assuming the best-case scenario, that all 45 remaining machines were sold in the ten months from January to October, which seems unlikely, a very modest average sales turnover of one machine a week is indicated, which bears no relation to Ramsaye's picturesque description of demand – which was presumably obtained from Paul.

Franck Maguire presumably first encountered the spurious – or 'bogus' – models early in the New Year, for on 17 January he sent Edison a cable – stressing the need for an urgent reply – asking that he 'approve by cable adding your name to our plaintiffs against users your name spurious machines quick give date to our agreement with you'.[47] Anxious because he did not receive an immediate response, Maguire sent another cable the following day:

> Cable yesterday vital importance continent deal hangs on it parties using one genuine with four spurious machines must serve writ tomorrow morning answer quickly your joining us makes success absolute much at stake.[48]

It is probable that the partners thought that Edison's positive response was inhibited by the idea that he might become financially committed to the British legal action for, on 19 January, Joseph Baucus wrote to him from the company's New York office:

> In consideration of your authorizing us to use your name as plaintiff in an action to be begun against Georgiades and Hough to prevent the unauthorised use of your name upon the spurious Kinetoscopes being manufactured and marketed by them we hereby agree to save you harmless of and from any part and all costs and charges and expenses of any kind arising out of said action.[49]

Edison agreed to this proposal (Maguire had entered his writ of summons in the High Court the day before Baucus's letter was written) and on 29 January an interim or temporary injunction – pending a full hearing before a Judge in Chambers – was issued by the Court against Georgiades, Tragidis (his name was given in the court records as 'Tragedis') and Hough, restraining them from continuing to use the name 'Edison' in connection with the sale or promotion of their facsimile kinetoscopes.

Notes

1. *Pall Mall Gazette* (3 February 1890): 2; *Morning Advertiser* (4 February 1890): 4; 'Mr. Edison's Latest Invention'; *The Amateur Photographer* (7 February 1890): 85; 'Gesture and Speech Mechanically Reproduced', *The Photographic News* (February 1890): 104; 'Photographing a Speaker's Gestures', *The Photographic News* (28 March 1890): 240. The development of the kinetoscope at the Edison laboratory, from concept to commercial product, has been examined in detail by Gordon Hendricks, *The Kinetoscope* and Paul Spehr, *The Man Who Made Movies: W. K. L. Dickson*.

2. Letter of 10 February 1890, offered as Lot 439 in the proposed auction of *The Will Day Historical Collection of Cinematograph & Moving Picture Equipment* (London Harris & Gillow, 21 January 1930): 51. One hundred copies of this catalogue were printed, but the sale never took place.

3. 'A Machine Camera Taking Ten Photographs a second', *Photographic News* (28 February 1890): 157–159. Friese Greene's erratic and sometimes fraudulent photographic and cinematographic career has been analysed in detail by Brian Coe, 'William Friese-Greene and the Origins of Kinematography', *Photographic Journal* (March/April 1962).

4. 'Mr. Edison's Latest Invention' *The Times,* (29 May 1891): 5; 'Edison's Latest Invention', *The Photographic News* (5 June 1891): 418–419.

5. A comprehensive account of the complex product development and exhibition history of this instrument has been given by Deac Rossell in *Ottomar Anschütz and his Electrical Wonder* and *Faszination der Bewegung: Ottomar Anschütz zwischen Photographie und Photographie*. The author also issued an English language edition of the latter work in a limited edition of 28 copies in 2002.

6. Edison to Gouraud, 12 May 1894, TAED D9426AAO (10 February 2017).

7. Ibid. Surviving documentation at the Edison site does not make clear what territory Gouraud was interested in, but in view of the scale of the order total proposed, it was probably world-wide (excluding the United States and Canada). At this time Gouraud had an established office in Whitehall Court, London, and it seems likely that he intended to reserve Britain for himself and cover his investment by selling off the 'rights' to other countries as sub-contracts.

8. Gouraud to Edison, 17 May 1894, TAED D9426AAA (10 February 2017).

9. Gilmore to Gouraud, 9 July 1894, TAED D9426AAG (10 February 2017).

10. Gouraud had been visiting the United States in the summer of 1894, but had arrived back in the UK on 14 July.

11. Hendricks, *The Kinetoscope*, 110, n.1.; Spehr, *The Man Who Made Movies: W. K. L. Dickson*, 318/19; Musser, *The Emergence of Cinema*, 82. The Certificate of Incorporation for Maguire and Baucus was filed with the New York Bureau of Corporations on 23 December 1895. The company had a nominal capital of $40,000.

12. Musser, *Before the Nickelodeon*, 46, Table 1. The enthusiastic welcome the kinetoscope received when it arrived in Mexico City has been described by Hendricks, *The Kinetoscope*, 66–68.

13. Maguire and Baucus to Edison, 30 August 1894, TAED D9428AAD (10 February 2017).

14. Ibid. Maguire and Baucus did not in fact invest $20,000 immediately. Their purchases from the Edison Manufacturing company were: September $9,397, October $2,678, November $11,532. Musser, *Before the Nickelodeon*, 46. Table 1. An increase in their working capital would also have been required, and this was presumably provided interest-free by Irving Bush.

15. A summary of the various cable exchanges is given in Gouraud's letter to Edison of 31 August 1894, TAED LB061219 (10 February 2017).

16. Edison to Maguire and Baucus, 3 September 1894, TAED D9428AAE (10 February 2017). It should be noted that no formal contractual agreement for Britain is preserved at the Edison Historic Site, although agreements do exist for both the French and German territories. In view of the obvious speed at which the switch from Gouraud to Maguire and Baucus took place, it is possible that no separate British agreement was prepared. In a letter to Edison's General Manager W.E. Gilmore from Maguire and Baucus of 5 September, reference is made to 'the contract made between Mr. Edison and ourselves dated September 3 1894', which still leaves it unclear whether this reference is intended to refer to a now lost agreement, or to the 3 September letter from Edison.

17. Maguire and Baucus to W.E. Gilmore, 5 September 1894, TAED D9428AAG (10 February 2017).

18. Ibid.

19. Source for purchasing figures, Musser, *Before the Nickelodeon*, 46. Table 1.

20. For the mutoscope promotion of regional companies, see Brown and Anthony, *A Victorian Film Enterprise*, 84, Table 4.

21. National Archives, UK Incoming Passenger Lists, 1870–1960. Series BT26.

22. Maguire to Edison, 9 November 1894, TAED D9428AAK (10 February 2017).

23. *The Era* (10 November 1894): 24.

24. *The Westminster Budget* (26 October 1894): 754.

25. See Musser, *Before the Nickelodeon*, 44.

26. This was machine number 141, one of the batch 141–150 noted in shipment order 201, and dispatched to Maguire from the Edison Manufacturing company on 21 September 1894. It was auctioned at Sotheby's, London, on 2 October 1992 (Lot 554, illustrated in catalogue) and sold for £19,500 to Ray Phillips, American kinetoscope historian and collector.

27. Original leaflet in a private collection. Copy supplied by Stephen Bottomore.

28. 'Edison's Very Latest. A Chat with the Kinetoscope Man', [London] *Evening News and Post* (24 October 1894): 2.

29. The *British Journal of Photography* (Lantern Supplement) (4 January 1896):3.

30. 'What Edison's Living Pictures are like. Exhibition of the Kinetoscope', *The Westminster Budget* (26 October 1894): 754. Suggestions that the pictures would be shortly projected, and combined with a phonograph were very frequently published and probably derived from Maguire repeating claims made previously by Edison. The *South Wales Daily News* (19 November 1895) noted that 'Mr. Maguire did not say whether the mechanism is susceptible of being reversed. It is conceivable that people would be amused to see the accomplished fact revoked, and the clean-shaven man become the man in need of a shave'.

31. *The Times* (6 November 1894): 6. At 16 frames per foot, the figures quoted by Maguire would suggest film lengths from 47.5 feet to 162.5 feet. The article in *The Century Magazine* was of course written by W. K. L. Dickson and his sister, not by Edison. The extended playing time 'prize-fighting' kinetoscopes were not in London at this date. The three critical letters were published in *The Times* on the 20, 27 and 30 October 1894.

32. Maguire to Edison, 9 November 1894, TAED D9428AAK (10 February 2017). The Royal Archives at Windsor Castle confirm that there is no record of the Prince of Wales visiting this exhibition. Maguire sent Edison a collection of press cuttings from British newspapers commenting on the Oxford Street opening which, although preserved at the Edison Historic Site, have been badly mutilated by having several reviews removed.

33. 'Edison's Very Latest. A Chat with the Kinetoscope Man', [London] *Evening News and Post* (24 October 1894): 4.

34. Ramsaye, *A Million and One Nights*, 837.

35. Maguire to Edison. 9 November 1894, TAED D9428AAK (10 February 2017).

36. National Archives. J.17/314. The production numbers of two of the machines brought to England – 69 and 84 – support the early date given by Georgiades, who included Edison's authority for them to be shown without restriction, as an 'exhibit' to his deposition statement.

37. Mannoni, *The Great Art of Light and Shadow. Archaeology of the Cinema*, 406–407. Mannoni failed to connect the Boulevard Montmartre address with Georgiades, but the link is positively established by the inclusion of the address on the front cover of a publicity brochure issued by the Greeks in London before December 1894. (Cover reproduced in Barnes, *The Beginnings of the Cinema in England 1894-1901 Volume One*, 6.).

38. Ramsaye, *A Million and One Nights*, 138.

39. US National Archives, New York Passenger Lists, 1820–1957.

40. Raff and Gammon Collection, Baker Library, Harvard.

41. National Archive, UK, Incoming Passenger Lists, 1878–1960. Series BT26.

42. *Lightning. The Popular and Business Review of Electricity* (13 December 1894): 370.

43. Ramsaye, *A Million and One Nights*, 148. John Melachrino was born in Constantinople. He was listed in the 1891 British census as aged 37 and living in lodgings in Cockspur Street, St Martins-in-the-Fields, close to the Strand.

44. Talbot, *Moving Pictures* (1912), 34. This statement appears to be the origin of the plausible, but completely false suggestion that Edison was unable to protect his kinetoscope property rights in Britain by preventing the misuse of his name in connection with the 'bogus' machines produced by Paul for himself and the Greeks. Although repeated by film historians such as Will Day and Terry Ramsaye, Paul chose not to correct them, probably because to do so would have been an admission that he had been involved in an activity held by the High Court to have been a criminal enterprise. Paul left the British film business at the end of 1909, and the publication history of *Moving Pictures*, researched and written in 1910 and the first half of 1911, suggests that Paul's interest in assisting the author may have been for the opportunity it offered to him for securing the presentation of a valedictory version of his part in early British film history.

45. Birt Acres annotated copy of *Moving Pictures* is held in the BFI library. His comments on the false claims supplied by Paul to Talbot are of considerable corrective interest and film history value. Some are reproduced by Laurent Mannoni, Donata Pesenti Campagnoni and David Robinson, *Light and Movement. Incunabula of the Motion Picture 1420–1896* (Pordenone: Le Giornate del Cinema Muto: 1995): 418–427.

46. Ramsaye, *A Million and One Nights*, 148–149.

47. Maguire to Edison, 17 January 1895, TAED D9517AAF (10 February 2017).

48. Maguire to Edison, 17 January 1895, TAED D9517AAF (10 February 2017).

49. Baucus to Edison, 19 January 1895, TAED D9517AAK 910 February 2017).

Chapter Three

Cameras and Conflict

His success in obtaining an injunction had been anticipated by Franck Maguire, and three days before the notice was published he included a warning in his *Era* advertisement that the Continental Commerce Company would prosecute any unauthorised use of Edison's name in connection with a kinetoscope exhibition.[1] The scope of this threat was extended a month later to confirm that anyone using an imitation machine would not be supplied with films.[2] This was clearly a move specifically designed to destroy the future sale of Paul's remaining stock, and place him in a position of being unable to recover the cost of their production. It was apparently a successful strategy for, according to Frederick Talbot, 'Paul himself found it impossible, even by resort to subterfuge, to satisfy his own needs'.[3]

Another early result of the impact of the Court order was the dissolution of the Greeks' partnership, which was announced in *The London Gazette* for 15 February 1895. Paul had presumably had advance notice of their intention to part, and ten days before notice was published he had met American-born Birt Acres to discuss the construction of a film camera and the 'independent' production of British films, a move intended to restore the saleability of Paul's machines.[4]

An interesting feature of the Paul-Acres association is that a mutual friend of both, Henry Short, had informed each about the other as far back as December 1894.[5] Acres was a professional photographer who had lived in England since 1889, and, at the beginning of 1895, was general manager of Elliott and Son's large 'Dry-Plate' works at Barnet, North London, a position he resigned at the end of April.[6]

Potentially this was a promising association between two men possessing complementary skills, but unfortunately the relationship appears to have been characterised by suspicion and deception from the beginning. A basic problem was that the objectives expected from it were not shared. Paul (aged 25) was a young practical businessman expecting to find an immediate solution to his kinetoscope sale problem by making use of Acres photographic knowledge. As his later letter to Edison indicates, Paul intended to use the films Acres produced to break into Continental Commerce Company's British business.

For Acres (aged 41) successful filmmaking held the promise of gaining personal prestige in the photographic world, but he too may also have been hoping to make

NOTICE is hereby given that the Partnership heretofore subsisting between us the undersigned George Georgiades and Theo Tragidis carrying on business as Dealers in Novelties at 62 Broad-street in the city of London under the style or firm of the American Kinetoscope Company has been dissolved by mutual consent as and from the 11th day of February 1895. All debts due to and owing by the said late firm will be received and paid by the said Theo Tragidis.—Dated 11th day of February 1895.

GEORGE GEORGIADES.
THEO TRAGIDIS.

Fig. 6. The dissolution of the Greek's partnership is announced in
The London Gazette.

a large amount of money from the venture. In both his letter to Ludwig Stollwerck of 6 August 1895, and to the editor of *The British Journal of Photography* in April 1896, he complained that Paul had promised to put a large sum of money into the manufacture of films but had failed to do so. It seems probable that it was his belief in Paul's persuasive promises that was the reason why Acres gave up his managerial position at Elliott's. He certainly retained considerable personal bitterness against Paul for many years, as his comments in Talbot's 1912 book testify. Acres lacked Paul's talent for business, but he was not entirely trusting and stated in 1912:

> I say that Paul never made or had any idea to make a film for the Kinetoscope until I made them for him. Even then I did not allow him at my works as I knew that an ordinary mechanic could copy the Kinetoscope, but making the pictures was a vastly different thing.[7]

There seems no doubt that Acres supplied the photographic knowledge, and that Paul constructed the camera, since Acres later paid him for doing so, but this does not provide an answer to the disputed question of who – on the balance of probability – designed the camera. The contemporary claims of both men can be presented, beginning with Paul's version:

> On February 5 and 6, 1895, I designed and constructed (with the co-operation of Mr S[hort]) a working model. By March 16 I had made drawings of, and finished, a complete Kinetograph, for which Mr Acres found a lens, but in designing the mechanism of which he took no part.[8]

Acres contrary version:

> Mr Paul admitted to me that he had no idea how to make such an apparatus, but that he would work out my ideas for me. I accordingly showed Mr Paul how the thing could be accomplished, and made sufficient drawings to enable him to work the machine out. From that date until the machine was finished I attended Mr Paul's workshop every evening, modifying and superintending the manufacture of this machine. Mr Short was only present on rare occasions[9]

It seems improbable that Paul was able to design and construct 'a working model'

Fig. 7. Birt Acres.

Fig. 8. R. W. Paul.

of the camera just two days after his first meeting with Acres. How would Acres have had the time to explain anything even in general terms? Acres later claimed that 'At the time Acres showed his design Paul had not the faintest idea that it was necessary to arrest the film for exposure'[10] and his statement appears to be credible if considered in conjunction with accounts Paul later gave to Frederick Talbot and Terry Ramsaye. Talbot notes that before he met Acres, 'Paul's first idea was to convert the ordinary Kinetoscope into a projecting apparatus. While he was quietly considering the feasibility of this scheme ...'.[11] That Paul regarded this scheme as feasible is certainly a strong indication that, before he had met Acres, he had not understood that a basic mechanical principle of a motion picture camera and a projector is that the film must be moved through both intermittently. Paul later admitted to Terry Ramsaye that:

> Early in 1895 I had not realized the necessity for intermittent movement of the film, but it is certain that I did so by October of that year; this of course refers to projection, and is stranger as I had already made several cameras with intermittent motion.[12]

This is not only strange, but an explanation that lacks any credibility. If Paul did not appreciate the need for intermittent motion in a projector – and by extension a camera, how was it possible for him to have constructed a workable camera without any assistance from Acres who had the photographic knowledge that Paul lacked? Attribution of design facility is also relevant when linked to the matter of the camera patent 10,474, for the 'Kinetic Lantern' that Acres applied for on 27 May. If Paul had been solely responsible for the design, why would he be willing to allow Acres to apply for the patent? Paul's explanation for this strange action on his part, that he agreed because 'the demand for films was rapidly falling off',[13] can be shown to be untrue. Film prices, including Paul's,

accurately reflected market demand, and they did not decline before the late autumn of 1895. The input of Acres' ideas and suggestions may also have been an important positive contributory factor at design stage since the cognitive process of invention is not necessarily dependent on practical mechanical ability.[14]

It does however appear, by his own account, that Acres was placed, like the Greeks before him, in a disadvantageous position by Paul's superior commercial skills. Writing only just over four months after the event, Acres claimed that Paul had 'induced' him:

> … to sign an agreement which I afterwards found was so cleverly worded that he could keep me doing nothing for 6 months if it suited his purpose, and further (altho' I did not understand it at the time everything being done on the rush) I could not supply anyone else with films.[15]

'On the rush' was a correct impression for, having 'locked-in' Acres to a contractual agreement on 28 March, Paul then wrote to Thomas Edison the following day. In this letter, which Acres may not have known had been written, and in which – significantly – he as the filmmaker is not mentioned, Paul positioned himself as a potentially more effective British representative for Edison's motion picture interests than Franck Maguire and the Continental Commerce Company. Appealing to Edison's self-interest he offered 'an exchange of films' and co-operation 'in stopping sundry attempts now being made here to copy your films'. The appeal failed however. After the Edison rejection, British film production continued throughout April and May. About twenty individual subjects, some of which were based on Edison originals, are known to have been filmed during this period, and these are discussed in Chapter Eight. The scale of developing and printing activity can be quite accurately estimated. On 16 May Acres wrote a commendatory letter to the European Blair Company in which he confirmed that by that date he had already processed 6,000 feet of raw film and had ordered an additional 4,000 feet.[16] At 40 feet length for each roll, this would indicate that during the first six weeks of British film production about 150 prints had been struck – although of course this total may not have been sold – and that estimated future sales demand at this time indicated that a further 100 prints would be needed. At a cost of eight shillings per roll charged by the Blair company, Acres had therefore spent a cumulative total of £100 on raw stock by this date.

It will be recalled that Acres resigned his position as general manager of Elliott's 'Dry Plate' works at the end of April, probably influenced by Paul's promise of a large-scale film production business in which it appears that Acres may have had a financial interest linked to the number of prints produced. It is important to draw attention to Acres own perception of the central role he considered he had played in organising the association. Writing to *The British Journal of Photography* in April 1896, he noted:

> Mr Paul's letter [Published in the BJP 27 March] would give your readers the impression that a kind of partnership existed between Paul and myself, and speaks of 'our first saleable picture'. The truth is that, during the construction of the

machine, Paul spoke of putting a large sum of money into the manufacture of films. I expressed myself willing, under such conditions, to give him a share in the venture...I finally appointed Paul agent, Paul agreeing to take a minimum number of films. Later on, Paul said he could not sell the minimum number, and so it became necessary for me to make other arrangements[17]

Money was not the only grievance Acres had. He was also annoyed at the claim made by Paul in his advertising that he was the 'sole' manufacturer of the films, and had 'discovered that instead of pushing the sale of films [Paul] was opening up exhibitions for his own profit with my films ...'.[18] Despite the number of personal relationship problems that existed, it was not this cause but for a rather more pragmatic financial reason, of lower than expected film sales, that persuaded Acres to abandon his association with Paul.

What impact did the introduction of British films have on the kinetoscope film market? Using the known quantity of raw stock ordered from the European Blair company as a base figure, it can be shown that, the maximum number of 40 foot prints that could have been produced was 250. The period of British filmmaking lasted for two months, from 30 March (The Oxford and Cambridge Boat Race) to 29 May (The Derby). An average weekly output of 31 prints is therefore indicated, a decidedly modest total that, apart from not satisfying Acres, was not likely to have caused Franck Maguire any problems.

The conclusion must be that Paul's response to Maguire's refusal to sell Edison films to purchasers of the imitation machines, although of considerable interest to film historians, is unlikely to have been a profitable venture. Commercial failure was not only responsible for Acres' departure, but for Paul's temporary loss of interest in film production.

J. E. Hough

Paul was not alone in laying plans to obtain a camera and to begin film production at this time. James Hough (1848–1925) is the 'forgotten- man' of early British film history. Ignored by earlier historians such as Talbot, Ramsaye and Barnes, Hough's involvement in Anglo-American kinetoscope developments is nonetheless of considerable interest, and extends well beyond his role as a defendant in the kinetoscope legal action. It was, for example, James Hough, and *not* Robert Paul, who was the first Englishman to commission the building of a cine-camera, which he did more than a month before the initial meeting between Paul and Acres in February 1895.

Hough's absence from the currently accepted narrative of British attempts made during 1895 to establish an independent source of film production has inevitably skewed the actual historical record regarding this particular development, and has enabled a strongly hagiographic focus on Robert Paul to be promoted instead.[19] This is a mistaken perspective that requires amendment. As the detailed information about kinetoscope history in Britain which is presented in this study indicates, Paul was only one of many people associated with British kinetoscope activity, and indeed by no means the most innovative. His descent

Fig. 9. James Edward Hough.

into plagiarism for example compares badly with the genuinely innovative kinetoscope design work of John Henry Rigg of Leeds.

A review of Hough's pre-kinetoscope commercial activity suggests that he was an entrepreneur of considerable ability, able first to identify, and then become involved in successive growth markets. He was born at Failsworth near Oldham in Lancashire. In an affidavit sworn in *Edison-Bell Phonograph Corporation Ltd* v *J. E. Hough t/a The London Phonograph Company* (1894) he claimed 'that since 1868 he had been practically acquainted with the finer operation of mechanics, [and] was accustomed to work from patent specifications'.[20] In affidavits sworn in various phonograph infringement cases, Hough described himself as a 'Mechanical Engineer' Where this training was acquired is not known, although it is probable that it was from employment in the Lancashire textile industry which was the dominant business sector in Oldham during the nineteenth century.

In 1872 Hough became a co-founder of Shepherd, Rothwell, and Hough, an Oldham-based company manufacturing 'Eclipse' sewing machines for a rapidly growing domestic market. This partnership was dissolved in November 1887, and Hough then moved to London, giving his occupation as a 'Furniture Dealer' in the 1891 census. According to *Kelly's Post Office London Directory* he continued to follow this occupation in 1892 and 1893 from two different addresses in Shoreditch. During these years, he registered four British patent applications related to improvements in bicycle wheels and tyres, and by the following year was officially trading in the booming bicycle business with *Kelly's* listing him as a 'Cycle Agent' in Shoreditch.[21]

For reasons that are not clear – there was no obvious synergy – it was contemporary practice for phonographs and recording cylinders to be sold by bicycle shops, and this is perhaps how Hough first encountered them. By his own account, he began selling and exhibiting phonographs in December 1893.[22] This was an illegal activity since Edison's British phonograph patents had been assigned to the Edison-Bell Phonograph Corporation Ltd in January 1893, and the company soon began a legal action against Hough seeking a permanent injunction.

The attraction to Hough, and numerous other phonograph infringers in Britain,

was related to the very high profits available from illegal exhibition of the machine. One of Hough's own witnesses told the court in the Edison- Bell case, that Hough was taking between £1 to £5 *daily* at the shop at 62 Old Broad Street which he had rented on a short term six month lease.[23] Because he had made minor adjustments to the phonograph stylus, Hough thought he would be safe from prosecution, and he openly traded as the 'London Phonograph Company' 'Chief Office in Europe for Edison's newest and best Phonographs' By October 1894 he had transferred his business to 3 Broad Street Buildings, Liverpool Street.

Hough's American agent was New York- based Walter Isaacs, described by Terry Ramsaye as a 'Phonograph Mechanic', and it is quite probable that Isaacs was the source for at least some of Hough's illegal importations into Britain of Edison phonographs.[24] Through his contact with Frank Maltby, a New York mechanical engineer, Isaacs learned at the end of 1894 that Maltby had successfully built and tested a motion picture camera for Charles Chinnock, a former Edison associate. Isaacs passed this information on to Hough in London, and Hough, who had been dealing in kinetoscopes for several months, commissioned Isaacs to order a camera from Chinnock. Chinnock recalled in evidence he gave in an American legal action in 1911 that:

> Some time in December 1894 either Mr. Walter Isaacs visited me or wrote me the result of which caused us to have an interview. I visited his home and showed him some pictures that I had taken of Robt. Moree [sic] and James Lahey and about four or five days later he visited my home and gave me an order for a camera at a price, and as I remember he did not state at that interview who this camera was for.[25]

Perhaps, because Chinnock had only received a verbal order and had no idea who his customer was, he did not begin work on the camera. This inaction resulted in an angry note being sent to him from Hough in January 1895:

> The Photographic M/c is not to hand nor have I any advice that you have sent it. This is manifestly wrong & I shall hold you responsible for the delay.[26]

The consequential effect on both the history of the kinetoscope in Britain, and on the production of the first British films, as a result of Chinnock's non-compliance in fulfilling the order he had received, hardly needs stressing. Would Robert Paul have been interested in linking up with Birt Acres to produce a film camera in early 1895, if Hough already had one operating in England? Certainly, a true case of an 'accident-of-history' resulting in a change in the sequence of development of British film production.

On 4 February 1895 (the day that Robert Paul first met Birt Acres) the Judge in the Edison-Bell case made an order (on Hough's petition) appointing a special examiner in New York to take testimony from Thomas Edison and others – who were witnesses on Hough's behalf – and in an affidavit sworn on 1 March, Hough confirmed that it was his intention to sail to New York within a few days in order that he could be present at Edison's examination. There was now a convenient opportunity available for a personal meeting with Chinnock (who lived in

Brooklyn) and a chance to expedite work on the camera. Chinnock's later recollection of Hough' visit was that:

> Sometime in May [1895] I received a visit from Mr. Hough and Mr. Werner, and I also think that Mr. Isaacs was present and a contract was drawn up after they had satisfied themselves that I really could take pictures and had a satisfactory camera, as this camera had already taken pictures of Mr. Hough and Mr. Werner in a scuffle on a stage, and [after] these pictures had been shown them, and tested, they gave me an order for two cameras and ten Kinetoscopes, and paid me $1,000 cash on account.[27]

> … I understood from Mr. Hough that the camera that he purchased was to be used in England, and the camera that Mr. Werner purchased was to be used in France. I also understood from them that they had been making great efforts to get a camera and had failed.[28]

Presumably Hough and Werner had 'been making great efforts to get a camera' from February, when it had become clear that Chinnock was not going to supply the camera that Hough had ordered, to mid-March when Hough had left England to travel to America. Who had they contacted in those six weeks, and had their search been in England or in France? It is certainly possible that Hough had heard about the Paul/Acres association, although Paul did not begin to advertise British films for sale until April – after Hough had left the country. Were he and Werner aware that British films were available at the time they signed the camera and kinetoscope contract with Chinnock? Charles Chinnock's 19-year-old son Alvah wrote out the agreement that had been reached:

> This agreement made this 3d day of May in the year of our Lord Eighteen hundred and ninety-five between Chas. E. Chinnock of Brooklyn, party of the first part, James E. Hough and Michael Werner, of the second part.

> Witnesseth, that in consideration of One Thousand Dollars ($1000.00) now paid by the parties of the second part to the party of the first part and a further sum of One Thousand One Hundred Dollars ($1100.00) to be paid by the parties of the second part to the party of the first part, the party of the first part agrees to supply –

> Two photographic machines capable of taking photographs at the rate of 46 per second of time and suitable for the manufacture of Kinetoscopic films.

> Ten kinetoscopes similar to the one shown by the party of the first part to the parties of the second part, at, 157 6th Ave., Bklyn [sic] at the date of this contract.

> Delivery to be as follows. The photographic machines to be delivered on or before the 20th day of May instant. The ten kinetoscopes on or before the 1st day of June next – allowance in time to be made for strikes or other accidents – which prevent the manufacture of his [sic] machines – which upon presentation of Bills of Lading to the Hong Kong and Shanghai Bank, the balance of the purchase money aforesaid namely Eleven Hundred Dollars ($1100.00) to be paid.

> The necessary instructions in the use of the Photographic machine shall be imparted to the parties of the second part before the machines are delivered to them.

> Signed by the within named parties in the presence of :–

Witnesses

Walter Isaac [sic]	James E. Hough
J. W. Lahey	Michael Werner
	C. E. Chinnock[29]

Although Hough had not seen a Chinnock kinetoscope until 3 May, he must have been confident that it would be possible to reach an agreement with Chinnock, because he had begun advertising his 'Anglo-American' kinetoscopes – 'How to make money this season' in *The English Mechanic* on 26 April, and *Bazaar, Exchange and Mart* from 15 May. This advertising programme provides firm evidence that Hough really did intend to exhibit and sell the Chinnock machines in England, where they would have been the fourth design on the market, joining the genuine and the 'bogus' Edison models, and John Rigg's "Baby", or reduced size kinetoscope.

The number of kinetoscopes ordered by Hough and Werner was so low – five models each – that it seems likely that they were intended for demonstration models to obtain trade orders, rather than use by the public. Caution may also have been a consideration. By May the kinetoscope market in Britain was already failing, and an astute businessman like Hough was probably unwilling to risk the substantial investment involved in launching a new model without first obtaining advance orders.

The Chinnock association came to a surprising and somewhat mysterious conclusion. The contract obliged Chinnock to deliver the cameras by 20 May, but they never arrived, and after waiting a month, Hough sent the following angry letter on 22 June:

> As I have not yet received the photographic M/c – I now beg to inform you I shall refuse to accept the same if presented and shall proceed against you for breach of your contract with me – I consider your treatment of me most scandalous.[30]

Chinnock then delivered the cameras, and was paid his outstanding balance of $1,100.[31] Construction of the ten kinetoscopes ordered was completed, but they were not delivered, which of course rendered the camera of no practical use, and destroyed Hough's plans to present it with English-made films.[32] His *English Mechanic* advertising for the Hough/Chinnock kinetoscopes ceased after 14 June, and that running in the *Bazaar, Exchange and Mart* ended on 31 July

The delay in sending the cameras, and the non-delivery of the kinetoscopes is an indication that there had been a serious deterioration in relations between the parties. Unfortunately, Chinnock was not asked in 1911 what the cause had been.

London Phonograph Co.—Exhibitional and Commercial Edison's Phonographs. Latest records, supplies. Also Anglo-American Kinetoscopes. Send for list. Largest depot in the trade. Genuine.—Edison Phonograph Agency, 3, Broad-street Buildings, London.

Fig. 10. J. E. Hough advertises the Chinnock kinetoscope in *The English Mechanic* (26 April 1895).

It was apparently not a problem with money, and as far as the cameras were concerned things appear to have started well if Chinnock's testimony is believed:

> They [the cameras] were started immediately after the order was received [3 May] and they were rushed through in the shortest possible time ... My recollection is that it took about three weeks to complete them.[33]

Three weeks suggests that Maltby's completion date was about 24 May, yet Hough had still not received his camera a month later. The ten kinetoscopes ought to have been completed by 1 June, and apparently were, but were not sent to England or France. It seems therefore that some event had occurred at the *end* of May which had not been present earlier, and was regarded as very serious by Chinnock, since his subsequent actions suggest a deliberate intention to damage his customer's commercial interests.

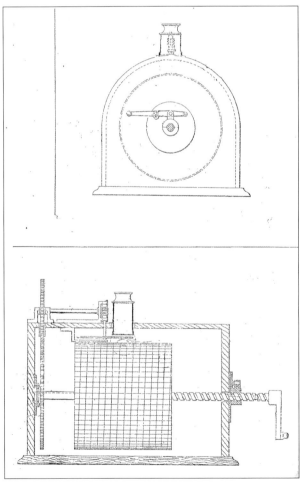

Fig. 11. The Chinnock kinetoscope.

A credible candidate could have been a British provisional specification patent application for the kinetoscope that Hough made on 18 May.[34] There are certainly some rather strange circumstances surrounding this filing. For example, why did Hough apply in his own name for an invention which was not his, and for which Chinnock had made no application to the American patent office? One is reminded of Hough's earlier claim in an English court that he 'was accustomed to work from patent specifications'. Was Chinnock aware of what Hough intended to do or did it come as an unpleasant surprise to him? Had Hough appropriated Chinnock's drawings? Why did Hough make this Brit-

ish application while he was still living in New York, instead of waiting until he had returned to England? What was the cause of the obvious urgency in this case?

With regard to this final query it should be remembered that the 18 May application date is entirely consistent with Hough's expectation that he would receive the camera about 20 May, and the kinetoscopes shortly after. To be able to show potential purchasers that the machine they were being asked to buy was 'protected' with a patent would have been obviously advantageous in commercial terms. If Hough had no authority to appropriate Chinnock's work, and especially if Chinnock discovered Hough's actions by chance, there would certainly be cause established for revenge, by working to frustrate and ruin Hough's filmmaking and kinetoscope exhibition plans.

Notes

1. *The Era* (26 January 1895): 27.

2. Ibid. (23 February 1895): 25.

3. Talbot, *Moving Pictures* (1923): 36. An order for unknown goods, amounting to the substantial total of $181, was placed by Paul with the Edison Manufacturing Company in late January or early February. It is possible that this may represent evidence of 'subterfuge', and was an attempt by Paul to obtain a supply of films without Maguire's knowledge. See Thomas Edison National Historical Park, 159/636.

4. The date of the 4 February initial meeting was given in Paul's letter to the Editor, *The British Journal of Photography* (27 March 1896): 206–207.

5. *Paul*: 'In December 1894 I was manufacturing kinetoscopes, and my friend, Mr S, suggested that if I would construct a camera for taking the films he would introduce me to Mr Acres, who could undertake the photography'[Letter to the Editor, *British Journal of Photography* (27 March 1896)]: *Acres*: 'Towards the latter end of 1894, Mr H. W. Short ... informed me that he knew a man who was making Edison kinetoscopes and who would do anything to get films ...' [Letter to the Editor, British *Journal of Photography* (10 April 1896)]. Henry Short's father, Thomas Short (1833–1906) was a partner in Marriott and Short, scientific instrument makers based in Hatton Garden, and presumably Henry Short and Robert Paul first met each other as a result of their shared professional interests. Short's connection with Birt Acres came about through a mutual interest in photography, for both men were members of the Lyonsdown photographic club in Barnet, where the first recorded British demonstration of film projection was given by Acres on 10 January 1896 (see Barnes, *The Beginnings of the Cinema in England 1894–1901. Volume One*, 65).

6. *British Journal of Photography* (26 April 1895): 268.

7. Acres' annotated copy of *Talbot, Moving Pictures* (1912): 35. Reuben Library, British Film Institute.

8. Letter to the Editor, *The British Journal of Photography*, Vol. 43 (27 March 1896): 206–207.

9. Letter to the Editor, *The British Journal of Photography*, Vol. 43 (10 April 1896): 239.

10. Annotated copy of Talbot, *Moving Pictures* (1912): op. cit., 38.

11. Talbot, *Moving Pictures* (1923), 36.

12. Ramsaye, *A Million and One Nights*, 151.

13. Paul to the Editor, *The British Journal of Photography* (27 March 1896).

14. For an exploration of this theme in specific relation to early kinetoscope development, see W. Bernard Carlson and Michael E. Gorman, 'Understanding Invention as a Cognitive Process: The Case of Edison and Early Motion Pictures, 1888-1891', *Social Studies of Science* Vol. 20, No. 3, (1990): 387–430.

15. Acres to Stollwerck, 6 August 1895. Schokoladenmuseum Stollwerck Cologne. The letter was reproduced and transcribed in Lange-Fuchs, *Der Kaiser, der Kanal und der Kinematographie*, 40–43. The period that this film production agreement was intended to remain in force is not known, although Paul noted in his *British Journal of Photography* letter of 17 March 1896 that it was 'for a term of years'.

16. Loiperdinger, 'A Foreign Affair', 78 and note 1. Paul confirmed the total of 10,000 feet in his 1936 BKS/SMPE paper: 'I do not believe that our total output [of films] for the year [1895] exceeded ten thousand feet'.

17. *The British Journal of Photography* (10 April 1896): 239.

18. Acres to Stollwerck 6 August 1895. Lange-Fuchs, *Der Kaiser, der Kanal und der Kinematographie*, 41. For verification of Paul's claim to have been the 'sole' manufacturer of the films, see his advertisement in *The English Mechanic* (21 June 1895): vi. It may be of significance that Acres was out of the country at the time of its publication.

19. The uncritical attitude taken towards Paul is perhaps understandable in the case of Talbot and Ramsaye since both had relied completely on him for information about the events of 1895, and were hardly in a position to contradict the living source of the 'selective' facts that they had been supplied with. A more recent assessment by John Barnes, which concludes that Paul possessed 'genius' and that Acres was merely an 'amateur' (Barnes, *The Beginnings of the Cinema in England 1894–1901. Volume One*, 228) represents a more problematic and questionable judgement. Referring to the misleading and incomplete Talbot/Paul version of Paul's role in British kinetoscope history, Deac Rossell has commented: 'Reading this account again today is deeply distressing, and it is hard to judge whether Talbot or Paul is the more unreliable reporter present … That this account has been so influential in film historiography is an embarrassingly grave error', Rossell, *Rough Sea at Dover*, 79–80, note 25.

20. Chancery case E 783 For a summary of the arguments presented by both sides in this important phonograph patent infringement case, see John Cutler (ed.) *Reports of Patent, Design, and Trade Mark Cases* (RPC) Vol. 11., 594–601. The 'master' British phonograph patent cited in all the Edison-Bell actions was 6027 of May 1886.

21. For the commercial background to the late Victorian cycle sector, see A. E. Harrison, 'Joint Stock Company Flotations in the Cycle, Motor-Vehicle, and Related Industries 1882–1914', *Business History* Vol. 23, No.2, (July 1981): 165–190. These sectors were all notorious for attracting fraudsters.

22. RPC op. cit., 597, and see ibid., 473.

23. op cit., 597, lines 31 & 32; and 598, lines 23 & 24. An average working class salary at this time was between £1 10s and £2 for a 50-hour working week. The usual price charged to listen to a phonograph cylinder in the 1890's was 2d, which would suggest that Hough was attracting between 120 and 600 customers a day at his London shop.

24. Ramsaye, *A Million and One Nights*, 363. Walter Isaacs later became associated with cine-infringing activities, and was enjoined by both American Biograph (1897) and Thomas Edison (1898) in cases heard in the Southern District Court of New York. In addition, he was involved in the tangled Anglo-American tale of Charles Urban's "Bioscope" projector. See Richard Brown. 'American Rivalry in the early English film business', *Film History* vol. 10, no. 1. (1998): 23.

25. Testimony of Charles E Chinnock. 9 May 1911. Equity 5-167. Southern District of New York, in *Motion Picture Patents Company v Independent Moving Pictures Company of America*, pp. 19 & 20. Answer to Question 50.

26. Hough to Chinnock 15 January 1895. Defendants Exhibit in *Motion Picture Patents Company* case.

27. Chinnock testimony in Equity 5-167, p. 20. Answer to Question 50.

28. Ibid., 22. Answer to Question 62. For Michael (Michel) Werner and the connection of the Werner family with the kinetoscope in France, see Mannoni, *The Great Art of Light and Shadow. Archaeology of the Cinema*, 407–415. See also Hendricks, *The Kinetoscope*, Appendix D, 'The Chinnock Kinetoscope', 161–169.

29. Defendants Contract Exhibit, 3 May 1895. Equity 5-167.

30. Hough to Chinnock 22 June 1895. Defendants Exhibit. Equity 5-167.

31. Chinnock was quite specific in his recollection that the cameras *were* delivered to Hough and Werner in June, and that he had received the balance due for them. (Testimony p.19. Answer to Question 49. Equity 5-167.) In his deposition statement of 27 April 1911, p. 12, Chinnock noted that he had paid Walter Isaacs an introductory commission out of the balance money he had received.

32. Chinnock testimony p.24. Answer to Question 67. 'I made them [the kinetoscopes] but I did not deliver them'

33. Chinnock testimony p.23. Answer to Question 66. Equity 5-167.

34. British patent number 9881. 'Improvements in means for Viewing a series of Pictures for the purpose of obtaining from same an Appearance of Movement' Provisional specification filed 18 May 1895. Hopwood, *Living Pictures*, 100, and figs. 65 and 98, directs attention to the similarity of the Hough (Chinnock) method of achieving the appearance of motion, to Georges Demeny's drum-form "Phonoscope". It was perhaps for this reason that Chinnock did not apply for a US patent, as American applications were subject to an 'official' examination for novelty. In Britain at this date the correct form of registration only was required, and there was no patent office examination for novelty.

Chapter Four

The Legal and Intellectual Property Context

By January 1895 the introductory phase of British kinetoscope history had ended. The next phase, which would last for approximately six months, would be a period when national marketing of the machine would take place. This was also a time when conflict, linked to the promotion of the Edison kinetoscope, and to the copyright ownership of the first British films occurred.

It has been noted that the first action of this kind was initiated in the New Year by the Edison-appointed British concessionaires. The second example of kinetoscope-related conflict occurring in 1895 resulted from personal disagreement. Paul had formed an association (not a formal partnership) with Birt Acres, and, during April and May, the first British films were produced.[1] However, differences, which appear to have been linked to incompatibility of temperament and conflicting objectives, soon arose, and by the end of May film production had ceased and the two men had parted. Fortunately, this Paul/Acres dispute is well documented from contemporary sources. Highly personalised – and therefore inevitably subjective – accounts presented by the participants themselves, were aired in an exchange of letters published in *The British Journal of Photography* in March and April 1896.[2] Despite very necessary reservations about their objectivity, the fact that these letters were written only a year after the events they refer to, clearly enhances their value as historical documents. To these 'public' letters, can be added a remarkable 'private' letter referring to the same events, written by Birt Acres in August 1895.[3]

When events such as these occur in early film history the important role of existing national legal and statutory 'control' procedures becomes clear. The extent of regulatory control present in British kinetoscope history was linked to both 'internal' and 'external' forms. External controls were connected to statutory legislation such as common law and intellectual property, while internal controls facilitated operational management organisation. The use of contractual agree-

45

ments to define commercial obligations; as in the case of Edison and Maguire and Baucus, Paul and the Greeks, Paul and Acres and the Stollwerck company and Acres, are examples of this procedure being implemented. The known incorporation of 'exclusivity' clauses in all these agreements is a further example of a formalised approach being adopted.

Commercial advantage in the kinetoscope business was also gained by first locating, and then removing from competitors someone who possessed information-based knowledge even if this had not yet been brought to practical application. This is what happened in the case of Acres. His value to Robert Paul was his photographic knowledge, which included a specific interest in 'instantaneous' photography. The agreement that Paul prepared prevented Acres from producing films for anyone else for several years. By mid-1895 after Acres had proved that he could successfully take films with his portable, and patented, camera he was 'head-hunted' for his skills by the Stollwerck company, and offered both generous financial terms and organisational support to develop further ideas.

The use made by kinetoscope entrepreneurs of statutory law in its various forms is also of considerable interest in providing an accurate indication of the level of personal commercial sophistication present at this first stage of film history. An appreciation of the legal and intellectual property environment that existed in Britain at the time of the introduction of the kinetoscope is important in giving a context to, and an understanding of, their actions.[4] This is a feature that can best be examined within its contemporary context by a focus on the themes contained in contrasting case-studies where legal statute and intellectual property law can be shown to have played a central role. The examples that have been chosen for analysis are: –

(1) The application of common law process in relation to misrepresentation and fraud in *The Continental Commerce Company v Georgiades and Others* 'Passing-Off' action heard by the High Court in 1895.

(2) The law of Photographic Copyright applied to the production and ownership of the first British films, and, *inter-alia*, a definition of the correct legal relationship that existed between Robert Paul and Birt Acres in this area.

(3) British patent procedure as it was in 1894/5, together with a quantification of kinetoscope-related patent demand during this period.

Common law process in relation to misrepresentation and fraud

When the fraudulent imitation of products was alleged, an action for 'passing off' and false representation could be brought in the Queens Bench division of the High Court with a permanent injunction and damages sought.[5] It is most important in the present context to emphasise that 'passing off' was a criminal offence under civil law, and it was therefore completely irrelevant whether Edison had, or had not, applied for provisional patent protection for his kinetoscope in Britain, except that, if he had, he would have received statutory redress. But even when no formal registration had taken place the Court would always restrain a proven case of fraud by a common law injunction. Contrary to the account

originated by Robert Paul and accepted, without challenge, by film historians for over a century, Thomas Edison was able to prosecute those who were producing copies of the kinetoscope in Britain.

Common law procedure for fraud was not concerned – as in the case of intellectual property – with the invasion of property rights, nor did it defend commercial brand names or become involved in cases of trade competition. Instead, what was protected in a 'passing off' case was the trading 'goodwill' established between a company and its customers. The presumption made was that the possession of a 'good name' in business was the reason why custom was attracted to a company. Therefore although 'goodwill' was an intangible concept, it still possessed value which would be damaged or reduced by fraudulent misrepresentation. It was this defined basis on which the Continental Commerce action was founded.

The criteria of proof required in such a case was precise. The plaintiff had to show to the Court that he sold goods to which a distinctive trade name was attached ('Edison's kinetoscope') and that there was 'goodwill' in trade connected to it (Edison's personal reputation). The allegation was that Paul-made kinetoscopes were falsely described by the name 'Edison' to which 'goodwill' was attached, thereby damaging its value by misleading customers into buying copies when they thought they were buying genuine models

With regard to evidence presented to the Court, it was not sufficient for the plaintiff simply to allege that the defendant's goods were similar to his; he was required to show beyond doubt that the defendants had actually represented their goods as his, and that, consequently intentional deception was involved. If a retail outlet was concerned (as it was in this case), then the Court would additionally consider the appearance or 'get-up' of the shop advertising to determine whether it was intended to deceive potential customers. It was to settle that question that photographs were introduced by James Hough during his cross-examination (see Deposition document in Appendix 5).

The crux of the legal action initiated by Maguire was therefore not simply that Edison kinetoscopes had been copied, but that purchasers and users of the 'bogus' machines had been deceived, by acts of both commission and omission, into believing that English models were in fact (and not simply by appearance) genuine Edison machines. It is of considerable significance in this context that neither Georgiades nor Tragidis were able to produce documented proof that Paul-made kinetoscopes bore either his or their own identifying 'plates' until after the action against them had been initiated.

What the Greeks required from Paul were exact facsimile models, identical in appearance to the genuine machine, even to the inclusion of the floral design carved on the wooden case. Under these circumstances fraudulent misrepresentation was clearly intended, and documentary evidence suggests that Paul was aware of the true nature of the enterprise he was engaging in and took defensive action to secure his position should legal problems arise. Why would he have done this unless he was aware, from the beginning, of illegality, and that a 'Passing off' action was possible?

It is therefore of interest to examine Paul's legal position, especially as he was not subsequently enjoined as a defendant. In his deposition evidence (see Appendix 5) George Tragidis revealed that a contractual agreement had been created for the manufacture of the imitation kinetoscopes, and offered to show a copy of it to the Court 'provided the price is left out'. The existence of a formal agreement is a significant factor since it provided Paul with an effective defence, by proving that he was not the initiator of the fraud, and also by defining his 'status' – and hence his legal culpability – to that merely of a workman or contractee carrying out instructions received from a contractor. Had there been no formal contractual agreement in existence, Paul would have been regarded as a free moral agent and there can be little doubt that he would have been indicted as a co-conspirator in the fraud. Who suggested that the agreement should be drawn up will probably never be known. Is it likely that two itinerant Greek showmen would have been interested in such a formality? Would they have been aware of its significance regarding the relationship between themselves and Paul? Or was Paul deliberately manipulating his associates in an attempt to evade any possible consequences to himself from his involvement in the scheme?

Considering the circumstances, it becomes understandable why Paul subsequently suppressed all mention of the legal case that Maguire and Edison successfully brought in Britain, since the judgement of the Court in this matter was proof that he had been involved in a criminal enterprise, and that there had been no justification for his piratical actions. Having created a false version of events he was then forced to live with it. As late as 1936 in his BKS/SMPE paper he was still suggesting that what he had done was justifiable as a consequence of 'Finding that no steps had been taken to patent the machine ...'. Terry Ramsaye's judgement of Paul's historical integrity, given in 1926, after Ramsaye had contacted him for information, should be recorded. 'Paul, conservative and precise, does not indulge in undocumented memories' he concluded.[6] It is surely appropriate that it is documentary evidence that can now enable the incomplete story Paul left behind to be re-examined.

Photographic copyright ownership in the first British films

A general account of the relationship between Robert Paul and Birt Acres can be found in Chapter Three. In this section attention is focussed specifically on questions of copyright ownership in the first British films produced. Rival claims were of course made by both Paul and Acres, but even if some are true, they only represent a personal opinion and cannot be considered authoritative unless examined and confirmed as far as possible in the context of contemporary common law and the statutory regulations regarding photographic copyright

Although there was no British copyright protection available until 1912 for film as an entity, copyright in a 'still' photograph was available, and the legislative terms and conditions for this were included in 'The Fine Arts Copyright Act' of 1862.[7] Logically a single exposure, forming part of a sequential series of photographs forming a film, could – if removed from the sequence and treated in isolation – qualify for copyright protection, and could be registered at Stationer's

Hall a procedure which then enabled an applicant to take legal action for infringement.[8] Supplementary to the Fine Arts Act, case-law relating to the practical application of photographic copyright had been established by the High Court shortly before 1895. *Nottage v Jackson* (Court of Appeal 1883) had held that a photographer employed to produce a negative was the true 'author' of the photograph and retained ownership of it. However, *Pollard v The Photographic Company* (Chancery 1889) limited the photographer's autonomy and held that a photographer who had been employed and paid to take a photograph was not justified in printing copies for his own use and then subsequently exhibiting or selling them. Thus it can be seen that the Courts had achieved a 'balance' where, in the event of a dispute, no one party could gain an advantage over the other. The authoritative *British Journal of Photography* noted in February 1895 that the correct legal position was that:

> If the photograph is taken for a customer who pays for its being taken, then the copyright belongs to him. The negative remains the property of the photographer, and the sitter cannot claim it; but he is entitled to restrain the photographer from printing copies for any purpose except to the customer's order … If it is desired in such a case (usually termed work done on commission) that the copyright should belong to the photographer, it must be reserved to him by an assignment in writing.[9]

These definitions can now be considered in the context of statements made about their association by Paul and Acres. According to Paul:

> On February 4 [1895] Mr. Acres called at my works, and agreed that, if I constructed the camera and tools at my own risk and expense, he would use it for taking films for me solely … On March 28 … Mr. Acres sign[ed] an agreement to produce films for me for a term of years from that date … .[10]

But according to Acres it was he, and not Paul, who set the conditions under which he agreed to join the project:

> The truth is that, during the construction of the machine, Paul spoke of putting a large sum of money into the manufacture of films. I expressed myself willing, under such conditions, to give him a share in the venture … I finally agreed to appoint Paul agent, Paul agreeing to take a minimum number of films. Later on, Paul said he could not sell the minimum number, and so it became necessary for me to make other arrangements which I accordingly did, having first cancelled the agreement with Paul. If Paul thinks that he has any rights in the boat race or any other of my negatives, I would suggest that he makes copies of same in any shape or form, and publishes or makes any use whatever of such copies; we will then have an opportunity of deciding whose property they are.[11]

This, it should be noted, is the position at the beginning of 1896 after Acres had parted from Paul, and undoubtedly at this date he would have held full copyright possession, something he was later keen to emphasise in his advertising although this claim has been obscured.[12] However, whether he had held full copyright *throughout* the association is more problematic for it is known that there was an agreement, drawn up by Paul, and signed by Acres on 28 March 1895, binding

Acres 'to produce films for me for a term of years'.[13] Acres later complained to Ludwig Stollwerck that Paul:

> ... induced me to sign an agreement which I afterwards found was so cleverly worded that he could keep me doing nothing for 6 months if it suited his purpose, and further (altho' I did not understand it at the time everything being done on the rush) I could not supply anyone else with films.[14]

Here we can see Paul employing the same tactic he had earlier used with the Greeks for the construction of 'bogus' kinetoscopes – that of gaining a commercial advantage by 'locking-in' the other party to the terms of a contractual agreement, the implications of which they did not fully understand. Acres' belated discovery that Paul lacked sufficient capital, is paralleled and confirmed by Paul's later admission that he abandoned his proposed Time Machine entertainment at the end of 1895 (see Chapter Six) 'for lack of funds'.[15] The reason why Acres was pressurised into signing a film production and developing and printing agreement 'on the rush' was, according to Paul in his *British Journal of Photography* letter, that 'the demand for films was rapidly falling off' There is absolutely no documented evidence that this was the case at the beginning of April, and indeed Paul's later actions suggest that he himself did not believe that this was so. If he had thought that the kinetoscope business had no future at this time, why did he not close down his own proposed film production enterprise? Even more cogently, if he really believed that demand for films was falling off, why would he, under these circumstances, take the illogical decision to pitch the price of his films in his advertisements to match Maguire's top level premium rate of £3 each? This strategy suggests confidence rather than doubt about the future.

The real reason for the 'on the rush' urgency to get Acres to sign-up is likely to have been that Paul was anxious to contact Thomas Edison as quickly as possible – something he did by writing to him the day after Acres had signed the agreement. In terms of determining copyright assignment the question is, did Paul pay Acres a salary as an employee, or did he offer him a share of the profits from the sale of prints? Since the film production agreement is 'lost' it will probably always be impossible to define Acres status with certainty. There seems to be agreement that the contract was an 'exclusive' arrangement which prevented Acres from taking films for anyone else. But this does not necessarily mean that Paul owned the copyright in the images. If Acres was 'employed' by Paul *and was paid for his services*, then he would have had ownership of the negatives, but not of the prints struck from them that Paul was selling, sometimes with the misleading claim 'New subjects just taken by R.W. Paul'. If this was the situation it would have meant that Paul would have been unable to obtain further prints either for his own use or to sell to his customers after the two men ceased to work together.

But if Acres was an 'independent' associate and his remuneration for the work he did for Paul was a share of the profits from the sale of prints, a positive case could be made for his entire copyright ownership. Since he both shot the films and was responsible for the developing and printing work, there seems no reason why, under these circumstances, he would not have owned full copyright at all times

in the photographic images that had been produced. If this was the case, then Acres' 1896 claim that, 'I finally agreed to appoint Paul agent, Paul agreeing to take a minimum number of films' might have correctly defined the Paul/Acres legal relationship with regard to the films that had been taken, with Paul owning no rights in any of the kinetoscope films produced, despite the impression to the contrary he gave to Edison, and included in his advertisements.[16]

Patent Procedure

A distinguishing feature of the operation of the British patent system in 1895 – and indeed before 1905 – was that, unlike procedure followed in the United States and Germany, the British state, through its patent office, did not assume responsibility for conducting an 'official' examination into the validity of claims made by a patentee. This contemporary situation is of relevance to all kinetoscope related applications. The consequence was that the value of the granted patent was considerably reduced.[17]

The British Journal of Photography compared English procedure unfavourably with the German system:

> Owing to the strict investigation made by the German Patent Office before a patent is given, the validity of a similar patent under the International patents arrangement, is seldom questioned in any other country. In England the Patent Office simply takes the money and asks no questions, and the same thing can be patented, over and over again, even if it were not original in the first instance … It cannot be too strongly impressed upon would-be patentees that the English Patent Office will grant a patent for an invention that may have no originality whatever in it, and which may even have been patented before, though, of course, such a patent would have no validity if contested in a court of law.[18]

A further informed comment and summary on British procedure, and its disadvantages, was given by the American Commissioner of Patents in 1888. His strictures should be borne in mind by film historians when the status of any cine-related patent issued between 1894 and 1904 is considered:

> Under the British system, the English Patent Office is little more than a registration office. The patent when issued is but a certification, and is of no value as property. No one would invest in it until it should be submitted to learned and skilled experts … . When it is called to mind how easily associations and corporations can be formed to promote the introduction of patent property and to foist the same on the public, and how easily legal opinions can be secured urging and supporting the validity of the patents involved in the scheme, the danger and disadvantages of the system become apparent, so that it is beneficial neither to the inventor nor to the public.[19]

There certainly was room for improvement. A contemporary British critic, under the heading of 'Disadvantages attaching to [British] Patents' described, under various colourful headings, some of the tricks that the less scrupulous employed to abuse the system. Their titles indicate some of the disingenuous methods used, including 'Blackmail', 'Advertising', 'Commercial', 'Scarecrow', and 'Dog-in-the-manger' tactics used.[20] Patentees, who at this date were usually individuals

rather than companies, were often not interested in 'working' their invention but were instead looking for a capitalist who would buy out their interest or enter into a licensing agreement. A patent in this situation was intended to provide reassurance to the potential investor that a monopoly could be sustained. A variation on this method was a scheme devised by William Friese Greene in 1896, by which he managed to extract payments from Birt Acres and J.A. Prestwich for the 'right' of working under his so-called 'master' cinematograph patent 10,131 of June 1889.

Since a characteristic feature of a patent is that, unlike a trade mark, it is a depreciating asset with a finite period of value, speed of registration was an important factor to patentees if attracting investors was their object. In these circumstances, it is not surprising that patent activity was sensitive to market changes in demand, particularly so in the case of new products like the kine-toscope which lacked a verifiable commercial track record. If reference is made to Table 1 it will be seen that both the number, and the date of registration of kinetoscope-related applications for provisional protection exactly mirrors the demand profile for the same period which can be verified from kinetoscope price trends and which is in itself linked to the declining British kinetoscope market in the second half of 1895.

An operational feature of British patent procedure to which attention should be directed concerns the significant fall-out which occurred between 'provisional' and 'complete' filing stages. The consequence – not always appreciated by film historians – was that the true level of interest shown in a particular class of invention was not in any way indicated by the number of patents granted. The Comptroller General's annual report for 1895, lists a total of 25,062 applications, of which 20,698 filed a provisional specification, and 12,553 proceeded to full specification.[21] Thus, between provisional and full stages there was a substantial 39.4% reduction. Table 1 shows that the kinetoscope-related reduction over the same period was far worse at 75%.

Under the terms of the 1885 Patent Act (operative in 1894/5) applicants had nine months in which to file a complete specification. If they failed to do this then the provisional specification was declared void and destroyed.[22] The detail that now remains is restricted to the name, number, and descriptive heading assigned to the provisional application Although it is most unfortunate from a historical aspect that this body of documentation is no longer available, it must be remembered that the action was taken, under statute, in the interest of the patentee and in order to protect the confidentiality of claims that had been made, and was not due to 'the whim of some short-sighted civil servant' as John Barnes suggests.[23]

An examination of British kinetoscope-related patent applications given in Table 1 discloses some interesting information. It is possible to show for the first time that Robert Paul's patenting activity in this field from early 1895 to early 1896, was far more extensive than has previously been believed. Of importance in providing an insight into his creative development, is that it can also now be established that the so-called *Time Machine* patent (19,984) was not created in

Table 1: British kinetoscope related patent applications

Date	Name/s	Number	Description
27 December 1894	Anderton, J. and Lomax, A	25,100 ★	Improvements in kinetoscopes
3 January 1895	Wray, C.	182 ★	Improvements in kinetoscopes
10 January 1895	Paul, R. W.	664	Attracting the attention of Sightseers
16 January 1895	Lomax, A.	1028	Improvements in kinetoscopes
17 January 1895	Lomax, A. and Anderton, J.	1115	Improvements in kinetoscopes
14 March 1895	Lomax, A.	5377	Kinetoscope films
30 March 1895	Barron, G. and the Interchangeable Automatic Machine Syndicate Limited	6562	An improved mechanical kinetoscope for exhibiting photographic picture in motion, in combination with Phonograph mechanism
4 May 1895	Heinze, H. J.	8884	Kinetographs, kinetoscopes, kinetophonographs
18 May 1895	Hough, J. E.	9881 ★	Viewing pictures for obtaining an appearance of movement
18 June 1895	Smart, A. C.	11,878	Magic lantern apparatus for kinetoscope exhibition
23 September 1895	Paul, R. W.	17,677	Kinetoscope apparatus
24 October 1895	Paul, R. W.	19,984	Exhibition or entertainment
25 February 1896	Paul, R. W.	4168	Reproducing stage performances
2 March 1896	Paul, R. W.	4686 ★	Projecting kinetoscope pictures on the screen

Applications marked ★ proceeded to the final stage and were published.

conceptual isolation, but instead ought to be linked, as an example of parallel development, to a 'Kinetoscope Apparatus' application (17,677) filed just a month earlier.[24] Another feature of Paul's patenting activity in this period is that it shows a continuing interest in establishing a presence in 'entertainment' spectacles unrelated to the kinetoscope. In view of later developments, it is particularly significant that this interest continues to as late as the end of February 1896, as application 4168 proves. After March 1896, there is a change of direction, and thereafter no further 'entertainment' related applications are made – all are now linked to some aspect of cinematography.

Table 1 also establishes the true extent of kinetoscope patent interest shown by known phonograph infringers such as Lomax, Barron, Heinze, and Hough. Hough's application has already been discussed in relation to Chinnock, but other interesting applications made include those by Lomax (5377) for 'Kinetoscope Films' and Barron (6562) for an early kineto-phonograph. In the absence of further details some intriguing questions are suggested. Did Smart's application of June 1895 incorporate an early form of film projector?[25] What further 'improvements' to the kinetoscope did Lomax propose in 1028 just three weeks after he had patented his multiple-view prism device in December 1894? Could the Lomax application in March for 'Kinetoscope Films' (5377) be of potential significance in suggesting that Lomax had developed a camera by this date, or was his application less imaginatively – but perhaps more realistically – connected to the 'duping' of prints?

A complicating factor, with regard to an assessment of cine-related patents, is connected to Henry Hopwood's book *Living Pictures* published in 1899. Although often relied on as authoritative by film historians, it is in a number of ways a very misleading source of information. There is for example no indication given that the author was employed by the Patent Office, and consequently no acknowledgement of the unsatisfactory situation surrounding British patent practice. This is a disingenuous position to adopt especially when it is linked to suggestions by the author that the book should be regarded as 'a standard work of reference on the subject' and is misleading in the extreme when the claim is made 'that every specification pertinent to my subject is at least mentioned' when it is not made clear anywhere that only *published* applications are included and, moreover, that these have not been granted a British patent on the basis of their merit or 'novelty' but simply because the applicant had paid the fees required to proceed to full specification stage.[26] If an attempt is made to assess the patent position prevailing at this stage of early film history, Hopwood possesses very limited value as a source that can be relied on. and none whatever as a guide to the true level of patent interest in 'Living Pictures' between 1895 and 1898.

Notes

1. If a partnership had been formally established by contractual agreement, Board of Trade regulations required, for the protection of creditors, that notice of dissolution had to be advertised in *The London Gazette*. This was done in the case of Georgiades and Tragidis (see Fig. 6) but a check which has been done for 1895 and 1896 has confirmed that no similar entry exists for Paul and Acres.

2. Paul to Editor, *British Journal of Photography* (27 March 1896): 206–207. Acres to Editor, *British Journal of Photography* (10 April 1896): 239. An earlier letter from Acres was published on 13 March 1896, but is inconsequential. The text of the three letters is given in Barnes, *The Beginnings of the Cinema in England 1894–190. Volume One*, 35–37.

3. Acres to Stollwerck, 6 August 1895, Stollwerck Archives. Document located by Hauke Lange-Fuchs, and transcribed and illustrated in Lange-Fuchs, *Der Kaiser, der Kanal und die Kinematographie*, 40–43. For full accounts of this unlikely business association, see also Lange-Fuchs, *Birt Acres* and Martin Loiperdinger, *Film & Schokolade*.

4. The historical development of British Intellectual Property Law is examined by Sherman and Bentley (1999).

5. Fulton, 1902, 244. A similar type of action for fraud and forgery could be brought under the terms of *The Merchandise Marks Act* of 1887 (50 & 51 Vict. c28), but this was not a course available to Maguire as Edison

did not register his trade mark (his signature) in Britain until 1900. For the historical development of 'passing off' law see Christopher Wadlow, *The Law of Passing Off. Unfair Competition by Misrepresentation* (London: Sweet and Maxwell, 2004): 16–31.

6. Ramsaye, *A Million and One Nights*, 150.

7. 25 & 26 Vict. c. 68

8. Brown, 'The British Film Copyright Archive', in Harding and Popple (eds.), *In the Kingdom of Shadows. A Companion to Early Cinema*, 240–244. Brown's research showed for the first time that a large number of British registrations of film clips as photographs had taken place from 1897 onward. See also Christie, '"What is a Picture?" Film as Defined in British Law Before 1910', in Braun et al (eds.), *Beyond the Screen: Institutions, Networks and Publics of Early Cinema*, 78–84. Developments in this area of law in the United States were in advance of those in Britain. In the important case of *Edison v Lubin* (1903) the Court held that copyright in photographs extended to the film as a whole, not merely to individual frames. See Peter Dechernay, 'Copyright Dupes: piracy and new media in *Edison v Lubin* (1903)', *Film History* Vol. 19 (2007): 109–124.

9. Ernest J. Richards, 'Copyright in Photographs', *The British Journal of Photography* (8 February 1895): 89–90.

10. Paul to Editor, *British Journal of Photography* (27 March 1896): 206–207.

11. Acres to the Editor, *The British Journal of Photography* (10 April 1896): 239.

12. See for example his advertisement in *The British Journal of Photography Almanac* (1897): 610, (written c. October 1896), which notes that he has 'The Largest Selection in the World of COPYRIGHTED FILMS [emphasis in original] as shown before H. R. H. The Prince of Wales.' Barnes, *The Beginnings of the Cinema in England 1894-1901 Volume One*, 221, transcribes this advertisement but, given the importance of assessing Acres' contribution to early British film history, most unfortunately omits his claim for copyright.

13. Paul to Editor, *The British Journal of Photography* (27 March 1896): 206–207.

14. Acres to Stollwerck, 6 August 1895, see Lange-Fuchs, *Der Kaiser, der Kanal und die Kinematographie*, 41.

15. Will Day, 'Claims to Motion-Picture Invention', *The Photographic Journal* (July 1926): 366. Paul gave the same reason in his letter to Oskar Messter of 5 August 1932 (Will Day collection).

16. For an additional discussion on some of these issues, see Deac Rossell, 'Rough Sea at Dover: a genealogy'.

17. Statutory regulations in operation in 1894/1895 were those included in the 'Patents, Designs, and Trade Marks Act of 1888 (51 & 52 Vict. c.50). The Patent Act 1902 (2 Ed. 7 c.34) established the principle that, after January 1905, British applications should be examined for 'novelty' after a complete or 'full' specification had been filed.

18. 'English Patents', *The British Journal of Photography* Vol. 43 (14 August 1896): 514.

19. *Report of the Commissioner of [US] Patents for the year 1888*, Washington, Government Printing Office (1889): xl.

20. Martin, *The English Patent System*, 29–32.

21. *Thirteenth Report of the Comptroller General of Patents, Designs, and Trade Marks for 1895* (London: HMSO, 1896)

22. Section 4 of the (Amendment) Act 1885 to the Patents, Designs, and Trade Marks Act 1883 refers. For a full review of the historic development of patent specification procedure, see Davenport, *The United Kingdom Patent System*, 30–33.

23. Barnes, *The Beginnings of the Cinema in England 1894–1901 Volume One*, 275, n. 5.

24. The text of the specification of 19,984 was reprinted in Ramsaye, *A Million and One Nights*, 155–157. *The Time Machine* and the legends that built up around it, are discussed in Chapter Six.

25. Alfred Christie Smart (1864–1901) was a wealthy Australian architect-turned-artist who came to London in about 1895 to exploit his patented 'pyro-tint' system of painting on wood. He also patented a 'cuff protector' in 1895.

26. Hopwood, *Living Pictures*, Preface, xii. For biographical details of Hopwood see John Barnes, *Filming the Boer War. The Beginnings of the Cinema in England 1894–1901* (London: Bishopsgate Press, 1992): 120.

Chapter Five

Marketing the Kinetoscope in Britain

It is interesting to compare the organisational approach taken to marketing the kinetoscope and the mutoscope 'peep-show' instruments in Britain during the 1890's. In the case of the mutoscope this was done by the formation of a series of regional equity-funded joint-stock companies each with a defined territory, and each committed by contractual agreement to buy a substantial number of machines.[1] In contrast in Britain the kinetoscope was sold indiscriminately, machine by machine, into an 'open' market that the concessionaires soon lost control over. Moreover, the climate of illegality surrounding the Edison phonograph in Britain undoubtedly encouraged the willingness of entrepreneurs to adopt commercially amoral attitudes to the invasion of Edison's property in the case of the kinetoscope business.

Kinetoscope exhibitors whose destiny it was to be the first to introduce films to the public, were mainly small-time opportunists, prepared to take on the exploitation of new products before their long-term viability had been established, or while they were seen to represent a price-based opportunity created by an attempted monopoly situation as in the Continental Commerce Company example. Potential, but short-term, profits encouraged short-term objectives, which required quick returns from revenue based funding. As is noted later in this chapter, the unfavourable money-taking potential of the kinetoscope design was recognised by Alfred Lomax of Blackpool who applied for a patent in December 1894 for a multiple viewer. Bearing in mind that many exhibitors regarded the kinetoscope as a 'novelty' with a short-term future, rather than as the start of a future great business, the diversity of marketing activity that was engaged in is perhaps quite surprising.

After an introduction, which considers the financial viability of British kinetoscope exhibition, the different forms of marketing used to promote the kinetoscope business are discussed. Based on the traditional divisions of the 'Marketing Mix' (Price, Promotion, and Distribution), the sub-divisions which existed as part of each main class are also noted. The significant degree of promotional diversity revealed, provides further confirmation that film exhibi-

tion by kinetoscope although a new business in 1895, was not in any way an immature one in the methods used to 'sell' it to both the 'trade' and to the public.

'Price' was involved in a wide range of transactional functions, from the access cost to film exhibition, to the price behaviour of kinetoscope machine sales which provides a valuable insight into the fluctuating levels of market demand. In the section on 'Promotion', the comprehensive use made of print and media is examined in detail. Subjects considered in the section on 'Distribution' include a description of the different forms of exhibition/exhibitor that existed, and how regional supply chains independent of London centrality were established and functioned.

Financial Viability

Due to the lack of surviving financial information, the profitability (or otherwise) of British kinetoscope exhibition cannot be positively established. It can be expected that in individual cases trading results would have been influenced by factors such as positioning in the case of a shop, or by local conditions in the case of an itinerant exhibition. Nor should it be assumed that there was an automatic correlation between business levels and profitability. Although demand levels would have been higher between January and April 1895, than thereafter, entering the market at this early stage would also have been more expensive. The establishment by the summer of a second-hand market of price discounted machines significantly reduced start-up costs, and would have enabled exhibitions to remain viable even in a reduced market and in marginally profitably situations.

Although the key financial performance ratio of return on capital cannot be calculated, this does not mean the levels of patronage required for the recovery of start-up costs cannot be estimated. In Table 2, Edison and Paul kinetoscope prices are compared. If a hypothetical prospective exhibitor wished to make a start in the kinetoscope business and wanted one kinetoscope plus three films at £3 each, he would pay a total of £79 for an Edison machine, and £49 for the Paul model. At the normally charged viewing price of 2d, it follows that 9,480 viewers for the Edison, and 5,880 for the Paul example, would be required to recover the respective start-up costs. Additional to this estimate an allowance would have had to be made to recover running costs such as the rent of a shop, and the replacement of worn-out or 'stale' films. If he was peripatetic, then the exhibition life of the films would be extended, but set against this saving would be the cost of travelling and hotel expenses. The figures presented in Table 2 have been calculated on the assumption – verified by a number of contemporary references – that an exhibition would be likely to operate on a twelve hour, seven-day basis. The results suggest that a show which was able to attract an average of about seventy patrons a day, could return the exhibitor his start-up investment within nineteen weeks' operation with an Edison machine, and approximately twelve weeks with a Paul model. These are encouragingly low figures in the case of a 'novelty' whose future 'life' was unknown, but expected to be short.

Table 2: Nominal operating comparison

Viewers per week	Gross revenue	Viewers per day Average	Recovery period (weeks) Edison Machine	Recovery period (weeks) Paul Machine
250	£2.1s.8d	35.7	37.9	23.5
500	£4.3s.4d	71.4	18.9	11.7
750	£6.5s.0d	107.1	12.6	7.8
1000	£8.6s.8d	142.8	9.4	5.8

Price

The use made of price in the British kinetoscope business was more comprehensive than might be expected. Functional use can be summarised as:

- 'Strategic' – introduced with the intention of controlling the market in machine sales.

- 'Demand-led' – Price variations influenced by actual sale prices.

- 'Viewing' price – The cost price charged by exhibitors for access to films.

The first category includes Franck Maguire's and Thomas Edison's use of a very high – or 'skimming' – introductory price level. This was predicated on the assumption that any kinetoscope price set at this first stage would be inelastic in character due to the unique characteristics of the kinetoscope, and that consequently competition would not be encountered. This was never true in Britain because Maguire was unable to establish a monopolistic position, or to control the market in the way that he had believed that he would be able to do. Whether Edison was sincere in believing that Maguire could achieve this position when allocating the concession is more doubtful. Only two months after the 'official' debut, a reduced-price response emerged in the form of the Paul-made facsimile machines selling at nearly half price of the 'genuine' models. This expected development was also strategic in character, although instead of initially offering product improvement features – including 'new' film titles – it relied instead on competition-induced price elasticity of demand to gain a quick share of the market. At the end of March 1895, Paul attempted to strengthen his market position by arranging a film distribution exchange with Edison, but his approach was rejected.

The second category of kinetoscope price levels was linked to a second-stage of market development created mainly after April 1895, when the 'novelty' factor no longer applied, and the price level that governed buying or selling of machines was now influenced by re-sale competition, and probably also by return-on-capital concerns. Unlike strategically-set sale prices, second-stage levels provide an accurate reflection of actual market demand. The combined effect of Paul's discounted price, and a generally falling market, meant that the Continental

Commerce Company/Edison premium level was no longer maintainable, and in April Franck Maguire announced a price reduction.[2]

As 1895 progressed two new niche markets emerged, both of which relied on discounting. The first was a spin-off from the manufacture of the Paul facsimile kinetoscopes. Component parts for a kinetoscope were now available, and it became possible for anyone to engage in 'do-it-yourself' construction. The total cost of this method is unknown, although it was presumably below the £40 level set by Paul for his assembled models. Many of the dealers known to have supplied kinetoscope parts were also engaged in illegally marketing phonographs. Apart from London, the West Yorkshire area was a main supply source for these items. Maguire was unable to respond to this challenge, either based on price, or by entering this niche, since all his machines were fully assembled in the United States, and shipped to London in a completed state. While the DIY market was a created one, a second-hand or used market in kinetoscopes was a consequence of market decline in kinetoscope exhibition. It is clear from the evidence of sales advertisements that some dealers and former exhibitors, realising that they were not going to make a quick and easy fortune, were prepared to cut their losses and sell at very low prices to secure a quick sale.

Table 3: Kinetoscope price trends in the UK, January to July 1895

Name of dealer/company	Location	Price	Source and date
Paquet	London	£50 (Edison)	*Era* 19/1
Kinetoscope Manufacturing Co. (Wray)	Bradford	£50 (Paul)	EM 25/1
Exhibition Novelty Co. (Duval)	London	£58 (Paul) for a minimum order of two machines	*Era* 9/1
Kinetoscope Manufacturing Co.	Bradford	'From' £40 (Paul)	*EM* 1/3
Exhibition Novelty Co.	London	£42 (Paul)	*Era* 9/3
Northcote & Co.	London	£30 (probably a Paul machine) 'with Phono combined, £60'	EM 22/3
Exhibition Novelty Co.	London	£35 (Paul)	*Era* 23/3
Dixon	Luton	£70 (Edison) 'with three films'	*Era* 23/3
Bernstein	London	£40 (probably a Paul machine)	*EM* 5/4
Kinetoscope Film Co. (Young)	London/ Amsterdam	£31 10s (unknown origin – possibly Paul)	*Era* 13/4

[Sources: *The Era* and *The English Mechanic*.]

The Continental Commerce Company announces a reduction in prices,
Era **13/4 and** *EM* **19/4.**

Name of dealer/company	Location	Price	Source and date
Jones	London	£40 (Edison)	*Era* 20/4
Bernstein	London	£35 (probably a Paul machine) 'improved' kinetoscope	*EM* 3/5
Interchangeable Automatic Syndicate	London	£30 (a kinetophone – probably Paul's)	*EM* 10/5
No name	London	£80 (two kinetoscopes plus four films. Cash only) Re-advertised in the *Era* 25/5 for £60	*Era* 11/5
Ernest	Brighton	£50 (Unknown origin) for two machines	*Era* 18/5
Automatic Syndicate	London	£27 (Edison) for second-hand machine	*EM* 24/5
Davis, Opera House	Cork (Ireland)	£40 (Edison) 'plus three films'	*EM* 8/6
No name	London	£15 (Edison) Two 'genuine' machines. Owner 'going back to States'	*Era* 27/6
Northcote & Co.	London	£30 (Unknown origin) 'Kinetophonograph £60'	*EM* 5/7

In the case of 'viewing' price levels, comprehensive analysis is prevented by the availability of contemporary information. While exhibition announcements are numerous, most showmen appear not to have thought it necessary – or perhaps wise – to include a note of what access to their kinetoscope would cost. At the height of interest in kinetoscope-film exhibition between January and April 1895, the most commonly adopted price appearing in advertisements was two-pence (2d), to which some exhibitors were careful to add that it was for 'Each scene' or 'per scene'. Examples of the 2d price being charged have been noted in Bristol (January), Preston (February), Halifax (February) Southsea (February), Belfast (February and April), Brighton (March), and Dublin (April). At the end of May an exhibitor in Leeds who had been charging 2d, now included the line 'Reduced to 1d' which suggests that his business level had by that date declined.

On the East coast of Scotland examples of a 3d price (not encountered anywhere in England) appear in Perth (December 1894) Dundee (January and February 1895) and Aberdeen (February). Interestingly, perhaps because of this high price, there are examples of price differentiation found in some of these cases. For example, while a show in Dundee was charging 3d in February, another one at

the same time in the affluent, smaller nearby town of Broughty Ferry, only charged 2d, while at Aberdeen the exhibitors advertising noted that children would be admitted at half-price. It might have been expected that reduced child prices would have been a general feature of kinetoscope exhibition, but no further examples have been traced. Possibly exhibitors were not anxious to attract children, to ensure that revenue levels would not be adversely affected. In an attempt to maximise revenue levels by ensuring that all machines received equal levels of patronage, irrespective of the appeal of individual films, 'package' deals were offered at larger exhibitions. At the Continental Commerce Company exhibition in Oxford Street, patrons could view five films for a shilling (12d), or all ten on show for one shilling and sixpence(18d). At least a limited choice was offered in London, but this was not the case when five machines were shown together in Newcastle-on-Tyne, for here customers were not allowed to select individual film titles, but obliged instead to pay one standard charge of a shilling for access to the whole show.

Promotion:
Printed Promotion
A comprehensive range of print was utilised to support the marketing of the kinetoscope business. The diversity present is a reliable indication of the mature level of support available from this function. The use of print can be divided into two areas. Firstly, self-generated handbills, catalogues, and brochures, and secondly the use made of media such as newspapers and journals for some form of advertising whether to the general public or the 'trade'.

Conveniently for Franck Maguire at the recently opened Oxford Street exhibition, William Dickson and his sister wrote an account of the kinetoscope which was published in New York in January 1895.[3] Maguire obtained a supply of this brochure, and had the cover overprinted with the London shop address and the heading, 'Compliments of the Continental Commerce Co.' which suggests that he intended that they should be given away to more important visitors or 'trade' customers, as a souvenir of their visit. Three copies of the overprinted version have been located in Britain. One is in the Barnes Collection, a second in the Holmes Collection, National Fairground and Circus Archive, University of Sheffield, and a third in a private collection. A facsimile edition of this booklet, taken from a copy in the Museum of Modern Art, New York, was issued in 2000. The Dicksons also wrote *The Life and Inventions of Thomas Alva Edison* (London: Chatto and Windus, 1894). This book, which Edison considered 'extremely well gotten up', included an illustrated account of motion picture work (pp. 300–319). It was published in Britain in November 1894, only a few weeks after the Oxford Street exhibition had opened, and was promoted as a Christmas 'gift' book. Unlike the booklet, it is of common occurrence, and must therefore have achieved good sales, despite having received some sarcastic reviews related to the accuracy of some of the claims made by the authors, and the overblown writing style they adopted.

Although no British posters featuring the kinetoscope are known, it would be

Fig. 12. Typical flyer advertising a kinetoscope exhibition, c. 1895.

surprising if none were produced, given the popularity of this form of advertising.[4] Handbills were the most fragile and ephemeral form of publicity produced, but there were also factors assisting their rate of survival. Not only were handbills printed in very large numbers, their small size made it convenient for them to be preserved in the scrapbooks that Victorians were so fond of compiling. Three different Continental Commerce Company examples are known, together with

an early example issued before December 1894 by the Greek partnership of Georgiades and Tragidis, and an interesting 'concertina' version printed for the International Kinetoscope Company exhibition in Regent Street. Surviving provincial examples include one from Manchester and one from a show at Gallowtree Gate, Leicester.[5]

It is perhaps significant that all surviving handbills include an address for the show they promote – an indication that this particular form of advertising was most favoured by the 'static' rather than the itinerant form of kinetoscope exhibition. Handbills may have been given out to passers-by by a member of staff standing at the door of the show, but a popular method of gaining wider distribution that was often used by businesses at the time, was to hire a 'sandwich' board man and have him walk round the immediate locality advertising the attraction and dispensing handbills as he travelled.

It is evident that kinetoscope dealers were adept at producing a wide range of printed material. The most common example was the basic price list, but in addition other very interesting, and quite ambitious, examples of promotional literature were created. Unfortunately, none of the examples cited appear to have survived. A dealer from Manchester registered what was probably a self-written booklet at Stationer's Hall in December 1894,[6] while H.J. Heinze of the International Agency in London, issued a free catalogue (or perhaps magazine?) called *Sound and Sight*, which was claimed to contain information on phonographs, kinetoscopes, and kineto-phonographs.[7] A month later Heinze was offering a free 'Historical Pamphlet' together with 'castings, parts, and films' for kinetoscopes.[8] This is evidence that he was stocking kinetoscope component parts obtained from Robert Paul. Likewise, Victor Taylor, a phonograph infringer based in North Kensington, ran a sales promotion in January 1895 based on the recent availability of component parts produced by Paul ('How to construct an Edison kinetoscope equal to one costing £70' was the headline) and sold a 'How To' booklet explaining everything to his customers for the not particularly cheap price of four shillings.[9]

Although the loss of these dealer lists and catalogues has been total, it is likely that at the time there would have been numerous examples in circulation. John Henry Rigg of Leeds, manufacturer of the innovative 'Baby' kinetoscope, claimed in evidence given in a phonograph case that he had issued five catalogues in 1895 alone. Nor should it be assumed that because most of these dealers were operating on, or below, the borderline of legality, the presentational quality of their publicity was necessarily poor. George Barron of the Automatic Syndicate was unlikely to have charged 2d for his 'illustrated' catalogue of kinetoscopes, including 'Three view attachments direct from States' unless he considered it sufficiently attractive to encourage his potential customers to pay 2d for it. An example of a 'top-end' 32-page phonograph catalogue issued in early 1894 by the leading dealer J. L. Young, can be assessed in detail for both content and presentational quality since a copy has been preserved at the National Fairground Archive. In addition to price lists, it features a biographical sketch of Edison, a

short history of the phonograph, nine pages describing the various uses that a phonograph could be put to, 'hints to exhibitors' on how to present the instrument, and even a fascinating advertising script prepared for use in selling products by phonograph. Virtually every page is illustrated with a photograph or a woodcut illustration. It is in fact much more than a basic catalogue and resembles a magazine.[10] Young also dealt in kinetoscopes – 'The only place in Europe for improved kinetoscopes, and up to date English and Continental films' – and if he issued a similar kinetoscope catalogue it is likely that it too shared the same high standard of presentation.

Newspapers and journals provided a vital support role which supplemented self-publicity.[11] The extensive use that kinetoscope exhibitors made of local newspapers throughout Britain can be seen from an examination of Appendix One. While newspaper advertising was directed to the general public and announced kinetoscope displays, selected journals functioned as a 'market place' for the trade. By the late Victorian period journal coverage was comprehensive, and the interests of any group of society, whether professional, financial, or leisure orientated could be accurately targeted by an advertiser.[12]

As far as kinetoscope dealers in particular were concerned, the most extensively used titles were *The English Mechanic*, and *The Era*. Kinetoscope advertisements, including those for the first British film titles, were displayed in *The English Mechanic* among a heterogeneous mixture of products, ranging from patent medicines to engineering tools and notices for business opportunities. Readership ranged from those with an interest in 'popular science' to skilled workingmen with aspirations. As a consequence, many advertisements and some articles implied that wealth and personal advancement could be achieved by association with a new invention, especially if it was linked to an iconic 'self-help' popular hero such as Thomas Edison.[13]

The Era, in which the Continental Commerce Company advertised, was of newspaper size, and better printed on higher quality paper than the *The English Mechanic*. Kinetoscope dealers found *The Era* of particular value since it was read not only by members of the theatrical profession, but by showmen and exhibitors of 'novelty' attractions, who were always looking for new products that they might exploit. It might be thought that the leading photographic journals, such as *The British Journal of Photography* and *The Amateur Photographer* would have been chosen by advertisers to promote a product such as a kinetoscope, but this was not the case, even though these journals published articles and notices relating to it. A possible explanation may be that photography, both professional and amateur, was predominantly a middle-class interest at this date, and readers were therefore unlikely to aspire to be a travelling 'showman' exhibiting a kinetoscope.

Distribution:
Regional Distribution and Innovation
Although London was the main centre for the national organisation of the British kinetoscope trade, business was never wholly focussed in the capital, and film

exhibition distribution in 1894–1895 was far more complex than might be thought. Provincial activity also provided an integral – and sometimes innovatory – contribution to sector evolution, and the West Riding of Yorkshire in particular was notable for being the location where some of the most interesting kinetoscope developments occurred.

A discussion of regional developments and their characteristics naturally introduces the question of the role of logistics, and of how in practice, distribution channels operated, and local distribution networks were organised. Effective marketing support for both the sale and the exhibition of machines was required in the kinetoscope business to yield maximum revenue generation. It is however necessary to emphasise that British kinetoscope distribution patterns used for both machine supply and for film exhibition, were not reactive creations in response to the arrival of the kinetoscope, for the networks used were pre-determined and largely created to service the requirements of the phonograph trade. In the case of the kinetoscope, both the extent of geographical dispersion, and the speed at which this was achieved by any given date, can be estimated from the information presented in Appendix One which lists all British exhibitions that it has been possible to trace

The management of regional distribution varied widely in operation, ranging from exhibitions controlled directly by the Continental Commerce Company, to speculative expeditions run by individual entrepreneurs. In several cases Franck Maguire used members of his own staff, or 'authorised' agents to run provincial exhibitions. The Continental Commerce Company was named in a newspaper report from Newcastle-on-Tyne as the exhibitor of five Edison machines – 'the largest number outside London' – shown for several weeks in January 1895 at Mawson, Swan, and Morgan's department store in Grainger Street.[14] Thomas Edison's commercial relationship with Sir Joseph Wilson Swan (1828–1914) who had amalgamated his electric lighting company with that of Edison's in 1883, was probably the reason why the exhibition at Newcastle received particular attention.

When the kinetoscope was introduced into Ireland in February 1895, Maguire's assistant manager, John Quain styling himself manager of the 'Edison-Kinetoscope Exhibition Company', travelled to Belfast to arrange the kinetoscope's debut directly, even though a local agent was available. It seems likely that it was the perceived importance of this National event, added to the commercial potential arising from a kinetoscope display at a subsequent 'Art and Industry' exhibition at the Linen Hall, that was responsible for the additional attention given in this case.

To achieve the prime objective of a kinetoscope exhibition being surrounded by large groups of the public – including hopefully some 'trade' buyers – 'Popular Science' themed events represented an ideal symbiotic venue. Exhibits were miscellaneous and usually featured the introduction of electricity for new domestic uses such as cooking and lighting a house. The kinetoscope's appeal to modernity could be fully exploited at such a venue if headlined as "Edison's

Latest Wonder" – a useful way to also attract the interest of those familiar with Edison's name, but unfamiliar with what a film exhibition was. Early 1895 shows of this kind, where a kinetoscope is known to have been exhibited, include 'The World's Fair' at Islington in January 1895, an 'Annual Carnival' at Olympia in Newcastle in January, 'Art and Industry' presentations at Belfast (February and April) and Stockton-On-Tees (March), a 'Gas and Trades' exhibition held in Tunbridge Wells in May and a 'Home Arts and Industries' show presented in May at Sutton in Surrey. Later in the year Robert Paul exhibited sixteen of his facsimile kinetoscopes at the 'Empire of India' exhibition held at Earls Court. It is very likely that a kinetoscope presence at further presentations of this kind occurred, but has yet to be traced.

Once a main exhibition of this kind had ended, a kinetoscope exhibitor would capitalise on the exposure he had received by taking his machine/s on an extended tour. Exact movements in individual cases are naturally difficult to trace due to the problem of being sure that the same presentation was involved in different towns, but it is known that a kinetoscope showman present at the Stockton 'Art and Industries exhibition, went, after the show had closed, to nearby Middles-brough, and then toured various towns on the East coast of Scotland.

A similar network covering a large geographical area was developed by Frederick Dalton, who described himself as an 'authorised agent' and may in fact have had some connection to Maguire and the Continental Commerce Company, perhaps on a shared expenses and profits basis. When Dalton presented three kine-toscopes at Bradford in December 1894, he claimed that this was the first time the machine had been shown outside London, and it seems unlikely that an early and large show of this kind, held at an important location, could have occurred solely by chance and without the prior agreement of the Continental Commerce Company. Although Dalton was based in the small spa town of Matlock Bath in Derbyshire, he travelled widely, and in addition to giving purely local shows such as one at Belper, is known to have run exhibitions in Leeds, Sheffield, and Bradford in West Yorkshire. Considering the location of his base, it would be surprising if he did not also visit the East Midlands cities of Derby and Notting-ham.

An example of a regional stockist supplying both kinetoscopes, kinetoscope parts, and films obtained from Robert Paul in London, is that of Cecil Wray (1866–1944) of Bradford. The detail of the Paul/Wray association is not known, but, bearing in mind Paul's preference for formal contractual commercial agree-ments, as shown in the case of the Greeks and Birt Acres, it is likely that his association with Wray incorporated such subjects as regional exclusivity, and a formulated scale of commission payments linked to the different products sold. Like Paul, Wray was an electrician – a shared professional background that located both men in a 'high technology' business area, and suggested their above average receptivity to new products. Both Wray and Paul were also associate members of the Institution of Electrical Engineers – Wray joining in 1889, and Paul in 1890 – so it is quite possible that some social contact may have occurred

before 1895. In a further similarity to Robert Paul, Wray also owned an electrical manufacturing business – the Wray Electrical Engineering Company – established in 1894.

Whether Paul approached Wray in December 1894 with the intention that he become a regional stockist for 'bogus' kinetoscopes, or whether Wray's interest in the machine was first aroused by seeing a kinetoscope exhibition given in Bradford in the same month, is not known, but what *is* certain from the evidence of Wray's advertisements is that, during the six-month period of his association with the machine, only Paul's models were sold by him.

During 1894 Wray moved to 6 Cornwall Terrace, Manningham Lane, Bradford, and it was from this address that his kinetoscope-related patent, and his first kinetoscope advertisements were issued.[15] Wray never included his own name in his advertisements preferring instead to use his business title – 'The Kinetoscope Manufacturing Company'. By the end of January 1895, he was not only advertising Paul's machines (at £50, compared to Franck Maguire's 'official' level of £70) but also offering individual parts, enabling a purchaser to construct his own instrument. Castings for the metal parts were priced at 30 shillings, Edison motors at £4, and lenses, eyepieces, batteries and oak cases were all available separately.[16]

Wray also supplied exhibitors with films. By 5 April 1895 – the same date that Paul first began advertising 'New Topical Subjects' – Wray was offering a 'list of 50 subjects' which, if the total claimed is accurate, must have included Edison titles in addition to the new English films taken by Birt Acres for Robert Paul. Wray later claimed that he had rented as well as sold (duped?) kinetoscope films.[17] In either July or August 1895, Wray joined the Edison-Bell Phonograph Corporation as their Bradford branch manager – yet another link between the two sectors. His kinetoscope advertising had ceased for some time prior to this, but he retained his interest in film exhibition, and returned to the business in early 1896. In terms of his part in the marketing evolution of the British kinetoscope business as it developed in the early part of 1895, it can be seen that Wray functioned as a Northern England main 'hub' supplier, marketing Paul's products, and *inter-alia* by his presence responsible for building up a geographically concentrated regional network of smaller West Yorkshire dealers. The ability of these smaller dealers to supply kinetoscope parts is confirmation that they were selling Paul machines probably obtained from Wray. West Yorkshire businessmen involved in the kinetoscope trade included the Roberts brothers in Liversedge, John Hamer, a market trader from Halifax (who rather grandly described himself as an electrical and mechanical engineer) and Harry Pitt, who ran the Spen Valley cycle works in Cleckheaton, and who confusingly also called *his* business 'The Kinetoscope Manufacturing Company'. Hamer's enthusiasm for the new product led him to overstock, and he was still trying to sell off kinetoscopes at 'greatly reduced prices' in May 1896.[18]

Before discussing John Rigg's unique innovatory kinetoscope design, the history of another main regional dealer, based in the large holiday resort of Blackpool,

Fig. 13. Competing kinetoscope advertisements.

will be given. Alfred Lomax (1862–1937) like Cecil Wray in Bradford, operated a fixed-site business, selling and renting kinetoscopes, phonographs, and 'American Novelties for Exhibition Use'. In common with many others involved with kinetoscopes, Lomax had been trading illegally in phonographs, and had been

enjoined by the Edison-Bell company in 1893 for infringing their patents.[19] Although he gave local demonstrations of the kinetoscope, Lomax was not a travelling showman, but functioned, as did Wray, as a local stockist and supplier for his area. He had a pioneering interest in developments in 'motion pictures', and as early as May 1893 had republished *The Phonogram* article on 'The Kine-tograph' in the form of a letter to the editor of *The Blackpool Gazette*.[20] This provincial publication, occurred only seventeen days after the kinetoscope's first public demonstration at the Brooklyn Institute of Arts and Science in New York on 9 May.

Supplies of the Edison kinetoscope had arrived in England by October 1894, and Lomax had received a machine by the first week in November, and gave a demonstration of it and an interview to his local newspaper a week later. [21] Six weeks afterwards, in conjunction with John Anderton, a scientific instrument maker in Birmingham, Lomax applied for a patent for a 'multiple view attach-ment'.[22] This was intended to address an obvious practical problem '... as at present constructed, only one person at one and the same time is enabled to see the view ... this has been found to be a serious disadvantage to its general and profitable use, especially when employed for the purpose of exhibition'.

Unlike Cecil Wray, Lomax initially sold only genuine Edison machines – indeed in his early 1895 advertisements he specifically cautioned against the Paul imitations. 'Look out for spurious machines sold as genuine'.

The marketing territory that Lomax covered is known to have been a wide one, for example he regularly advertised between January and May 1895 in the *North Eastern Daily Gazette* published in Middlesbrough. But his interest in selling 'genuine' machines did not mean that Lomax was obtaining his supplies from the Continental Commerce Company. In fact, as Fig. 13 shows, Maguire specifi-cally distanced his company from Lomax's activities.

In what can be fairly described as an ingenious strategic move, Lomax had arranged to be appointed the 'Sole British Agent' for the Kansas Phonograph Company, one of the subsidiary companies controlled by Thomas Lombard and North American Phonograph Company. Maguire had no means of preventing the importation of genuine machines ordered from the Edison Manufacturing Company by either the North American Phonograph Company or the Kansas Phonograph Company, and sent to England for the use of their appointed agent. Once again, the limited operational value of Maguire and Baucus' 'sole' kine-toscope sales agency was exposed, and confirmation was available that a new competitive challenge was just as likely to come from astute dealers in the provinces, as from plagiarists such as Paul and the Greeks in London.

A significant change in the business occurred after April 1895 as Lomax's advertising copy confirms. Advertisements published from 3 May to 29 July in *The Blackpool Gazette* now announce that he was offering 'English and Edison's' kinetoscopes for sale. Why, after previously directing criticism at them, was he now stocking Paul's machines? The most likely explanation is an economic one. British market conditions for the sale of kinetoscopes were very different in May

from what they had been at the beginning of the year, and Maguire had announced a price reduction in April. The agency agreement Lomax had with the Kansas Phonograph Company is unlikely to have been able to provide the price flexibility that was now required to counter falling demand, and the presence on the market by this time of price discounted second-hand Edison machines.

Before April 1895, everyone involved with the kinetoscope business was either selling genuine Edison machines and films, or Paul's facsimile copies. But in Leeds there emerged a manufacturer – the only one in Britain – who not only designed his own kinetophone (a combined kinetoscope and phonograph in the same cabinet) *before* this combination was offered in Britain by Edison through Maguire and Baucus, but also, no doubt in response to the needs of travelling showmen, took the standard kinetoscope design and modified and adapted it so that, although it would still accept the same length of film, it was smaller, lighter and more portable. It is this innovative regional work that distinguishes John Henry Rigg, and sets him apart from less imaginative copyists and adaptors.

Although becoming involved with the kinetoscope later than others – his first advertisements for them appeared in March 1895 – Rigg made rapid progress. He had been illegally manufacturing phonographs since about October 1894, and his first kinetoscope advertisements reflected his dual interests. On 29 March, he was offering 'Kinetoscopes with all the latest improvements, with or without phonograph combined. Films and batteries' and a week later 'Combined phonograph and kinetoscope – music and words with pictures – great attraction'[23] The reference to 'Music and Words' is a tantalising reminder that Rigg had set up a recording studio in his house in Skinner Lane, and boasted to be able 'to draw upon the best talent entering Leeds weekly, so we are able to supply songs etc. right up to date' A further advertisement of 21 June gives the first hint of another original development. 'Machines run with half cost of any other' it claimed. Three weeks later *Bazaar, Exchange and Mart* carried this announcement:

> Don't buy until you see our new portable Baby Kinetoscope. Takes standard films – send for list – Patent applied for.[24]

A check has shown that no patent application for the 'Baby' kinetoscope was made, but that this interesting machine existed, is confirmed by a dealer's advertisement offering one for sale. A description of this model which appears to be derived from a now lost catalogue, was published in the November 1895 issue of *The Railway Supplies Journal*. After describing the range of phonographs (illegally) manufactured by Rigg, this account continues:

> The firm's Kinetoscopes are even more astonishing. The mysterious mechanism brings before the eye reproductions of actual scenes; with their actual living motion in a manner so marvellous and life-like that it is difficult to believe that living persons are not before the onlooker. These instruments are now run with two cells in place of four required by the old type, at the same time only taking the same current. The films can be put in in half the time required before, and there are many other improvements that cannot here be specified.

Then we have the Baby Kinetoscope, which is made to take standard films, but is so constructed that it can be easily carried by anyone, the weight complete being about 36lb. The price for machine alone is £16; or, with complete outfit, £25. It is guaranteed perfect in every detail, and is stated to be the only one on the market.

One of Mr. Rigg's great triumphs is the Kinetophone, in which, after a great number of experiments, he has succeeded in combining the Kinetoscope and the Phonograph, so that not only are the figures seen moving, but their voices are heard, or, in a dance, the music to which the dancer keeps time. We are informed that this firm are the first manufacturers in England to offer these combined machines to the public.[25]

A month later Rigg himself gave a further brief description of the 'Baby' kinetoscope in *The English Mechanic*, written, no doubt, in answer to a 'planted' question:

Is it possible for a kinetoscope measuring 25 x 14 by 12in., and weighing 36lb. (including battery) to be of any use, and able to take and operate standard sized films as effectively as a standard-size kinetoscope, and if a two-cell battery would be sufficient to light up same? Do you think it would be possible for a novice, totally ignorant of electrical matters, to take charge of and operate in public a kinetoscope as described, and would you advise the purchase by such novice of a second-hand kinetoscope, or would it be better to try a new machine from maker?[26]

Kinetoscope – Yes, we make a kineto, this size and weight without battery. The actual working parts are the same as in larger type, with this difference: the bobbins carrying the film are arranged in such a manner as to take only one-half the space, and yet to take a full-length film. With two cells and the lamps I use, it is possible to get 10 c.p. to 12 c.p.; 5 c.p. to 6 c.p. is ample, as a rule. It requires no knowledge of electricity to run a kineto. The question of purchase of second-hand machine is depending on querist's own judgement. J. H. Rigg.[27]

If the kinetoscope-related histories of Wray, Lomax, and Rigg are considered, the decentralised and innovative character of the regional British kinetoscope business is emphasised. By no means all marketing activity was controlled from London, and certainly not by Maguire and the Continental Commerce Company. Regional ingenuity, in creating supply centres and distribution chains, and in exploiting the novelty value of the machine by featuring it at large exhibitions, assisted and complemented its 'micro' distribution through the country by travelling showmen. This intensive geographical coverage requiring local logistical support could not have been organised by Maguire centrally, even if he had been able to secure and maintain a monopoly business. The speed at which exploitation activity took place was largely possible because the structure for achieving this had already been created – and the required personal promotional skills acquired – through previous experience gained in the illegal phonograph trade.

A parallel example to the multi-national *supply* chain developed by Alfred Lomax, was the multi-national *distribution* network created by Jonathan Lewis Young. (1859–1940) Like the Lomax example, Young's business model was designed

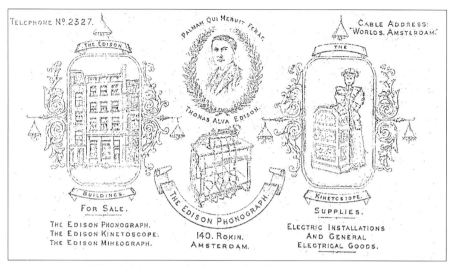

Fig. 14. J. L. Young's business card for his Amsterdam office.

originally for the illegal importation of phonographs, and was then adapted to include the trade in kinetoscopes.

Young, who had been an assistant and later manager to Colonel Gouraud in England, established his own business in Fore Street, London in 1893.[28] Young's brother William went to Canada from where he imported phonographs from the United States. These were then shipped to London where some were diverted to Amsterdam where Young had established an office not later than May 1894.[29] Young's choice of Amsterdam was not solely for easy access to Britain and the Western European countries, but for the rather more cogent reason of a lack of intellectual property supervision, for Holland had no patent laws at this period. Working with a Dutch associate Theodore Van Heemstede Obelt (1857–1918).[30] Young established himself as the chief source of the illegally imported phonographs circulating in Britain. Young's former manager William Lynd stated in an affidavit sworn in February 1894 that 'probably' 200 phonographs had been sent to London from Amsterdam since 1892. The High Court issued a 'perpetual' injunction against Young trading in phonographs in England in June 1894.

The main beneficiary of Young's illegal activity, was of course Thomas Edison who gained phonograph production work for his factory, some of which had been lost when he sold the phonograph business to Edison-Bell. Was Edison knowingly using Young as an industrial distributor? Stephen Moriarty the managing director of Edison-Bell in London had no doubt about Edison's complicity:

> [After the sale of the phonograph business to Edison Bell] ... he directly and indirectly, with the connivance of his immediate subordinates, set to work to flood Great Britain and Ireland with illegal machines of the amusement type. These machines were sent here in hundreds ... [Edison-Bell] made their own investigations,

73

and satisfied themselves that Mr Edison was the cause and at the back of all this illegal traffic, and no persuasions of mine could make them alter their minds, until one day they brought the fact home to me, so complete was their proof that it was Mr Edison, and he alone, who was aiding and abetting sellers of these illegal machines in their territory.[31]

Young began to trade in kinetoscopes in Britain and Holland early in 1895, and issued an elaborate business card featuring a kinetoscope and a phonograph. He established a French base in Paris in 1893, trading from the Rue du Gaumartin, and his Dutch address was given on an illustrated handbill he produced for the French market which included a price list for kinetoscopes and accessories.[32] He appears to have been exclusively a trader and does not seem to have been involved at any time in exhibiting kinetoscopes in either London or Amsterdam.[33]

Young had a better status than Hough in Britain, probably because he was not involved in either kinetoscope exhibition, or connected to the Greeks' dishonest scheme to deceive customers with facsimile machines. At least in January 1895 Maguire thought that Young had 'dealt satisfactorily up to date', and he contacted him to ask for his help in obtaining incriminating evidence that could be used in the forthcoming court case against James Hough. The expectation that a phonograph infringer – with an injunction issued against him – would be prepared to inform on the illegal activities of another infringer awaiting trial, was somewhat unrealistic, and did not produce the positive result Maguire had hoped for. Judging by a lack of further advertisements, Young appears to have abandoned the kinetoscope trade by the autumn of 1895, although he maintained his interest in phonographs, and eventually sold the Paris branch of that business to the Werner brothers.

While larger companies created national and international supply chains for phonographs and kinetoscopes, the web of British kinetoscope exhibition was, by contrast, both created and organised by a large number of individual 'small' itinerant exhibitors many of whom already had existing phonograph interests at the time when they began presenting films. Their marketing function was vital to the viability of the kinetoscope trade, but their status was not high and many were allegedly impecunious. According to the Secretary of the Edison-Bell company (commenting on the character of the patent infringers his company regularly prosecuted):

> Practically all the [phonograph] defendants were persons of no substance. In only one case have the plaintiffs been able to recover any costs, and in no case have they been able to get any damages or payment by way of royalties. The general practice has been for the defendant to contest the action up to trial, putting the plaintiffs to as much cost as possible, and then to allow judgement to go by default, and disappear.[34]

It is to be expected that the Edison-Bell company would seek to demean the exhibitors they were prosecuting. Yet if these men were 'persons of no substance', how were they were able to equip themselves with what were very expensive instruments? A 'genuine' Edison kinetoscope obtained from the Continental Commerce Company cost £70 before April 1895, Paul's reduced price kinetoscope

was still a substantial £40, while Young's 'Exhibition' phonograph was advertised in his 1894 catalogue at £52 10s.[35] These were considerable sums in a contemporary context, equal to a six-month wage total for a working-class man. In these circumstances, it might have been expected that advertisements offering rental plans, or perhaps some form of staged payment, would be evident in journals such as *The Era*, or *The English Mechanic*, but only one such example has been located.[36] The assumption must therefore be that start-up capital for the 'small' itinerant kinetoscope exhibition business was provided privately by family or friends.

There is a similar lack of information about working capital, which was presumably provided in most cases from receipts. Since kinetoscope exhibitors had no fixed-capital resources that would be of interest to banks as security, a possible role for 'sleeping partners' is suggested. This would access an informal method of equity participation without the disadvantages attached to a formal shareholding structure. It is also quite possible that more important dealers such as Young, Hough and Paul used some form of depreciation system to write-down kinetoscope values and thereby mitigate the decline in business after June 1895.

In order to provide an illustration of the operation followed by an individual itinerant kinetoscope exhibitor, the career of James Dewhurst Walker (1868–1920) can be presented as a representative example. This type of personalised information is rare, for itinerant kinetoscope exhibitors tended to be anonymous, and were the least likely as a body to leave accounts of their activity. Fortunately for the historical record, Walker later became an important figure in the British film business before 1918, and was therefore of sufficient interest to film trade journals for several interviews giving his early personal history to be published.

While working as a journalist for the theatrical and entertainment journal *The Era*, Walker attended a demonstration of the phonograph given by Colonel Gouraud, and, realising the money that could be made from its exhibition, established a touring company in conjunction with his wife and his brother William. When the kinetoscope became available it was included as an additional attraction to the show.[37] The beginnings of such an itinerant business were typically modest:

> His modus operandi was to secure an empty shop, or if that was not available, he carried his own "fit-up" and secured an empty space in a busy thoroughfare, and continued giving entertainments for a week or longer until he thought it advisable to move on to another town. In addition, schools, bazaars, at homes, and private parties were visited, and proved to be a steady and reliable source of income.[38]

Although this description was written from recollection twenty years after the event, it can be shown to be accurate by comparison with a similar statement made in the Hough infringement case heard in July 1894:

> [Phonographs] were sold or let out to persons who exhibited the same in small shops or stalls and in temporary places of business …They exhibited in the streets or in shops of which they were weekly tenants, or at stalls at fairs &c.[39]

Itinerant kinetoscope exhibitors worked very hard for their money. The kinetoscope was heavy – especially so with the supply of accumulator batteries that had to be carried with it – and, unlike the phonograph it could not be 'broken down', and had to be manhandled on and off railway and street carriages. Long hours were standard. Kinetoscope shows that are known to have remained open for twelve hours a day, from 10am to 10pm, include South Shields, Dublin, and Belfast, while an exhibition in Preston ran from 10am to 11pm. When Frederick Dalton exhibited in Bradford during December 1894, he opened every day (including Christmas and Boxing Day), and when his 'run' in Bradford ended, transferred on the following Monday to Leeds. Even in a smaller town such as Halifax (and in the depth of winter) J. D. Walker opened his show for twelve hours a day. This was the advance announcement he published in a local newspaper:

EDISON'S LATEST INVENTION. THE KINETOSCOPE.

Our agent from America will have for exhibition at No.8 Market Street Halifax, from next Wednesday February 13, two of these most wonderful inventions. A small charge for admission, to defray expenses and keep select, will be made (2d). This [is] far and away the most marvellous thing in the world surpassing the Phonograph. Come and see the world's greatest invention. Open from 11am to 11pm. Orders for machines also taken.[40]

It should not be assumed that phonograph and kinetoscope exhibitors wandered aimlessly round the country. For centuries showmen had followed a pattern of travel dictated by exhibitions, fairs, and guild events. As established phonograph exhibitors, the Walker's followed such a pre-planned pattern of exhibition, 'working' industrial areas in the North of England during the winter, and then migrating to the South coast for the summer season. Coastal towns of a larger size were of particular value to an exhibitor of novelties like the kinetoscope and the phonograph because the constant weekly change of patronage made possible a continuous stay of several months. The Walkers applied in March to the Pier Committee in Bournemouth to obtain a beach licence for the summer months. In this particular case, seventeen applications were considered by the committee of which nine were approved, and eventually the Walkers found themselves sharing the sands with two minstrel troupes, a Punch and Judy show, two Italian ice cream vendors, a couple of beach photographers, and a temperance refreshment stand.[41]

A now irrecoverably lost part of the itinerant show was the central role that *oral* presentation featured as a communication aid. In this case, it was adaptation rather than innovation that was required. In introducing film exhibition by kinetoscope, the showman was promoting a new form of a very old 'peepshow' entertainment. The 'street' exhibitor in particular relied on a carefully prepared sales pitch, or 'spiel', designed to interest, inform, and tantalise a group of uncommitted spectators, and convert them into paying customers.[42] Street trading was by no means an unusual activity at this period – a passer-by might have been interested in, but would certainly not have been surprised to see, a kine-

toscope film exhibition operating in the street. The extent to which streets at this period were used as public spaces for a whole range of activities can be verified from contemporary photographs or from early films particularly those in the Mitchell and Kenyon collection.[43]

The final aspect of British kinetoscope marketing activity to be considered involves examples of product life-extension strategies incorporating 'add-on' features. In the case of the kinetoscope this took the form of so-called 'prize-fighting' or extended running time models, and the 1895 launch of the Edison kineto-phonograph. In the first case the Edison Manufacturing Company built an enlarged kinetoscope to exhibit the Leonard-Cushing six round boxing contest, filmed for the Latham's Kinetoscope Exhibiting Company at the 'Black Maria' studio on 14 June 1894.[44]

In January 1895 Maguire and Baucus claimed to have an order for six of these enlarged machines, and Irving Bush wrote to William Gilmore Edison's General Manager, in an attempt to have the price reduced to them from $300 to $250.[45] The appeal was in vain and Edison refused to lower his prices.[46] However, one set of these machines had definitely arrived in London by the end of February and the resulting exhibition may have been the customer that Maguire and Baucus had referred to in January. On 2 March, *The* [London] *Standard* reported that:

> A private view was given last evening at the Exhibition Room, 175, Piccadilly, of the first of a new series of moving photographs, to be opened to the public today, and intended to represent the various phases of sporting life – prize fights, racing, and rowing matches. This inaugural set gives each of the six rounds of a contest between Mike Leonard, of Brooklyn, and Jack Cushing, of Harlem, New York …. The pictures are larger, and the time record is longer, than in the kinetographs [sic] now to be seen at so many exhibition places in London. The display is certainly attractive and amusing.[47]

A further report, in *Sporting Life* of the same date, revealed interesting additional information. The managers of the show, Mills and Conroy (of whom nothing is known) when asked about future Edison films, promised 'a perfect picture of the Oxford and Cambridge Boat Race and the Derby', both subjects that were to be filmed by Acres in the next few months. Franck Maguire had indeed, since the end of 1894, been urging Edison to send a cameraman to England. Could it be that these events had been selected as suitable subjects? If so, the opportunity to be the first to secure them was lost through Edison's delay.

By 12 April Maguire and Baucus were exhibiting the Leonard-Cushing contest at 70 Oxford Street,[48] but (no doubt due to the high cost involved) the lack of press notices and advertisements suggest that this attraction did not become established in Britain. An advertisement published in the *Portsmouth Evening News* in September offered two 'Double Kinetoscopes' for sale ('May be seen working on Clarence Pier, Southsea; owner leaving England'), and it is likely that these machines were part of an original set of six.

The Latest Wonders.

E DISON KINETOPHONES
(Combined Phonograph and Kinetoscope).

EDISON KINETOSCOPES.

Reduced Prices.

Sole Agents for Mr Edison,
Europe,
Asia,
Africa,
Continental
Commerce
Company,
70, Oxford-street, London.

Notice.—Temporary Injunction has been granted this Company against users of Mr Edison's name on or in connection with bogus Machines.

No Films Sold to
other than our own Customers.

K INETOSCOPES and FILMS.

New Subjects just taken by R. W. PAUL,
the Only Manufacturer in Europe.
Oxford and Cambridge Boat Race.
Pickpocket Arrest, Railway Station Scene.
Bootblack Scene, Sundry Performers.

Large Stock of Kinetoscopes and Films. Lists Free.
R. W. PAUL, Sole Maker,
44, Hatton-garden, London, E.C.
Telegrams, "Calibrate, London."

K INETOSCOPES.
The only place in Europe
for Improved Kinetoscopes and
Up-to-Date English and Continental Films.
Don't buy anywhere else till you see our Machine.
Price Thirty Guineas each.
Films, Two Guineas and upwards.
Send for Catalogues.
THE KINETOSCOPE AND FILM COMPANY,
69, FORE-STREET, MOORGATE-STREET, LONDON, E.C.

K INETOSCOPES.
KINETOSCOPES, KINETOSCOPES.
FILMS, FILMS, FILMS, FILMS.
Wholesale and Retail Machines in any quantity. Films to order
in a few hours. Only place for Films in England.
DUVAL, 272, Gloucester-terrace, Bayswater, W.

Fig. 15. Rival kinetoscope dealers' advertisements,
The Era (4 May 1895).

Delay was also the problem in launching the Edison kinetophone in Britain. In his agreement of 11 March 1890 with the Edison United Phonograph Company, Edison had reserved to himself the right to use the phonograph with 'dolls, toys, toy figures and clocks'. Stretching credibility to the limit, he claimed in 1895 that the kinetoscope was a 'philosophical toy … intended for amusement rather than for any serious use' and that 'toy figures' described the reduced images recorded on film. A draft agreement of 9 March 1895 between Edison and Maguire and

Baucus repeats this claim, and agrees to send phonographs to them for use in the kinetoscope for 39 dollars each. However, none appear to have been actually supplied at this time. On 9 May Edison wrote to Maguire and Baucus in New York:

> We will furnish you with the reproducing portion of the Phonograph, without recording mechanism, same to be used in combination with the Edison Kinetoscope, so that the figures can be caused to speak or sing, as the case may be, for the sum of Fifty ($50.00) Dollars each, with the necessary devices to attach the same to the Edison Kinetoscope [49] ... in no event are you to sell the reproducing portion of the Phonograph separately but only when combined with my Kinetoscope ... you must carry out the above instructions in good faith as otherwise it might injure me by being entangled in litigation.[50]

There is a minor mystery at this point. The Continental Commerce Company began advertising that they could supply the kinetoscope 'with or without Phonograph attachment' in *The Era* on 13 April, coupling its introduction with an 'Announcement Extraordinary. Reduction in prices'. Where were these phonographs coming from? Was Edison supplying them in advance of his confirmatory letter of 9 May, or could Franck Maguire have been obtaining his supplies from one of the English dealers?

Even by the middle of April the Continental Commerce Company was far too late to gain any advantage from being the first to announce and supply a combined machine. Once again Maguire and Baucus had failed to control the British market and gain price leadership. As early as 30 November 1894, the London based Northcote and Company had announced in *The English Mechanic*: 'Phonographs and Kinetoscopes combined. The very latest, greatest, and most sensational novelty ever produced. A fortune for those first in the field'. By 1 March they were reminding potential customers 'Note we are the sole agents for the combined machines. Phonograph parts. State requirements. It will pay you'.[51] Whatever the doubtful truth of this exclusivity claim it did not prevent resourceful dealers like John Rigg of Leeds from attempting to gain a share of this particular market by offering a comprehensive 'package' for exhibitors:

> **Kinetoscopes. Kinetoscopes. Kinetoscopes.** And all supplies, separate parts, repairs, broken films repaired.
>
> **Kinetophones. Kinetophones. Kinetophones.** Combined phonograph and kinetoscope, music and words, with pictures. Great attraction.[52]

The prices of kinetophones fell very rapidly in a short time which, apart from the effect of normal trade competition, is probably an indication that they were not popular. Logically, a showman stood to lose revenue by exhibiting a kinetophone. There was a maximum price that could be charged – probably no more than that for access just to the films. If the two machines were kept separate, a customer would be likely to pay for access to each and revenue would be doubled. By the end of March Northcote and Co. were offering 'Complete exhibition outfits £30, with phonograph £60'.[53] The Automatic Syndicate were also selling a combined

machine for only £30. These are price levels that Franck Maguire would have found it difficult to compete with because the agency system under which he operated meant that supply prices could only occasionally be reduced. Although no advertisement by Robert Paul for kinetophones has been noted, it appears from a report in *The Photographic News* in September 1895 that he was exhibiting them at the 'Empire of India' exhibition at Olympia. The journal commented:

> It was long ago suggested that the kinetoscope could be wedded to the phonograph, and, if we remember rightly, a promise was held out that entire operas would be produced in this way. The first attempt which we have met with in this direction forms a side show at the Indian Exhibition, and it is a dismal failure. Possibly the particular instrument which we sampled may have been a faulty specimen. The phonographic part was certainly badly adjusted, the sounds emitted being crude and very disagreeable. The poetry of motion should be wedded to good music, or to none at all.[54]

Notes

1. Brown and Anthony, *A Victorian Film Enterprise*, Table 4, 84.

2. *The Era* (13 April 1896) and *The English Mechanic* (19 April 1895).

3. W. K. L. and Antonia Dickson, *History of the Kinetograph, Kinetoscope, and Kineto-Phonograph* (New York: Albert Bunn, 1895).

4. T. R. Nevett, *Advertising in Britain. A History* (London: Heinemann, 1982).

5. Illustrated in Barnes, *The Beginnings of the Cinema in England 1894–1901 Volume One*, 14.

6. Talbot French, *Edison's Wondrous Kinetoscope* (Manchester: T. Fowler and Co., 1894). Entered in the 'Books Commercial' section of Stationer's Hall on 21 January 1895. No copy has been located.

7. *English Mechanic* (5 July): vi.

8. Ibid. (8 August 1895) v.

9. Ibid. (25 January 1895) vi.

10. Young also published *The Phonogram*, 'A Monthly Journal Devoted to the Science of Sound and Recording of Speech' in May 1893. A facsimile reprint of the first three issues has been republished.

11. Perhaps surprisingly, endorsements are rare, although in one example noted, an exhibitor in York claimed his show was 'Patronised by the Bishop of Chester and the Mayors of Leeds and Bradford', *Yorkshire Herald* (25 February 1895): 1.

12. For examples illustrating the extensive range of categories and titles available at the end of the nineteenth century, see J. Don Vann and Rosemary T. Van Arsdel (eds.), *Victorian Periodicals and Victorian Society* (Toronto: University of Toronto Press, 1995). Of particular interest in the present context is William H. Brock's paper on science journals, which includes a section on 'Popular Science' (82–83).

13. For the publication history and social context of *The English Mechanic*, see W. H. Brock, 'The Development of Commercial Science Journals in Victorian Britain', in A. J. Meadows (ed.), *Development of Science Publishing in Europe* (Amsterdam: Elsevier Publishing, 1980): 111–115.

14. An exhibition of five machines was advertised in the *Birmingham Daily Post* (30 January 1895) and the same number were shown at the Palace Theatre at Douglas, Isle-of-Man during July and August.

15. Brit. Pat. No. 182 of 1895. 'Improvements in or relating to the Kinetoscope' Provisional Specification filed 3 January 1895. The object of the patent was 'to enlarge the [kinetoscope] pictures, or transfer or reflect them on an enlarged scale on to a curtain or its equivalent'.

16. See for example *The English Mechanic* (25 January 1895): vii; and (15 March 1895): v.

17. *The English Mechanic* (5 April 1895): vi. Wray's claim for renting is made in a letter to the Editor of *The Bioscope* (26 December 1912): 977.

18. *The English Mechanic* (13 May 1896): viii.

19. See Frank Andrews. 'Out-Takes 3', *Hillandale News*, No. 170 (October 1989): 267–269. For a summary of

the highly complex relationships existing between both American and British phonograph companies in the 1890's, see Andrews, *Edison Phonograph. The British Connection*, 2–23.

20. 'The Kinetograph or Phono-Camera' Letter to the Editor dated 24 May. *The Blackpool Gazette* (26 May 1893): 6.

21. 'Kinetscope (sic) in Blackpool: The Agent Interviewed', *The Blackpool Gazette* (16 November 1894): 2. 'In conversation with Mr. Lomax, our representative elicited the information that he had cabled for three more machines, a client having arranged to take over the trio at a price of £250' For his own account of developments see, Alfred Lomax 'Kinetoscope and Lantern', *The Optical Magic Lantern Journal* Vol.7 No.87, (August 1896): 132–134. Lomax mentions in this account that he 'had charge' of the Anschütz 'Electrical Wonder', next to the kinetoscope 'the most perfect mechanism ever produced in machines for illustrating motion'.

22. Brit. Pat. No. 25,100. 'Improvements in Kinetoscopes' Provisional Specification filed 27 December 1894. The text of the full specification was printed in *The British Journal of Photography* (Supplement) (6 December 1895): 93 and 94. An advertisement in *Exchange and Mart* (24 April 1895) placed by the 'Automatic Syndicate' (Barron) refers to '3 View attachments at half price of other agents' indicating that such a device was manufactured, although whether this was by Lomax is not known.

23. *Bazaar, Exchange and Mart* (29 March 1895): v.

24. *Bazaar, Exchange and Mart* (12 July 1895): vi.

25. 'Mr. J.H.Rigg's Phonographs; Kinetoscopes &c', *Railway Supplies Journal* (2 November 1895):15.

26. *The English Mechanic* (6 December 1895): 365.

27. *The English Mechanic* (20 December 1895): 405. Confirmation that the 'Baby' kinetoscope was actually produced and sold, is provided by a series of advertisements in the *Bazaar, Exchange and Mart* magazine beginning on 17 February and continuing until 9 March. The seller was Walter Naylor, 'Consulting Engineer' of Rotherhithe, Kent.

28. For further information on Young, see Andrews, *Edison Phonograph. The British Connection* and Barry Anthony, 'Music Hall and the Birth of Records and Films', *Music Hall Studies*, No. 9 (Summer 2012): 372–378. Detailed information about Young's earlier career was given during his bankruptcy proceedings in early 1895, See 'Bankruptcy Proceedings', *The Electrical Review* Vol. 36 (22 March 1895): 358 and ibid., Bankruptcy Proceedings', (28 June 1895): 809. The case file of Young's bankruptcy has not been preserved in the National Archives, Class B9.

29. Initially at 150, De Playter Kaade, and then at 140 Rokin. The Royal Archives in the Hague hold a letter from Young to Queen Emma (5 May 1894) offering to demonstrate a phonograph. His request (which was refused) was no doubt a plan to obtain a royal endorsement, which could then be incorporated in advertising and promotion material.

30. Heemstede Obelt was granted a number of British phonograph patents and two cine-related British patents, 1039 (14 January 1897) and 1216 (16 January 1897).

31. Moriarty to Thomas Collier Platt, 4 March 1896, TAED D9623AAS (10 February 2017). Relevant to the question of Edison's involvement are suggestions made by the lawyers Seligman and Seligman, that Edison's attorneys Dyer and Seeley, had been helping J. E. Hough defend the patent infringement action brought against him by Edison-Bell, see Seligman and Seligman to Edison, 24 January 1895, TAED D9523AAR (10 February 2017). If this was true, it is unlikely that such action was taken without Edison's approval.

32. Reproduced in Friedrich v. Zglinicki, *Der Weg des Films* (Berlin: Rembrandt Verlag, 1956). The illustrations in this brochure of the interior and exterior of the 'Black Maria' studio and of the film of a sneeze (Musser, *Edison Motion Pictures, 1890–1900*, No. 19) appear to have been taken from the Dicksons' biography of Edison.

33. For the history of kinetoscope exhibition which began in this city in December 1894 see Adrian Briels, *De Intocht van de Levende Photographie in Amsterdam* (1971): 6–10.

34. Affidavit of William Smith (Paragraph 12), 3 February 1897, in *Edison-Bell Phonograph Corporation Limited v John Henry Rigg*. Chancery E. 69 of 1897.

35. Young was advertising the Edison 'Exhibition' phonograph, with 14 sets of hearing tubes and 20 'high class' records, for 60 guineas in the June 1893 issue of *The Phonogram*.

36. 'Edison's Kinetoscopes. Three machines for hire by the month. For terms apply Kineto. 21, Jubilee Street, Llandudno.', *The Era* (8 June 1895). Later in the year these machines which had been shown on the Pier, were offered for sale.

37. 'Then and Now. Pictures in '97 and in '09', *The Kinematograph and Lantern Weekly* (26 November 1908):

729. James Walker later became a co-founder of the 'Walturdaw' film production and exhibition company (1900) and managing director of 'J. D. Walker's World Films' (1914).

38. 'The House of Walker and its wonderful development', *The Kinematograph and Lantern Weekly* (28 December 1916): 61. An advertisement in *The Era* (30 June 1895) offered, in addition to a kinetoscope and three films, 'Two signs [on] Oil Cloth'. These were presumably part of the promotional 'fit-up' equipment required for the type of street show that Walker refers to.

39. *The Edison-Bell Phonograph Corporation Ltd v Hough*, Chancery E.783. RPC. Vol. 11, pp. 595–596.

40. *The Halifax Courier* (9 February 1895): 1.

41. Minutes of the Bournemouth Pier Committee (28 March 1895): 318–319. A similar pattern of migration was adopted by the Roberts brothers of Liversedge in West Yorkshire, who had a kinetoscope address on Southport Pier during the summer months of 1895 and the London dealer Grahame who exhibited on the pier at Llandudno in North Wales.

42. A comprehensive range of illustrations of peepshows can be found in Richard Balzer, *Peepshows. A Visual History* (New York: Harry N. Abrams, 1998).

43. Andrew Prescott, 'We had fine banners. Street Processions in the Mitchell and Kenyon Films', in Vanessa Toulmin, Patrick Russell and Simon Popple (eds.), *The Lost World of Mitchell and Kenyon. Edwardian Britain on Film* (London: BFI Publishing, 2004): 125–136. For a contemporary photograph of street entertainment – a 'Punch and Judy' show – see St. John Adcock, 'Sideshow London', in George R. Sims (ed.), *Living London* (London: Cassell: 1903): 281.

44. Musser, *Edison Motion Pictures, 1890–1900*, No. 40. For accounts of the Latham's important role in early American film history see Hendricks, *The Kinetoscope*; Musser, *The Emergence of Cinema*; Rossell, *Living Pictures*; and Spehr, *The Man Who Made Movies*. The specific early film role of prize-fighting is covered in Dan Streible, *Fight Pictures. A History of Boxing and Early Cinema* (Berkeley: University of California Press, 2008). With regard to the Lathams, Paul Spehr has drawn the author's attention to 'strong man' Eugene Sandow's interest in July 1895 in obtaining the British concession for their 'Eidoloscope' film projector (Woodville Latham's testimony in *Amet v Latham v Casler v Armat*. Patent Interference 18,461, December 1897, 75). Due to problems with illumination, Sandow appears not to have proceeded with his idea. A search of London newspapers and Kelly's trade directory for London for 1895 and 1896 has failed to locate any mention of either the Latham's or Sandow.

45. Bush to Gilmore, 14 January 1895, TAED D9515AAA (10 February).

46. Gilmore to Bush, 17 January 1895, TAED D9517AAJ (10 February 2017).

47. 'Edison's Kinetoscope', *The Evening Standard* (2 March 1895): 3.

48. *Sporting Life* (12 April 1895): 4.

49. Phonographs supplied for the kinetoscope were marked 'For use in connection with the Edison Kinetoscope only' (Phillips, *Edison's Kinetoscope and Its Films*, 81, and illustration 50). Only 45 combined machines were built by the Edison Manufacturing Company (Hendricks, *The Kinetoscope*, 125). In most cases, as with Maguire and Baucus, the Edison company only supplied a device which it was intended that the customer should fit to the machine to enable it to work with the phonograph

50. On 20 August 1895 Edison was enjoined by the Edison United Phonograph Company in the United States from shipping phonographs abroad. It is very likely that Stephen Moriarty who was the Managing Director of Edison-Bell in Britain, and also Vice-President of Edison United, was involved in initiating this action.

51. *The English Mechanic* (30 November 1894): viii.

52. Ibid. (1 March 1895): v.

53. *The English Mechanic* (5 April 1895): v.

54. *The Photographic News* (13 September 1895): 12.

Commercial Decline and New Beginnings

Decline in a product life-cycle is a normal occurrence, although it is not inevitable. Often the cause for decline is previous over-exposure, and a failure to 'refresh' the product by introducing new 'add-on' features. This situation occurred in Britain with Edison's repeated failure to support the Continental Commerce Company with a kineto-phonograph combination, the facility to produce British and European films, or his frequently announced film projector. As has been shown, British rivals soon supplied gaps in the market with products of their own. Nor were causes of decline wholly product-related in the kinetoscope case. It is certainly arguable that the 1895 kinetoscope market could have been made more stable and been better capitalised if Edison had been prepared to agree at the outset to the creation of a British equity-funded, joint-stock company, with sufficient capital available to promote 'branded' national coverage thereby increasing the barriers to entry to rivals and reducing the fragmentation of the market that occurred.

With the exception of fast-moving consumer goods, products in decline rarely disappear suddenly. Instead an intermediate stage is entered in which, against a background of falling prices, the product loses its former market function as a prime source of revenue and profit, but remains to occupy a less 'front-line' and often non-profit position. As will be shown, towards the end of 1895, and even into 1896, kinetoscopes were still exhibited round the country but less for the showman's personal gain and more to benefit local communities through fund raising activities at Bazaars and Conversaziones.

An analysis of the commercial market also suggests diversity in decline. During the second half of 1895, exhibitor receipts are likely to have declined most in urban areas where the kinetoscope had been intensively exhibited. Shop exhibitions were certainly a casualty at this time. According to Stephen Moriarty of the Edison-Bell company:

> … these [kinetoscope] shops were deserted at night time by the Agents, and in many cases I am informed the rent for the shops was not paid, the term applied to them here being known and characterized in the papers as that there was "another Kine-

toscope moonlight flitting", which means that they took the Kinetoscope away during the night, and left the rent and other things unpaid.[1]

Although Moriarty was hardly an objective commentator bearing in mind his dislike of Edison, proof has been located that an event similar to those he describes did occur. The following advertisement was published in *The Era* in August 1895:

> For Sale. To Showmen and others. Kinetoscopes. Kinetoscopes. Kinetoscopes. Immediate sale, under distraint for rent. One genuine Edison machine, with six films and accumulators, and six English machines. Finished make. £50 the lot to clear. Apply Keen and Co. Estate Agents, 87, New Oxford Street, London. W.[2]

Exhibitors in smaller towns where the kinetoscope had only been shown occasionally by itinerant showmen, were probably not so badly affected as those running city shops, while those exhibiting at seaside resorts during the summer season of 1895, may still have found that the kinetoscope was a profitable business. As late as June 1896, an exhibitor was advertising in *The Era*: 'Wanted good position to exhibit Edison's Kinetoscope and Phonograph. Must be in busy part. Seaside preferred'.[3]

Price Behaviour

Price behaviour after July 1895 shows a pronounced distinction between machines and films. Not unexpectedly machine prices continue to fall to very low levels as indicated in examples taken from the *Exchange and Mart* magazine:

> October 4, 1895. Edison Type Kinetoscope £10. Cost £36
>
> January 3, 1896. Kinetoscopes. £42 machines at £10.10s each
>
> June 18, 1897. Kinetoscopes. 3, in perfect working order, including films and batteries, ready for immediate exhibition. £30. Cost £95.
>
> May 6, 1898. Kinetoscopes (3) Complete, including films and batteries. Originally cost £108. Will accept £25. Perfect condition, ready for immediate exhibition.

If the purchase prices quoted are genuine, then by these dates machines were selling for approximately 25% of their original cost.

A peculiarity of the British kinetoscope market during 1895 is the scarcity of advertisements for film sales whether on their own, or in conjunction with the sale of a kinetoscope. This could indicate several things. In view of Franck Maguire's attempt early in the year to limit the distribution of films, it is quite possible that an active 'second-hand/exchange' market developed, providing dealers with a low-cost method of obtaining 'fresh' titles. Some demand for prints would also have been met by 'duping' or illegal copying, a service that most providers are likely to have considered unwise to advertise. However, the London dealer Fred Duval (Frederick William Trautner) claimed to be able to supply 'Films to order in a few hours' in his advertisement in *The Era* of 4 May 1895. Although the wording is, no doubt deliberately, ambiguous – it could just mean that a comprehensive selection of titles was available – confirmation that Duval was indeed running a film copying business is provided by his later and more

Fig. 16. Philip Bernstein's advertisement for films in *The English Mechanic*, 30 August 1895.

explicit notices. For example, his advertisement in *The Era* of 2 May 1896 shows that by that time he had adopted Franck Maguire's tactic of using the availability of films to sell machines. 'Films made to order at few hours' notice and at wholesale prices, but only sold with our machines.' An advertisement from *The Era* of 30 May 1896 shows that he was also running a general copying service: 'Contracts taken for copying and developing films'.

Whatever their origin, film prices held firm while machine prices declined – a trend that must indicate continuing demand. In his deposition evidence given on 2 February 1895 in the Continental Commerce Company case (see Appendix 5) James Hough said that film prices at that time ranged from £2. 15s. to £5. Jonathan Young's prices in April were 'two guineas and upwards' and in Robert Paul's advertisement in *The English Mechanic* of 21 June 1895, £3 was quoted for the film of the 'Derby' horse-race, and it is implied that the same price applied to other titles such as *The Boxing Kangaroo* and *The Pickpocket's Arrest*. Price differentiation is also indicated in the Paul example by the statement 'Others at reduced prices'.

Price differentiation was also an outstanding feature of Philip Bernstein's interesting advertisement in *The English Mechanic* of 30 August. The appearance of an extensive range of Edison titles is also an indication that the previous Continental Commerce monopoly of supply had been broken, and that by this date, and probably earlier there was no difficulty for dealers in obtaining Edison films. A cross-check with the production dates for each of these titles given by Musser in *Edison Motion Pictures, 1890–1900* provides confirmation that price levels have been set according to the known popularity of the title, rather than being linked to the age of the film. Especially interesting are the rare references to 'prize-fighting' films. The full length of the bouts noted extended to five rounds (therefore five films), so the price quoted of £4 provides evidence, that in Britain each round could be obtained separately and presumably shown in a 'normal' sized machine.

Acres and Paul

Although the second half of 1895 was a time when the kinetoscope declined into commercial insignificance, it was also a period when both Birt Acres and Robert Paul became involved with interesting projects. As Acres' filmmaking activity in

Germany on behalf of the Stollwerck company is fully described in Chapter Eleven, this section focusses attention on the preparatory arrangements that were made, the unexpected involvement of Thomas Blair (the raw film manufacturer), and the main terms of the contracts.

The story of Robert Paul's interest in producing an entertainment based on themes from H. G. Wells' science-fiction novel *The Time Machine* was noted as early as 1896, and Paul's fortunate preservation of his provisional patent specification of October 1895, enabled Terry Ramsaye to incorporate it in *A Million and One Nights*. Paul's ideas, and Ramsaye's claims for them, have often been copied since, sometimes with new theories added, but invariably lacking detailed re-examination, or challenging features such as conceptual originality. It is relevant that this should be done in the present study of the kinetoscope, since the Time Machine project provides a link between Paul's contentious association with Acres and his 1896 emergence as an important personality in the British projected film business.

It is likely as John Barnes has suggested, that the group of films that Birt Acres took of the 'Derby' race on 29 May 1895 were the last he produced for Robert Paul.[4] The changing character of their relationship, and the various causes behind Acres growing dissatisfaction with his association with Paul have been discussed in Chapter Three. The fact that Acres filed his multi-purpose provisional patent specification for an 'Improved Apparatus for Enabling Photographic Images to be Taken, Projected, or Viewed in Rapid Succession' on 27 May, appears to have been a preparatory move towards arranging a future commercial association with the German chocolate manufacturer Stollwerck Brothers.[5] It is not known exactly when contact between Acres and Stollwerck first occurred, but it must have been shortly after 29 May at the latest, when Acres is known to have visited the office of their English branch company 'The London and Provincial Automatic Machine Company' to express praise for the quality of the film stock supplied to him by the Blair company.[6] It is possible that Thomas Blair (1855–1919) introduced Acres to the Stollwerck company, for he was certainly closely involved in the preparation of the later contractual agreement arranged between Acres and Stollwerck.[7] Acres was in Germany by 12 June, and probably earlier, since a first draft agreement was prepared on that date. The date was significant, for the day before the British patent office had confirmed its acceptance of Acres provisional camera application. A second draft agreement was drawn up on 18 June. In a letter to Acres the company confirmed the arrangements covering his visit:

> We beg to confirm our conference about your visit to Hambourgh and Kiel. We will pay all expenses which you have for this trip from London, to Cologne, Hambourgh, Kiel, [and] Berlin, and you will take photos for Kinetoscope use in Hambourgh and Kiel. The negatives are our property but you are entitled to use these negatives for the English trade and any profit which you can make remains in your hand but you must make the condition on the sale of the positiv films from those Hambourgh and Kiel negatives that they ought to be used only in England. As our installation in Germany to produce positive films is not yet ready you will deliver us for 14/- [per]

40 foot each any number of negatives which we will order you for our trade in Germany, France, America etc. etc.[8]

Acres filmed various celebrations connected to the opening of the Kaiser Wilhelm/Kiel Canal on June 19, 20, and 21, and these are described in Chapter Eleven. By taking films in Germany in June, Acres was in breach of his 'exclusive' film production agreement with Paul of 28 March. By July he had agreed to give Stollwerck's an option to purchase his British business, including his camera patent 10,474, 'and all stock in trade of Kinetograph Cameras ... and all finished films with photographs thereon and all negatives already prepared, with the exclusive right of producing finished films therefrom and the copyright in and sole right of reproducing such pictures in all parts of the world'.[9] If Stollwerck's bought the business they were to pay Acres £500, and a salary of £150 a year for three years as manager.

In order to implement these plans and confirm the legality of his future relationship with Stollwerck's it was now necessary for Acres to arrange for the agreement with Paul to be cancelled. The tactic he adopted to gain this relied on his knowledge that by July Paul was now unwilling – or, as Acres believed, financially unable – to invest further capital in an English filmmaking project. When they met on 12 July (according to Paul), or 13 July (according to Acres), Acres therefore emphasised to Paul 'that he was no longer in a position to make films without being financed'.[10] This produced the desired reaction, and Paul agreed to cancel the contract between them on Acres 'paying for the outfit and compensation'. Acres could confirm to Stollwerck that he was now 'at liberty' to arrange for 'the sale of films in England in addition to Germany and other countries ...'.[11]

Acres returned to Germany in early August, presumably to make arrangements to have his application for a German patent for the camera transferred to Paul Müller, a Stollwerck employee.[12] Whether Paul had known of Acres' commercial relationship with Stollwerck Brothers when they met in July seems unlikely, but it is certain that he had become aware of the arrangement by 6 August for on that date he met Ludwig Stollwerck, and gave him, according to Acres, 'a one sided statement' which, not surprisingly, implied that it was he, and not Acres, who had been responsible for the design of the Kinetograph. Acres told Stollwerck in a letter of the same date that Paul was, just three weeks after cancelling the contract, 'sorry now that he has done so, as he begins to realize that there is a future for Kinetographic work'. If this really was Paul's changed attitude it seems likely that his idea in arranging to meet Stollwerck was not only to denigrate Acres' reputation and spoil his chance of future success with the company, but to gain for himself what now appeared to be a promising business opportunity.

August and September 1895 marks a most interesting development of Acres work which, since he did not first report it until later in 1896, may have been connected with confidential experimental work carried out for Stollwerck. The review of notices located in British photographic journals given below, although not providing documented proof of Acres claim for successful 1895 demonstrations of projection, are particularly notable, both for their repetition and for the

consistency of their statements for which no rebuttal has been traced. Is it likely that Acres would have continued to make these claims for several years if they had been false? The British photographic world of this period was one in which members took a keen interest in new developments and in which prominent established personalities such as Acres, who was a member of the Royal Photographic Society, were known personally to a wide circle of other professionals and journalists. A reputation for probity was important.

The well-informed regular columnist in *The British Journal of Photography*, G. R. Baker, reviewing progress in cinematography, noted in July 1896:

> It is, I think, only fair to Mr Acres to state that in the spring of 1895 he photographed the Oxford and Cambridge boat race and the race for the Derby, this being the first time any natural events were attempted, and he showed them in public on January 12 1896, while they were privately shown as early as September 1895.[13]

At the end of the same month Acres gave an interview to the *Daily Mail* newspaper in which his claim for successful projection was quite explicit: 'When I had completed my screen-kinetoscope I determined to show it ... This was last August [1895] many months before M Lumiere's invention was exhibited'.[14] The August claim was again made in an article on 'Animated Photography' which Acres contributed to *The Amateur Photographer* in October,[15] and repeated early the following year in a lecture on 'The Making and Exhibiting of Living Pictures', which he gave to members of the Camera Club.[16] A biographical profile of Acres, 'Prominent Men in the Lantern World' added the information that 'Towards the end of September [1895] he showed to one or two gentlemen well-known in the photographic world these animated pictures on a screen, the picture measuring about 7 feet by 5 feet'.[17] The first documented demonstration of film projection in Britain was given by Acres to members of the Lyonsdown Photographic Society in North London on 10 January 1896, and this was followed four days later by a similar exhibition to the Royal Photographic Society.[18]

The beginning of a new way of presenting film had now been successfully established. Unlike kinetoscope presentation, the basic economics of projected exhibition offered far greater profit potential, and with this an opportunity for the long term survival of this particular business sector.[19]

At the time when Paul agreed to cancel his film production agreement with Acres it would be logical to assume that his decision was strongly influenced by the steep decline in British kinetoscope business. From Paul's perspective in July – presumably unaware of Acres' arrangement with the Stollwerck company – an investment of further time and money into film production would have been pointless. Because he was supplying kinetoscopes to 'trade' buyers, Paul would have been fully aware of the true extent of decline in sale prices. Indeed, it is quite possible that by the mid-year point his remaining stock of machines were now worth less than their production cost.

Paul's 'showcase' presentation at the 'Empire of India' exhibition at Earl's Court,

JUBILEE PROCESSION and MACHINE for £5, Complete. Edison Standard Kinetoscope, costing £30, with Motor, Lamp, and a New 40ft. Film, Queen at St. Paul's. May be seen working. Apply. R. W. Paul, 44, Hatton-garden, London, E.C A Complete Show in itself.

Fig. 17. *The Era* (2 October 1897). Paul continues to market the kinetoscope.

ended on 26 October, and the day before, *The English Mechanic* published the following advertisement:

> Kinetoscopes (16) from the Indian Empire Exhibition as new. Taken over £1,500. New Kinetoscopes and Films. Remainder of 200 machines. Very low prices to clear.[20]

If the revenue figure given is accurate, and Paul charged the 'standard' price of 2d established by the Continental Commerce Company, it indicates that over the 20-week period of the exhibition (27 May – 26 October) approximately 180,000 people viewed films. This was a high average of 562 per week per machine. Paul's claim that 200 'bogus' kinetoscopes had been produced contradicts his later statement that he made 'about sixty' machines during 1895 by a considerable margin.

The higher figure, if correct, suggests that Paul had very badly miscalculated demand, perhaps due to anticipating a successful outcome from his approach to Edison for an exchange of films. It may perhaps have been a later unwillingness to admit to an embarrassing commercial error that was the cause of a lower figure being given. A circumstance tending to support the accuracy of the higher figure is documentary proof that as late as June 1897, an unknown quantity of unsold kinetoscopes remained, with Paul trying a new marketing plan to clear them.

For the remainder of 1895 Paul's non-electrical interests appear to have been concentrated on the development of a multi-sensory entertainment based on H. G. Wells' recently published science fiction novel *The Time Machine*.[21] Paul's provisional patent application for this project was first published by Terry Ramsaye, and more recently by John Barnes.[22] It is a most interesting document that is worth critical examination.

A convenient starting point is to consider first the status of the text. Why is it so long and detailed at this provisional stage, and, more importantly, are the 'novel' methods described for presenting the entertainment (for the conceptual ideas of course belong to Wells) really original? In this connection, it is most important that the *Time Machine* patent document is considered not in isolation, but in relation to two other Paul provisional applications which appear to share common features. Neither proceeded to final stage, and the details of what they claimed are therefore unknown. Application 17,677 of 23 September was for a 'Kine-toscope Apparatus' and was filed just a month before 19,984, while application 4168 of 25 February 1896 'Reproducing Stage Performances' provides proof of

89

Paul's continuing interest in the entertainment sector. Lacking the knowledge required to produce films for the *Time Machine* presentation, Paul wrote to the Lumières on 25 November to ask if they were manufacturing 'kinetoscope' films. He was informed that they were not, but intended shortly 'to put a new machine on the market, called the 'Cinématograph' for which we shall be making films'.[23] In view of Paul's later 1896 competition with the 'Cinématographe' presentations at the Empire Theatre in Leicester Square, it is most interesting to have this proof that he had contacted them three months before they arrived in Britain.

With regard to length, contemporary patent practice intended that a provisional specification should consist of no more than a brief summary describing the nature of the invention rather than its detail.[24] The applicant then had a further nine months in which to file his 'full', or final detailed specification. In this case, the supposedly 'provisional' *Time Machine* text totals almost 850 words. In comparison, Birt Acres used just over 200 words to present the provisional specification for his camera patent 10,474 of May 1895. What probably happened in this case is that the text that Terry Ramsaye was provided with was in fact the 'full' specification prepared by Paul in anticipation of an imminent application for the grant of a patent. If this was so it would suggest that Paul maintained an interest in this particular idea to a later stage than has been assumed, and indeed a report published in *The Amateur Photographer* in early March 1896, provides proof that he was still discussing his plans for the *Time Machine* with journalists after the arrival of the Lumières:

> Still Another Lantern Kinetoscope
>
> This time it is called the 'Theatrograph' and was shown by Mr. R.W. Paul in the library of the Royal Institution, [on 28 February] and this gentleman proposes to give exhibitions on a large scale at the next Earl's Court exhibition, the show not only to include scenes from the various Theatres, but also imaginative subjects in illustration of Mr. Well's fourth dimensional romance 'The Time Machine'.[25]

As a context to discussing the level of originality of presentation described by Paul, it should be noted that granted patent specifications incorporating multi-sensory presentations, are to be found in sub-class 'Exhibitions, Scenic and Spectacular'.[26] The comparative examples chosen are representative of the total of similar examples available, and have been intentionally limited to a few years immediately preceding Paul's 19,984 specification. As an initial example, H. Hardy's application, 1455 of 25 January 1892 is worth quoting at length since it refers specifically to many of the features which Paul claimed as original in his *Time Machine* text. Had he perhaps read it?

> The object is to show subterranean or submarine wonders, and produce the effect of travelling to great depths in a lift, while the lift only moves down a few feet. The spectators enter the car, the car is then started abruptly and gradually stopped below the level of the entering floor. Endless curtains painted to imitate the walls of the shaft, strata, or rocks, are caused to travel outside the cage in an upward direction, and the cage is rapidly vibrated by an eccentric. ... the passengers step out to visit the subterranean chamber ... [in] which divers or submarine scenes may be shown. ...

Cold and hot air is gradually mixed as the car is supposed to descend. The car may be stopped at different times before the same aperture to allow the spectators to witness different panoramic scenes, exhibitions, &c. Caves or grottoes, mines with miners at work, volcanoes, divers, sunken ships, and other scenes may be represented. The passengers return by another lift, the movement of the curtains &c. being reversed.

In a similar pattern, W. R. Millward's patent of 20 December 1894 notes that:

A longitudinal swinging and rocking motion is given to a [model] ship carrying the people and crew, by eccentrics, levers, links, and a platform, which is pivoted to a frame mounted on the eccentrics; and a transverse rocking motion is imparted to the platform and ship by a crank and a double jointed link. The sea is formed of painted canvas ... broken masts or wreckage may be placed on the surface. ... By this invention, the rolling, pitching, and heaving of a ship at anchor are imitated.

It is clear from these examples and others of a similar type,[27] that Paul's claim that his *Time Machine* presentation was 'novel', cannot be sustained. If considered in terms of a multi-sensory, virtual travel presentation, it was obviously very similar in both conception and arrangement to many other near-contemporary granted patents.

Nor was it the first to incorporate the use of film as a component part of a larger entertainment, Thomas Walter Barber's provisional application, 22,990 of 27 November 1894 for 'Improvements in apparatus for photographing and exhibiting Cycloramic views' was filed almost a year before the *Time Machine*, and refers in the specification to 'another form of the apparatus for exhibiting the continuous flexible film...to produce a continuous picture'. In fact, when the text of Paul's specification is examined, it is clear that it was magic lantern slides rather than projected film which were intended to be the main means of achieving the optical effects. 'Slides or Films' (the two are always conjoined) are first mentioned in the third of four proposed methods of achieving a 'realistic effect'. While intermittent motion is mentioned, an equal suggestion that 'the mechanism [for projection] may be similar to that used in the kinetoscope' indicates that Paul still has a very imperfect understanding of the principles involved in projected film presentation. Six months after the *Time Machine* document was produced Paul was interviewed by *The Era* and presented a very different indication of the role that film had played. Reading Wells' novel '...had suggested an entertainment to him, of which animated photographs formed an essential part'.[28]

The personal and intellectual property relationship between Paul and Wells was unusual in several ways. In 1924, Wells had told Ramsaye that 'he was unable to remember details of the relation[ship].[29] But by 1929 he had come to believe that he and Paul had initiated a joint application in 1895 – a confused position that he maintained until shortly before his death. Paul responded to an article Wells had written for the journal *Nature* in 1941, in which the author had included the claim that '... we took out a provisional patent that would have made us practically the ground landlords of the entire film industry'.[30] Paul answered this statement by asserting his sole authorship, and added some interesting detail:

> My provisional specification described means for presenting the main incidents in Mr. Wells's story, "The Time Machine". … It was to discuss details of such scenes that I invited Mr. Wells to my office in Hatton Garden towards the end of 1895. He listened patiently to my proposals, gave his general approval to my attempting to carry them out, and proceeded to talk of subjects suitable for the primeval scenes. Having recommended for my perusal some books on extinct monsters he left without further discussion as to future action, and many years elapsed before I had the pleasure of meeting him again.[31]

The copyright situation that existed at the time was unusual and unfair to authors. Case law, established in *Schlesinger v Bedford*,[32] meant that Paul did not require Wells' collaboration, or even permission, to use material in his book even though the text was covered by literary copyright. The respected *Law Quarterly Review* had commented in 1891 on 'the curious state of the law which allows anybody to dramatise a novel without the author's consent, though he may himself have dramatised it or be meaning to do'.[33] Paul would certainly have been aware of this legal anomaly, and aware also of the considerable interest that the publication of *The Time Machine* had aroused. To intend in such circumstances to secure a patent monopoly solely for himself, on the basis of another man's work, is an action entirely consistent with the opportunistic side of his character that Paul had, earlier in 1895, displayed in his willingness to invade both Edison's and Acres' property.

Both Paul and Acres made a successful transition, and established a significant presence in the film world of the 1890s. Paul used his considerable business ability to establish himself as a leading film producer. By 1897 Acres had established a developing and printing, and film coating business. As far as is known they did not meet again after July 1895.

Notes

1. Moriarty to Platt, 4 March 1896, TAED D9623AAS (10 February 2017).

2. *The Era* (31 August 1895): 25.

3. *The Era* (20 June 1896): 25.

4. Barnes, *The Beginnings of the Cinema in England 1894-1901 Volume One*, 57.

5. This unlikely association, and the background for it on Stollwerck's side, has been extensively researched. See Lange-Fuchs, *Birt Acres* and *Der Kaiser, der Kanal und der Kinematographie* and Loiperdinger, 'Ludwig Stollwerck, Birt Acres, and the Distribution of the Cinématographe Lumière in Germany'; *Film & Schokolade*; and 'A Foreign Affair'.

6. An undated memorandum of Acres' visit from Ernest Searle, the Manager of the London and Provincial Automatic Machine Company, is quoted in Loiperdinger, 'A Foreign Affair', 80.

7. The statement of their account, 'Respecting the agreement with Mr Birt Acres', submitted to Stollwerck's by the London firm of patent agents Wilson, Bristows and Carpmaels, includes the following entries related to Acres. *June 25* [1895] 'Writing to Mr Blair in reply to a letter from him as to rendering us assistance in the matter' *July 1*; 'Attending Mr Blair, conferring with him as to the proposed agreement' *July 1*; 'Writing to Mr Blair to let us have the exact address of Mr Acres'. The authors' are most grateful to Deac Rossell for providing a copy of this and other Acres-related documents from the Stollwerck archive. A selection of these are reproduced in Lange-Fuchs, *Der Kaiser, der Kanal und der Kinematographie*. For a contemporary interview with Thomas Blair which discusses the kinetoscope, see 'The Photographic Revolution', *Black and White* (20 July 1895): 79.

8. Stollwerck Brothers to Acres, 18 June 1895. Acres provided his written confirmation of these terms on the

same day. From the style and date of these letters it is clear that they were written in Cologne after Acres had arrived in Germany.

9. Clause 17 of agreement between Acres and Stollwerck Brothers of 15 July 1895. Since there was only two or three days between the cancellation of the British agreement with Paul and the date of the signed contract with Stollwerck, it is obvious that the terms had been agreed before Acres had met Paul. Detailed information on the conditions incorporated in this contract, and the research and development work Acres undertook for Stollwerck Brothers, is given in Loiperdinger, 'A Foreign Affair'.

10. These are the words, reported by Paul, that Acres had used, Letter to *The British Journal of Photography* (17 March 1896).

11. Acres to Stollwerck, 13 July 1895. Letter reproduced in Loiperdinger, *Film & Schokolade*, 83.

12. German patent 92,247 of 25 August 1895. Loiperdinger, 'A foreign Affair', 83, suggests that it was the need for commercial confidentiality which was the reason why Müller was chosen as a nominee, but the real cause was related to German patent law of 7 April 1891, which required an applicant for a patent who did not reside in Germany to appoint a resident representative. With regard to the progression of his British application, Acres had agreed in the contract of 15 July that he would use 'due speed' to obtain it for Stollwerck's benefit, but in fact he did not submit the full specification until 27 February 1896, having taken his entire permitted allowance of nine months from the date of filing the provisional specification. There is no indication that Stollwerck's subsequently exercised their option for purchase, and this is probably the reason why completion was not expedited.

13. *The British Journal of Photography* (Supplement), (3 July 1896): 49–50.

14. 'The Kinematograph's Inventor. H.R.H. the Prince of Wales, and Mr. Birt Acres', *Daily Mail* (31 July 1896): 7. Quoted in *Photography* (6 August 1896): 519.

15. *The Amateur Photographer* (9 October 1896): 298.

16. *The Journal of the Camera Club* (May 1897): 65

17. 'Prominent Men in the Lantern World. No. VII – Mr Birt Acres', *The Optical Magic Lantern Journal* (May 1897): 80–81.

18. Barnes, *The Beginnings of the Cinema in England 1894-1901 Volume One*, 65.

19. Considering the issues involved in the study of film history, the American scholar Douglas Gomery has very pertinently emphasised that: 'While the study of film may involve a concern with aesthetics, technology, ideology, and audience, it is the study of film as an industry which remains central, and is basic to all other cinema studies.' Douglas Gomery, 'Hollywood as Industry', in John Hill and Pamela Church Gibson (eds.), *The Oxford Guide to Film Studies* (Oxford: Oxford University Press, 1998): 245.

20. *The English Mechanic* (25 October 1895): viii.

21. The combination of H.G.Wells, science fiction, virtual travel, and the manipulation of time by film, has encouraged mainly theoretical debate on these subjects in which reference is made to the *Time Machine* provisional patent. Comment on the various theories discussed is beyond the scope of an empirically-based history, although it should be noted that standards of factual accuracy when reference is made to early British film history are not always satisfactory. In the case of two American examples that have been noted, the author's, both academics from an English Literature background, have evidently not even bothered to read Paul's text before enlightening [?] their readers with various speculation about its importance, since they refer to the patent application being made by Paul *and* Wells, which a simple check of the text printed in Ramsaye or Barnes would have shown was an incorrect assumption. A British study in this area, which includes an extensive bibliography, is Keith Williams, *H. G. Wells. Modernity and the Movies* (Liverpool: Liverpool University Press, 2007).

22. Ramsaye, *A Million and One Nights*, 155–157. Barnes, *The Beginnings of the Cinema in England 1894–1901 Volume One,* 39–40.

23. Jacques Rittaud-Hutinet (ed.) *Letters: Auguste and Louis Lumière* (London: Faber and Faber, 1995): 54–55. Cecil Wray had addressed a similar enquiry to the Lumières on 15 October 1895, ibid., 31. A notice of the Lumière performance in Paris was published in *The Amateur Photographer* (29 November 1895): 353–354. An earlier notice giving details of how the Cinématographe worked, was published in *Nature* (29 August 1895): 419. Paul regularly advertised his business in this journal in 1895.

24. A provisional specification 'is to describe generally and fairly, the nature of the invention and not to give the mode of carrying it into practice', James Roberts, *The Grant and Validity of British Patents for Invention* (London: John Murray, 1903): 55.

25. *The Amateur Photographer*, Vol. 23 (6 March 1896): 222. Another late reference to the Time Machine

entertainment was published in a *Daily Chronicle* interview of 29 February 1896, which noted that, [Mr. Paul] 'has some startling ideas in his head, nothing less we understand, than a vivid realisation of some of the imaginative scenery pictured in Mr. Wells' "Time Machine"'. Paul's provisional application 4686 for a film projector was filed on 2 March 1896, four days before the *Amateur Photographer* account was published.

26. Included in Abridgement Class 20 – 'Buildings'.

27. Attention is also directed to H. Motte, 12,845 of August 1890, E.W. Keeler, 2830 of February 1891, W Keast 23,847 of December 1893, and A. Lake 24,169 of December 1893. A similar form of presentation was later reincarnated as 'Hale's Tours'. See Christian Hayes, 'Phantom carriages: Reconstructing Hale's Tours and the virtual travel experience', *Early Popular Visual Culture*. Vol.7 No 2. (2009): 185–198.

28. 'A Chat with Mr. Paul', *The Era* (22 April 1896): 17.

29. Ramsaye, *A Million and One Nights*, 153.

30. H. G. Wells, 'The Man of Science as Aristocrat', *Nature*, Vol. 147 (19 April 1941): 467.

31. Paul to the Editor, *Nature*, Vol. 147 (17 May 1941): 610.

32. *Law Times Review*, Vol. 63, 762 and 764.

33. *Law Quarterly Review*, Vol. 7 (1891): 198.

Chapter Seven

Edison's Latest

Acartoon stork decorated the menu for a supper held at the Horseshoe Hotel, Tottenham Court Road, London, on 17 October 1894. The bird was depicted as a waiter carrying a fruit-laden platter, but, in keeping with tradition, it also served as the harbinger for a new arrival.[1] Before the meal, Thomas Edison's latest progeny, the kinetoscope, was proudly displayed to a large party of journalists at premises in nearby Oxford Street. Like an enthusiastic god-father Franck Z. Maguire of the Continental Commerce Company regaled his guests with fascinating facts about the infant machine and glowing predictions regarding its future. Next day the kinetoscope parlour was opened to the public, an event which marked the beginning of the motion picture industry in the United Kingdom.

The appearance in England of Edison's latest wonder was not unexpected. Books, newspapers and magazines frequently carried accounts of recent inventions and imminent technological breakthroughs. Possessing a firm belief in the power of publicity the world's most famous inventor, Thomas Edison, was always quick to announce his latest projects, even when they were only in a rudimentary or notional stage. Some ideas, such as a hand-held communication device, were purely conceptual and not to be realised in his lifetime, whilst others, notably the kinetoscope, were described to the public years before their final development. Despite such defaults and delays, his name had become synonymous with relentless innovation. Shortly after the Oxford Street launch the *Yorkshire Evening Post* commented:

> The world has got into the habit of taking Mr. EDISON at his word. Nothing can surprise us now when it is fathered by Mr. EDISON. He has reeled off so many startling inventions before our astonished gaze that we refuse to be even thrilled by anything he can do now. If the New York papers were to record that he had invented a grappling-iron by which the moon might be captured and brought to earth as a rival to the Ferris wheel and the Eiffel Tower, we should only express a doubt if the enterprise were to pay. There would be no scepticism as to its possibility. That being the general state of mind regarding Mr. EDISON, we call for no wonder on the part of his new invention called the Kinetoscope which is now on view in London. It is an ingenious invention and one that can be seen to lead to larger results.[2]

Some residents of the United Kingdom may have allowed themselves just a

moment's wonder if they had read newspaper reports circulating in June and July 1894. A syndicated item announced that 'the most curious application of Mr. Edison's electrical inventions' was about to be seen in London.[3] It was claimed that the entire third act of Sidney Grundy's play *Sowing the Wind* currently running in New York was to be reproduced 'on a London stage' by means of a kinetoscope and a telephone. How an individually viewed device with a film duration measured in seconds might be seen, at length, by an audience was not explained, and how a live telephone relay might be synchronised to pre-existing photographic images was similarly ignored. 'This extraordinary combination is already complete,' readers were assured 'and will almost immediately be on its way to this country'. A sound film version of *Sowing the Wind* did not, of course, materialise, but later in the summer Irving Bush, Franck Maguire and his assistant R. F. Swayze arrived in London to launch the kinetoscope.

Maguire, Baucus and their financial backer Bush had moved quickly to establish a European base. It is probable that news had already reached them of kinetoscope exhibitions being given in Paris by Georgiades and Tragidis. On 11 August, over three weeks before Edison granted them sole agency for Europe, they ordered ten kinetoscopes to be delivered to Bush in London (the machines were not actually consigned until 13 September). Soon after the foundation of the Continental Commerce Company on the 10 September, Maguire had set out for England, arriving probably on 23 September. Ten more kinetoscopes were consigned on 21 September, and on 5 October five machines were despatched from London to J. C. Williamson in Australia.[4] Bush and/or Maguire managed to secure a prime location for the first UK kinetoscope exhibition, renting a shop in an area noted for its fashionable stores, theatres and restaurants. Number 70 Oxford Street stood on the north side of the road, on the corner of Newman Street, a short distance from Oxford Circus. Close by at numbers 30–32 was newly opened Frascatti's Restaurant where an excellent dinner might be had in palatial sur-roundings for five shillings. Just a few doors further at 14–16 was the Oxford Music Hall, one of London's earliest variety theatres, but rebuilt in 1892 with the most up-to-date facilities. In the week of the kinetoscope's opening the Oxford's all-star programme included the juggler Paul Cinquevalli who, a year and a half later, made an abortive attempt to introduce Edison's Vitascope into the UK. Also featured was a 'grand and novel ballet' titled *Carnaval Electrique*, a production that made spectacular and innovative use of electric lighting.

As vice-president and London representative of the Continental Commerce Company, Maguire was determined to emphasise the genteel nature of his exhibition. Whilst his company could not exercise control over those purchasing machines, it could, at its Oxford Street premises, insure that the kinetoscope was clearly differentiated from the cheap, automatic sideshows that proliferated throughout the UK. The frenzied exploitation of the phonograph had provided a salutary lesson, particularly when the London Stereoscopic Company exhibited the original tin-foil model at the Royal Aquarium as part of 'a chorus of monkeys and in the company of swimmers, boxers and Circus performers'.[5] Colonel

136 LONDON W. C. — Oxford Street from Tottenham Court Road. — LL.

Fig. 18. Oxford Street looking west from Tottenham Court Road.
Number 70 was located in the far buildings on the right-hand side of the street.

Gouraud had attempted to disassociate the 'perfected' phonograph from such a fairground environment by aiming his central London exhibition at an affluent and, presumably, more august audience. The Gainsborough Gallery, in Old Bond Street, was engaged from 6 April – 1 June 1889 and small-scale demonstrations of the device were accompanied by lectures from Professor Douglas Archibald. Admission prices were set at a shilling and two shillings and sixpence, and the exhibition room was decorated with various models of the phonograph and life-size portraits of Queen Victoria and the Princess of Wales. But despite Gouraud's efforts to dignify the phonograph many showmen still contrived to obtain the device and, by 1894, it had become a standard feature of low-price amusement arcades and rowdy fairgrounds.

American Films for British Audiences

Although the Continental Commerce Company strictly controlled the environment in which films were initially viewed, it seems to have made less effort to select subjects suited to the English market. Consequently, the succession of American variety acts framed in the same manner and lasting for the same time soon lost their initial novelty. They had originally been ordered in two batches from the Edison Phonograph Works. Shipping Order 53 on 13 August 1894 consisted of five subjects, *Armand D'Ary*, *Bar Room Scene*, *Bertoldi*, *Carmencita* and *Wrestling Dog*, whilst Shipping Order 128 of 19 September 1894 was for *Annabelle Butterfly Dance*, *Annabelle Sun Dance*, *Barber Shop Scene*, *Bertoldi*, *Blacksmith Shop*, *Boxing Cats*, *Caicedo*, *Carmencita*, *Horse Shoeing*, *Three Little Girls* –

97

French Dancers, *Sandow* and *Wrestling Match*. Eight films are known to have been demonstrated on the preview evening. These were:

1. *Annabelle Serpentine Dance*. Filmed in August 1894. One of the first films to be made of the kinetoscope favourite, Annabelle Whitford. The young dancer appeared manipulating diaphanous skirts in her own version of an act developed by Loïe Fuller during the early 1890s. With a presentational process favouring a lone figure brightly lit against a dark, featureless background, the hypnotic, undulating movements of 'serpentine' and 'skirt' dances (usually performed by Annabelle) were probably the most popular of all kinetoscope subjects.

2. *Bar Room Scene*. Filmed May 1894. An early story telling films, depicting a troublesome drunk being thrown out of a bar by a pot-man and a police officer. The swiftly unfolding and relatively crowded narrative of the subject probably encouraged re-viewing.

3. *Barber Shop Scene*. Filmed late 1893. A reproduction of the interior of a barber's shop, with a customer being lathered and shaved beneath a sign announcing 'The latest wonder. A shave and hair cut for a nickel'. There was an implication, as noted by Musser, that the viewer was being 'shaved' of a nickel, or its equivalent, by paying to see the film.[6]

4. *Bertoldi. (Table Contortion)*. Filmed March/April 1894. The young English contortionist, Ena Bertoldi, dressed in short doublet and tights, bending over backwards in part of her variety act.

5. *Blacksmith Shop*. Filmed Spring 1893. A blacksmith and two helpers drinking from a bottle and then hammering a piece of iron. Scenes of hard-working men were, of course, popular recreational viewing.

6. *Carmencita*, Filmed March 1894. The first woman to appear in a kinetoscope film, Carmencita had been performing her high-kicking Spanish dances in the United States since 1889. She came to London for the first time in 1895, but her live music-hall act seems to have been less well-received than her film appearance.

7. *Cock Fight*. Filmed September 1894. A close-up shot of battling bantams, with two laughing spectators betting on the outcome.

8. *Wrestling Match*. Filmed early 1894. A long-shot of two struggling contestants.[7]

Views of scantily dressed women; wrestlers and the all-male world of the barber shop may have appealed to the hard-bitten journalists who attended the launch, but their suitability for a wider English audience was questionable. Cock fighting, for instance, had been banned in England as a cruel sport since 1835. A comment in the *London Daily News* regarding 'a female acrobat exhibiting some curious contortions; and a disreputable fight in the bar-room of a public house' suggests that there was some disapproval of the content of the films.[8] Others queried the eventual status of the kinetoscope. In a review of Antonia and W. K. L. Dickson's *The Life and Inventions of Thomas A. Edison* appearing on 30 October 1894 (the day of the book's publication) the *London Evening Standard* considered that the device was 'still on the dubious line between a scientific toy and a practicable means of abolishing time and space'.[9] With films lasting for only 20–30 seconds

the kinetoscope seemed to linger on the former rather than the latter side of the line. A reporter visiting the shop four days after its opening described his initial experience:

> When at last my turn came I applied my eye to the glass slit at the top of the first box and whi-r-r-r, a living, moving scene was flashed before my gaze. It was an American bar-room. Two men came in, ordered drinks, disputed about something, began to fight. In rushed Policeman O'Jones, collared them, and took them off with great despatch. This curious scene was enacted twice during 30 seconds and then, with a whirr, the whole scene passed away, and I passed on to the next box, which represented Sandow showing his muscles.[10]

The same reporter who viewed *Bar Room Scene* suggested to Maguire that his clientele was 'an exceedingly good class of people'. Maguire replied:

> O yes, fashionable London comes to our show as much as everyone else, or more for that matter, and people come from the country and Continent to see us. Quite recently a man came all the way from Paris to inspect the invention, and finished up by buying several machines to take back with him.[11]

A New Branch

Having been in London since the summer Irving Bush and his wife Bella left for the New York on 3 November, bearing with them a collection of newspaper cuttings praising the exhibition. Subsequently, Edison was sent an album of glowing reviews and reports, most of which appear to have been paraphrases of, or direct quotations from, Continental Commerce Company publicity. Soon after Bush's departure the company opened a second parlour at 432 Strand. Like its companion exhibition it was set in one of London's principal shopping streets, close to the famous centre for toys and novelties, the Lowther Arcade, and facing Charing Cross railway station. But Maguire, Baucus and Bush had misjudged how long it would take for growing competition and failing novelty to impinge upon the popularity of their exhibition. It soon became apparent that several factors, including Edison's delay in sending them a camera to obtain European subjects, were likely to severely affect business. By January 1895, rival kinetoscopes parlours were reported to be operating in Bond Street, Holborn, Oxford Street, Piccadilly, Regent Street and the Strand.[12] In May Robert Paul's kinetoscope and films were exhibited in the far from fashionable area of North Holborn and the following month either Edison or Paul devices became accessible to a massive working-class audience at one of London's largest open-air spaces:

> Bank Holiday was a delightful one on Hampstead Heath, which was visited by quite a hundred thousand holiday makers, who came from all parts of the metropolis by trains, tram-cars, omnibuses, and on foot. The morning there was brilliantly fine, with a genial breeze, and before noon the Heath had become a scene of great and varied activity, which increased until late in the afternoon. The parts of the Heath near the railway station – known as Lower Heath or East Heath – had, as usual, on these occasions, all the character of an Old English fair brought up to date. There were long rows of stalls and hosts of coker-nut shies, swings, skipping pitches, peep

shows, and tents, in which according to the announcements, wonderful performances, such as a lady walking head downwards on a glass roof, to say nothing of performing fleas, etc. were to be seen. In the Vale of Health, near the well-known tea-gardens, a steam round-about and swing-boats did a good trade, while at various places Edison's phonograph and "kinetoscope" offered their allurements to the curious or scientifically inclined. In one instance the phonograph was fitted up on smart-looking pneumatic-tyred bicycle, the whole affair being a regular "swell" turn-out.[13]

As noted in Chapter Five, the Continental Commerce Company adjusted its strategy early in 1895 by planning a separate exhibition for a specific audience. Following the lead of the Kinetoscope Exhibiting Company, which had set up several parlours to exploit prize-fight films in the United States, it acquired six enlarged kinetoscopes and films of the boxing contest between Mike Leonard and Jack Cushing. It was arranged for the devices to be diverted from the Kinetoscope Exhibiting Company's account with Edison, Irving Bush writing to the managing director of the Edison Manufacturing Company on 16 January 1895 that 'it is our intention to make a special drive on these machines and to arouse interest in the Kinetoscope business generally through this special exhibition'.[14] With increased film capacity and a lower running speed the devices considerably extended the length, if not the range, of the viewing experience.[15] As each kinetoscope showed an individual round from the contest, around six minutes were devoted to a single event. As well as providing extended running time, an enlarged image was reported, the effect presumably achieved by a magnifying viewing lens. When the Leonard-Cushing films were displayed at the exhibition Hall, 175 Piccadilly, on 1 March 1895 it was reported that the promoters (either the Continental Commerce Company or their agents) intended 'to represent the various phases of sporting life-prize fights, racing, and rowing matches', but lack of press coverage suggests that the experiment was extremely short lived.

By April 1895 when Edison's kinetophone was finally put on the market in the United States the Continental Commerce Company was urgently in need of a fresh novelty to boost its flagging sales. Yet Edison had consigned the foreign rights of the phonograph, except for its use in toys, to the Edison United Phonograph Company, and any employment of the device in Continental Commerce Company kinetoscopes would seem to contravene the agreement. On 19 April 1895 Baucus wrote to Edison from his New York office suggesting that they could circumvent the problem by describing the kinetoscope as a toy. It was a somewhat cynical standpoint considering that his company was normally at pains to claim that the device was anything but a toy. Continental Commerce Company advertisements for the kinetophone began to appear in the English press from the beginning of May 1895 and an unknown number of phonographs were sent to London for insertion into kinetoscopes. As it was lack of synchronisation, the added cost of the device and, perhaps, pirate copies resulted in extremely poor sales, a failure that was compounded when Edison was legally enjoined from selling phonographs for kinetophones abroad on 20 August 1895.

With the commercial failure of the kinetophone the development of the kine-

toscope reached an impasse from which there was neither time nor ingenuity to escape. The eyes and the backs of audiences had been strained to breaking point and they were now happy to suspend their viewing activities until the arrival of the newest latest and most marvellous invention, projected film. The Continental Commerce Company continued to advertise from 70 Oxford Street until December 1895, although it is not clear whether films were still being exhibited at the address. Despite its central position, the Strand exhibition had closed by August 1895. Its replacement was also a peep show, but one which featured live subjects:

> The Edison kinetoscope has vanished from opposite Charing Cross, and its place is taken by a collection which would rejoice the heart of Sir John Lubbock. Ants of many descriptions, and all very self-important, are shown under lenses engaged in multifarious duties and practices the virtues which have made their name famous.[16]

Following the demise of their kinetoscope business Maguire and Baucus continued to act as British agents for Edison films although their relationship with the inventor became increasingly fractious. In March 1897, Maguire wrote to Edison 'we were building for the future and now for the first time I realize my mistake'.[17] At around the same time the pair engaged a dynamic young American, Charles Urban, who renamed the Continental Commerce Company the Warwick Trading Company and set it on the route to becoming one of the major players in the early British film industry. Maguire and Baucus frequently promoted other products and, in 1896, they were also involved with the Placer Gold Fields of Ecuador and the Playa de Oro Mining Company.[18]

Irving Bush, who appears to have left the partnership at an early stage, continued to pile million upon million by creating a major transport terminal on the Brooklyn waterfront and by backing major projects such as Bush Tower in New York and Bush House in London. After spending several years in England Baucus returned to the United States in 1905 to resume a full-time legal career. Maguire moved from one new technology to another. In 1904 he was reported to be vice-president of the De Forest Wireless Telegraph Company and European representative of Lee de Forest, then actively developing wireless as a means of communication.

Notes

1. The menu card is in the Bill Douglas collection, University of Exeter. Both it and a contemporary photograph of the venue are illustrated in Barnes, *The Beginnings of the Cinema in England 1894–1901 Volume One*, 9. To celebrate the centenary of this presentation, Stephen Herbert of the Museum of the Moving Image (MOMI) arranged a replica dinner at which each guest was presented with a strip of reprinted kinetoscope film as a souvenir.

2. *Yorkshire Evening Post* (22 October 1894): 2.

3. *Liverpool Mercury* (5 June 1894): 5.

4. See Chris Long, 'Australia's First Films 1894–1896: Facts and Fables', Cinema Papers No. 91 (January 1993): 38. The kinetoscopes were sent on the Orient Line's mail steamer Orizaba, arriving in Sydney on 17 November 1894.

5. Gouraud to Edison, 4 May 1889, TAED D8959ABD (10 February 2017).

6. Musser, *Edison Motion Pictures*, 1890–1900, 27.

7. Full synopses of these and all other Edison kinetoscope subjects are to be found in Musser, *Edison Motion Pictures, 1890–1900*.

8. *London Daily News* (18 October 1894): 3.

9. *London Evening Standard* (30 October 1894): 5.

10. *Evening News and Post* (24 October 1894): 4.

11. Ibid.

12. *Fun* (22 January 1895): 36.

13. *Hendon and Finchley Times* (7 June 1895): 5.

14. Bush to Gilmore, 16 January 1895, TAED D95177AAI (10 February 2017).

15. The enlarged kinetoscope used around 148 feet of film, as opposed to 40 feet used by conventional devices.

16. *Pall Mall Gazette* (19 August 1895): 1.

17. Maguire to Edison, 23 March 1897, TAED D9717AAA (10 February 2017).

18. *St James's Gazette* (11 May 1896): 15.

Chapter Eight

The First British Films

Although geographically close to Oxford Street and the Strand, the area around Hatton Garden was socially and culturally far removed. Honest and illicit industries had co-existed amongst the courts and alleys of this northern part of Holborn for centuries. Despite its proximity to the luxury shops and restaurants of the West End and to the banks and businesses of the City of London there were few signs of wealth or grandeur in the locality. An open-air market in Leather Lane sold goods at knock-down prices, small shops and gaudy pubs abounded and a variety of workshops provided cramped accommodation for watchmakers, glassblowers and metal workers. In 1891 Robert William Paul moved into this shabby area, establishing an electrical instrument manufacturing company at 44 Hatton Garden with nearby workshops at Great Saffron Hill. It was here that the first practical British film camera was constructed.

There is no record of how much time Paul spent in the crowded streets around his premises. Curiosity may have drawn him the short distance to Bleeding Heart Yard where legend had it that the devil dismembered Lady Elizabeth Hatton after dancing with her throughout the night. Or had he wanted an evening's uncomplicated relaxation, there were two nearby music halls which provided lively, if somewhat vulgar, entertainments. To what extent Paul interacted with his diverse and discordant neighbours is not known, but during the early 1890s he certainly become exposed to a world far different from that of his middle-class upbringing. Following his arrangement with Georgiades and Tragidis to produce replica Edison kinetoscopes he became involved with a group of opportunist and often unscrupulous characters. Of these the most disreputable was almost certainly William Turnour Thomas Poulett, a notorious fraudster and self-publicist who was to play an important role in Paul's exploitation of the kinetoscope.

Stepping uneasily into Paul's raffish world during the early months of 1895 was the genteel figure of Birt Acres. He had been introduced to Paul by their mutual colleague Henry W. Short as someone who would be able to help in the increasingly urgent quest to produce British films. An American by birth and a gentleman by nature, Acres had settled in Barnet, a suburb of orderly, tree-lined roads and a population bent on self-improvement. Nearby Holloway provided the home for the most popular fictional representative of the lower middle-classes, Mr George Pooter, the blundering anti-hero of George and Weedon Grossmith's *The*

Diary of a Nobody (published in book form in 1892). Acres had greater self-aware-ness and sophistication than the pompous Pooter, but his occasional bouts of affronted dignity gave him more than a passing resemblance to the accident-prone diarist. Despite a demeanour of prickly self-importance Acres was a talented photographer with imaginative plans to extend the boundaries of his art. Professionally he was employed as a manager by the well-known photographic manufactures Elliott and Son, although the company also valued his photo-graphic skills and frequently exhibited examples of his work. Acres was an active member of the Royal Photographic Society, contributing studies to several of its annual exhibitions. It seems likely that by the early 1890s he had already conceived the idea of taking and projecting motion pictures. In December 1893, he patented an apparatus for rapidly projecting magic lantern slides to create the illusion of movement[1] and on 22 September of the following year he unveiled a similar device at the Royal Photographic Society's Annual Exhibition. When Acres patented the Kinetic movie camera on 27 May 1895 he described it not only as an apparatus 'for enabling photographic images to be taken', but for the same images to be 'taken, projected, or viewed in rapid succession'.[2]

It appears that Paul and Acres first met on 4 February 1895. Thereafter, the parts played by each man in the construction of their movie camera are clouded by claim and counterclaim. In a letter to the *British Journal of Photography*, written a year after the events, Paul stated that he and Henry Short 'designed and con-structed' a camera on 5 and 6 February 1895, producing a finished machine on 16 March 1895.[3] Acres responded that he had spent every evening for several weeks overseeing the development of the machine at the Great Saffron Hill workshops, very occasionally assisted by Short.[4] In an annotation to Henry V. Hopwood's *Living Pictures*, in which the author noted that Acres had filmed the University Boat Race with 'his Kinetic camera', Paul added 'with a camera made by R. W. Paul'.[5] Whatever the truth, the ill-matched partners had a working camera by the middle of March 1895. It was then time to decide what type of subjects should be photographed. Having copied Edison's kinetoscope in such close detail, it seems likely that Paul would have advocated producing imitations of Edison's films. Acres, on the other hand, was an enthusiastic photographer with a passion for recording open-air scenes. The portable nature of their camera made both options possible. Eventually, they decided on a pragmatic filming programme that included staged and actuality subjects. With his long experience in the field of photography Acres took on the role of cameraman and, although Paul may have suggested subjects, finished films appear to have been the respon-sibility of Acres alone.

Early Film-making

Acres' first film was quite unlike anything that Edison or Dickson had produced. Although clearly staged, *Incident Outside Clovelly Cottage* depicted a slice of everyday life, photographed not on a shallow stage in a cramped studio but in a real street in the open air. At the front of the Acres' broad-fronted, distinctly un-cottage like home in Park Road, Barnet, his wife Annie was seen pushing a

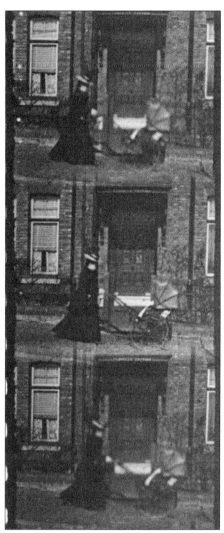

Fig. 19. Mrs Annie Acres depicted in the earliest British film, February-March 1895.

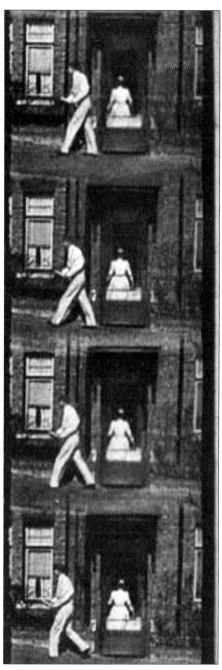

Fig. 20. A further sequence from *Incident Outside Clovelly Cottage*, showing Henry W. Short.

baby in an ornate perambulator. Henry Short, dressed in white and wearing a cap, marched purposefully from right to left and opened a low, garden gate, while a maid dressed in a pale uniform hurried away into the gloomy recesses of the house. Immediately film's potential for conveying width and depth, light and shade was engaged in a way not previously attempted by Edison. On 29 March 1895 Paul sent a strip of the film to the American inventor, suggesting that they might co-operate by exchanging their productions. Edison rejected the idea, probably from straightforward commercial motives, but also, perhaps, because he detected an implied threat in the comment: 'In case you decide to entertain the proposal I shall be pleased to co-operate with you in stopping sundry attempts now being made to copy your films'.[6]

The simple, domestic scenes recorded outside Clovelly Cottage may have seemed strangely inconsequential to Edison, but other subjects filmed by Acres in the spring of 1895 would have been reminiscent of his own productions. Although Paul and Acres had little knowledge of the world of entertainment they quickly located a number of performers, both human and non-human, who were filmed on a crude stage, apparently in Acres' back garden. On 5 April Paul indicated that full-scale production was under way, advertising: 'Kinetoscopes and films: New Topical Subjects Daily: Large stock'.[7] Two weeks later, on the 20 April, he confirmed that the films he was offering (and erroneously claiming to have taken) were English, listing four specific titles and 'sundry acts', i.e. variety perform-ances.[8] On 19 May Paul announced 'New English Films, Twenty Subjects Ready'.[9]

Differing only in that they were filmed against a light rather than dark back-ground, two recently discovered Acres variety subjects closely resemble the format of Edison productions.[10] The first *The Boxing Kangaroo* probably aimed to capitalise on the long-term popularity of a famous animal act at the Royal Aquarium. Had it been available 'Professor' Landerman's seven-foot-high mar-supial would have been too large and active for their limited stage area. Instead, a smaller creature was engaged for the film. A similarly scaled down opponent in the form of a young boy is seen sparring with the kangaroo, with the contest taking place under the watchful supervision of a traditionally uniformed animal trainer. In the second film, *Dancing Dogs*, one animal is encouraged to jump through a hoop, while another manipulates flowing robes in imitation of the dancer Loïe Fuller. The film had an earlier parallel in Edison's *Wonderful Performing Dog/Skirt Dance Dog* (filmed 17 October 1894), but it may have drawn its inspiration from local London entertainments such as Mons. Richard's troupe of dogs then appearing at the famous Palace Theatre of Varieties, London. When asked by a reporter 'Which is the great serpentine-dancer?' Richard responded 'Chiquita, *ma perle noir* (my black swan). You have seen how she turns round – always in time, and keeps her dress in position, and how she keeps bowing and bending to the beat of the music.'[11] A further animal act, *Performing Bears*, was advertised in *The English Mechanic* on 14 June 1895.

With the novelty of moving pictures receding, films made in the United States

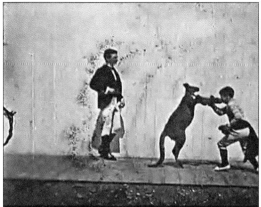

Fig. 21. *Boxing Kangaroo*, 1895 (BFI National Archive).

Fig. 23. *Dancing Dogs*, 1895
(BFI National Archive).

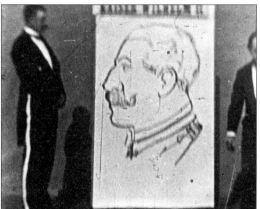

Fig. 22. *Tom Merry, Lightning Cartoonist, Sketching Kaiser
Wilhelm*, 1895 (BFI National Archive).

became increasingly irrelevant to British consumers. In many productions, Americanness was represented by what Charles Musser has described as the 'male, homosocial world of the Edison Laboratory' and a 'culture of rugged masculinity'.[12] In contrast, the type of films made during the Paul-Acres partnership acknowledged that their viewers would include women, children and those not particularly familiar with barber's shops, bar-rooms and cock-fighting. Reacting to the limitations of Edison's productions, Paul and/or Acres also selected themes that would resonate with United Kingdom audiences. In 'Tom Merry' (William Mecham, 1852–1902) they found a nationally famous personality who supplied home interest when he appeared in four films of his music-hall act.

As a well-known stage cartoonist Merry's appearance carried with it celebrity appeal, whilst the caricatures he produced for the popular press would have made his art recognisable to a wide public. He had been appearing at music halls for

107

Fig. 24. Crude set drama (given title), attributed to Birt Acres (BFI National Archive).

the previous 20 years in an act that remained remarkably unchanged. As early as 1877 a reporter for *The Era* attending the Raglan Music Hall, North London, wrote: 'Mr Tom Merry, the gifted caricaturist draughtsman drew with marvellous rapidity large and readily recognised portraits of Beaconsfield, Gladstone, Midhat Pasha, Mr Murray and Mr Parker'.[13] Merry's ability to produced oversize cartoons in less than a minute was ideal for kinetoscope exhibition. The surviving footage of *Tom Merry, Lightning Cartoonist, Sketching Kaiser Wilhelm* depict the artist having just finished a 6 ft high portrait of the German Emperor with a liveried attendant looking respectfully on (Malcolm Cook has suggested that this secondary figure represents the Kaiser).[14] The same format was almost certainly employed for the films *Tom Merry, Lightning Cartoonist, Sketching Bismarck*; *Tom Merry (Lightning Artist) Sketching Lord Salisbury*; and *Tom Merry (Lightning Artist) Sketching Mr Gladstone*. The provenance of the Merry films is obscure, with no reference to them surviving from 1895. However, the fact that both Paul and Acres had joint ownership of at least one of the films after the conclusion of their partnership strongly suggests that they originated during the first half of 1895. Merry's music-hall appearance during 1895–1856 were limited to a handful of performances in February and March 1895.

How performers were induced to appear in the films has not been established. With limited financial resources neither Paul or Acres would have been able to offer large payments and it is possible that artists were persuaded that the

kinetoscope provided a valuable form of advertising for their live acts. In April 1896, a Tom Merry subject projected by Paul caused an entertainment journal to express concerns over the employment of variety performers in films. Writing of Britain's first 'film star' *The Encore* observed: 'In the Animatographe at the Alhambra, one of the pictures indicates Mr Tom Merry making a caricature of Bismarck. We think that his name should be announced in some way, for he is practically giving a show for nothing'.[15] It might be significant for his film appearances that, during 1895, Merry was undergoing financial difficulties, being declared bankrupt at the end of the year.

During the 1890s Acres, did have at least one acquaintance with a background in popular entertainment. Frederick Stuart Debnam (1870–1915) was a popular North London comedian whose principle occupation was given as 'photographer's artist'. During the 1890s Debnam was living in Barnet and was apparently employed by Elliott and Fry. His obituary claims that 'whilst at Barnett he was associated with Birt Acres, who produced the very first moving picture – a girl jumping in Park-road, Barnet'.[16] He is known to have appeared in at least one Acres film *The Village Blacksmith* in which he acted out the words of the famous Longfellow poem (and parlour ballad) in 'dumb show'.[17]

First Fiction Films

Three simple dramas are known to have been made during the Paul-Acres partnership. *Bootblack Scene*, also titled *Comic Shoeblack*, was a comedy representing a worker commonly encountered polishing shoes in city streets. Frame illustrations published in a contemporary periodical show that an attempt had been made to create the illusion of a British, or London, thoroughfare with newspaper posters and childish graffiti decorating the background wall (the reproduction of posters to add authenticity to staged scenes had been employed in stereoview subjects since the 1850s). The earliest surviving Acres fiction film, *Arrest of a Pickpocket*, employed the same set and actors to present a made-up scene that was both melodramatic and realistic.[18] Although occurring in a confined area the film is a precursor to one of cinema's most enduring genres, the chase movie. A pickpocket is seen at the moment he is apprehended by a pursuing policeman and a uniformed sailor. The miscreant struggles, but is held firm and escorted away by the brave 'bobby' and gallant 'Jack Tar'. It is a film that suggests a respectful, middle-class approach to its subject, where-as the popular theatre and music hall of the late 19th century frequently depicted the police as the ponderous, slow witted butts of artful criminals

In *Carpenter's Shop/Beer Time in a Carpenter's Shop* Acres again presented a conventional point of view that had more in keeping with artistic and literary genres than popular entertainment. Victorian painting and illustration abounded in representations of work, more often or not depicting 'honest' toil as the foundation of a well-ordered society. Of all the images depicting manual labour, *Work* by Ford Madox Brown (painted 1852–1865) provides the most complete synthesis of attitudes towards the subject. At the centre of the painting several 'navvies' are seen digging up a road in Hampstead, North London, watched by

Fig. 25. *Arrest of a Pickpocket,* 1895 (BFI National Archive).

characters emblematic of different social classes and attitudes. A feature of the painting that coincides with the Acres film is that of a labourer pausing in his exertions to take a swig of restorative ale. It was a device that was also employed in one of Edison's earliest films, *Blacksmith's Scene* (1893), and one which American historians such as Charles Musser place in a backward-looking category: 'in terms of American work culture, this scene already presents a nostalgic view, for, as Roy Rosenzweig has remarked, by the late nineteenth century, work and socializing were increasingly separated, with workplace drinking considered part of a bygone era'.[19] In Britain, the representation of three workmen sharing a potful of beer may have accorded more with contemporary practice, but it still evoked the drink's long heritage. As Peter Bailey observed 'the English workman was the great ale-swiller and meat-eater whose industry and stamina put the puny continentals to shame or flight, in work or war …'.[20]

The Outside World

Paul later recollected that their first attempt at filming took place on Blackfriars Bridge, but was unsuccessful because the camera operator neglected to insert the lens. Such an implausible failure was not the case when Acres came to film his

COMING INTO DOVER HARBOUR.

Fig. 26. A stormy sea at Dover depicted in *Home Words for Hearth and Home* (March 1884).

masterpiece, *Rough Sea at Dover*. Dating the film has proved difficult, but if, as is generally thought, the view was one of the earliest films taken it would have been consistent with Acres' interests in photographing nature in all its changing states.[21] A review of an exhibition presented by the Photography Society of Great Britain (later the Royal Photographic Society) in 1892 demonstrates that the film's inspiration was of long standing:

> There are some capital examples of instantaneous photography, particularly a well-defined group of flying pigeons, by Mr F. Blake, and five photographs showing the changes of form of a group cumulus clouds in less than half a minute, by Mr Birt Acres. In a sea-coast view, seven feet long [five feet high], enlarged from a negative of Mr Acres, by Messrs. Elliott and Son, the momentary aspect of the breaking waves and moving sky is recorded with convincing fidelity, but the unrelieved blackness of the shadowed rocks in the foreground detract something from its value.[22]

The medal-winning photograph, taken at Mortehoe, on the north Devon coast, was massively enlarged from an 8½ by 6½ inch negative. It was provided with a title, 'Break, break, break at the foot of thy crags, O Sea!', which added a literary dimension to the image's impressive pictorial qualities. Quoting a poem by the recently deceased Poet Laureate, Alfred, Lord Tennyson, the photo evoked an extremely well-known work rich in nautical metaphors. It was a poem that had

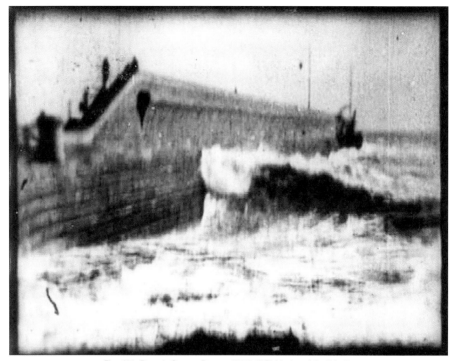

Fig. 27. *Rough Sea at Dover*, 1895 (BFI National Archive).

often been illustrated and Acres' image was provided with an artistic gloss by being printing in tones of green. 'Break, break. Break ...' was widely shown throughout England during 1892–1893, featuring alongside other Acres' enlargements and lantern slides depicting 'cloud studies and wave-breaking effects'.[23] Instantaneous views of skaters taken in a wintery Hertfordshire were also projected[24] and it is likely that Elliott's enlargements of yachts and fishing smacks were originally photographed by Acres. Two years before taking his first moving picture he was intent on expanding the size of photographic images to display them to audiences.

Rough Sea at Dover was clearly better suited to large scale reproduction than peepshow viewing, depicting the length of a stone causeway, Admiralty Pier, projecting into the English Channel. Although grainy and indistinct, the surviving film with its view of giant waves crashing towards the camera is still impressive. It was the type of scene that was often reproduced in Victorian art and, like much Victorian art, its imagery was open to varying interpretation. Violent seas and storm-lashed coastlines were expressive of the awesome power of the natural world, but were also metaphors for the United Kingdom's sometimes embattled, but always defiant island status. As the western perimeter of Dover Harbour, Admiralty Pier was the nation's first line of defence. At its heavily fortified

Fig. 28. The Oxford and Cambridge Boat Race, Hammersmith, 1895. Acres' film may have been taken from a similar viewpoint or from the bridge.

extremity, the two largest guns in the country stood ready to repel any seaborne invaders. Although the cannons were never used in anger, the pier was under constant attack from the sea. By the 1860s photographers such as Valentine Blanchard, Edward Fox and W. Brooks had begun to parallel the work of artists, using faster shutter speed to provide 'realistic' evocations of the nation's constant struggle with the encroaching ocean. As Acres had already exhibited large-scale versions of his photographs and had also shown sequences of lantern slides to create a rudimentary illusion of movement, it is probable that he had projection in mind when filming many of his early subjects. Once exhibited on screen *Rough Sea at Dover* realised Acres' vision to such an extent that it became one of early cinema's most popular films.

First News Films

The divergence from Edison's studio bound, carefully arranged views was seen at its clearest in two sporting subjects filmed by Acres. In photographing the University Boat Race and the Derby Stakes horse race he was tapping into a national pre-occupation with measuring the progress of the year by a series of traditional occasions. Such a familiar almanac was fostered by newspapers and illustrated periodicals who not only covered the recurring events in minute detail, but also spent considerable time discussing their approach and aftermath. Both races were free to spectators, attracting massive crowds drawn from all classes. The resulting opportunities for juxtaposing the appearance and behaviour of

Fig. 29. The famous Derby crowd recreated in an 1859 stereoview by Alfred Silvester.

different levels of society were irresistible to journalists, illustrators, writers and artists. Across the country, the nature of the events created a keen interest in many who had never visited the West London towpath or the gentle slopes of the Epsom Downs.

The Boat Race, photographed at Hammersmith Bridge on 30 March 1895 was the first film made by Acres that can be precisely dated. Without the benefit of a telephoto lens, a Cambridge eight closely pursuing an Oxford crew along the Thames probably had minimal visual impact when seen in a kinetoscope. But set within an overall scene of riverbanks and massed spectators the view would have been wonderfully evocative to an audience used only to still representations of the event. Despite its limitations, *The Boat Race* was immensely significant in the development of cinema. As the first film of a genuine historic event it created a new raison d'être for the medium, attracting viewers not only by being a representation of movement, but of topicality. Preserved on celluloid, the reality of occasions such as the boat race could be replayed at any time in any suitable venue. It was a significant victory over the constrictions of time and space that contemporary observers were quick to claim.

As with other media coverage, context and narrative shared equal importance in the Acres film *The Derby, 1895.* Derby Day was as much famous for its hordes as for its horses, attracting nationwide interest as the roads from London to Epsom in Surrey became choked by a stream of carriages and wagons conveying passengers to the event. The countryside around the race course was transformed into a giant recreation ground with entertainers, refreshment booths and fairground attractions catering for the large number of people seeking a memorable day out. It was a crowd-dominated scene that was captured by such artists as John Everett

Millais in *At the Races* (1853). William Powell Frith in *Derby Day* (1858) and Aaron Green in *At Epsom Races* (1871) and by the novelist Charles Dickens who wrote that on Derby Day 'a population surges and rolls, and scrambles through the place, that may be counted in millions'.[25]

As early as 1859 a London photographer, Alfred Silvester, had attempted to convey the atmosphere of the race by employing elaborate sets and many extras in a series of stereoviews. Topicality was assured by publishing the set on Derby Day:

> Six hours after the great Race has been run will be issued a STEREOSCOPIC PICTURE, being a perfect facsimile of the race course at the most important point in the field, comprising nearly 100 excited spectators which will be the largest number ever taken in a stereoscopic group.[26]

Although being described as 'perfect facsimiles' Silvester's stereoviews were, in fact, small works of art, inspired by paintings and illustrations. It was not until the Acres film that a remote audience could experience the dynamic ebb and flow of Derby Day. Soon after the event Acres talked excitedly to Earnest Searle about the scenes he had recorded. Searle, reported to Ludwig Stollwerck:

> Mr Acres was in yesterday, with a large amount of praise for the film, which enabled him to obtain four or five excellent negatives of the Derby. They are so good in print that he values them at £100 a piece. He made one of the police clearing the course; the preliminary canter; the parade; the race itself, and then the huge crowd swelling out to the course after the race. He says they are simply splendid.[27]

Why Acres filmed multiple scenes is open to debate. Described in Paul's advert as the 'finest film made', *The Derby, 1895* was almost certainly the first three scene motion picture. Edison had already demonstrated the possibility of representing a multi-scene event, i.e. a boxing contest, by employing separate films exhibited in a row of kinetoscopes, but Acres' movie presented 'Clearing the Course, the Race, and Rush' at a single viewing.[28] Whilst Edison's kinetoscope productions were continuously filmed records of simple episodes, Acres *The Derby, 1895* employed a series of selected views to provide a conspectus of a much longer and more complex event. It is possible that Acres was thinking forward to the possibility of projection when he obtained this encapsulated view of the race. Certainly, his projected film exhibitions made use of the various shots, including the famous Derby crowds. In April 1896, a reviewer emphasized the narrative nature of three linked views:

> In three tableaux, "The Derby, 1895", is most vividly recalled. First the course is cleared, and the seething Epsom crowd in front of the grandstand lives again. Then courses the preliminary canter, and the whole picture is suggestive of suppressed excitement. The reproduction of the race is a startling success. The point of view is close to the Jockey Club stand, and one sees the final struggle faithfully rendered, and Sir Visto forging in front in the last few seconds as in the actual race. Once more the crowd breaks bounds, and as the screen becomes blank again it is difficult to realise that one is not at Epsom after all.[29]

Fig. 30. Birt Acres filming the Derby, 1895.

Fig. 31. The Derby of 1896 showing the building from which Acres filmed the previous year's race.

Fig. 32. *The Derby, 1895* (BFI National Archive).

Fig. 33. *The Derby, 1895.* Crowd spilling onto the course at the finish of race (BFI National Archive).

Acres later claimed that he had been 'granted special to erect a stand which enabled him to reproduce ... [the] Derby with a minuteness of detail which is most astonishing',[30] but the famous photograph showing him filming at the finish (presumably in 1895) clearly indicates that his position was on a balcony of a two-story building which had formed part of the Epsom layout for several years. A location adjacent to the winning post and facing the Grandstand is confirmed by a view of the race held in the BFI Ray Henville Collection.

Alongside the two major sporting events Acres continued to photograph scenes of everyday life. Having taken the first news movies, he soon produced the earliest example of another popular genre, the railway film. Advertised for sale on 20 April 1895 *Railway Station Scene* presaged the hundreds of views of railway engines that became a standard feature in early cinema programmes. Acres made several films showing trains in 1895–1896, of which the most likely contender for *Railway Station Scene* was, perhaps, *Highgate Tunnel, with the Passage of a G. N. E. Luggage Train*. Acres' appearance strolling on the platform may well have been filmed by his colleague Short. Another transport related subject, the departure of a large steam ship from a harbour with onlookers waving, also appears to have been filmed by Acres in 1895, although it is known only from details of Paul's film show at the Royal Institution on 28 February 1896. Paul did not have a working camera by this time and his possession of the film suggests that it was filmed during their partnership.

Who bought Paul's Kinetoscopes and Acres' Films?

Paul later claimed that he had constructed six kinetoscopes by the end of 1894 and about 60 during 1895. The purchasers of most the machines can be conjectured at from several factors. Paul himself referred to 'a demand from travelling showmen and others'.[31] Most of the kinetoscope exhibitions recorded in contemporary newspaper adverts and reviews were those relating to official functions or shows presented in town centres and holiday resorts. Of 37 film subjects mentioned as being shown in the United Kingdom, all but four originated in Edison's studio.[32] The scarcity of films known to have been made by Acres during his partnership with Paul suggests that they were being shown at venues not usually reported in the press, i.e. small-scale and ephemeral shop exhibitions and in the fairs that were regularly held throughout the country. Although members of the former group may not have been quite as disreputable as the rent dodging 'moonlight flitters' described by Stephen Fossa Moriarty in a letter of 1896, they were still held in relatively low public esteem.[33] As for the fairground community, they were outside normal society and the entertainments that they offered were often categorised as pandering to low and lascivious tastes.

Whilst it presumably described genuine Edison machines in action, an account of the fair at Lincoln in April 1895 also suggested the nature of other visually-orientated amusements alongside which Paul's kinetoscopes would have appeared.

> Proceeding down Monk's-road to the fair, the position of which is clearly indicated
> by the sounds aforementioned, I noticed first, by the plough works opposite the

pleasure ground, a number of curious looking contrivances of a box shape with the attractive name of the Kinetoscope attached. These, I found, belonged to Mr. P. Bernstein, of London, and are machines containing Edison's latest invention, which enables one to witness "living pictures" of a most desirable type, the actions of acrobats, contortionists, skirt dancers, boxers and innumerable other wonders being reproduced in a most faithful and life-like manner by quickly revolving photographs. Mr. Bernstein's two phonographs close by are exceptionally fine machines, and afford a splendid opportunity for hearing a good song or musical selection in as distinct a tone as could be desired. But a terrible noise of drums and a number of gaily decked individuals perambulating outside a lavishly gilded arrangement, dragged me away from Edison's mysteries to the more explainable wonders of a *fin de siècle* ghost show. Having paid my modest fee to see the goblins, spooks, or ghouls, or whatever terrible thing might turn up, I took my seat inside the tent and settled down in a close and very worldly atmosphere to enjoy the thrilling adventures of the renowned Sweeney Todd, who politely, and to the great delight of the appreciative audience, played chief ghost, and after a great deal of unnecessary talk, killed off everybody in a most easy way, but whose end I did not stop to see, though I suppose he went the way of all such double dyed villains. The illusions were very good, and are rendered especially so if you do not know how it is done, and school yourself to think the very material forms you see are visitors from a different sphere or just the vision of a haunted being ... I walked on to the "Art" Galleries, which as usual were accompanied – as were everything else on the ground – with loud voiced music (?) and equally loquacious proprietors. I should not advise any friends of Mrs. Chant to go within ten yards of these exhibitions, the outside of which is enough to shock any pure-minded soul, but for those who admire – apart from sensuality or suggestive thought – art of this description, there is ample scope for criticism. Some of the pictures viewed through the hole which reminds me of the passage "looking through a glass darkly" are very good and fairly well worth seeing, but for the majority of the rest – they are perhaps better left undescribed, "nodings on" expressing their character accurately.[34]

The prospect of the latest scientific wonder becoming associated with spooks, ghouls and maidens with 'nodings on' would not have appealed to Edison's authorised agents or many of their customers. Edison's imprimatur was expensively bought, but it was not easily protected in the spheres of fairs, short-rental shops and even, possibly, street exhibition. It seems likely that Paul's cheaper replicas often operated in such transient areas of the market and that they were misrepresented as Edison originals. It was difficult for Paul to distance himself from the dubious dealings of James Edward Hough and Georgiades and Tragidis, but with the sales of 'bogus' kinetoscopes to other showmen, he could effectively claim that the way in which they were exploited had nothing to do with him.

Notes

1. UK patent no. 23,670, Filed 3 December 1893.

2. UK patent no. 10,474, Filed 27 May 1895.

3. *British Journal of Photography* (27 March 1896): 206–207.

4. *British Journal of Photography* (10 April 1896): 239.

5. Barnes, *The Beginnings of the Cinema in England 1894–1901 Volume One*, 35.

6. Paul to Edison, 29 March 1895, Thomas Edison National Historic Park. Illustrated in Barnes, *The Beginnings of the Cinema in England 1894–1901 Volume One*, 23.

7. *The English Mechanic* (5 April 1895): vi.

8. *The Era* (20 April 1895): 7.

9. *Lloyd's Weekly Newspaper* (19 May 1895): 18.

10. Films in the collection of The National Fairground and Circus Archive, University of Sheffield.

11. 'A Chat with the Serpentine Dog Dancer', *The Sketch*, (20 February 1895): 201.

12. Musser, *Edison Motion Picture, 1890–1900*, 33.

13. *The Era* (30 September 1877): 4.

14. Malcolm Cook, 'The lightning cartoon: Animation from music hall to cinema', *Early Popular Visual Culture*, Vol. 11, No.3 (2013): 248.

15. *The Encore* (17 April 1896) (page no. unavailable).

16. *Hendon and Finchley Times* (8 October 1915): 8.

17. *Hendon and Finchley Times* (19 March 1897): 6.

18. Collection of the National Fairground and Circus Archive, University of Sheffield.

19. Musser, *Before the Nickelodeon*, 34.

20. Peter Bailey, *Leisure and Class in Victorian England* (London: Routledge, 2007): 89.

21. Contrary to current opinion, Richard Brown believes that *Rough Sea at Dover* was not intended to be viewed in a kinetoscope, but was instead shot at the end of 1895 with the specific intention that it should be premiered as part of the programme of *projected* films presented by Acres to members of the Royal Photographic Society on 14 January 1896.

22. *The Graphic* (1 October 1892): 405.

23. *Western Morning News* (12 January 1893): 8.

24. Ibid. (26 January 1893): 5.

25. *Household Words* (7 June 1851): 241.

26. *The Illustrated London News* (27 May 1859): 527.

27. Stollwerck archive.

28. *The English Mechanic* (14 June 1896): vi.

29. *Preston Herald* (22 April 1896): 4.

30. *Barry Herald* (29 May 1896): 7.

31. Robert W. Paul, 'Kinematographic Experiences', *Journal of the Socirty of Motion Picture Engineers* Vol. 37, Issue 5 (November 1936): 496.

32. A recently discovered report of a sale of work held at the Rectory, Barnet, on 4 July 1895, see *The Barnet Press* (6 July 1895): 8, refers to a kinetoscope showing *The Arrest of a Pickpocket*, *The Boxing Kangaroo*, *Comic Shoeblack* and *The Derby*. A connection with Birt Acres is not only suggested by the location, but by additional technical details. The report states that "The camera is the invention of Mr Birt Acres, and the pictures are also made by him. The machine for showing them is Edison's pattern."

33. Moriarty to Thomas Collier Platt, 4 March 1896, TAED D9623AAS (10 February 2017).

34. *Lincolnshire Echo* (23 April 1895): 2.

A Premiere at the Nag's Head

Following their initially successful collaboration Paul and Acres soon found that their working relationship was soured by mistrust and disrespect. Acres claimed that Paul had not fulfilled his promise to provide funds for the project, whilst Paul countered that Acres had taken undue credit for the invention of the camera. There were probably differences of opinion about the type of subjects that should be filmed and the way in which they should be employed. As well as selling kinetoscopes and films to a multifarious and mendacious group of showmen, Paul had started to plan his own exhibitions. The move appears to have been made without Acres' knowledge and was cited as one of the major factors leading to the break-up of their partnership.

Paul's first venture as an exhibitor attracted considerable attention, although the publicity surrounding it was tinged with condescension and derision. Shortly before 15 May 1895 editors of newspapers and magazines were surprised and somewhat amused to receive an invitation to a premiere to be held in the shabby backstreets of North Holborn. Beneath an imposing ancestral crest, Viscount Hinton invited them to 'a private view of the KINETOSCOPE' announcing that 'a life-like reproduction will be given of the first English Scenes taken by the European manufacturer Mr Paul'. It was humorously reported that the address given, 39 Leather Lane, was none other than a common public house, the Nag's Head. In reality, the exhibition, bedecked with flags and with Viscount Hinton's name prominently displayed, appears to have taken place at number 39a, adjacent premises which seem to have been associated with the once notorious inn.

Like many buildings in the crowded centre of London the Nag's Head site had a complex history and a complicated footprint. Two paintings by Thomas Hasmond Shepherd show that, in 1857, the tavern was approached from the narrow street through an archway, with an inner courtyard typical of many London coaching inns. By the late 1860s the Nag's Head was regarded by many as a hotbed of political agitation and by others as a cradle for fledgling democracy. In November 1867, a gathering of costermongers at the tavern formed a 'Protective and Benevolent Society' intended largely to oppose changes to trading laws

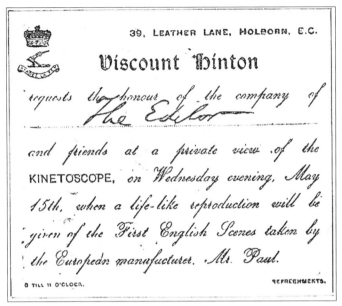

39, LEATHER LANE, HOLBORN, E.C.

Viscount Hinton

requests the honour of the company of

The Editor

and friends at a private view of the
KINETOSCOPE, *on Wednesday evening, May
15th, when a life-like reproduction will be
given of the First English Scenes taken by
the European manufacturer. Mr. Paul.*

8 TILL 11 O'CLOCK. REFRESHMENTS.

Fig. 34. Preview invitation to the Leather Lane exhibition.

brought about by the new Metropolitan Street Traffic Act. A month later, the landlord was warned by the police that he was in danger of losing his license if he continued to allow the Holborn branch of the Reform League to hold meetings on the premises. In time, the site came to encompass not only the tavern, but shops, cellars, store-rooms, private accommodation and a small factory. During the early 1870s the 'Steamworks' at the address was the base for the Elastic Tissue Company, a firm that manufactured state of the art bandages. The premises sometimes attracted criminal activity. In September 1890 John Sullivan, a local printer, stole a sheep's carcase that was hanging outside Corbett's butchers shop at 39 Leather Lane. It was an audacious, but incompetent robbery committed within full view of a police constable. Although the policeman does not appear to have been assisted by a sailor, the apprehension of the thief may well have resembled *The Arrest of a Pickpocket*.[1]

Viscount Hinton's Patronage

Paul's apparent decision to allow William Poulett, or 'Viscount Hinton' as he preferred to style himself, to host the first official presentation of British kine-toscope subjects throws considerable doubt on his judgement, probity and even basic common sense. It was true that Poulett was well known throughout London, but as a rogue and a vagabond rather than a respected member of the aristocracy. Seven years before, the noble crest that adorned the kinetoscope invitation was used to fraudulently obtain valuable goods from a group cap-tugging retailers.

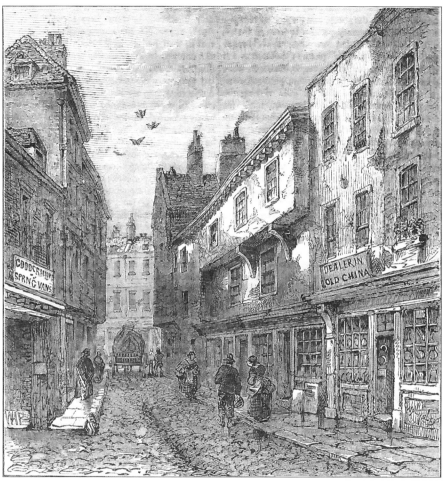

Fig. 35. Leather Lane, looking towards High Holborn. Number 39 probably on extreme left.

Poulett's background was so controversial that it is worth examining in detail. His mother, the daughter of a marine pilot, had married Lieutenant William Henry Poulett, a nephew to the fifth Earl Poulett, in 1849 under what proved to be contentious circumstances. Conflicting accounts claimed that the cash-strapped Poulett had entered the relationship as the result of a £500 bet with fellow officers or that the couple had lived together for some time before the ill-matched marriage. Whatever the circumstances, the birth of William Tournor Thomas after only six months caused Poulett to abandon his young wife, refusing to accept the child as his own, although he continued to pay an annual allowance. If anything, his attitude hardened even more when, in 1864, he became Sixth Earl Poulett, owner of the magnificent Hinton St George estate in Somerset. Despite the new earl's rejection of his wife and disputed child, sympathetic members of

123

the Poulett family provided financial support to allow young William to receive a well-rounded education at Church House School, Merton (where class-mates included the future theatrical impresario Augustus Harris who, in 1896, was to present the first public showing of R. W. Paul's projected films).

Having been marginalised in high society, the teenage Poulett was welcomed into the egalitarian and permissive world of the theatre and music hall. At the age of 19 he married a dancer, then appearing in the well-known ballets presented at the Canterbury Theatre of Varieties, Lambeth. Poulett also took to the music-hall stage, adopting the *non-de plume* Cosman. During the period 1868–1871 he appeared as a female impersonator in a comedy double act and as a pantomimist, playing at the Surrey Theatre and at small London music-halls. In 1872 his wealthy relatives provided the capital to launch 'Lord Hinton's Burlesque and Comedy Company', a small touring troupe which failed after a short time. At other times, he appeared under the name Willie Dean in East End melodramas and as Charles Dormor in 'legitimate' drama. He may also have performed as a clown and a Punch and Judy showman.

Substantial gaps in Poulett's own record of his life may be attributed to less creditable activities. A series of unsubstantiated reports in American and British newspapers suggest a long criminal career. He was said to have enlisted in the 70th Regiment of Foot in 1879, only to serve six months' imprisonment for desertion and swindling merchants in Calcutta. At Port Said, Egypt, in 1883, he was apparently arrested for attempting to kill a croupier in a gaming house, but escaped before the case was brought to court. It is a matter of fact that Poulett served a term of imprisonment in the United Kingdom. Following appearances at the Lambeth Police Court and the Old Bailey in 1886, he was sentenced to twelve months' hard labour for a fraud that involved using his family name and supposed expectations to obtain large amounts of credit. The case aroused widespread public discussion, with Poulett asserting his claim to the title, but the prosecutor, Montague Williams, arguing that 'he had no more right to go about representing that he was Lord Hinton, and that he was entitled to property as the heir of Lord Poulett, than an utter stranger'.[2]

If American eyewitnesses were correct it appears that Poulett chose not to employ the title when he visited the Lantonia Race Track, Ohio, in 1889. After racking up betting debts and loans to the value of $3000, he is reported to have fled before his victims realized that they had been honoured by a visit from a British aristocrat. An 1899 article by Julian Rochefort in *Lloyd's Weekly Newspaper* entitled 'Seeing Life with Lord Hinton' described a night spent at an illegal gaming house in North London which came to an abrupt conclusion when Poulett floored a 'chucker out'. Whether or not the sensational accounts were accurate, Hinton was generally considered to be far beyond the pall of 'good society'. During the late 1880s and early 1890s he continued to press his claim on the title by exhibiting a barrel-organ to which he attached a notice declaring: 'I am Viscount Hinton, eldest son of Earl Poulett. I have adopted this as a means of earning a living, my father having refused to assist me. Through no fault of

Fig. 36. Viscount Hinton' sets out for a day's organ-grinding.

my own.' For several years, he and his wife were familiar figures on the streets of central London, setting out from various addresses in the King's Cross and Clerkenwell area to play their mechanical music and to expose the cold-hearted villainy of the Sixth Earl.

Paul's Parlour

Whereas the first American kinetoscope subjects were exhibited in well-appointed premises in popular London shopping areas, the 'first English views' were presented in a seedy backstreet publicly identified with working-class politics and street traders. Moreover, the show's host was a figure mired in controversy, possessing only a disputed legal right to the name and title printed on the preview invitations. Paul's choice of location may have been dictated by convenience or cost, but why he elected to put his trust in Poulett is difficult to explain. As someone who knew nothing of the world of popular entertainment, it is possible that he enlisted the errant viscount's assistance to secure performers to appear in films. Befitting a well-educated conmen Poulett also possessed a pleasant and convivial manner. Soon after the start of the Leather Lane exhibition *The Westminster Budget* published an account of him in action:

A VISCOUNT AS SHOWMAN

Of course it is Viscount Hinton. Tired of organ-grinding, this illustrious scion of a noble house is to be found daily in the salubrious neighbourhood of Leather-lane, Holborn, where he is acting as showman to a kinetoscope entertainment which has been organised by Mr. H. [sic] W. Paul, the electrician, of Hatton-gardens. Whoever yearns, therefore, for the honour of a chat with this distinguished member of his order can gratify his desires – for the trifling sum of one penny. There is nothing haughty about Viscount Hinton. It is an affable and condescending viscount who shakes you

by the hand as you enter the establishment and shows you how to put your penny in the slot. Of course the thing is taking immensely in Leather-lane. There are comparatively few viscounts about the neighbourhood, and the new-comer is regarded with proportionate respect. And it cannot be imputed to him that he shirks his duties. Every customer that enters receives a cordial welcome at his hands, while the duration of his labours certainly exceeds the limits of an eight hour day. But for all that it is much better than organ-grinding, he says – the labour of which, he explains, has permanently crippled his right arm. As to the story that he was once captured by brigands, and only released when it became clear that no one would cash up to ransom him, that, he declares, is a fairy tale; though it is perfectly true, he says, that before he turned to music as a means of livelihood, he had made no little of a name for himself on the stage in the capacity of clown – in proof of which he refers you proudly to Debrett.[3]

The magazine *Fun* provide another account of a visit to the Leather Lane establishment. Its garbled nature and suggestions of Promethean-like intrigue may have derived from Poulett's own description of the kinetoscope:

> Thursday, May 23rd.-To Viscount Hinton's, if you please. Yes, the same; the Viscount Hinton who wheels about a piano-organ; the Viscount Hinton, eldest son and heir to Earl Poulett.
>
> What did I there? To see the latest in piano-organs? No. But to see the latest thing in kinetoscopes.
>
> I'll tell you. The kinetoscope is fairly well known by this. Not so well known though is the 'Photographure' with[out?] which the kinetoscope is practically useless. Up till a few days back secrets of the 'Photographure' were locked up in Edison's laboratory, but now they have been discovered and brought to light by a Mr. Paul, of Hatton Garden, who has succeeded in producing English living pictures quite as well as Edison has succeeded in producing American tableaux vivants.
>
> I won't tell you these secrets. It would probably be robbing Viscount Hinton, who, as it were, has acquired the patent of Mr. Paal, [sic] of Hatton Garden.
>
> Go and see for yourself at 30, Leather Lane, Holborn. It will only cost you ONE PENNY[4]

A contemporary illustration portrays the top-hatted viscount and patrons of the entertainment whose clothing and manner mark them out as members of the working class. As the sort of characters traditionally associated with Leather Lane they might have been the result of artistic license or they may have been accurate representations of the exhibition's clientele.

Poulett derived limited benefit from his brief experience as a kinetoscope exhibitor. Just over a year later he wrote to a Mrs Wightwick regretting that his inability to pay the rent in Wellington Street had forced him and his wife to leave London. They were being supported by the 'the charity of others' in Southsea, although they hoped to find a way back to their old haunts.[5] Poulett's eventual return to London did not bring about a change in his bad luck. He returned to organ-grinding and, following the death of the Sixth Earl in 1899, his claim on the title was

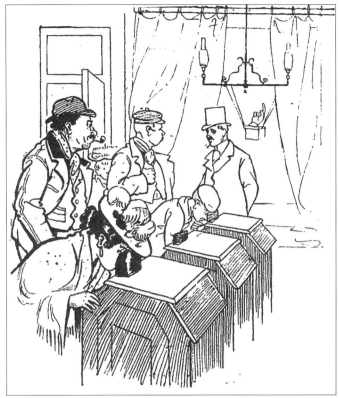

Fig. 37. Viscount Hinton presides over Paul's Leather Lane exhibition.

rejected by the House of Lords. He died of heart disease in April 1909, not at an ancestral mansion in the English countryside, but in the infirmary of the Holborn Workhouse.

Further Exhibition

It is possible that the Leather Lane exhibition was intended as a trial run for the kinetoscope's appearance at a much larger venue. With the backing of a group of unidentified businessmen Paul arranged for 16 machines to be located at one of the year's leading entertainment attractions, the Empire of India Exhibition, which ran at Earls Court, West London, from 27 May until 26 October 1895. The brainchild of Hungarian showman Imre Kiralfy, the exhibition filled an area of 24 acres with an idealised recreation of Indian architecture, history and culture. If footfall was anything to go by the kinetoscopes should have netted a small fortune. On bank holiday Monday in June, 63,683 people were admitted to the exhibition grounds, a figure exceeded a week later when 72,000 attended. Contemporary newspaper accounts provided detailed accounts of an Indian market place, the Imperial Palace, illuminated fountains and, something not seen in

India, a 300-foot big-wheel capable of seating 1200 passengers. Although sideshows provided by magicians, fakirs, jugglers, dancers, bands and orchestras were described in detail, the kinetoscope (or kinetophone to be more precise), was only referred to once. Whilst phonographs and the Electrophone (a telephone that relayed live entertainment to the listener) were frequently mentioned as being present at the exhibition, the only notice (a bad one – see Chapter Five) of a kinetoscope sideshow occurred in the *Photographic News* for 13 September. With a large and constantly changing flow of visitors to Earls Court it is difficult to see how Paul's kinetoscopes could have failed to make a profit, but they do not appear to have been sufficiently impressive to provoke a great deal of comment.

The Komic Kinetoscope

Paul and Acres had officially ended their partnership by July 1895. It is possible that Acres' output of films during the period was more extensive than we now know. Although, on 2 June 1895, Paul was advertising that he had 20 subjects available, two weeks earlier Acres had written to the European Blair Camera Company complimenting them on the quality of their raw film.[6] Considering the length of kinetoscope bands his estimate that he had 'exposed nearly six thousand feet of your film during the past week or two' suggests a total of considerably more than a hundred films. Of course, titles were duplicated, but, as Paul offered 'films of any subject to order', it is possible that some films were made for other exhibitors. When Paul introduced his Theatrograph projector in the spring of 1896 he was able to offer for sale 50 subjects that had already been made for the kinetoscope.[7] In the early summer of 1895 problems were encountered with films breaking, an unexpected financial loss which Acres attributed to exceptionally hot weather. Friction occurred between the partners and Acres claimed that he had replaced damaged items at his own cost.

The alleged success of the kinetoscopes at Earls Court did not result in Paul pressing on with the business. After losing the movie camera when his partnership with Acres collapsed he became unable to supply further British films for kinetoscopes which desperately required the appeal of domestic subjects. In October, he offered the exhibition machines for sale. Paul, with many others, had realised that the future of film exhibition lay in projection and in the autumn of 1895 he drew up elaborate plans to create an entertainment which fused film, lantern slides and fabricated scenery. His proposed realisation of H. G. Wells' current science fiction success *The Time Machine* aimed to involve the public in a wrap-around experience that presented scenes from the past and future. It was an ambitious scheme considering that he possessed neither a camera nor a projector. It was not until the spring of 1896 that he developed equipment to take and project films.

Despite the limited duration of its popularity the kinetoscope was absorbed into contemporary popular culture. The word 'kinetoscope' was often employed as a journalistic synonym for a realistically described episode or sequence of consecutive incidents, and was sometimes applied to series of connected cartoons. In a curious parallel to both Wells' novel and Paul's diorama/cinema concept, the

American writer Brander Mathews published 'The Kinetoscope of Time', a short story in which the machine became a vehicle for transporting the viewer to witness historic and fictional incidents. On the stage, an English melodrama titled *Outcasts of London* became possibly the first work of fiction to portray film-making by featuring a kinetoscope showman whose movie camera played a crucial part in a blood-thirsty and unlikely plot (see Appendix 3). And, in November 1895, the flamboyant playbills of Paul's local music hall, Sadler's Wells, proclaimed the Haytors' comedy troupe to be a 'Kinetoscope Kombination and Phonograph of Phun'.[8]

Paul personally embraced the music hall in 1897, when he married a ballet dancer. Although her profession had a proverbially bad reputation Ellen Daws could claim a degree of theatrical respectability. Her origins were humble -she was the daughter of a bankrupted tripe-dresser from Islington – but her aunt, Mrs Nye Chart, was one of England's greatest provincial theatre managers.[9] Paul seems to have acclimatised easily to the world of opportunistic showmen, get-rich-quick entrepreneurs and easy-going music-hall performers. Acres on the other hand had no wish to be part of any such 'Kombination'. 'One circumstance concerning Mr Birt Acres must be mentioned with approval' commented *Photography* in 1896. 'He is a scientific enthusiast, with a very proper sense of the dignity of the difficult calling he has made his own, and his angry regret that it should thus in its infancy be associated so intimately with the music hall must have been shared by many who heard him.'[10]

Notes

1. *Reynolds's Newspaper* (29 September 1890): 8.

2. *The Globe* (13 March 1886): 5.

3. *Westminster Budget* (24 May 1895): 5.

4. *Fun* (4 June 1895): 239.

5. Private collection. Letter dated 24 September 1896.

6. Stollwerck archive.

7. 'A special series of subjects is in preparation, but any Kinetoscope film, of which fifty subjects are already published, may be used'. *The Photogram* (April 1896): 103.

8. *The Era* (16 November 1895): 14.

9. Mrs Nye Chart was lessee of the Theatre Royal, Brighton, from 1876 until her death in 1892.

10. *Photography* (5 November 1896). Transcription in Alan Birt Acres, *From Frontiersman to Film-maker* (Hastings: The Projection Box, 2006): Appendix III, 20. CD-ROM.

Chapter Ten

Magic, Magnates and Galvanic Forces

The clamouring showmen who took the kinetoscope on the road had no idea whether it was going to be a nine or a ten days' wonder. They were certain, however, that in their world of incessant novelty the device had to be relentlessly exploited before public interest became fixed on the next 'latest innovation'. Others in the business of entertainment and edification took a less frenetic approach, seeing the kinetoscope as an extension of their main employment or even, potentially, as the first step in the creation of a new industry. Among this sector were several performers who exhibited, sold or constructed kinetoscopes and two major players in the music-hall profession whose large-scale, multi-faceted projects offered an ideal niche for the invention.

Fred W. Duval

Of many professions entering films during the mid-1890s, one of the most influential was that of magician. The interest of George Méliès, Maskelyne and Devant, Carl Herz, Leopoldo Fregoli, Albert Edward Smith, J. Stuart Blackton and several others originated not so much through a desire to make trick films, but rather because they were skilful mechanics and keen to introduce novelties with which to augment their acts. Even before the first films were projected, the kinetoscope had attracted two British magicians, Fredrick William Trautner and Samuel Stott. On becoming a performer Trautner (1861–1916) transformed himself into 'Fred W. Duval', but by either name he has been largely overlooked by film historians. Although briefly recorded as a supplier of cameras, projectors and films in 1896, his role as a kinetoscope retailer and exhibitor has not previously been examined. Born to German and English parents in London, his early employment in his mother's dress shop led to him opening his own business as 'Madame Trautner, Costumier' in 1885. By the close of the 1880s he had been attracted to stage magic. After successfully advertising models for a trick known as 'The Galatea Mystery' he wrote to *The Era*:

> I am a man in a large way of business with my wife at the above address-I may as well
> at the same time state-as "court dress and mantle makers," and my name is Frederick

Trautner. I have lately taken a fancy to conjuring and making "mechanical tricks" and "illusions".[1]

The income derived from dressmaking, conjuring and selling his magical devices, enabled Trautner, his wife Maud and their two young daughters to enjoy a comfortable lifestyle. The 1891 census shows them employing two servants and occupying apartments close to Hyde Park at 102 Gloucester Crescent, Bayswater, West London. But the family's fortunes were unstable and in April 1892 Trautner appeared in the court of bankruptcy. His insolvency was attributed to bad seasons and to his inability through illness to augment his income by working as a conjuror. A debt due to him of £50–60 for a stage illusion called 'The Three Graces' also looked as though it would never be paid.[2] Undeterred by this setback Trautner decided to exploit the latest invention of the scientific 'wizard', Thomas Edison. In September 1893, he placed an advert in *The Era*:

> WANTED, Five Young Gentlemen to join Advertiser in forming Syndicate of Six, Capital £600 to run one of the most Successful and Paying Concerns of the Age. Contracts and all stock are now working. For interview, address PHONOGRAPH, 102, Gloucester-crescent, Bayswater, London.[3]

Whether Trautner located the five wealthy young gentlemen to join him in his phonograph venture is unknown, but by the next year he had hatched a new money-making scheme. Once again, he looked to Edison for inspiration, placing an advert just one month after the kinetoscope's UK debut:

> WANTED, Partner. Young, Energetic Man, with Capital at Command to join Advertiser in Making and Working the latest Novelty, Edison's Kinetoscope. Will sell by hundred. Must start immediately. For interview, address KINETOSCOPE, 272 Gloucester-terrace, Bayswater, London.[4]

Note the phrase 'making and working'. It appears that Trautner was a sufficiently skilled mechanic to implement his plan to build copies of Edison's invention for, by the end of November 1894, he had set up the Exhibition Novelty Company, offering kinetoscopes 'to showmen and others' for cash on delivery.[5] At first the company operated from 272 Gloucester Terrace (102 Gloucester Crescent had been renamed and renumbered), but by February 1895 it was offering the non-Edison kinetoscopes from new premises in central London:

KINETOSCOPES, KINETOSCOPES, KINETOSCOPES,

> Finest Machines obtainable. Made in England. Now is the time to buy. £60 a-week being taken in London Exhibitions. Finest investment of the Age. Price, Complete, with Films and Accumulator, £58 each. Not less than Two Sold. Call or write, MANAGER, Exhibition Novelty Company, 104, High Holborn, London.[6]

The price for Trautner's kinetoscopes was soon reduced. On the 9 March 1895 machines and films were advertised for 40 guineas, falling to £35 by 23 March. 'Why pay £70?' asked the Exhibition Novelty Company, 'Only restriction, not to use the name "Edison"'.[7]

Not content with making and selling kinetoscopes, Trautner planned to employ them in a London exhibition. On 12 January 1895, he advertised:

> WANTED, Partner to Join Advertiser, who has Three Edison's Kinetoscopes ready for Exhibition. Must be Young and Energetic. Capital £150. Everything ready to start.[8]

By 4 May he was still searching for a partner, or perhaps seeking another collaborator:

> WANTED, Partner with £150, to start Kinetoscope Exhibition in West End. Shop and Machines are ready. Fine position. Guaranteed Salary of 30s. a week. For appointment AMERICAN, 272 Gloucester-terrace.[9]

Four days later he placed another advert which, confusingly, again referred to his kinetoscopes as being Edison machines:

> PARTNER (Sleeping or Active). -Energetic man with £200. Wanted, to join advertiser with eight Edison's Kinetoscopes, in opening exhibition, West London; large profits; grand chance.[10]

On 4 May 1895 Trautner announced that he could offer 'Wholesale and Retail Machines in any quantity'. At a time when the Continental Commerce Company were attempting to restrict the supply of Edison films to the exhibitors of 'bogus' machines, he confidently stated that he could supply 'Films to order in a few hours' and that his establishment was the 'Only Place for Films in England'.[11] As Trautner appears not to have placed advertisements for the second half of 1895 it is impossible to follow the progress of his sales or exhibition businesses. What is known is that when films were first projected in the United Kingdom in 1896 he was one of the first to market cinema equipment.

Herr Samuels

Unlike Trautner, Samuel Stott (1863-1941) concentrated on exhibiting the kinetoscope and using it to supplement his various entertainments. Nothing is known of his early life, but by the early 1890s he was established as a photographer and magician in Dundee, Scotland. As a 'Drawing Room Conjuror' most of his performances were given at events organised by schools, churches and local societies. In February 1892, the *Dundee Courier* reported on a 'Grand Conjuring and Musical Entertainment in aid of the Monifieth Gas Lamp Fund':

> A cabinet séance terminated the entertainment by Herr Samuels, who performed some wonderful feats in getting loose after being tied firmly to a stool, and getting out of a pair of handcuffs, &c.[12]

It is likely that Stott made appearances with a phonograph before exhibiting the kinetoscope. A phonograph was certainly being used to entertain the Dundee public as early as the winter 1893–1894, as attested by ironic comments in a local paper which poked fun at the patronising attitude assumed by fellow journalists in Glasgow:

> Things are looking up (says the Glasgow *Evening News*) in Dundee-even although St Andrews regards the Nethergate 'Varsity with scorn. A damsel from the slopes of

> Bennethill has graduated B.A. at London; three electric lamps and two lady doctors
> have been added to the lions of the city; and there is a public phonograph in full
> working order in a disused Overgate beef-shop.[13]

Despite Glaswegian elitism it was a Dundonian who introduced the kinetoscope
into Scotland. As Herr Samuels, Stott demonstrated the device to a reporter from
the *Dundee Evening Telegraph* on Friday, 21 December 1894, announcing that its
first commercial exhibition was to take place in neighbouring Perth. Alongside
a full description of the device the newspaper published a prediction that was
soon to be fulfilled:

> Wonderful as the kinetoscope is, it is easy to see that it is capable of great development.
> It will not be long before we have kinetoscope lectures, in which wonderful perform-
> ances will be shown upon a large screen, taking the place of the lime-light pictures
> now so popular.[14]

It appears that Stott remained with his other business interests in Dundee, while
a Mrs Duncan took charge of the Perth exhibition at 204 High Street. Presum-
ably, Mrs Duncan was the variety performer Jessie Duncan who occupied the
same address as Stott (27 Crichton Street, Dundee) and who may well have been
related to his wife (professionally named Maggie Duncan). Given the brevity and
individual viewing requirement of kinetoscope films, Jessie Duncan would prob-
ably have been well-qualified to amplify the exhibition with humorous patter and
even musical accompaniment. After a short season in Perth Mrs Duncan came to
Dundee where she established the show in a shop at 57 Overgate, during the first
week of 1895. The kinetoscope was on display throughout the day and a 3d
admission fee was charged. By 22 January 1895 the kinetoscope had transferred
to 38 Union Street where it was advertised as being 'patronised by the Elite of
Dundee'.[15] A plan for Mrs Duncan to take the device on tour does not seem to
have materialised for on 7 February 1895 Herr Samuels demonstrated the device
at the Annual Meeting of Scottish Union of Naturalist Societies, held at Univer-
sity College, Dundee.[16]

Stott's stage skills were also invaluable, as suggested by a review of a hospital
entertainment presented two years earlier: 'Herr Sammels [sic] adds to his clever
tricks the charm of an entertaining manner, and his jokes vastly amused the
patients'.[17] On Saturday 9 February 1895, the kinetoscope was exhibited at Stott's
home address, 27 Crichton Street, for one day, again for the charge of 3d.[18]
Subsequently, Stott's kinetoscope featured for short periods as an added attrac-
tion at several local events and at 25 Crichton Street where Mrs Duncan was again
in charge. Whether in collaboration with Stott or working alone Mrs Duncan
continued kinetoscope exhibitions for a lengthy period, announcing the success
of a Trilby subject at Edison's Electric Bazaar, 25 Crichton Street, as late as
January 1897.[19] At the end of the year she advertised 'Kinematographs, Phono-
graphs and other novelties' from the same address.[20]

Although he continued to exhibit the phonograph and the magic lantern by the
end of 1895 Stott seems to have left the kinetoscope to Mrs Duncan. The first
public display of projected films in Dundee took place at the Royal British Hotel

on 5 October 1896 when the Lumière Cinématographe was introduced by a local optician and magic lantern showman, Peter Feathers. If Stott had not seen the initial show, he was given an opportunity in January 1897 when he appeared at the annual entertainment for the 'homeless and destitute' boys who were accommodated on the training ship *H.M.S. Mars*. After feasting on plum pudding on a three masted man-of-war from the early days of Queen Victoria's reign, the children were introduced to the technological marvels of the Cinématographe, by Feathers, and the phonograph, by Stott. More in keeping with the venerable surroundings Herr Samuels evoked a traditional sense of wonder in his young audience by providing an hour-long display of conjuring.[21]

Stott's involvement with the kinetoscope was neither the beginning nor the end of his career in the entertainment industry. It represented a relatively short-term venture which was abandoned in favour of more time-honoured forms of public amusement. In many ways, the kinetoscope was not an easy device to exploit. Setting aside mechanical issues such as dependence on electricity, its major drawbacks were the limited selection of film subjects and their extremely short duration. Without a considerable promotional effort from the exhibitor, a trip to see Herr Samuel's kinetoscope was, potentially, a very quick and unsatisfactory way to spend three pennies. Whereas the phonograph could be used to provide an extended entertainment to a large audience, the kinetoscope could only be exhibited to an expectant and perhaps impatient queue. The ease with which phonograph recordings could be made of local celebrities meant that demonstrations established a strong community interest. There was no such rapport with the kinetoscope, neither was the process of manufacturing moving pictures so clearly and dramatically conveyed. But despite its advantages phonograph exhibition brought other pitfalls. In October 1897, the Edison-Bell Phonograph Corporation Ltd brought an action against Stott to prevent him infringing their patents. It was demanded that he should hand over any machines that he possessed and to submit an account of all profits he had made from exhibiting them in Dundee.[22]

Professor Alf Jones

The involvement of 'Professor' Alf Jones (c. 1848-1912?) with the kinetoscope appears to have been far less extensive than that of Trautner or Stott, but his promotion of various optical and mechanical devices during the last quarter of the 19th century suggest a widespread public interest in technological entertainments, even within the unruly environment of music hall. Exhibited from the mid-1870s, his Pedascope mixed magic and science by dispensing with a projecting lantern to independently display images on a pedestal-mounted screen. In 1880 Jones attempted to integrate mechanical illusion within a conventional variety turn:

> 'DIALLAGIC,' a New, Novel and Startling Entertainment, introducing Four Persons, including three Vocalists (Two Females and One Male), with new Ballads (Specially written) and Mechanical Appliances, Entirely New and Novel in their construction, and calculated to mystify and amuse.[23]

While continuing to exhibit the mysterious Pedascope, Jones appears to have become the first person to introduce the tin-foil phonograph to the music-hall stage. His scientific explanations of the device and simple playbacks of recordings of the human voice were in marked contrast to the variety programmes in which they were presented. At the Royal Albert Hall, Gloucester, in March 1885, 'Professor' Jones' 'Talking Machine' and his lantern show depicting incidents in the Soudan War shared the bill with a sketch entitled *The Bigamist; or, the Wages of Sin* and Miss M. Tyson singing 'You Naughty, Wicked Mashers'.[24]

By the start of the 1890s Jones was increasingly selling conjuring equipment, theatrical special effects, fairground rides and showmen's novelties from his base at 17 Enkel Street, Holloway, North London. The items that he regularly offered for sale ranged the gamut of popular theatrical entertainment. In 1890 a 'Dioramic Representation of an Earthquake, in Seven Scenes, with Modelled Figures and Ships' came complete with original music, accompanying lecture and stage fixtures.[25] On a more personal level, in the same year he advertised 'Electric Lights for Head, Nose, Ears, made and invented for the best people'.[26] He continued to sell and exhibit Edison's phonograph throughout the early 1890s, adopting a similar strategy with the Berliner Gramophone from 1891. As a music-hall performer he had little use for the kinetoscope, but he advertised machines for sale in March and April 1895.[27] As a long-standing exhibitor of various optical displays to large audiences, Jones took an early interest in projected film. In late May 1896, he announced that his 'New Animated Photograph Machine' was available for engagements 'at home or abroad', subsequent advertisements for the devise suggesting that he was manufacturing copies of the Lumière Cinématographe.

A. J. Vidler

Alfred Jones gave his profession as electrician and many of his innovations relied on electricity for their motive power or impact. Not far removed from sensational stage presentations (and sometimes not removed at all) were a series of quasi-scientific applications that exploited public perception of the potential benefits of electricity. A popular science publication of 1893 reported:

> ...[t]he multitude regard electricity with a certain awe, and are always ready to attribute to its agency any effect which appears mysterious or inexplicable. The popular ignorance on this subject is largely taken advantage of by impostors and charlatans of every kind. Electric and magnetic nostrums of every kind, electric elixirs, galvanic hair-washes, magnetised flannels, polarized tooth-brushes, and volcanic nightcaps appear to find a ready sale, which speaks unmistakably of the less than half-knowledge which is possessed by the public concerning even the elements of electrical science.[28]

As proprietor of the Medical Electric Bath and Battery Depot, of 8 Motherby Lane, Lincoln, during the early 1890s, A. H. Vidler (1864-1939) strongly criticized such catchpenny devices as electric socks, belts and vests. The true path to electrical efficacy lay, of course, in the sponges, stomach tins and foot warmers which he sold as the district representative of Herr Louis Cohen. His patron, a

German inventor, was multi-talented, combining a long study of phrenology and physiognomy with the development of electric coils and batteries which were advertised as a cure for 'rheumatism, gout, indigestion, bad circulation, liver torpidity and all nervous ailments'.[29] Herr Cohen also lectured extensively on life skills and self-help, his advocacy of temperance coinciding with Vidler's similar views.

Vidler combined his promotion of Herr Cohen's inventions with employment as a printing machine operator for local newspapers. It was his spare-time activities as a singer of parlour ballads and performer of humorous recitations at temperance movement concerts that probably caused him to acquire the electrically driven instrument that changed the course of his career. In 1894 he began to exhibit a loud speaking Edison phonograph, demonstrating the device to audience of up to 500. Unlike Alfred Jones, Vidler aimed his exhibitions at the family-orientated audiences who attended local church bazaars, flower shows and charity concerts. A year later he had added the kinetoscope to his electric repertoire, presiding over three machines at a Grand Educational Bazaar held at the Drill Hall, Lincoln, in November 1895. By May 1896 a film projector, inaccurately described as an 'Edison Kinetograph', took its place alongside the kinetoscopes and phonograph that he was exhibiting at the Drill Hall.[30] Throughout the 1890s and the first decade of the twentieth century he presented an entertainment that combined lantern slides and films, some of which made himself.

Horace Edward Moss

Trautner, Stott, Jones and Vidler were in the rank and file of the entertainment profession, but two of its top brass, Horace Edward Moss (1852–1912) and Oswald Stoll (1866–1942), also exploited the kinetoscope. As part of their search for more efficient and uncontroversial entertainment systems Moss and Stoll promoted the device before continuing to become key figures in the growing film industry. For them motion pictures probably represented an easily regulated element in the often-unpredictable environment of show business. Both men had come to dominate the variety theatre through their acute organisational skills and by a commitment to eradicate 'unwholesome' elements from the entertainments that they provided. When projected films arrived Moss and Stoll did much to foster their popularity as an intrinsic part of music-hall programmes. Moss died while the cinema was still in its infancy, but Stoll went on to become the United Kingdom's major film producer.

Moss's mission to reform rowdy music-hall entertainments was possibly more pragmatic than that of the philosophical and aesthetic Stoll. During the early 1870s he collaborated with his father, managing the family music hall in Lorne, Scotland, also supplying the piano accompaniments to scenes of the Franco-Prussian War displayed by a travelling Diorama. By 1877 he had acquired the Gaiety, a small music hall in Edinburgh. With perhaps a degree of hindsight an obituary noted:

The ideas of the modern "variety" theatre were simmering in his brain. He had the conviction at heart that heat, suffocating tobacco fumes, the smell of drink, and "frowsy" or stupid artistes were not necessary concomitants of pleasure. He already faintly foreshadowed the ideal variety theatre-a palace of cleanliness, light, brightness, good music, good, honest fun, scientific invention, and superb physical skill.[31]

Three years later Moss acquired a second hall in nearby Leith, soon followed by a third in Sunderland and a fourth in Newcastle. He continued to purchase music halls in the north of England and Scotland, building a network which benefited from central booking of performers and co-ordinated advertising and administration. Moss headed a movement away from single, independently-owned music halls such as his father's to 'circuits' of theatres, each of which operated as a limited company paying dividends to share-holders from widely ranging social backgrounds. Those investing in music halls needed to be assured that their returns were not jeopardised by bad publicity, making Moss's commitment to 'honest fun' and 'scientific invention' an attractive proposition. With the Empire Palace (opened in Edinburgh in 1892), he established a template for large, comfortable variety theatres aimed at middle-class as well as working-class audiences. Moss' Empires Ltd was registered in 1899, bringing together 10 companies and 14 theatres with a joint capital of £1,650,000. Such was his success in changing the popular perception of the music hall that he was honoured with a knighthood and the promise of the first Royal Command Performance which only failed to materialise when the Empire Palace was destroyed by fire.

Moss's involvement with the kinetoscope occurred at an annual Edinburgh event with which he was closely associated. From 1888, Moss had rented the Waverley Market to present a 'Great Christmas and New Year Carnival'. Showmen, stall-holders and variety entertainers occupied the vast, covered space over the Christmas period, providing seasonal amusement for large numbers of visitors from Edinburgh and the surrounding area. Over a three-week period around 200,000 people converged on the market, with the adjacent railway station and tramways providing excellent transport links. Admission was 6d and the usually stark interior was festooned with decorations and specially installed electric lighting. Unlike Moss's music-hall ventures the Carnival was targeted at children as much as adults. With an endless flow of patrons, conditions for exploiting the kinetoscope could not have been bettered. On 21 December 1894 (the same day that Stott demonstrated his kinetoscope in Dundee) Moss gave a private showing of his two devices, assisted by 'Edison's representative' R. F. Swayze (of the Continental Commerce Company).[32] At the 24 December opening the kinetoscopes were major attractions.

Edison's Kinetoscope, with its wonderful life-like views, at once attracted attention, and was visited by crowds of delighted spectators during the evening'.[33]

Waverley Market Carnival. In securing this wonderful invention Mr. Moss has been exceedingly fortunate, the building being constantly filled with people waiting their turn to examine the living pictures.[34]

At the following Christmas Carnival Moss featured the kinetophone in place of

the kinetoscope and in 1896/7 both were discarded in favour of the Lumière Cinématographe.

Oswald Stoll

Oswald Stoll, who was to become a close business associate of Moss, had a similarly suitable venue in which to exhibit the kinetoscope. When he took possession of the Philharmonic Music Hall, St Mary Street, Cardiff, in 1892, it had been providing conventional variety entertainments for the previous 15 years. As he had already opened the Empire Music Hall in the same city, Stoll decided to rename the theatre the Panopticon and to develop it along different lines. A roller-skating rink and a gymnasium were added, with a wax-works exhibition, a picture gallery and a programme of constantly changing side-shows. Stage performances frequently consisted of magic and acrobatic acts, while the public were encouraged to take part in singing, athletic and beauty contests. The establishment was open from 10 am to 10 pm and the admission price was 6d. Although he was to become the UK's most powerful music-hall entrepreneur Stoll was critical of the power exercised by music-hall performers. 'Many artistes go on for years commanding salaries based on their value in byegone days', he told a reporter when setting up his first joint company with Moss in 1895. 'Rising artistes rise in price rapidly, but falling artistes fall in price but slowly. In reality it will be an excellent thing for artistes to realise that they cannot live for a day on pristine glory alone'.[35]

Like Moss, Stoll was keen to promote technological forms of entertainment, partly because they appealed to an information-seeking, and therefore, 'respectable' public, and because they offered greater levels of control than could be exercised over live performers. On one occasion, however, live and mechanical entertainment were combined. In September 1893, the Panopticon was equipped with 100 'Theatrephone' receivers through which customers could listen to performances transmitted from Stoll's Empire Music Hall. At Christmas 1893-4 Stoll imitated Moss by instituting a 'Mammoth Xmas and New Year Carnival', temporarily removing the seating from the auditorium and creating additional space on an upper floor where he installed a mirror maze and Edison's phonograph. For the Panopticon's second Carnival in 1894-5 Stoll acquired three kinetoscopes. He had been exhibiting them from 17 December 1894 and had placed long advertisements in the local press:

> Among the manifold items of interest, the features are Magneta, the Floating Lady, whose evolutions in Mid-air, entirely unsupported, are an incomprehensible and unsolvable mystery; and Edison's Latest Invention, the Greatest Surprise of this Generation, the Edison Kinetoscope.[36]

The machines were reported to be the property of Mr A. S. Martens, a New Yorker who was currently running the kinetoscope exhibition at the Royal Aquarium, Westminster. At a time when the addition of Edison's name conferred immense prestige, Martens, who claimed to have worked for the inventor, unusually credited William Kennedy Laurie Dickson with the development of the device.

Entertainment on a Grand Scale

Moss's annual Christmas event and Stoll's Panopticon were part of a new framework of entertainment that had evolved to meet the needs of a changing society. During the first half of the 19th century British entertainment venues such as pleasure gardens, night houses, song and supper rooms and the earliest music halls had generally been on a small scale and had been closely linked with prostitution and the sale of alcohol. By the 1860s a male dominated environment had become increasingly isolated by a social and political shift towards temperance, respect for the rule of order and regard for family values. The process of taking holidays became more common, with increased time available for leisure pursuits. Some exhibition practices survived throughout the century and many showmen presented the kinetoscope in temporary premises and fairground booths much as they had previously exploited peepshows, freaks and waxworks. But, with many earlier establishments and institutions falling into disrepute, a variety of large scale, multi-functional buildings were created to offer combinations of art, culture and entertainment, often varying in quality or intent, but almost invariably aimed at a family orientated audience.

R. W. Paul's kinetoscopes were stationed at Earls Court (opened in 1887), a site which hosted massive, themed exhibitions, supported by shops, sideshows and theatrical performances. The Royal Aquarium (opened in 1876) where Martens had one of the earliest British kinetoscope exhibitions, provided all day entertainments which included flower shows, art exhibitions, bicycle races, magic lantern displays, variety acts and high-diving from the dome. In Islington, the Royal Agricultural Hall complex (opened in 1862) contained a theatre and an immense arena for horse, cattle and dog shows; military tournaments; classical concerts and an annual 'World's Fair' whose attractions at Christmas 1894–1895 included the kinetoscope. The mix of what the Royal Aquarium described as 'instruction and amusement' was replicated at Winter Gardens and Exhibition Halls throughout the country. Possessing less intellectual pretensions, but still firmly aimed at a diverse and generally respectable clientele where seaside piers such as those at Southsea and Portobello and entertainment complexes like the Palace, New Brighton; the Olympia, Newcastle; and the Derby Castle on the Isle of Man – all of which installed the kinetoscope into their programmes of entertainment.

Moss's and Stoll's Subsequent Film Career

On 13 April 1896 Moss's Edinburgh Empire Palace provided the venue for the first public display of projected films in Scotland. Although T. More Howard's 'Cinematograph' display (which amongst other films featured Acres' *The Arrest of a Pickpocket*) was technically disappointing, Moss persevered with the new invention, introducing the Lumière Cinématographe on 1 June 1896 and the 'American Biograph' on 24 May 1897. Stoll had experimented with a short season of continuous film exhibitions at the Panopticon in June and July 1896, with a 'Photo-Electric Marvel', the Camera Matographe, being shown at half hourly intervals from 2 pm until 10.30 pm.[37] Moss and Stoll had limited opportunities

to exploit the kinetoscope, but with the arrival of projected films their involvement with moving pictures became greatly expanded. As owners of interconnected syndicates of music halls, they could make large scale and extended bookings, introducing a cinema experience to mass audiences throughout the United Kingdom. To some extent the partners also influenced film content. When Moss's music halls exhibited the Lumière Triograph in 1897, scenes of local interest were specially commissioned, while Moss and Stoll were closely associated with many synchronized productions featuring performers from their entertainments.[38] Moss himself appeared in a short sequence filmed by Walter Gibbons in 1900. Following World War I Stoll became increasingly involved with the film trade, opening cinemas and setting up his own studios. During the 1920s Stoll Pictures (later Stoll Picture Productions) became the largest producer of British films.

Postscript

Mrs Duncan and 'Professor' Jones fade from the historical record during the late-1890s, while Vidler went on to open cinemas in Lincoln during the early 1900s. About a year after his first connection with the kinetoscope, Trautner, in his Fred W. Duval guise, became one of the earliest UK suppliers of cameras, projectors and films. Although he placed a series of advertisements in *The Era* he was categorised by John Barnes in *The Beginnings of the Cinema in England* as one of a group 'who have left little or no trace of their activities, and await further research'.[39] By 1901 he had changed his name to Frederick Valerie and apparently reverted to his original occupation of 'court dressmaker'.[40] In 1911 the census recorded him as Frederick Trautner, living in an eight-bedroom house in Blenheim Crescent, Kensington, West London. In keeping with his long-term regard for the value of advertising he described himself as an 'advertising consultant'. Having abandoned the exhibition of the phonograph and kinetoscope by 1897, Stott decided to create his own 'Wonderland' in a converted shop at 213 Overgate. There he offered such curious and time-honoured shows as 'Mdlle. Ella the Second-Sited and Tattooed Lady', 'Chambers, the Armless Carpenter' and 'Duff Jim's Nautch Girls'. Early in the new century he transferred his exotic activities from Dundee to Edinburgh. His various attractions were presented at the Iona Street Showground, an open area that had been the home of a wide variety of rides, booths and other attractions since the 1890s. Despite presenting of live shows and fairground rides, he was fully aware of the growing popularity of motion pictures in the entertainment industry. In November 1905, he advertised: 'to let ground Iona Street Carnival, Edinburgh, now until the end of January. Good opening for Cinématograph Show'.[41]

Notes

1. *The Era* (4 January 1890): 8.
2. Ibid. (9 April 1892): 16.
3. Ibid. (30 September 1893): 22.
4. Ibid. (17 November 1894): 23.
5. Ibid. (24 November 1894): 24.

6. Ibid. (9 February 1895): 23.

7. Ibid. (9 March 1895): 29, and (23 March 1895): 24.

8. Ibid. (12 January 1895): 22.

9. Ibid. (4 May 1895): 23.

10. *London Evening Standard* (8 May 1895): 10.

11. *The Era* (4 May 1895): 24.

12. *Dundee Courier* (12 February 1892): 3.

13. *Dundee Courier* (10 January 1894): 3.

14. *Dundee Evening Telegraph* (22 December 1894): 2.

15. *Dundee Courier* (22 January 1895): 1.

16. Ibid. (8 February 1895): 3.

17. *Dundee Courier* (7 January 1893): 6.

18. Ibid. (9 February 1895): 1.

19. *Dundee Evening Telegraph* (2 January 1897): 1.

20. Ibid. (24 December 1897): 1.

21. *Dundee Courier* (25 January 1897): 4.

22. Ibid. (16 October 1897): 4.

23. *The Era* (22 February 1880): 18.

24. *Gloucester Citizen* (31 March 1885): 4.

25. *The Era* (11 January 1890): 18.

26. I6 December 1890): 23.

27. Ibid. (2 March 1895): 23, and (27 April 1895): 23.

28. Robert Routledge, *Inventions and Discoveries of the Nineteenth Century* (London: Routledge, 1893): 388.

29. *Lincolnshire Chronicle* (5 September 1893): 2.

30. Ibid. (29 May 1896): 5.

31. *Hull Daily Mail* (26 November 1912): 4.

32. *Edinburgh Evening News* (22 December 1894): 4.

33. *Glasgow Herald* (25 December 1894): 5.

34. *Glasgow Herald* (2 January 1895): 5.

35. *South Wales Daily Post* (27 May 1895): 2.

36. *South Wales Daily News* (17 December 1894): 1.

37. *South Wales Echo* (22 June 1896): 3.

38. i.e. Walter Gibbons Bio-Phono-Tableaux, 1891; Gaumont Chronophone, 1904.

39. Barnes, *The Beginnings of the Cinema in England 1894-1901 Volume One*, 198.

40. 1901 Census.

41. *The Era* (11 November 1905): 31.

Chapter Eleven

Birt Acres and the Kaiser's Kinetoscope

At the time that his relationship with Paul reached its lowest ebb Acres discovered a far more conducive environment for film-making. In international businessman Ludwig Stollwerck he found a patron that he could trust and respect, and in the ceremonial events of Kaiser Wilhelm II's Germany he encountered subjects that did not offend his photographic sensibilities. Acres' English films presented an oblique view of national identity, but in Germany his productions were overt evocations of a militaristic society and its charismatic leader. Whether intentional or not, his views of warships, troop inspections and celebrations of past victories demonstrated the potential of movie propaganda for the first time.

The short partnership between Paul and Acres foundered in July 1895, with Paul expressing dismay over Acres' decision to patent the Kinetic camera in his own name and Acres claiming to be disgusted by Paul's sharp practice and dishonesty. Acres appears to have been recruited to make films for Stollwerck by Ernest Searle, the managing director of the London and Provincial Automatic Machine Company, a company floated in 1893 to exploit the growing popularity of vending machines. The company's original prospectus detailed close links to the famous chocolate manufacturers Stollwerck Brothers (Schokoladen-und Susswarenfabrik Stollwerck and Co) and to the famous British firm of match makers, Bryant and May. During the late 1880s Ludwig Stollwerck had invested heavily in new sales technology, positioning thousands of coin-operated machines to dispense his company's sweets in public places. Soon, the process was extended to deliver matches, cigarettes, toiletries and even entertainment in the form of mechanical music and displays of stereoviews. In 1894, the success of such devices led to the formation of a subsidiary company, Deutsche Automaten-Gesellschaft Stollwerck and Co (DAG), with the responsibility for exploiting machines and setting up arcades intended for their use.

Stollwerck had been keen to introduce machines displaying moving photographs for some years before he brought Edison's kinetoscope to Berlin in March 1895. In 1892, he had set up a company to exploit George Demeny's Phonoscope,

followed in 1894 by an attempt to acquire Anschütz's Schnellseher. By investing 50,000 Reichsmarks in April 1895 he became a partner in the Deutsch-Oster-reichische Edison-Kinetoskop-Gesellschaft, taking on the responsibility for kinetoscope slot machines in Germany and Austria-Hungary. With the meagreness of supply and imaginative stodginess of Edison subjects Stollwerck must have seen Acres and his movie camera as a golden opportunity to guide film production in a more creative direction. It is possible that it was Stollwerck, rather than Searle, who first encountered Acres. Aided by the managing director of Bryant and May, Gilbert Bartholomew, he had arrived in London in March 1895 for discussions regarding German rights to Edison's phonograph.[1] By whatever circumstances Acres and Stollwerck were brought together, the result was that Robert Paul's disaffected partner arrived in Cologne on 11 June 1895. At a meeting on that or the next day he not only explained his camera, but provided rough outlines of two potential devices that would have been of further interest to Stollwerck. The first was a printing machine for 35mm film and the second an apparatus that would project movies onto a small screen. On 18 June 1895 Acres signed a preliminary contract with DAG which provided Stollwerck with the rights to exploit the camera in all countries except for England and the United States. On the same day arrangements were put in place for Acres to start filming a series of public events in Germany.

Acres must have experienced a sense of relief at being able to abandon what he considered to be vulgar and banal material. 'I have always aimed at taking interesting historical events, and not going in for comic knock-about scenes' he subsequently reflected.[2] In his German subjects of 1895 Acres was able to realise a vision of future film-making expounded a year earlier in a *Century Magazine* article by William Kennedy Laurie Dickson and his sister Antonia:

> Hitherto we have limited ourselves to the delineation of detached subjects, but we shall now touch very briefly upon one of our most ambitious schemes, of which these scattered impersonations are but heralds. Preparations have long been on feet to extend the number of the actors and to increase the stage facilities, with a view to the presentation of an entire play, set in its appropriate frame.

> This line of thought may be indefinitely pursued, with application to any given phase of outdoor or indoor life which it is desired to reproduce. Our methods point to ultimate success, and every day adds to the security and the celerity of the undertaking. No scene, however animated and extensive, but will eventually be within reproductive powers. Martial evolutions, naval exercises, processions, and countless kindred exhibitions will be recorded for the leisurely gratification of those who are debarred from attendance, or who desire to recall them.[3]

Limited by a gigantic, electrically driven camera and to some extent by the ideological mind-set of the Edison studio, Dickson was unable to fulfil his own predictions until he became chief camera operator for the American and British Biograph companies. But Acres, with a portable camera and an encouraging patron, was free to move away from the studio-bound themes found in Edison films. From his first film-making attempts he had engaged potential observers

in a way that Edison's films did not, replacing the unobtrusive lateral movement of stage performance with subjects that moved towards or away from the camera within an extensive depth of field. With Dickson's head-on and intricately layered projected views still some way in the future, Acre's kinetoscope depictions of sporting and ceremonial events provided a surprising new way of seeing the world.

Although breaking fresh ground both Dickson and Acres appear to have been heavily influenced by earlier photography, particularly stereoscopic views whose three dimensions, like movement in motion pictures, created an illusion of reality.[4] Just as anonymous French photographers had recorded the 'Inauguration du Canal de Suez' in a series of stereoviews in 1869, Stollwerck, in 1895, had engaged a photographer to take 3D images of the opening of a second engineering wonder, the Kaiser Wilhelm Canal. But now the event was to be presented in amusement arcades not only in the form of stereoviews displayed in 'panorama' peepshows, but as motion pictures taken for the recently installed kinetoscopes. Linking the Baltic and Northern Seas, the Kiel Canal, as it became known, had taken over 9000 workers eight years to construct. It was a proud achievement which the German nation and its emperor were determined to celebrate with the greatest possible aplomb. Stollwerck's DAG agreed to fund Acres and his assistant – none other than the inveterate facilitator Harry Short – on an excursion to cover the event, thus providing stirring and absorbing images for the public attending arcades in Kiel and Hamburg.

The German Emperor Reviews his Troops

Before filming the opening of the canal Acres travelled to Hamburg where, on the afternoon of 19 June 1895, he made one of the early cinema's most important films. *The German Emperor Reviewing His Troops* depicted a regiment of infantry standing to attention on the lawn outside the Dammtor railway station. Acres filmed the Kaiser approaching the camera from a distance, a set-up that was later to challenge one reviewer who considered that 'the exaggerated perspective had a most comical effect'.[5] Accompanied by his four young sons, the mayor of Hamburg and several staff officers, the German Emperor made his way along the line, stopping occasionally to inspect a soldier. As he came close to the camera he halted to salute to his loyal troops and, by inference, viewers of the film. It was the earliest motion picture of a European monarch and marked the start of the Kaiser's long lasting love affair with the movie camera. *The German Emperor Reviewing His Troops* remained a popular subject when the Kineoptikon projector was introduced in March 1896, also featuring on the programme at the launch of Edison's Vitascope the following month. It seems that at least two other films were taken at Dammtor station on 19 June, with Acres filming the reception of the Kaiser by Mayor Lehmann and the departure of the royal party in a ceremonial carriage.

There were soon more opportunities to film the German Emperor. Having arrived in Kiel on the 19th or 20th June Acres filmed a test strip at the entrance of the canal (*View of the Kiel Canal* preserved in the British Film Institute Archive).

Fig. 38. Entrance to the Kaiser Wilhelm/Kiel Canal, filmed by Acres in June 1895.

On the day of the official opening, 20 June, around 10,000 people gathered to witness a naval review featuring more than 80 international warships and hundreds of other vessels including a large Atlantic liner. Despite apparently encountering some problems Acres managed to secure several shots of shipping, including a view of Kaiser Wilhelm on the bridge of his steam yacht *Hohenzollern*. Next day the laying of the final stone and official naming of the canal took place in brilliant sunshine, attended by ranks of colourfully costumed soldiers, military bands and government representatives from across the world. It was a deeply theatrical scene which Acres' brief film could hardly be expected to recapture. The *Pall Mall Gazette* reported:

> The Emperor wore the uniform of the Garde de Corps. His brazen helmet glistened in the sun as he clasped both hands and rested them on the hilt of his sword. The guns of the warships thundered a Royal salute, but above the din rose the wild and stirring music of the Grenadiers' band. They played an old German fanfare. It was bursting with life and made the sun gleam red. It was music to turn men into Beserks. It was of the ninth rather than the nineteenth century. Yet it seemed part of the scene and the central figure was in perfect accord with it. And as it made the blood jump, the guns boomed, now loud and dead, now sharp and ear-splitting, and the thousands shouted. For almost ten minutes the din continued, as the Emperor never moved. Then the National Anthem was played, and the ceremony was at an end.[6]

There is uncertainty as to whether Acres managed to obtain a film of the stone laying ceremony. A letter from Stollwerck's local agent, Emil Kobrow, suggests that he had only obtained harbour views, whilst *Keystone Laying Ceremony of the Kaiser Wilhelm Canal* is recorded in at least one Acres filmography Whatever historic scenes were secured at Kiel it was not without a degree of personal inconvenience to Acres. In a postcard home, he reported that 'we have opened the canal satisfactorily', but that some ships had got stuck. 'Everybody here seems to have lost their heads,' he grumbled 'I am only just dining 10.30 pm'.[7]

For the first time in film's short existence a major event had been covered in a series of related views. It was, of course, true that each subject could only be seen separately in the kinetoscope, but the intention to provide a connected overview of the ceremonies was clear. For this and later sequences of films Acres has been given little credit by film historians. Deac Rossell was the first to draw attention to the number of complementary films made by Acres:

> But now we know that Acres produced many of his films in matched pairs, as in *Fishing Boats Towed out of Harbour* and *Fishing Boats Towed into Harbour*, or *Sailboats Leaving Harbour* and *Sailboats Returning to Harbour*, we can directly see the conjoined influence of slipping slides for the magic lantern, where, due to the limitations of the painted or photographic medium, every motion in one direction was followed by a corresponding motion in the opposite direction. In many of his early films, then, Acres was replicating (unnecessarily for the new moving pictures) the normative habits of lantern slide production and subsequent exhibition.[8]

Influenced as he may have been by lantern slide exhibition, Acres also specialised in linked sequences that were more extensive and possessed greater internal structure than a simple departure and return. For example, *The Derby, 1895* was shot in five sequences; whilst the projected films *Princess Maud's Wedding* (1896), *Military Tournament, Cathays Park Cardiff* (1896) and *The Worthing Lifeboat* (1897) all consisted of multiple shots. In this approach, he was according with some lantern slide and stereoview practices, but was also laying the foundation for a more complex approach to motion pictures. Acres' desire to break new ground was reflected in an episode which took place shortly after the Kiel festivities. A suggestion from Stollwerck that he might film the North German Derby was politely declined because he had already photographed a horse race. Instead, Emil Kobrow arranged for him to take films of gondolas and a recreated Rialto Bridge at the Venice in Hamburg Exhibition on 22 June 1895.

If Acres were to permanently associate himself with the wealthy Stollwerck organisation it was important that he should extricate himself from his partnership with Paul. Consequently, on 13 July 1895, he persuaded Paul to cancel their contract and relinquish his claim on the camera for a payment of £30.[9] Having formally severed his ties, Acres entered an agreement with Stollwerck on 15 July, confirming that the German company would have exclusive rights to the camera outside England and the United States, and to any further improvements, including a new viewing device. After a few days, Paul had second thought about the cancelled contract and communicated with Stollwerck. A letter from Acres to

Stollwerck, dated 6 August 1895 and addressed from Friesenplatz 13, Cologne, suggests that Paul was either trying to wreck the new alliance or to extract money from the German company. In a furiously indignant letter filled with underlinings, exclamation marks and crossings out, Acres condemned his old partner:

> As you have this day heard a one sided statement from Mr Paul I feel I must communicate to you my side of the matter. First as to Mr Paul's statement that he greatly improved and practically designed my Kinetograph. If Mr Paul said that he is a liar, he has not the least idea of photography and until he had my sketches he had not the slightest idea of the requirements of such an apparatus.

> My connection with Mr Paul, which from the commencement has been very unsatisfactory was brought about by a mutual acquaintance who knew that I was at work on my apparatus and who also knew that Mr Paul had copied Edison's Kinetoscope and was making them for sale and could not sell as many machines as he wished because he could not supply films.[10]

Despite his ex-partner's interference Acres continued his relationship with the Stollwerck organization throughout 1895 and, indeed, for many years afterward.

The subjects already provided by Acres must have been sufficiently successful for him to be invited back to Germany to record an even greater demonstration of nationalistic fervour. Many European governments felt that the extensive 25th anniversary celebrations of the victory of Prussia over France at Battle of Sedan were inappropriate and bellicose. But the Kaiser, was never one to spare another country's feelings, particularly when such a display of schadenfreude provided the opportunity to demonstrate the might of Germany's armed forces. A carefully orchestrated day of rejoicing on 2 September 1895 focussed on the Tempelhofer Feld, a gigantic area of common land on the outskirts of Berlin which had been used for military manoeuvres and parades since the time of Frederick the Great. As with the opening of the Kaiser Wilhelm Canal, Sedan Day was blessed with blazing sunshine. Around 100,000 people gathered to watch military displays and parades and to catch a glimpse of the Emperor. His heroic demeanour prompted the *Pall Mall Gazette* to observe 'say what you like about him, he is a man and a Kaiser every inch of him, and nobody can engineer a national pageant better'.[11] Acres was much in evidence, apparently martially inspired as he carried his camera and tripod 'musket fashion' from location to location.[12] Films known to have been made were *Procession Headed by the Kaiser on Horseback through the Streets of Berlin*; *Charge of the Uhlan Lancers on the Templehofe Feldt at Berlin*; *Parade of Veterans of the Franco-Prussian War*; *American Soldiers on Parade at Sedan Day in Berlin*; and *Imperial Parade at the Tempelhof Field, Berlin 2 September 1895.*

Although his views of the opening of the Kaiser Wilhelm Canal and the Sedan festivities were exhibited in kinetoscope parlours in Germany, Acres' mission to bring historic occasions to a wider public was hampered by technical limitations. The kinetoscope's small viewable image was not suited to the reproduction of large scale events involving huge crowds. In fact, the Kinetoscope Company bulletin for December 1894 emphasised that *Finale of 1ˢᵗ Act, Hoyt's "Milk white Flag"* was significant because it showed '34 Persons in Costume. The largest

number ever shown as one subject in the Kinetoscope'.[13] Similarly, the patriotic enthusiasm generated within an audience for a theatrical performance or magic lantern show was not readily achievable in a queue of people waiting their turn to peer into the kinetoscope. Less than two years later, however, the availability of projected films meant that coverage of Queen Victoria's Diamond Jubilee resulted in a rapid expansion of the nascent cinema industry.

Despite what appears to have been a relatively low-key reception for the German kinetoscope films, their potential does not seem to have eluded Kaiser Wilhelm. His were to become familiar features on film across the world during the 1890s and 1900s. It was an eventuality that had been predicted as early as February 1896 when reports of President Felix Faure of France hiring an official movie camera-man prompted an English newspaper to comment:

> Despite national enmity the German Emperor will at once award the President with his order of good merit, for has not the latter been the means of placing in the Kaiser's hands an instrument whereby his dramatic actions can be handed down for the admiration of posterity. William, accompanied by his "Kinematographer", can now with an easy spirit give vent to those patriotic antics that he often indulges in, such as waving his sword under the unfurled flag for the encouragement of his raw recruits, feeling assured that his actions and awe-inspiring figure will not be the next moment forgotten, but preserved for futurity.[14]

During the latter part of 1895 Acres, like several other inventors, concentrated on constructing a machine capable of projecting motion pictures. By the end of December, he had supplied Stollwerck with the Electroscope device, an arcade viewer which enabled a few customers to view rear-projected movies on a small screen. But Stollwerck was looking towards the next stage of exhibition and was pressing for a machine capable of showing films to a mass audience. It is possible that Acres had developed a prototype projector by the autumn of 1895. In an 1897 interview, he claimed that towards the end of September 1895 he had shown animated pictures on a 7ft by 5ft screen 'to one or two gentlemen well-known in the photographic world'.[15] By 6 March 1896 his projector was sufficiently well-known to other photographers, for William Friese Greene and J. W. Collings (brother of movie pioneer Esme Collings) to write to him asking to borrow the machine for a trial exhibition at Olympia, West London, after their machine had broken down.[16]

On 20 December 1895 Acres agreed to supply a perfect machine for projection to Stollwerck within next three weeks. It seems almost certain that he developed such an instrument by the end of the year for, on 10 January 1896, he presented the United Kingdom's first public film show. His long-term strategy was to sell the English rights in his cameras, films and projectors to Stollwerck, but he first sought to demonstrate the viability of the process by establishing an exhibition site in central London. From February, he announced the imminent opening of his Kineoptikon at Piccadilly Mansions, on the corner of Piccadilly Circus and Shaftesbury Avenue. A degree of financial backing from the Stollwerck organisation was implied by the location of the exhibition hall. Stollwerck's London

offices were at 3 Shaftesbury Avenue, in the same block of shops and offices as the proposed centre for Acres' show. The Kineoptikon (to be known as the Kineopticon from May 1896) finally opened on 21 'March 1896, showing a selection of Acres' films, subjects taken for Stollwerck in Germany and, within the month, views specially photographed in the United States.

Although Stollwerck chose not to purchase the rights to the Kineoptikon, Acres continued to make and exhibit films for the next five years. In 1896 he set up the Northern Photographic Works at Barnet where he became one of the principle manufacturers of film stock. He was not a good business man, however, and he was declared bankrupt in 1909 and again in 1911. Posterity has been less than kind to Acres with many early film writers downplaying his achievements and even denigrating his character. His legacy was mired by controversy as historians disputed whether it was he or Paul who invented the first British movie-camera. Ironically, his achievements as the earliest international film-maker were largely overlooked because they fell outside the narrow scope of British film studies. It was not until Hauke Lange-Fuchs' biography in 1987 and Martin Loiperdinger's researches in the Stollwerck archives that Acres' true stature began to be realised. Such studies show that not only did Acres and Stollwerck share an ambition to establish a European film industry, but they also had a joint vision of movies as a medium for recording historic and newsworthy events. Anticipating coverage of Tsar Nicholas' Coronation in 1896 and Queen Victoria's Diamond Jubilee in 1897, Acres' kinetoscope views of events in Germany in 1895 showed how film could be used to provoke patriotism and foster imperial pride.

Notes

1. Gilbert Bartholomew to Stephen Moriarty, 22 March 1895, TAED D9523AAO (10 February 2017). Bartholomew later recommended that Stollwerck visited the Cinématographe-Lumière at the Empire Theatre, Leicester Square, London, on 16 March 1896.

2. *The Globe* (31 August 1896): 3.

3. Antonia and W. K. L. Dickson, 'Edison's Invention of the Kineto-Phonograph', *The Century Magazine* (June 1894): 206–214.

4. During the 1850s and 1860s the stereoview paralleled early cinema by providing wide coverage of news events such as fires, floods, military conflict, exhibitions and public ceremonies.

5. *British Journal of Photography* (1 May 1896): 33.

6. *Pall Mall Gazette* (24 June 1895): 3.

7. Postcard reproduced in Barnes, *The Beginnings of the Cinema in England 1894–1901 Volume One*, 57.

8. Deac Rossell, 'Second Thoughts: A Fresh Look at Birt Acres in the Light of New Discoveries'. Unpublished paper.

9. Stollwerck Archives, Acres to Stollwerck, 13 July 1895.

10. Ibid. Acres to Stollwerck, 6 August 1895.

11. *Pall Mall Gazette* (3 September 1895): 2.

12. *Amateur Photographer* (31 January 1896): 90.

13. Quoted, Musser, *Edison Motion Pictures 1890–1900*, 159.

14. *Bristol Mercury* (8 February 1896): 5.

15. 'Prominent Men in the Lantern World. No. VII.-Mr. Birt Acres', *The Optical Magic Lantern Journal*, (May 1897): 80–81.

16. Loiperdinger, *Film & Schokolade*, 327.

Chapter Twelve

Transatlantic Filming

On their introduction, it was widely prophesised that the phonograph and the kinetoscope would transform long held attitudes towards time and space. This was clearly the case with the phonograph which could easily be transported to different international locations and the resulting recordings disseminated or stored for future use. But, while the Kinetograph camera remained stubbornly rooted in its New Jersey studio, the ability of motion pictures to change public perception of the world remained severely limited. Despite the Dickson's lofty predictions about the future of film, Edison appears to have had little interest in widening the scope of his invention. When, only weeks after the kinetoscope's London opening, Maguire and Baucus pleaded for a camera to take European views, Edison delayed for months. By the time a cameraman was despatched to London in July 1895, Birt Acres had already taken numerous films in Britain and Germany. Theodore Heise's abortive mission was, however, the first attempt to secure films on a transatlantic basis, a project that was successfully achieved by Acres eight months later when his cameraman was sent to obtain the earliest motion pictures of New York, Montreal and Niagara Falls.

A Machine for Taking Pictures

There were two polite, but major qualifications in a letter that Franck Maguire wrote to Edison detailing the initial success of the kinetoscope in Britain. The slow supply of machines from Edison was preventing the Continental Commerce Company from expanding as quickly as it wanted and the absence of films made in Europe were impinging on the kinetoscope's popularity. In two places in the letter, dated 9 November 1895, Maguire emphasised the need for a movie camera:

> If you will kindly consider seriously the matter of sending over to us in this country, or placing in the hands of one of your men, a machine for taking pictures, it will aid the salability [sic] of the Kinetoscope at least a hundred per cent. Every day we have inquiries for scenes in Germany, in England, in France, etc., etc. Will you kindly help us out on this point? [...]

> To refer again to sending a machine over here to take the pictures, of course, you understand Mr. Edison that we are perfectly willing to pay for all the expenses that may be incurred in manufacturing a special Kinetograph for us, and also the salary of such men as you see fit to run it.[1]

Two months later the situation had not changed. On 9 January 1895 Maguire wrote to Henry de Fleurigny:

> I intend to use my best endeavours to have the Kinetograph brought to Europe, even though it may occasion a personal trip to see Mr Edison. It is to our interest as well as yours to have the Kinetograph here as soon as possible, and this shall be done as far as it is in my power.[2]

Edison's response, finally sent on 22 January 1895, suggested that European film-making was not high on his list of priorities:

> I will send a Kinetograph within six months to Europe to always be in the hands of my representative who will take such subjects as the Continental Commerce Co desire for six months after arrival – and all expenses of such representative both personal and for that necessary to take subjects shall be paid by the C C Co – that the negatives are to be sent to America and there developed and returned on order at the same price of films now charged.[3]

Sadly, for the fortunes of the Continental Commerce Company, and for the possible expansion of his own business, Edison did not arrange for a camera and operator to be sent until the summer of 1895. The reasons for the delay are unclear. It is possible that Edison and his staff were working on a lighter machine that could be more easily transported to different parts of Europe. Maguire's reference to 'scenes in Germany, in England in France' might indicate that his company was hoping to obtain local views rather than the usual diet of variety acts and comic episodes. When the decision was finally made, the choice of camera operator was unusual. Rather than selecting a mature member of his staff Edison chose Theodore Robert Heise, the 20-year-old son of one of his principle assistants.

The Short Sojourn of Theodore Heise

Heise had worked for Edison for at least two years prior to his European mission. His father, William Heise (1847–1910), had emigrated to the United States from Germany in 1868. As a locksmith and machinist his mechanical skills made him useful to Edison who hired him for the staff of his Laboratory when it opened in January 1888. In 1890, having previously worked on the phonograph, William Heise became Dickson's right hand man, spending several years helping to develop the kinetoscope. Heise and Dickson appeared together in 1892 in one of the earliest experimental films, as Charles Musser observes 'congratulating each other on a successful effort -the invention of modern motion pictures'.[4] After acting as camera operator for many kinetoscope subjects Heise, in 1896, photographed one of cinema's most famous films, May Irving and John C. Rice in the titillating close-up view of *The Kiss*. 'Young Heise', as he was known at the Edison Laboratory, presumably learned much about the construction and operation of the kinetoscope from his father. As for the choice and composition of film subjects he may well have been guided by Dickson. During 1894 Dickson and Theodore Heise apparently made 75 copyright applications for Edison motion pictures at the Library of Congress.

Edison was determined to preserve the secrets of the Kinetograph. In a letter written on his behalf on 15 July 1895, the general manager of the Edison Manufacturing Company, William Gilmore, made six stipulations about the impending expedition. Joseph Baucus was instructed that the apparatus should not pass out of Heise's possession 'for any purpose whatsoever'; film negatives should be sent directly back to Orange for developing; Heise was to act under the direction of Maguire and Baucus; Heise's services, use of camera and supply of film stock were to be charged at a rate of $8 per day with a further allowance of $4 per day to cover living expenses; the arrangement was to last for a period of 60 days from the date of Heise sailing from US; and Maguire and Baucus were to furnish the cameraman 'with the necessary facilities and the way through to take subjects properly'.[5]

On 20 July 1895 Heise sailed from New York, entrusted with the precious movie camera and bearing a signed letter from Edison addressed 'to whom it may concern':

> Mr. THEODORE ROBERT HEISE, whose signature is shown below, is authorised by me to take film subjects with my Kinetograph, now in his possession, for account of the Continental Commerce Company, Messrs. Maguire & Baucus or such interests as they may indicate. The Kinetograph which he has is to remain absolutely in his possession, and under no circumstances is said machine to be loaned, delivered, exhibited or to pass out of his possession, whilst acting as my representative abroad. Any subjects taken by me are also my property, and should not pass out of his possession, but be sent at once to me here, at Orange, New Jersey, U.S.A., to be developed.[6]

What occurred when Heise arrived in Europe remains one of early cinema's most intriguing mysteries. No films from the visit are recorded, nor any account of Heise's activities. Whether a mechanical malfunction or some inadequacies on the part of the young cameraman caused the failure of the mission, the management of the Continental Company were disappointed. When the Edison Manufacturing Company submitted an interim bill of $262 for Heise's services, the New York branch of the Continental Commerce Company replied on 28 August 1895:

> In our last letter from Mr Maguire from London, he states that he was unable to get any satisfaction out of Mr Heise, and consequently we would like to wait until we hear further from him before paying this bill.[7]

On 3 September 1895 Edison's company agreed to reduce its charges for Heise's services to six dollars a day.[8]

Towards the end of August 1895 Heise had travelled to Paris, requesting a passport from the United States Legation on the 24 of the month. The application reveals that Heise was 5 feet 7½ inches tall, with grey eyes, brown hair, fair complexion and an aquiline nose.[9] He also stated that he intended to return to the United States within a year, but, of course, no information about his filming activity was forthcoming. It is a possibility that he had travelled to Paris to meet

representatives of Edison's Kinétoscope Française. Heise remained in Europe until late summer, arriving back in New York on 24 September 1895. The passenger list of the *SS Circassia* sailing from Glasgow recorded him as a photographer, although whether he had succeeded in securing any films may never be known.

An Expedition to the United States

Had Heise succeeded in obtaining motion picture views of England, France or Germany, they would not have been the first external subjects to be made in those countries. In the United States, however, no such scenes had been recorded, except for a few kinetoscope films taken within yards of the Black Maria studio. It was left to the ex-patriate Birt Acres to organise a trip from Britain to the United States to secure the first footage of American street scenes and natural wonders. The generally advanced theory that Acres travelled to the United State with his camera sometime late in 1895 is almost certainly inaccurate. We must look to his colleague Henry W. Short as the world's first transatlantic cameraman, his brief journey occurring in March 1896.

If Georgiades and Tragidis were the 'fast-disappearing quarks' of early film history, a good deal of its mysterious dark matter was supplied by 'Harry' Short. Although shadowy he appears to have been omnipresent – a friend of Acres at the time he was making his early experiments in sequential photography, an associate of Paul when he had started replicating kinetoscopes, a chance acquaintance of the Greek exhibitors and a talented photographer who took some of the earliest travel films. Without his intervention, the course of British cinema might have been substantially different. Born in Kennington in 1864 he was only child of Thomas Watling Short, a scientific instrument maker whose offices during the 1890s were located at 40 Hatton Garden, close to those of Robert Paul. Although recorded as an apprentice scientific instrument maker in the 1881 census, by 1891 Short was listed as an electrician. His membership of the Lyonsdown Photographic Society indicates that he was an amateur photographer, the skills acquired in handling a still camera equipping him for film-making with both Acres and Paul. After accompanying Acres on his Kaiser Wilhelm Canal expedition, he appears to have been intrusted with the film related excursion to the United States.

'Henry Short', an electrician aged 31, was listed as sailing on *SS New York* from Southampton to New York on 22 February 1896, arriving on 2 March 1896.[10] The trip was extremely brief for Henry W. Short, again described as a 31-year-old electrician, returned to Liverpool on the *Lake Winnipeg* on 18 March 1896.[11] Such limited duration suggests that the trip had a precise purpose which had to be quickly expedited. The expedition may well have related to the opening of Acres' Kineoptikon on 21 March 1896 or the first showing of Edison's Vitascope at Koster and Bial's Music Hall, New York, on 23 April. The date of Short's return coincides so closely with the launch of the Kineoptikon that it seems plausible that Acres' was waiting for the arrival of the series of unprecedented views from the United States and Canada to add impact to the exhibition. With the Vitascope

projector, reliant on films made in the Black Maria studio, the exhibitors, Raff and Gammon, had decided to strengthen their show by introducing a selection of subjects taken by Birt Acres. At a trial run on 3 April 1896 a film of a Serpentine Dance by Annabelle was accompanied by a 'panorama of the latest English Derby'.[12] Three further Acres films were listed on the programme for the Vitascope premiere – *Sea Waves, Kaiser Wilhem, reviewing his Troops* and *Venice, Showing Gondolas (The Rialto Bridge at Venice)*. It seems likely that Short personally delivered the selection of Acres' subjects to the proprietors of the Vitascope show.

The films, presumably taken on the trip, may have been intended for exhibition in the United States as well as in Britain. Certainly, they anticipated by a few months' similar outdoor productions by the Eidoloscope, Edison and Biograph companies. The Acres film *The Steamer 'New York' at the Dock* could have been taken on either side of the Atlantic, but *Steamer on Long Island Sound* was clearly made in the United States. American street views provided at least two subjects; *Broadway, New York* and *Elevated Railway in the Streets of New York*.[13] Alongside the novelty of depicting trams, trains and pedestrians in motion, Acres' cameraman made an excursion to record one of the natural wonders of the world. Niagara Falls had attracted photographers since the earliest days of the medium. As early as 1840 the English businessman Hugh Lee Pattinson had exposed a Daguerreotype plate for twenty minutes to produce a surprisingly vivid impression of the cascades. With the introduction of the stereograph, innumerable 3D images of Niagara and its surroundings were produced. Artists too, had laboured to convey the grandeur of the scene. In 1889 Paul Philippoteaux' 400 foot by 50-foot painted diorama, *Niagara in London*, exhibited near to the Royal Aquarium in Westminster, inspired Colonel Gouraud to suggest to Edison that a phonograph recording be made of the fall's crashing waters. The cultural and artistic significance of Niagara was such that in 1894 Edison was prepared to put aside his usual policy of studio filming to transport the Kinetograph to Buffalo to obtain views. Although the plan was not realised Antonia Dickson's and W. K. L. Dickson's *History of the Kinetograph, Kinetoscope and Kineto-Phonograph*, published in 1895, included an imaginary frame representing the Falls alongside drawings depicting actual films of other subjects.

For Acres to obtain the first moving pictures of Niagara Falls appears to have been a major achievement, but the films aroused less comment than the simple shot of breaking waves on the Dover coastline. Having been taken in winter their quality may not have been good, although a surviving sequence suggests that the footage was dramatic. Three Niagara Falls films were usually presented together, i.e.:

i. *The Upper River just above the Falls/ View of Niagara just above the falls*

ii. *The Falls in Winter/The Great Horse Shoe Falls/Niagara Falls Close to the Waterfall*

iii. *The Whirlpool Rapids/Whirlpool Where Captain Webb was Drowned/Niagara Falls. The Great Whirlpool.*

Fig. 39. Unidentified film, probably *View of Niagara just above the falls*, March 1896
(BFI National Archive)

Whilst they do not appear to have been shown at the Kineoptikon exhibition in March, the films had become part of the programme by the following month.[14] Their initial exhibition took place before the first of many American films depicting Niagara Falls had been taken. The popularity of the subject, in the United States at least, was demonstrated in the same year by the Eidoloscope Company who filmed *Whirlpool Rapids, Niagara Falls* by early May; William Heise who took several views of the Falls for Edison by early June; and Eugène Promio for Lumière Brothers and W. K. L. Dickson for Biograph who made several films in September.

Short's travels to Germany and the United States were extended to other countries during the next year. His filming assignments, however, were no longer conducted under the auspices of his old friend Acres. In August and September 1896, he spent several weeks in Portugal and Spain, taking a selection of views for exhibition by Robert Paul's Animatograph. The following March he was again funded by Paul to film abroad, his Egyptian tour provoking Cecil Hepworth to comment on the irony of taking moving pictures of static pyramids. Such exotic expeditions were used to raise the reputation and profile of film-making by engaging an instruction-seeking audience. In doing so they enhanced the reputation of producers, particularly those as adept at advertising as Paul.

Although Theodore Heise was the first man to cross the Atlantic with a movie camera it is not possible to say whether part of his brief was to record actuality views of European landmarks which might be enjoyed via kinetoscopes back in the United States.[15] Similarly, there is no record of Acres' films of the opening of the Kaiser Wilhelm Canal or the Sedan Day celebrations being shown by British kinetoscopes.[16] But with the advent of projected motion pictures the possibility of linking sequences of film to provide simple travelogues became an attractive option. By the summer of 1896 the Lumière Cinématographe and Acres' Kineopticon[17] were both installed in New York music halls, showing scenes from the other side of the Atlantic Ocean.

Notes

1. Maguire to Edison, 9 November 1894, TAED D9428AAK (10 February 2017).

2. Maguire to de Fleurigny, 9 January 1896, TAED D9517AAC (10 February 2017).

3. Edison to Maguire, 22 January 1895 [date conjectured], TAED D9517AAL (10 February 2017).

4. Musser, *Edison Motion Pictures 1890–1900*, 25.

5. Gilmore to Continental Commerce Company, 15 July 1895, TAED D9517AAS (10 February 2017).

6. Thomas Edison National Historical Park/TAED D9517AAR (10 February).

7. Continental Commerce Company to Gilmore, 28 August 1895, TAED D9517AAW (10 February 2017).

8. Gilmore to Harry Miller, 3 September 1895, TAED D9517AAV (10 February 2017).

9. US National Archives.

10. US National Archives, New York Passenger Lists, 1820-1957.

11. UK Incoming Passenger Lists. 1878-1960. Series BT 26: National Archives, Kew.

12. *New York Herald* (4 April 1896): 5.

13. Musser, *Edison Motion Pictures 1890–1900*, 652 illustrates an unidentified film from the Hendricks Collection at the Library of Congress which shows an elevated railway in what appears to be a New York street.

14. The earliest reference to the Niagara films is found in the *Dundee Advertiser* (21 April 1896): 5.

15. *Edison and International Photographic Films*, Maguire and Baucus catalogue (April 1897) lists an isolated view, *Grand Boulevard, Paris*, which could conceivably have been taken on Heise's trip.

16. Films taken in Germany in 1895 did feature in projected exhibitions of Acres' films in the United Kingdom.

17. *New York Dramatic Mirror* (29 August 1896): 17, lists six Kineopticon films: *Train Leaving Tunnel*, *Waves at Dover*, *Beach at Brighton*, *Last English Derby*, *The Seine near Paris* and *The Boxing Kangaroo*.

Chapter Thirteen

Making an Exhibition

T he kinetoscope was undoubtedly a scientific marvel, but it was also tainted by association with rascally showmen, rollicking crowds and, more specifically, the much-derided penny peepshow. Photographic realism, which in many areas would be regarded as eminently respectable, itself became an equivocal element in the device's reception. From the 1860s exhibitors of commercial stereo photographs had been prosecuted for displaying 'obscene' subjects and just four months after the kinetoscope's premier in the United States a San Francisco parlour manager became the first person to be arrested for showing allegedly indecent films.[1] Despite the potential pitfalls, a number of individuals who exploited the device came from what would have been considered as reputable, public-spirited backgrounds. The nature of entertainment was changing. As extended, family-orientated holidays became more common, opportunities arose to provide new forms of entertainments catering for mass audiences. Such entrepreneurs as Alfred Lomax, Frederick Dalton, Henry Groves and Walter and Joseph Simpson chose to take the kinetoscope and to feature it in their efforts to bring about an informed, entertained and technologically-based society.

Alfred Lomax
Alfred Lomax (1861–1937) came from a Methodist family who were strong in their avocation of sober living, particularly for the inhabitants of their home town, Blackpool. In 1867 his father, Edward Lomax, was one of the founders of a temperance hall in Coronation Street, an establishment whose ministrations were cut short after only eight years when the property was bought and demolished by the Winter Garden Company. Edward's keenness for restricting the consumption of alcohol was matched by his enthusiasm for erecting homes for the town's rapidly expanding population. Among his developments were several houses in Caunce Street, making it probable that he was responsible for the construction of number 28, the home in which his family lived for many years. Not content with his career as a property developer, Edward opened a bookshop and acted as an auctioneer. With his sons, David and Albert, he moved into journalism, launching a local advertising publication and a short-lived newspaper, the *Lytham Sun*. Finally, the family set up a printing office in Caunce Street.

During the first 30 years of Alfred's life Blackpool changed from a small town fashionable for sea bathing to a gigantic holiday resort famed for innovative and

spectacular entertainments. Facilities such as piers (the first opened in 1863), a promenade, theatres, music halls, an aquarium, pleasure gardens and the famous tower were steadily added to cater for an ever-growing influx of holiday makers. By the early 1890s a resident population of 40,000 was increased by the arrival of two million visitors every year. Like his father, Albert's various employments frequently involved catering for a mass public. For a time, he ran a display of antiques at one of the town's earliest tourist attractions, Raikes Hall Gardens. In 1887 he acted as editor of the ill-fated *Lytham Sun*, later assisting in the running of the family printing business. At an early age, he had come under the influence of the Congregationalist preacher Rev James Wayman (1840–1899). Wayman's hands-on approach to community affairs may well have influenced Lomax's future activities. Described on his tombstone as a 'useful citizen', the charismatic pastor played an active part in Blackpool's everyday life. During his ministry (1869–1891) he co-founded *The Blackpool Times*, compiled the earliest corporation guide and became the first director of Victoria Football Club (later to become Blackpool United). Alongside eloquent sermons, Wayman delivered extended lectures which were accompanied by magic lantern displays.

In accordance with his Congregationalist background Alfred Lomax was independently minded and self-sufficient. Although at one-time chapel organist he was not averse to peddling popular entertainment. From 1893 he traded from The Phonograph Office (later The Edison Phonograph Office), selling machines and arranging exhibitions. An early appearance was humorously reported in a review of the Sportsman's Exhibition at the Norfolk Drill Hall, Sheffield, in 1893:

> Always keeping sport in view, the visitor may be a little puzzled on coming face to face with the phonograph, which has here an intelligent and experienced exhibitor in Mr A. Lomax, of Blackpool. But it will be seen on reflection that the instrument supplies indoor sport, or if that be questioned, one may draw a picture of the jaded sportsman seeking solace at the phonograph in the echoed strains of "Ta-ra-ra-boom-de-ay," or some other inspiring piece of music. Then records are taken here, and everybody who has seen and heard a record taken at the phonograph will allow that it is fine sport indeed. The Shakespearian reciter, declaiming in sonorous tones some fine passage into the funnel of the phonograph, is only less funny than the spectacle of a comic singer trying to pour some of his best comicality into the unresponsive machine. As an implement of sport, the phonograph may be allowed to pass. If any one inquires the price, the quotation will perhaps be considered no joke; but, after all, the prohibitive price of the apparatus does something for the peace of a man's domestic circle.[2]

Following the assignment of the Edison and Bell-Tainter patents to Edison-Bell in January 1892, Lomax became involved in a series of legal skirmishes with the corporation that extended throughout 1893–1894. He was a resourceful character, however, and the situation eventually resolved itself when he became a regional agent for the company.

Whilst remaining a passionate Blackpudlian or 'Sandgrown'un', Lomax closely followed international developments within his fields of interest. Like many

other inventors and showmen, he was aware of and ready to exploit any advances in phonograph and motion picture technology. As early as May 1893, almost a year before the first commercial exhibition of the kinetoscope, he had written to the *Blackpool Gazette and News* predicting that Edison's invention would be used to record military processions, civic parades, horse races such as the Derby, prize fights and football matches. His interest in moving pictures had been ignited by personal contact with the famous chronophotographer Edweard Muybridge. In 1896, he wrote 'years ago I had the pleasure of assisting him at one of his illustrated lectures, and was astonished at what he was able to illustrate of movement, both simple and complex, by projecting the images on to a large screen'.[3] Over a period of time Lomax examined several proto-motion picture devices. Again, in 1896, he reflected:

> Having for a period had charge of a number of these machines I know well their structure, and (next to Edison's kinetoscope) I feel convinced that the electric wonder [Anschültz's Schnellseher] is the most perfect mechanism ever produced in machines illustrating for motion. The climax, however, of all previous results is certainly to be found in the Edison kinetoscope, and, just now, the Edison vitoscope [sic] -also known as the Edison Theatre.[4]

After successfully exploiting the phonograph, Lomax acquired his first kine-toscope from the United States at the beginning of November 1894. He demon-strated the device to a reporter from the *Blackpool Gazette*, explaining that he had already ordered three more for an exhibitor who had agreed to pay him £250. To emphasize the prestigious link between his new acquisition and its inventor Lomax claimed that he had received a 'cordial invitation' to visit Edison at his New Jersey works.[5] Despite his enthusiasm for the kinetoscope Lomax soon attempted to improve its design. Following the examples of Muybridge and Anschültz, he drew up plans to increase the number of people who might view a film at one time. In December 1894, he and a colleague, John Anderton, patented a system by which the use of prisms displayed kinetoscope pictures to a small group of spectators.[6] In January 1895 Lomax applied to the council for a licence to exhibit both a phonograph and a kinetoscope at Blackpool market, but its refusal probably re-enforced a life-long mistrust of the local authority.

Whilst he usually gave his profession as 'printer' Lomax continued to trade in films, projectors, phonographs and cylinders until at least the end of the century. In his wider life, he was, like Wayman, a useful citizen. During the early 1900s he played a leading role in a debating society known as Blackpool's 'Mimic Parliament' (Blackpool had become a Parliamentary Division in 1885). Later, as founder and secretary of the Blackpool Property Owner's Association, he fre-quently challenged Blackpool Corporation on planning matters and other local issues. Although his father had assisted the spread of modern Blackpool and he himself had done much to promote mass media entertainments, Lomax's relig-ious views caused him to adopt a surprisingly conservative attitude. In 1902 the *Manchester Courier and Lancashire General Advertiser* reported:

> Mr A. Lomax said Blackpool was getting more and more like Paris on a Sunday. He

161

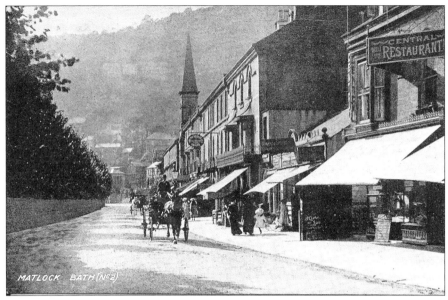

Fig. 40. Frederick Dalton's Central Hotel, Matlock Bath, Derbyshire.

deplored this. The trams were being run, public places of amusement were open on a Sunday, and in a hundred and one other ways the Sabbath Day was being made like any ordinary week-day.[7]

Frederick Dalton

The crowds who thronged the Blackpool Promenade in the 1890s had a parallel in the holidaymakers who flocked to a picturesque Derbyshire Peak District village known as the 'Little Switzerland'. It was at Matlock Bath, situated in the deep cleft of the Derwent river valley, that Frederick Dalton (1861–1949) ran a large-scale catering business and a kinetoscope exhibition enterprise. The fashionable popularity enjoyed by Matlock Bath following a visit by Princess Victoria (later Queen Victoria) in 1832, was democratised later in the century when newly-built railway connections made the locality accessible to all ranks of society. The spectacular views from High Tor and the Heights of Abraham, the riverside delights of 'Lover's Walk' and a wide choice of hydropathic establishments made the town as favourite a destination as many large seaside resorts. By the 1890s the summer months were busy with a daily influx of tourists arriving by train, horse-drawn charabancs and, more adventurously, on the new 'safety' bicycles. For those planning longer stay, nine hotels and numerous guest houses provided a variety of accommodation.

Dalton owned the Victoria Restaurant and the Central Restaurant, both extensive buildings that also operated as hotels. Born in Kettering, he was listed in the 1871 census as the son of a Toll Gate Keeper living in Girton, Cambridgeshire. By 1881

his father had died and his mother was described as a 'retired farmer'. Still living in Cambridgeshire, Dalton's profession was given as 'printer compositor'. Somehow, by the close of the 1880s, the young printer had managed to amass sufficient funds to set himself up as a restauranteur and hotelier. Running the two establishments was a major operation in the summer months (the Central Restaurant alone accommodated 500 diners), but during the winter Dalton had time on his hands combined with a slackening of his income. The introduction of the kinetoscope provided him with an added attraction for his restaurants and a separate occupation that could be pursued out of season. When he opened his exhibition of three kinetoscopes at A. H. Rigg's art gallery in Market Street, Bradford on 10 December 1894 he exploited the novelty of the devices by claiming, falsely, that they were the first to be shown outside London. That Dalton was aiming his entertainment at an orderly, respectful clientele was demonstrated by an advertisement that he placed for his Leeds exhibition on 4 January 1895: 'WANTED, reliable GIRL for pay-desk; must be recommended; honesty essential. Kinetoscopes, 72, Briggate'.[8] Generally, many kinetoscope exhibitions took place at events that carried with them an assurance of respectability, but proprietors of shops also attempted to re-assure their potential customers about the gentility of their shows. Continuing to tour until early spring, Dalton also advertised the rental of a shop with 'best promenade position in Blackpool ... suit five kinetoscopes'.[9] For some reason he was anxious to secure additional films, offering to purchase them even in a damaged state.[10] A gap between reported engagements from March to October 1895 strongly suggests that Dalton's kinetoscopes were being used in his Matlock restaurants. Like the Waverley Christmas Festival, a constant flow of new customers maximised the use of the machines and mitigated against a lack of variety in the film subjects.

There are indications that Dalton set up a kinetoscope exhibition company or/and had some form of agency with the Continental Commerce Company. At the opening of the Municipal Electricity Works, Tunbridge Wells, on 7 October 1895, the device was exhibited by 'Messrs. Dalton and Co., Matlock Baths', while the following day its appearance at a sale of work in Belper, Derbyshire, was reported to be 'under Mr F. Dalton, of Matlock Bath, the district manager'.[11] Later in the month the Grand Confetti Fete, in Cork, advertised that its kinetoscope and kinetophone were provided by the Kinetoscope Co., of Matlock.[12] It is likely that Dalton was connected with the Scientific Entertainment Company of Matlock Bath which exhibited a kinetoscope at the Calow Church Schools Bazaar, Chesterfield, on 6 May 1896, and which organised Cecil Wray's Cinetograph film shows at Bradford in June 1896.[13] Dalton certainly continued to exhibit kinetoscopes, kinetophones and phonographs into 1896. On 30 July 1896, he lost a kinetoscope and a phonograph when the horse-drawn wagon delivering the machines to the Bakewell Flower Show was involved in an accident.[14]

Dalton may well have been connected to 'A. T. W.', an enterprising kinetoscope parlour manager who wrote to the *Sheffield Weekly Telegraph* in September 1895:

I am managing an exhibition of kinetoscopes and phonographs in a shop in the most

prominent position in Buxton. It has been open all the season, during which period I have always left my copy of the "W.T." either on a chair or in some other noticeable place inside the shop, and numbers of people pick it up and read whilst waiting their turn.[15]

By the beginning of 1897 Dalton had started to exhibit a 'Cinematograph'. On the first day of a two-day Conversazione at the School of Science, Lincoln, he gave a film show which included several kinetoscope subjects (the device was demonstrated on day two by A. H. Vidler, another kinetoscope showman).[16] In August he demonstrated both the phonograph and animated pictures at a Grand Bazaar at Bulwick Hall, Northamptonshire, and in October he travelled to Ireland to show films at a similar event at Kinnegad.

Throughout his involvement with motion pictures Dalton continued to supervise his catering concerns, adding an even larger facility in the late 1890s. For a short time, he ran the Pavilion, situated in another picturesque Peak District village, Castleton. This giant wooden structure could accommodate an audience of 1000, with a large stage making it suitable for dances, concerts and perhaps film-shows. An early film depicting Monsal Dale, near to Matlock Bath, has been linked with the Scientific Exhibition Company.[17] It is possible that Dalton was commissioning films to promote holiday-making to 'Little Switzerland' and to his restaurants and hotels.

Henry Groves

Like Dalton, Henry Gabriel Groves (1855–1922) was a successful businessman operating in a popular spa resort. A schoolmaster's son, he had gained considerable experience as a bookseller and stationer before arriving in Royal Tunbridge Wells, Kent, in the late 1880s. His 'Fine Art Gallery' was situated in the Pantiles, a covered and colonnaded row of shops which provided the stylish centre of a long-fashionable town. As well as retailing a wide selection of paintings, prints, books, stationery and local photographs, Groves was also a talented singer and organist, dominating the local area's musical scene. He was a leading member of several musical associations and, as a concert agent, he booked many of Victorian England's most popular singers and musicians to appear in the town. On Easter Monday, 22 April 1895 he exhibited Edison's kinetoscope at the inaccurately named 'Pump Room', afterwards transferring the device to his nearby Art Gallery where it was put on display for a 6d admission fee, the same price charged for an exhibition of paintings.[18] The kinetoscope continued to entertain its elite audience until (at least) the end of June, when Groves loaned it to a bazaar, held at the Pump Room, to raise money for a local church charity. That Groves' kinetoscope was situated in one of the country's most prestigious shopping locations was demonstrated on 20 May 1896 when Princess Mary Adelaide, Duchess of Teck (granddaughter of George III and mother of future Queen Mary) promenaded along the Pantiles on her way to open a Royal Floral Bazaar at the Great Hall. Tickets to watch the princess's progress were available from H. G. Groves – priced at one shilling.[19]

Simpson Brothers of Hapton

If Edison was the universally accepted 'King of Electricity', there were two able princes of the vital force who presided over the Lancashire village of Hapton, now a suburb of Burnley. The brothers Walter Fitzallan Simpson (1857 1940) and Joseph Fitzallan Simpson (1869-1951) were both fascinated by electricity, setting up a company that was responsible for some of the earliest commercial and domestic lighting installations in England. With something approaching missionary zeal, they also promoted diverse applications of electricity such as cooking, heating, ventilation, telephones and motion pictures.

The Simpson's presence in Hapton was due to an industry that was endemic to Lancashire and the North of England. Their father, John Simpson, had built a single-story weaving shed in the village in 1867. By the 1870s Perseverance Mill had grown to house 600 looms, which were increased to 1000 following a further expansion in the late 1880s. From its earliest days, the mill generated a supply of gas which was used not only in the factory, but piped to many households in the village. Although the mill continued to flourish neither Walter nor Joseph followed their father's trade. In the early 1880s Walter qualified as a marine engineer with the Red Star Line, making transatlantic journeys to New York and Philadelphia. On one trip, he apparently visited Edison's Laboratory where he was deeply impressed by the development of the carbon filament light bulb. A life-long friendship with the inventor ensued, together with the inspiration for a new career.

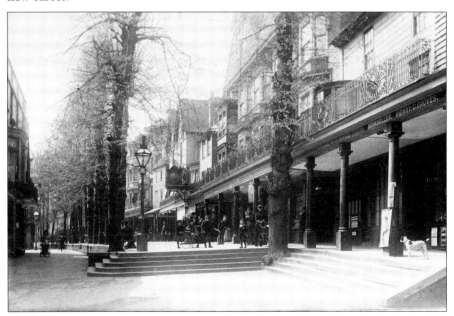

Fig. 41. The Pantiles, Tunbridge Wells, in the 1890s. Henry Groves shop and art gallery in the foreground.

165

While Walter worked on steam ships, Joseph applied himself to the study of electricity at the Mechanics Institute in Burnley. After taking exams in 1884-5 he served an apprenticeship with the Manchester and District Edison Electric Lighting Company. In 1888 Walter and Joseph established Simpson Brothers, an electrical engineering company with headquarters in Hapton and showrooms at 3 Hammerton Street in Burnley. They announced that they were 'prepared to enter into contracts for lighting by electricity, of mills, weaving sheds, shops, and gentlemen's residences, also the temporary lighting of bazaars for the coming winter'.[20] As a demonstration of their engineering skills the brothers installed three Swan incandescent lights enclosed in large, glass globes at strategic locations in Hapton, making it the first village in Britain to be illuminated by electricity. Power was provided by a small dynamo situated at Perseverance Mill. Five years later, in 1893, Simpson Brothers played a part in the much larger project to provide an electricity supply for Burnley.

In about 1894 the acquisition of a phonograph heralded a change of emphasis in which Simpson Brothers started to market and, in some cases, manufacture items related to popular entertainment. Walter, as a committed Wesleyan, and Joseph, a staunch champion of individual rights, were closely involved with the local community, making frequent public appearances. Although not commercially exhibited the Simpsons' phonograph was featured at several social events and public lectures in and around Hapton. With a personal interest in Edison's career the Simpsons would have been aware of the development of the kinetoscope. In 1890 moving pictures of a rudimentary kind had been exhibited in Burnley when Muybridge demonstrated his Zoopraxiscope at the Mechanics Institute. The following year the *Burnley Gazette* carried a feature on the kinetoscope headed 'Mr Edison's Latest Triumph'.[21]

The earliest adverts that Simpson Brothers placed for kinetoscopes in February 1895 did not carry the name of the company, i.e. 'Kinetoscopes, in stock and ready for delivery. Machines with all the latest improvements, no more broken films. Batteries and films stocked. 3 Hammerton-street, Burnley'.[22] Significantly, perhaps, another name was omitted from the advert, that of Thomas Edison. Despite Walter's claimed friendship with the inventor it is possible that Simpson Brothers were selling replica machines and were carefully avoiding charges of 'passing off'. In subsequent adverts Edison's name was again conspicuous by its absence: 'Kinetoscopes, Kinetoscope films, Kinetoscope batteries. Simpson Bros. Hapton, Burnley'.[23]

It has not been possible to establish for how long Simpson Brothers sold kinetoscopes, but that they remained interested in motion pictures is demonstrated by a legal case dating from 1896. After marketing the 'Edisim' projector in August 1896, they were successfully sued by J. H. Rigg who was able to demonstrate that it was a copy of his Kinematograph.[24] In October and November they advertised a 'Cinematographe' projector of their own make.[25] At the same time the Simpsons gave a number of film shows, exhibiting a 'Theatrograph' at a Burnley Working Men's Temperance Mission in November and the 'Cinematographe' at a concert

at Mount Pleasant School in December.[26] The brothers dissolved their partner-ship in 1898. Walter remained at the head of the firm, also serving a long term as Overseer for Hapton Parish Council. His last contact with Thomas Edison occurred on a visit to the United States in 1921. Joseph moved closer to the world of entertainment by becoming electrical consultant to the Blackpool Tower and Winter Gardens. In 1904 he joined Preston Town Council as Assistant Tram-way's Manager, becoming Manager in 1905 when he supervised the switch from horse power to electricity. He retired from his post as Preston's Chief Electrical Engineer in 1934.

★ ★ ★

For a short period, the kinetoscope was geographically and socially dispersed throughout the United Kingdom. Those who exploited the device came from many different backgrounds and held varying attitudes. They were merchants, electrical engineers, bicycle and sewing machine manufacturers, printers, pho-tographers, a caterer, an art dealer, a high-class dressmaker and an itinerant street musician (who just happened to be listed in *Debrett's Peerage*). The entertainment profession was represented by popular science lecturers, travelling showman, magicians, magic-lantern and phonograph exhibitors, theatrical retailers and music-hall managers. A variety of venues catered for a wide and, sometimes, homogenous public. Unlike theatres, music halls and public concerts customers were not segregated by graduated admission prices, physical arrangement or dress code. Kinetoscopes were ideally suited to the low-priced, egalitarian forms of entertainments that had started to be provided at exhibition centres, seaside piers and automatic amusement arcades. Whilst some kinetoscopes were exhibited alongside vulgar and risqué sideshows at fairgrounds, many became popular attractions at church fetes and charitable bazaars. Others were to be found in public houses, on beaches and in shops. They were even enlisted by the Conser-vative and Unionist Party at their election victory celebration held at the Queen's Hall, Westminster, in August 1895.

The kinetoscope might have continued to command public attention had it expanded its repertoire to include local scenes, views of national events or, perhaps, well-known performers accompanied by synchronised sound-record-ings. But the device became increasingly overshadowed by the prospect of projected films, suffering an almost total eclipse when they finally arrived. The audiences who settled comfortably back into their seats early in 1896 allowed themselves a collective sigh of relief:

> The world in general and London in particular has been given a new series of "living pictures" by some French inventors who have sufficiently tamed the kinetoscope to compel it to exhibit its wonders on the sheet of a magic lantern. No longer will the curious be compelled to hunt for pennies to deposit in a slot, and to bend the back at an angle of 45 deg. In order to gaze at a moving picture rather less than two inches square. Now you may go to the Marlborough Hall, alongside the Polytechnic –a theatre, by the way, which has been the scene of famous optical wonders in times past – and having handed in the customary shilling, you can sit at your ease and watch

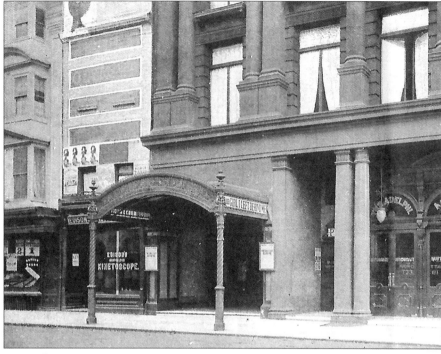

Fig. 42. A closed London kinetoscope parlour at 412 Strand, photographed between April and August 1895.

scene after scene pass before you, clearly shown on a white screen, with the figures of life-size proportions. Yesterday there was a fairly successful private view of the new show, although the inventors declared that they hoped to attain even greater perfection.[27]

As film changed in terms of projected image, overall length and diversity of subject matter the kinetoscope began to be regarded as an almost embarrassing plaything. Consigned with other 'toys' such as the Zoetrope and Praxinoscope to the attic of history, the device was generally ignored by those chronicling the story of cinema. The difficulties involved in researching such a short-lived phenomenon also contributed to its near exclusion from British film history. In 1946 Rachael Low and Roger Manvell chose to completely overlook the kinetoscope by starting their *The History of the British Film* in 1896. Thirty years later, in volume one of *The Beginnings of the Cinema in England* (published 1976) John Barnes referred to the kinetoscope as a London phenomenon, failing to mention any of its numerous provincial exhibitors or exhibitions.[28]

Despite years of historical neglect, the kinetoscope played a vital part at the beginning of cinema. Although individually and awkwardly viewed the device provided the first encounter with motion pictures for many thousands of people. It provided exhibitors with the experience of handling celluloid film, of assessing

audience reaction and introducing a new format into existing systems of enter-tainment. At this early stage, several themes were introduced that were to become major staple elements of film-making. A concentration on celebrity and variety performance had been established by Edison; whilst Paul and Acres demon strated film's potential for recording and relaying sporting events, scenic views and actuality scenes; and Acres alone, on his expeditions to Germany, had created the news film by depicting massive national ceremonies. Along with taking a far wider view of the world than Edison, Acres had also initiated an important and striking element of film technique by depicting subjects – waves, racehorses, Kaisers – moving towards and beyond the camera. Following the collapse of kinetoscope sales, the continuing availability of its films facilitated the expansion of projected film. With extremely few cameras developed by 1896 early exhibitors relied heavily on films originally made for the kinetoscope.

As most earlier attempts to create motion pictures encompassed magic lantern-like projection, the kinetoscope has sometimes been represented as a technologi-cal blind alley or as an impediment to the development of cinema. But Edison's tardiness in developing his own invention was not matched by other inventors who continued to work towards the goal of projection. In fact, the necessity to break Edison's monopoly of film production stimulated fresh and fruitful efforts. Many formats were considered, and many modes of exhibition trialled. As Deac Rossell has written 'the inventors and mechanics of the late 1890s foresaw many different cinemas'.[29] Although short lived, the success of the kinetoscope had been extremely profitable for its inventor and, following its decline, the ongoing commercial viability of individually viewed devices was demonstrated by the Mutoscope and Kinora. It was to take another ten years before the various groups with an interest in film exhibition coalesced to create an independent or separate 'cinema'. With more leisure time, increasing income and an unshakeable faith in scientific progress, the British public embraced many new forms of mass enter-tainment during the 1890s. For a limited period, the kinetoscope proved itself to be one of the most popular.

Notes

1. Hendricks, *The Kinetoscope*, 78.

2. *Sheffield Independent* (6 April 1893): 6.

3. A. Lomax, 'Kinetoscope and Lantern', *The Optical Magic Lantern Journal* (August 1896): 132–133.

4. *The Optical Magic Lantern Journal* (August 1896): 132-133

5. *Blackpool Gazette* (16 November 1894): 2.

6. UK patent 25,100. Filed 27 December 1894.

7. *Manchester Courier and Lancashire Advertiser* (5 May 1902): 9.

8. *Yorkshire Evening Post* ((4 January 1895): 4.

9. *English Mechanic* (5 April 1895): vii.

10. Ibid., vii.

11. *Derby Daily Telegraph* (10 October 1895): 4

12. *Cork Constitution* (5 October 1895): 4.

13. *Bradford Daily Telegraph* (12 June 1896): 2.

14. *Sheffield Daily Telegraph* (31 July 1896): 7.

15. *Sheffield Weekly Telegraph* (28 September 1895): 7.

16. *Lincolnshire Chronicle* (19 February 1897): 4.

17. Richard Brown, 'Films and Postcards', *Visual Delights Two*, (Eastleigh: John Libbey Publishing Ltd, 2005): 242.

18. *Kent and Sussex Courier* (12 April 1895): 5.

19. Ibid., 5.

20. *Burnley Express* (10 November 1888): 4.

21. *Burnley Gazette* (30 March 1891): 8.

22. *Daily Gazette for Middlesbrough* (26 February 1895): 1.

23. Ibid. (25 March 1895):1.

24. Barnes, *The Beginnings of the Cinema in England 1894–1901 Volume One*, 198.

25. *Burnley Gazette* (31 October 1896): 1.

26. Ibid. (25 November 1896): 1, and (16 December 1896): 2.

27. *Pall Mall Gazette* (21 February 1896): 9.

28. In the revised edition (1996) Barnes acknowledged 'no doubt Kinetoscope parlours were soon to be found in many provincial towns, but information about them is sadly lacking'.

29. Deac Rossell, *Living Pictures*, 162.

Chapter 14

The Machine as Evidence: The Survival or otherwise of the British Kinetoscopes

by Michael Harvey

Technology that has outlived its usefulness soon disappears and, once it does, we can quickly lose the capacity to understand how it worked and the experience of those who used it. In its brief existence, the kinetoscope initiated the global commercialisation of the moving image yet only a dozen of around 1000 machines manufactured have survived, due in some cases more to the dedication of individual collectors than the efforts of public institutions or the film industry.

Film, as a photo-chemical physical medium, is passing into history. An increasing proportion of people reading this have experienced moving images only in a digital form; for them, the notion of capturing and reconstituting movement as a series of images on a strip of celluloid probably seems arcane, the techniques involved in doing so an alien alchemy.

While a reliance on contemporary written accounts is an important aspect of any historian's body of evidence, it may give only a partial understanding of many subjects. By examining tangible objects, it becomes possible to gain a detailed knowledge of their form, function and place in history.

For example, a frequently-used source for the kinetoscope is the report in Gaston Tissandier's journal, *La Nature*, on 20 October 1894. The article's degree of detail and, particularly, the engravings by the journal's chief illustrator, Louis Poyet, two of which show the machine's interior, have ensured its importance. The

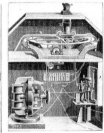

Fig. 1. The first two pages of Tissandier's article on Edison's Kinetoscope in *La Nature*.

section of Tissandier's article describing how it worked was extracted and published in English by the American journal, *The Literary Digest*, on 24 November 1894. The translation is not without error – for instance, the dimensions of a film frame are given as one sixteenth the size of a *carte-de-visite* rather than one sixth, as stated in the original – and reads somewhat awkwardly. Was this the fault of a translator unfamiliar with the technical jargon of a new technology, or does this reflect a degree of confusion in the original?

I have translated those passages dealing with the workings of the kinetoscope from the French original:

'With the kinetograph, Edison obtained his photographs on sensitive films, in the manner of M. Marey's method: he made the frames 2 centimetres by 3. The positives are printed on flexible bands of celluloid. These bands form a long ribbon which, during operation, runs at a high speed, driven by a sort of wheel. The photographs that are secured have been made in a very small fraction of a second; we can obtain 46 impressions per second, that is to say, two thousand, seven hundred and sixty per minute …These ribbons reach a considerable length and can contain several hundred images.

The kinetoscope in which this illusion is produced is the apparatus shown in Figure 2. It is enclosed in a wooden chest whose upper part is equipped with an eyepiece. You look through this to see a transparent photograph which is no bigger than a sixth of a carte-de-visite; all the characters are moving and the scenes are constantly animated in the most marvellous way.

How does this machine work? Figure 3 shows two compartments on top of each other; this shows the mechanism contained in one side of the cabinet. The other side is reserved for the ribbon of photographs, mentioned above.

At the bottom of Figure 3, in the lower compartment, we see the electric motor, C, that sets the mechanism in motion. It is an 8-volt Edison dynamo, powered by four batteries giving 80 amp-hours, at the rate of 3 amps. The current passes through a resistance, B, that can be varied to increase or decrease the light from the incandescent lamp; this illuminates the celluloid ribbon more or less, according to its thickness and transparency which is vary variable. Beside the motor, C, is another apparatus, AB, which we confine ourselves to describing its appearance; it is in some way independent of the kinetoscope and operates an automatic cash box which, when a coin is dropped into it, sets the machine in operation. This auxiliary unit may not be used.

In the top part of Figure 3, we see the metal disc, V, that forms a screen in front of the film ribbon, R. The small incandescent lamp that illuminates the ribbon is represented by L. The eyepiece, O, where the observer places his eyes, is mounted on a conical tube and protrudes from the top lid of the system. When the device is to be operated, the electric motor is switched on. By means of a mechanism of interlocked gears the motor rotates the circular disc V; this is provided with a slit, F, which allows the observer to see the photographs on the film ribbon shown at B, each time this slit passes under his eyes. Although the slit is the only one in the metal disc forming the screen, the disc turns with such great speed that the observer's eye does not perceive its rotation, and sees the successive photographs in a continuous manner

The photographic ribbon is integral with the horizontal disc to which it is connected by the gears; it rotates at the same speed and moves over the pulleys, PS. The speed of rotation is such that around forty-two photographs pass beneath the eyes of the observer in a second.

The film strip thus extends to about 15 metres in length; it forms an endless ribbon mounted on the front of the body of the kinetoscope, as shown in our Figure 4. The ribbon circulates around the pulleys represented, which are spaced from each other, from top to bottom, by 60 centimetres. We can count 750 chronophotographic proofs on the length of this celluloid film ribbon.'

I have attempted to simplify and clarify some of the 19th century formal language. Even so, it is still not easy to grasp exactly how the kinetoscope mechanism works. Tissandier exhibits the typical 19th century fascination with the statistics of new technology, giving various details about numbers of frames, film length and the running speed of the film[1] at two different points in his article which is a little confusing. He also fails to mention the important underlying principle of Edison's and Dickson's motion picture system – the sprocket holes along the film

Fig. 2. Edison Kinetoscope. Engraving by Louis Poyet (1846–1913).

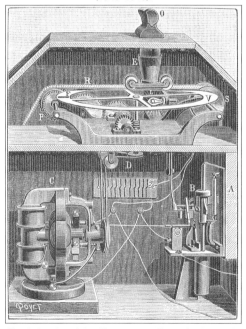

Fig. 3. Interior of the Kinetoscope. Engraving by Louis Poyet (1846–1913).

edge which ensured precise registration of successive images – despite Poyet's engravings clearly showing the teeth on the sprocket roller, P.

Even though they don't show the batteries, the illustrations are sufficiently detailed and accurate to act as the basis for an updated description of how the kinetoscope worked and was managed. A few extra photographs will show the details that Poyet did not. The following is based on my own acquaintance with two machines and is informed by the work of the American kinetoscope expert Ray Phillips (of whom, more later):

The kinetoscope viewer is contained in an oak cabinet, 123cm high by 46.5cm wide by 69cm deep, shown in Figure 2. The viewer looks through an eyepiece magnifier at the top to see what appears to be an illuminated moving image below, derived from a continuously moving strip of 35mm wide film printed with a succession of individual photographed images.

Figure 3 shows the interior of the side of the machine facing us in Figure 2. At the bottom left is an eight-volt Edison motor, powered from four 80 ampere-hour batteries (not shown) that were normally positioned on the right. The motor draws a current of three amperes so, in theory, the batteries would last for over 24 hours of running time before requiring re-charging.

It is possible to change the motor speed to run the kinetoscope at a slower or faster rate to accommodate films shot at different speeds, and to vary the brightness of the light shining through the film to compensate for variations in print density. This is achieved by connecting the power lead from the batteries to an appropriate point on the resistor, D – the closer the lead is inserted to the resistor's output, the faster the motor and brighter the light, and *vice versa*.

A drive belt runs upwards from the motor, around a couple of pulleys, to the bottom of the main drive shaft, just above D. The drive shaft passes though the base of the main assembly and rotates the shutter, V, screwed to the top of the shaft. The shutter, about 29cm in diameter, has a small 3mm slit, F, which allows a brief flash of light from the lamp, L, through each successive frame of film. The viewer sees a succession of images so rapid that they appear to be constantly moving.

Near the base of the drive shaft is a worm gear, W, that engages with a horizontal gear shaft that connects with two inter-connected gears at the far side (in this photograph, the shutter has been removed to show the mechanism).

175

These gears rotate the sprocket roller, P, whose teeth engage with sprocket holes on both edges of the film to move it through the machine. The gearing is so designed that it advances the roller by one frame of film for each rotation of the shutter.

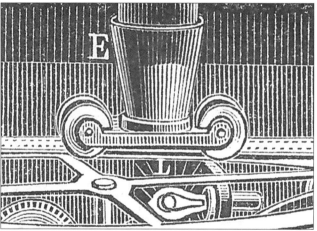

At the top, beneath the eyepiece, is a removable black cone, E, that sits just above the film. Its purpose is to prevent stray light from reaching the top surface of the film and also focus the viewer's attention on the rectangular aperture (the film gate) beneath which the film moves continuously.

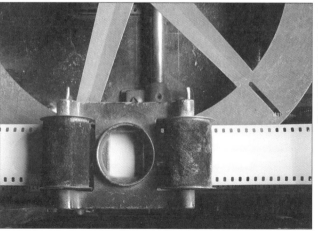

There are two small velvet-covered rollers either side of the film gate that bear down on the film, keeping it flat. Beneath the film is the rotating shutter, whose slit allows light from the bulb below to illuminate the film. In this photograph, blank film is shown.

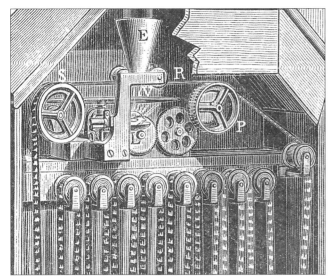

Emerging upwards from the spool bank, the film passes from left to right across the top, over the left hand idler roller, S, beneath the two small rollers and then over the sprocket roller, P, whence it returns down to the spool bank. Just beneath the shutter, V, is the lamp, L, with an upward-facing reflector.

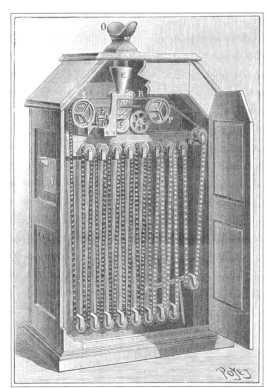

Fig. 4. Edison Kinetoscope: interior view showing spool bank and film path.
Engraving by Louis Poyet (1846–1913).

Figure 4 shows the interior from the opposite side (i.e. to the right of the viewer in Figure 2). This compartment houses the film and drive mechanism. The film loop is stored on a series of felt-covered rollers called a spool bank. There are eight pairs of fixed rollers and a single, floating roller on an arm, tensioned by a spring, which bears lightly on the film to keep it running smoothly.

The Kinetoscope Company issued precise instructions[2] on how to load a film, align the shutter slit with the film frames and adjust the lamp position. When new, the machine's shutter came separately and was first fitted onto the drive shaft, with its retaining nut left lightly tightened for later adjustment.

The spring was unhooked from the tension roller. The film loop was then unwound from its tin,

carefully drooped over the top of the two small rollers above the film gate, making sure the film ran from left to right with the top of the frames at the right, and then fitted between the flanges of the left-hand idler roller, S. The film was then re-sited under the small rollers and engaged with the sprocket roller, P.

The rest of the film loop was threaded up and down across all the rollers in the spool bank including the floating roller, and the spring attached to the exact point on the arm to tension it perfectly. This required care, as the film could tear during operation if the tension was too loose or too tight.

Next, the shutter was adjusted so that the slit would allow light through to the film gate at the precise moment a full frame was aligned within it. The operator slowly moved the film by manually rotating the shutter until a frame was centred in the gate. Then he loosened the retaining nut on the drive shaft and rotated the shutter until the slit was in the centre of the aperture, and then re-tightened the nut firmly.

The lamp reflector was moved to insert a bulb and adjusted to give an even, bright light. The operator then ran the machine and looked through the lens to check that it ran correctly. If the lines between the frames were visible, this was corrected by making small adjustments to the shutter position after stopping the machine. Once set, the kinetoscope was ready to show the film to customers.

Fig. 5. Four-position switch at the back of the kinetoscope.
Left, external view; right, internal view – the inverted 'L'-shaped lever releases the latch and turns the kinetoscope off when its attached wire is pulled.

In kinetoscope parlours, the machines were started by staff. The earliest version used in parlours had a knob on the end of a rod at the rear, connected to an internal switch that, when the rod was pulled, started it. This was soon replaced by a pivoted metal switch. It makes contact with four metal studs. That on the left (the 'off' position), has no electrical connection. The other three are connected to two resistance coils on the other side of the panel, inside the machine. As the

switch is moved clockwise, it makes contact with the second stud and sufficient power is released though both coils to allow the motor to tension up the drive belt and the kinetoscope mechanism. At the third stud, enough power passes through a single coil for the motor to overcome the mechanism's inertia and start it moving. At the fourth stud, direct contact is made and full power is applied, getting the machine fully up to speed, and the lever is latched in position. This system minimised the risk of damaging the film which could occur if the machine was started at full power.

The kinetoscope was turned off by a mechanism activated by the rotation of the idler roller, S. As it turns, a worm gear, like that on the drive shaft, engages with a worm wheel and rotates it at a relatively slow speed. On the wheel is a protruding pin when, once the wheel has completed a revolution, trips a lever attached to a wire that passes down to another lever on the side of the switch, releasing the latch so that the switch springs back to the 'off' position.

In the coin-operated kinetoscope – it was originally designed for that mode of operation – when a coin was inserted, it fell down a chute and became wedged between two sprung electrical contacts, completing the circuit and starting the machine. It was switched off using an adaptation of the stop mechanism that terminated in a rotating arm which temporarily forced the contacts apart and allowed the coin to drop.

But what of the films shown in the kinetoscope? Their production involved nothing less than a revolution in photographic techniques. Indeed, Thomas Blair[3], the film manufacturer whose products were used by both Edison and Paul, called the kinetoscope 'a photographic invention'[4] rather than an electrical one. He may have been biased, but for the new practice of cinematography to succeed, a huge scaling up of traditional photographic methods was required to handle the volume of film to be developed and printed, as well as to deal with the close tolerances required in the physical dimensions and characteristics of the materials used. The celluloid nitrate film stock[5] coated with light-sensitive silver salts in a gelatin emulsion produced by Eastman in the US and Blair, first in the US and then in Britain, came in two versions – one of higher light-sensitivity for use in the camera, where exposure times could be as brief as 1/100 second per frame, and another much less sensitive stock used for printing. Dickson used Blair's film stock for all the kinetoscope productions until September 1896. Its matt base was particularly suitable for prints because it diffused the light produced by the kinetoscope's clear filament bulb. Acres, the photographic expert in the Paul-Acres partnership, used Blair film for the Kinetoscope negatives and prints, but later on Paul favoured Eastman's film for camera use, as the transparency of its base resulted in clearer prints from the negative.[6] At that period, no film was sensitive to the red part of the spectrum, so lips and skin tones were reproduced much darker than they appear to the eye; however, this meant that films could be safely handled and observed in red light in the darkroom during processing without fear of 'fogging', or obliterating, the images on them.

179

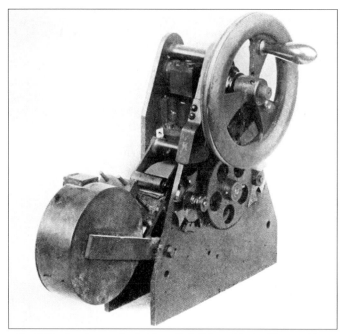

Fig. 6. 'Paul's rotary perforator' from F. A. Talbot, *Moving Pictures: How They Are Made and Worked.*

Raw film was supplied, un-perforated, in 50 foot rolls so before it could be used in the camera it was prepared in the darkroom by running it manually through a specially-constructed perforator. There were various designs of perforator. Paul stated that 'For perforating the film I made, for use in an ordinary fly press, a set of punches 32 in number, made to the Edison gauge, and fitted with pilot pins',[7] a rather laborious method involving punching out sprocket holes in the film, section-by-section. Acres, however, stated that he had commissioned the celebrated instrument-maker R W Munro to make a rotary perforator for him in 1895.[8] Such perforators consisted of two interlocking rollers, one of which had a series of punches around its circumference and the other a series of dies. The film was fed between the rollers and, as they turned, rectangular, round-cornered sprocket holes were punched along both sides precisely 3/16 in (4.75 mm) apart along its length, leaving just sufficient space for the one-inch-wide (25.4 mm) picture between the two rows of perforations.[9]

The process of exposure in the camera produced changes in the structure of the silver salts that could only be made visible by chemical development, which converted the exposed salts into microscopic grains of silver, followed by fixation, which dissolved the remaining unexposed silver salts, thus making the film safe to handle in light. Various methods were used to ensure that every part of the fifty-foot length of film was immersed in the chemical baths and received even development.

180

Fig. 7. Dickson's drawing of his film drum and trough system

Dickson's[10] approach to this problem was to wind the film, emulsion-upwards, spirally around a long metal drum that was then suspended in a shallow trough containing the developing solution and continuously rotated so that every part of the film was immersed in the liquid.

In Britain, Acres devised a method,[11] adopted and claimed by Paul after their partnership broke up, where the film was wound around a rectangular wooden rack designed to prevent any part of the film's surface touching another. This was then immersed into a trough or vertical tank holding the chemicals. The rack could be moved or 'agitated' during development to displace any air bubbles on the film's surface and allow fresh developer to reach the film.

Fig. 8. 'Paul's Complete Developing, Printing and Drying Outfit'. Left to right: rack for film, vertical trough, safelight, drying drum, sink and another film rack.

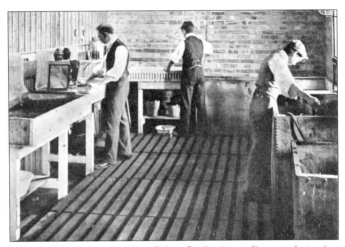

Fig. 9. 'Developing room ... at Robert Paul's pioneer film manufactory' from F. A. Talbot, *Moving Pictures: How They Are Made and Worked*. This is arranged in a 'U'-shaped configuration, with a developing sink at left – note safelights to enable inspection of the film to check progress – through to deep wash tanks with running water at right.

In both Dickson's and Acres' methods, when development was judged to be complete, the film holder was transferred to a water trough or spray to rinse off the developer, then to a fixing bath which removed the residue of unexposed silver salts, following which operations could continue in normal light. The film was washed thoroughly in running water and then put through a solution containing glycerine in order to counteract its tendency to curl and shrink in drying.

Fig. 10. Drying room at Paul's laboratory laboratory from F. A. Talbot, *Moving Pictures: How They Are Made and Worked*.

Drying was best done in a situation in where air could freely reach the film so that all of it dried at a uniform rate to minimise uneven shrinkage. This was achieved either by looping the films from ceiling hooks or by winding them onto large slatted drums that were hung in a heated room. The photographs of Paul's laboratory shown here date from after the kinetoscope period but illustrate the basic principles of early ciné film processing.

When dry, the negative was wound onto a spool ready to be printed. Printing again took place in a darkroom as unexposed, 'raw', film was used. Both Dickson and Acres devised printing machines in which the negative and the print stock were brought into contact, emulsion-to-emulsion, on a sprocket roller or drum – the negative on top, print stock beneath. The negative was exposed to light, causing positive images to be printed on the print stock that were revealed during subsequent chemical development.

In Dickson's electrically-driven machine, a sprocket drive bore down on the negative film to ensure the essential close physical contact with the print stock; over the top of the drum was a light source controlled by a resistor so that the operator could set the exposure as the films moved slowly through the machine.

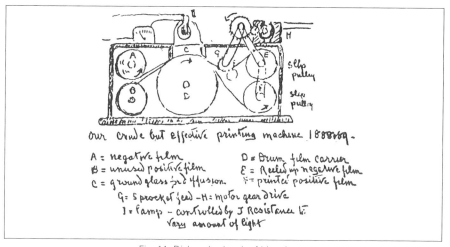

Fig. 11. Dickson's sketch of his printer.

Acre's hand-cranked printer employed a gas lamp behind a narrow slit above the sprocket roller. The operator judged the cranking speed (and thus the exposure time) by looking at how light or dark the negative was in the red safelight. This might sound a rough and ready technique but, over time, workers finessed their skills, evolving into the 'graders' and 'timers' of the film laboratory industry as its technology developed.[12]

When the two films had run their length through the printer, the print film went through a similar processing procedure as the negative. The finished print was trimmed to length[13] and the two ends joined together to form the endless loop

required in a Kinetoscope, after which it was carefully looped into a can, ready for despatch to the Kinetoscope operator when required.

There are only five surviving examples of kinetoscopes used in Britain. Three are not where you might expect them to be. Collectors, museums, inheritance, funding – or its absence – and the vagaries of the auction market have all played a part in determining their current locations.

Sadly, the only example of a Paul kinetoscope, in the Musée des arts et métiers in Paris, is in a forlorn state owing to an ill-judged attempt to replace its mechanism with a modern one.[14] Paul donated a small and important collection of equipment to the Science Museum, London in 1913 and it is probably fair to assume that had he still owned a kinetoscope he would have included it.

The Science Museum played a significant role in the history of three kinetoscopes used in Britain. In April 1918, Lieutenant Colonel Moore-Brabazon (later, Lord Brabazon), an aerial photographic reconnaissance pioneer in World War 1, wrote to the Museum's Director, Francis Ogilvie[15], alerting him to the collection of 'the very earliest and irreplaceable specimens of early cameras and projectors'[16] assembled by the cinema pioneer Will Day[17] which Moore-Brabazon thought should be acquired 'before they get damaged or lost'. David Baxandall,[18] the Museum's Keeper of Scientific Instruments, visited Day to view the collection, and recommended that the Museum should acquire it on loan for display. Day would have none of it, citing worries that, as he was writing a book[19] about the history of cinematography based on his collection, its display would allow 'others to usurp my collection of apparatus and data'.[20] But he left the door open for a future acquisition.

Two years later, with a new Director, Henry Lyons,[21] in post, Baxendall met Day again to discuss acquisition. Day was unwilling to donate the collection but an appeal he made in the trade press 'to induce those ... who have made fortunes out of the business' to purchase his collection, worth 'some thousands of pounds'[22] for the Museum produced no response. The Science Museum could not find a benefactor either, and a disappointed Day wrote to Lyons that 'as you know, I have received a very tempting offer from America ... and as I am in need of the money, it is certainly a temptation which is hard to resist, but I do feel that it should be kept here in this country as it is so important from a National point of view'.[23]

So matters remained for two years, then Lyons approached Day on 6 June 1922 about borrowing part of his collection to display in new gallery space at the Museum. Day grasped this opportunity and for the first time drew up a detailed inventory of items, amongst which was listed a 'Kinetoscope with motor, films &c, the first instrument brought to England by Tragidis and Georgiades from Edison in America, 1893'. Its description in the catalogue,[24] published when Day attempted to sell the collection in 1930 reads: 'This is the original Kinetoscope brought to England in 1893 (sic) and shown at their offices in Old Broad Street, London by Trajidis (sic) and Georgiades. The number of this instrument is 69,

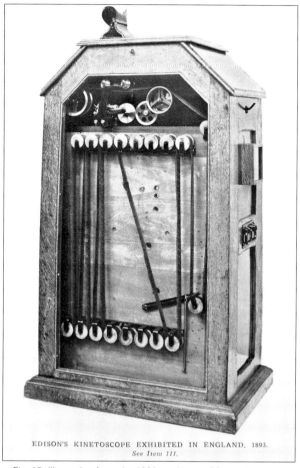

EDISON'S KINETOSCOPE EXHIBITED IN ENGLAND, 1893.
See Item 111.

Fig. 12. Illustration from the 1930 catalogue of Day's collection showing kinetoscope no. 69. The ear tube exit proving it was a kinetophone can be seen at the top of the rear panel (right of picture).

and it is complete with original electric motor, film, viewing lens and gallery of rollers for film manipulation.'

The provenance of this machine has been traced. The earliest of all ssurviving kinetoscopes, it was one of two (nos. 69 and 84) purchased from Holland Brothers, New York by Tragidis and Georgiades in 1894. They sold both, probably when their business was wound up in February 1895, to James D Walker, at that time a peripatetic exhibitor, who recounted using them in Bournemouth.[25] Walker and two partners later established the important film distribution and cinema supply company Walturdaw. After Walker's death, Day bought kinetoscope no. 69 from his widow, Mary, a pioneering female projectionist. Nothing is known about the fate of the other machine.

185

Day's machine had, in fact, been converted to a kinetophone at some point but this was not realised by Day or the Science Museum curators, as the phonograph was missing. However, the photograph published in Day's catalogue clearly shows the exit for the ear tube at the rear of the machine.

The Science Museum received Day's items on 27 June 1922 and by 26 August they were on display, to be joined in November by his latest acquisition, the Lumière Cinématographe used by Félicien Trewey for the first cinema show at the Polytechnic Institution on 20 February 1896. The exhibition, however, closed in September 1923 as the galleries had to be handed over to the Imperial War Museum. Three years elapsed before building work on the new East Block was sufficiently advanced for a suitable display space to become available. In October 1926, the first signs of tensions between Day and the Museum appeared. Moore-Brabazon, by then an MP, wrote to Lord Percy, President of the Board of Education, the government department responsible for the Museum, about Day who had complained of the 'formal and red-tapeish way' it was dealing with him. 'I'm not saying the Science Museum have been anything but perfectly regular in their correspondence with him', Moore-Brabazon wrote, 'but the old thing wants patting on the back and a bit of encouraging, and perhaps you would drop a hint to this effect to the Museum? If you make a small fuss of him you can do anything with the old man.'[26]

'Another generous lender has complained that Mr Day has received more consideration than he is entitled to!' exclaimed an exasperated Lyons in a memo. 'Mr W Day is not a little tiresome and expects that *everything* that he gets together must be placed on exhibition.'[27] But ruffled feathers were smoothed for the time-being, though continuing problems with the Museum's building programme and consequent pressures on gallery space caused frustrations over the next few years, as did Day's numerous unsuccessful attempts to sell his collection.[28] Nevertheless, it remained at the Science Museum,[9] displayed in handsome mahogany cases, well beyond Day's death in 1936. Indeed, a further 20 years passed, with several efforts at selling it by Day's sons, and attempts to raise money for its public purchase involving the Museum, the British Film Academy and the British Film Institute among others: all to no avail.

In 1953, Alexander Barclay,[30] the Keeper of Chemistry and Photography responsible for the cinematography collection, wrote to the Director, F Sherwood Taylor,[31] arguing a case for purchasing Day's collection which was by then being offered for £10,000. He suggested that the Science Museum's purchase grant should be doubled to £2,000[32] in 1954 and used entirely as a down-payment on the collection, in the hope of encouraging benefactors to contribute the rest. Responding to this radical proposal, the Director naturally asked 'how badly do we want this?'. He would have to face the task of negotiating this with civil servants at the Ministry of Education and justify the decision to deny funds to curatorial staff in other departments of the Museum. In a footnote written in 1958, Barclay commented: 'This project was left in abeyance ... it was thought that it could wait until a more favourable time, financially, presented itself'.[33]

That opportunity presented itself sooner than expected, and from an unexpected source: Henri Langlois of the Cinémathèque Française. With funds promised by the Minister of Culture, André Malraux, he purchased the collection in 1959 for 17 million old francs (approximately £12,334), and moved it to Paris in 1961.[34] But this trophy, which boosted the Cinémathèque's prestige as much as it diminished Britain's cultural heritage, was immediately consigned to a store. 'Several dozen magnificent instruments were released from their boxes in 1972, on the occasion of the opening of the Musée du Cinema at the Palais de Chaillot. But the rest of the collection remained hidden in the basement.'[35] The collection was finally catalogued by Laurent Mannoni between 1994 and 1996.

British film historians who understand the importance of technology still lament the loss of the Day collection. Some have blamed the perceived indifference of Science Museum curators for this loss but the evidence suggests the opposite: the will was there but the funds were not. Nor was there much support from the British film industry for securing the collection. It took a charismatic, driven Frenchman with access to the highest levels of government to show how it could be done.

In 1992, Ray Phillips was commissioned to restore Day's kinetoscope to a kinetophone. He made parts for the phonograph and replica pulley wheels copied from a kinetophone in Australia, acquired an Edison motor from an American collector, had a base made for it, and replaced the drive belts and ear tube assembly to make the machine the most complete kinetophone in the world.[36]

Well before it lost Day's collection, the Science Museum acquired its own kinetoscope and kinetophone. Its modest annual purchase grant meant that without additional financial support it could never acquire the collection at the price Day wanted, and if it were sold elsewhere the Museum would find itself with empty display cases. As a form of insurance, the Museum's workshops made excellent copies of some of the objects but not the kinetoscope. So an approach from artist, author, collector and Soho gallery owner, W Townley Searle[37] in May 1930, around the time Day published his sale catalogue, must have been welcome. 'As I understand you are losing the Will Day collection', Searle wrote, 'if you care to have my own to take its place, I shall be pleased to loan it'.[38]

Unsurprisingly, his collection turned out to be neither as extensive nor as important as Day's but it included an incomplete kinetophone that excited Alexander Barclay's interest: 'It differs from Day's example[39] by having a phonograph attachment inside the case, thus constituting one of the earliest 'talking picture' machines. Mr Searle is willing to lend it for exhibition or would sell the instrument for £6, the sum it has cost him to assemble it. ... He has now assembled all the parts he can secure but it is still incomplete. In view of its importance, I would suggest that the remaining pieces could be copied in the workshops from Day's example if the latter could be returned afterwards.'[40]

It was bought for £6 but Barclay never implemented his suggestion and the kinetophone remains largely as it did when it arrived at the Science Museum.

The kinetoscope came through a referral from Ernest Lindgren, Curator of the British Film Institute's National Film Library[41] in July 1948. James Henderson, son of the Stockton-on-Tees showman George Henderson, had offered it to the Library. Lindgren usually regarded technology as outside the Film Library's remit but was prepared to put forward a case for collecting it if the Museum was not interested, as 'the kinetoscope is the parent of commercial cinematography, and one on which films could actually be run would have a special interest for us'.[42]

On writing to Henderson, Barclay discovered that he had a range of equipment and films on offer that merited a visit to Stockton-on-Tees to inspect. Along with the kinetoscope, Barclay decided to acquire two projectors and two films. Henderson wanted £20 for the working kinetoscope, which included a 6 volt car battery used to power it. Barclay did not want a hazardous, inauthentic battery and an exchange of letters negotiating an adjustment in price went back and forth. 'Mr Henderson is a difficult man to come to terms with,' Barclay reported to the Director, 'and I suggest the only way of dealing with him is to make an inclusive offer for the lot'.[43] He offered £28, though he was prepared to increase it to £35. But Henderson accepted, and the Science Museum acquired kinetoscope no. 509.

Sadly, both machines, now at the National Science and Media Museum[44] in Bradford, are incomplete. The kinetoscope, curiously, has no eyepiece and the kinetophone, like some other machines in public collections, has had door panels replaced with glass to reveal the inner workings.

Indeed, according to Ray Phillips, *all* the surviving kinetoscopes are incomplete – but in different ways! Over a lifetime of study, starting in his teenage years in the 1930s, he has closely examined the kinetoscopes in public and private collections around the world. With that unique experience, he built up a comprehensive knowledge of the interior workings of the kinetoscope and used it to construct exact working replicas and restore some of the original machines.

By profession an insurance broker who ran his own business for 41 years – he admitted he 'didn't enjoy that at all'[45] – Phillips spent his spare time working to preserve Los Angeles' early architectural heritage,[46] making daguerreotypes, the earliest form of photograph, and pursuing his passion for Edison's phonographs and kinetoscopes. He epitomised the classic virtues of a collector, building an extensive knowledge and experience of his subject, unfettered by the concerns, accountabilities and distractions to which curators in public institutions are subject.

A unique example of a kinetoscope used in Britain passed through his hands. This came to market through Sotheby's in London on 2 October 1992. It was owned by a Devonshire family whose grandfather, Frederick Alexander Berrington, had reputedly bought it, a phonograph and a set of films in America while he was working on the Canadian Pacific Railway, and toured as a showman before returning to Britain with the machines around 1900.[47] But research by Richard Brown casts doubt on this romantic family folklore. According to the Edison shipment records,[48] the machine, no. 141, was one of a batch of ten sold

to Franck Maguire and despatched to London in September 1894. It was probably sold off when the Oxford Street kinetoscope parlour closed.[49] Berrington must have acquired it at that point or shortly afterwards. By 1901, he was living in Exeter and working as an agricultural feedstuff storekeeper.[50] On his death in 1945, the kinetoscope passed to his son George who, having been denied access to it through his childhood, experimented with getting it to work.[51] It was seen in working condition by John Huntley of the BFI in 1963.[52]

The auction proved to be exciting. Ray Phillips described it in a letter to a friend on 21 October 1992:

'The room was full, with standees at the back. As I was rather well forward I could not tell what bids might have come from there. However, I spoke to one man later, a collector from Austria. He said he had bid up to 15,000 pounds.

'Anyway, I don't remember where bidding started, probably at 8,000 pounds, but went up 1000 pounds at a time until I stopped at 17,000. A Mr Barnes, who, with his brother had a motion picture museum in Cornwall, now closed, but they still have the collection, bid 18,000. Then the auctioneer announced a 'left bid' of 19,000. That seemed the end, but my wife, who was sitting to my right, held up her hand toward me with her fingers spread out. I realised that *she* wanted me to bid 19,500 pounds, so I did and won the bid! *Isn't* that a wife for you!'[53]

Unknown to him at the time, the BFI was one of the unsuccessful bidders. Like the Science Museum with the Day collection, another public institution had been thwarted in its efforts to secure an important object. The kinetoscope had sold at a world-record price, well above its catalogue estimate.

When the kinetoscope arrived in California, Phillips examined it in detail.

'It has the appropriate Edison motor which was not operable when it arrived. One connecting wire was broken; one missing. The motor had had its original 4 ½" round metal base removed, as well as the 8" square, 1¼" thick board that it originally sat on. There were signs on the bottom of the motor compartment where the board had sat; even where the screw holes had been. A surviving board on #69, at the Cinémathèque Française, confirmed the 4 ½" base to the motor. I have seen one other motor with the base, at the Henry Ford Museum, and have a woodcut of a motor with the base on, as well. The on/off switch had been taken off the back of the motor compartment and was lying loose. The original wiring had all been removed. The original light and its socket had been removed and a six-volt automobile type bulb substituted, apparently operated directly from 220 volts, as there was a small transformer in the accumulation that came with the machine, to reduce 220 to 6. I don't know how they actually powered the motor as it is designed to run on 8 volts DC and, as I said, everything was disconnected; even the motor, attached only to a narrow oak board, which was in no way original. We would all like to think that this machine was in 'original condition', but no way!'[54]

Phillips restored it to working order and was intrigued to discover evidence that it was a unique example of a kinetoscope that used the early pull-rod starting mechanism.

In 1994/5, the machine returned to Britain, though that was not to be the end of its travels. Phillips sold it privately to Gordon Trewinnard, a British collector with a life-long interest in photography and early cinema apparatus. Trewinnard commissioned a notable project in 2000 to make exact working replicas of 14 of the earliest motion picture cameras and, with cinematographer John Adderley, used them shoot test film sequences – a remarkable proof of concept.[55] He sold the kinetoscope in another private sale to Qatar Museums in 2008/9 where it is in storage awaiting the completion of a new museum.

So, of the five surviving machines used in Britain, the two best examples are in foreign collections. This was almost entirely the result of a superior purchasing power that, sadly, British public institutions were in no position to match.

Notes

1. The issue of frame rate has long been a matter of debate among film historians but the fact that the machine was designed to allow variations of running speed suggests that the shooting of films at different speeds was anticipated. John Barnes in *The Beginnings of The Cinema In England, 1894–1901*: Volume 1: 1894–1896, quotes the Blackpool lanternist and kinetoscope showman Alfred Lomax as stating 'the pictures move at an average speed of 30 per second (though this is sometimes very much increased)'.

2. A copy of this is illustrated in Phillips, *Edison's Kinetoscope and Its Films*, 35.

3. Canadian-born Thomas Blair (1855–1919) moved to the US and began manufacturing celluloid roll film in 1891. His firm, the Blair Camera Company, was the main rival to Eastman. He moved to England in 1893 and established the European Blair Company with a factory at Foot's Cray, Kent. Up to September 1896, Blair was Edison's major supplier of film for the kinetoscope.

4. 'The Photographic Revolution: Interview with Mr T. H. Blair', *Black and White* (20 July 1895): 79.

5. A detailed account of the manufacture of 35mm celluloid roll film and its adoption as the film industry standard can be found in Spher, Paul C., 'Unaltered to Date: Developing 35mm Film' in *Moving Images: From Edison to the Webcam*, eds. Fullerton, John & Söderbergh Widding, Astrid (London: John Libbey & Bloomington: Indiana University Press, 2016), pp. 3–28. It is also worth looking at Mees, C. E. Kenneth, *From Dry Plates to Ektachrome Film: A Story of Photographic Research* (New York: Ziff-Davis Publications, 1961).

6. Spher, Paul C., 'Unaltered to Date: Developing 35mm Film', pp. 16–17 lays out the sequence of events.

7. Paul, Robert W., 'Kinematographic Experiences', *Journal of the Society of Motion Picture Engineers* (November 1936): 497.

8. Acres was ever ready to set the record straight about who did what in his partnership with Paul. His annotations in a copy of the first edition of Frederick A. Talbot's *Moving Pictures: How They are Made and Worked*, now in the BFI Library, contest Talbot's account of Paul's achievements. Here, he asserted that Eastman Kodak at Harrow refused to supply cine film 'as late as 1896 … it not being worth their trouble', and that he had commissioned the perforator – reasonably so, as Acres shot the films and would have needed one.

9. For further information about perforators, see Hopwood, *Hopwood's Living Pictures* (1915): 159–166; and Talbot, *Moving Pictures* (1914): 60–64.

10. Dickson, W. K. Laurie, 'A Brief History of the Kinetograph, the Kinetoscope and the Kineto-Phonograph', *Journal of the Society of Motion Picture Engineers* (December 1933): 435–455.

11. The claims made by Acres about his authorship of the processing methods in his annotations to Talbot's book appear logical.

12. For an overview of how the film laboratory business developed from these basic beginnings, see Crabtree, J. I. 'The Motion Picture Laboratory' in *A Technological History of Motion Pictures and Television*, Fielding, Raymond (ed.) (Oakland: University of California Press, 1983), 150–171.

13. Although films were nominally 50ft. long, some of the footage at the beginning was inevitably sacrificed due to light fogging while lacing up the camera and over-exposure as it ran up to speed. Spehr, *The Man Who Made Movies: W. K. L. Dickson*, 330, makes the point that most prints were 40ft long.

14. The machine is described in Phillips, *Edison's Kinetoscope and Its Films*, 100.

15. Sir Francis Grant Ogilvie (1858–1930), physicist and engineer. Director of the Science Museum from 1911 to 1920.

16. Letter dated 16 April 1918. Science Museum Registry File No. 544.

17. Will Day (1873–1936), a man of many parts – cyclist, elocutionist and magician – was inspired to become involved in the British film industry by the early shows of Paul and Trewey. At first a projectionist and cinema-owner, he finally became a film equipment dealer. He began collecting apparatus, films and manuscripts relating the early history of cinema in the early 1900s and spent many years writing a history "25,000 Years to Trap a Shadow", which was never published. He championed his friend, William Friese Greene, as the inventor of cinematography.

18. David Baxendall (1874–1938), the son of a Yorkshire grocer, gained a scholarship to the Royal College of Science. He joined the Science Museum in 1898, where he assembled a remarkable collection of astronomical and optical instruments and rose to be Deputy Keeper of the Science Division. His son, David, became Director of the National Galleries of Scotland.

19. Day had started writing his book in 1914, as reported in *The Bioscope* (28 May 1914): 900.

20. Letter from Will Day to F. W. Fulcher, Science Museum, 23 April 1918. Science Museum Registry File No. 544.

21. Colonel Sir Henry Lyons (1864–1944) was a geologist and Director of the Science Museum from 1920 to 1933.

22. Memo from David Baxendall to Director, 27 May 1920. Science Museum Registry File No. 544.

23. Letter from Will Day to Henry Lyons, 30 June 1920. Science Museum Registry File No. 544. The possibility of an American bid lurked in the background for some years, as it is mentioned in the article, in *Kine* (15 August 1929): 28, that announced Day's decision to auction his collection. At that time, a similar, equally unfruitful, appeal was made 'to those who may have profited by the development of the kinema to ensure the retention of this invaluable collection in British hands'. In a letter to Lyons on 30 July 1929, Day had given the contractual six-month notice to withdraw his collection from the Science Museum.

24. *The Will Day Historical Collection of Cinematograph & Moving Picture Equipment* (London: Harris & Gillow, 21 January 1930). Lot 111.

25. See J. D. Walker 'The Early Days of Cinematography', *The Bioscope* (12 December 1912)): 811–813.

26. Letter dated 27 October 1926, Science Museum Registry File No. 544.

27. Memo dated 29 October 1926, Science Museum Registry File No. 544.

28. On 3 June 1936, encountering severe financial difficulties, Day wrote to the Director, E. B. Mackintosh, asking if the Science Museum was in a position to purchase his collection. It was not, and Mackintosh told Day that he considered the price that the auctioneers were asking was 'prohibitive'. An internal Museum estimate valued the collection between £771.25 and £1741.50.

29. The kinetoscope was displayed at the exhibition organised as part of the *Homage to Louis Lumière* at the Polytechnic Institution on 20 February 1936.

30. Alexander Barclay was a chemist who served in the Special Gas Division in World War 1. He joined the Science Museum in 1921 and rose to become Keeper of Department IV, comprising chemistry, photography, optics, astronomy and mathematics, in 1938. In World War 2, his expertise was employed in Churchill's 'Department of Dirty Tricks'. His prime interest was photography. He retired in 1959.

31. Frank Sherwood Taylor (1897–1956), chemist and historian, was Director of the Science Museum from 1950 unto his death.

32. The Science Museum Annual Purchase Grant had been £1,000 since the 1930s, and had to serve the needs of all its 30 departments.

33. Memo, dated 24 August 1953 with annotation on 12 December 1958. Science Museum Registry File No. 544.

34. See pp. 192–193, Myrent, Glenn and Langlois, Georges P. (translated from the French by Lisa Nesselson), *Henri Langlois First Citizen of Cinema* (New York: Twayne Publishers, 1995).

35. Mannoni, Laurent, *Le Mouvement Continué. Catalogue illustré de la collection des appareils de la Cinémathèque française* (Paris: Cinémathèque française/Musée du Cinéma, 1997), 18.

36. Letter from Ray Phillips to Howard Hope, 31 October 1992. Private collection. Pictures of the kinetophone can be seen at http://www.cinematheque.fr/fr/catalogues/appareils/collection/visionneuse-de-film-35-mmap-95-1750.html

37. W. Townley Searle was a colourful character. Having formed a Gypsy and Folklore Club in 1911, he almost immediately fell out with the painter Augustus John, its President, who in a fury smashed the windows of the club! He wrote dubious bibliographic books on W. S. Gilbert and a Chinese cookery book. But he was sufficiently celebrated to merit a full-page portrait in a 1925 edition of *The Studio*.

38. Letter, 2 May 1930 to the Science Museum. National Media Museum object file 1930-486 (now incorporating Science Museum Registry File 3593, Townley Searle).

39. Interestingly, Searle wrote to Barclay on 31 May 1930 that 'My man says he will be able to finish the 'Kinetoscope' by the end of next week for certain ... He has seen the machine on display at the Science Museum and tells me that your specimen has no phonograph attachment'. Unfortunately, we don't know who 'my man' was but he seems knowledgeable enough to have recognised Day's machine as a kinetophone.

40. Memo from Alexander Barclay to Director, 24 June 1930. National Media Museum Object File 1930-486 (now incorporating Science Museum Registry File 3593, Townley Searle).

41. This was re-named the National Film Archive in July 1955.

42. Letter from Ernest Lindgren to Barclay, 6 July 1948. National Media Museum Object File 1948-277 (now incorporating Science Museum Registry file 8553, James Henderson).

43. Memo from Barclay to Director, 30 August 1948. National Media Museum Object File 1948-277 (now incorporating Science Museum Registry file 8553, James Henderson).

44. Founded as The National Museum of Photography, Film & Television in 1983, it became the National Media Museum in 2006 and was re-branded as the National Science and Media Museum in 2017. It is part of the Science Museum Group.

45. Quoted in *Los Angeles Times*, 10 December 1993 'Movie Frame of Mind: Kinetoscope Maker Brings Era Flickering Back to Life'.

46. See biography at http://www.leonisadobemuseum.org/history-phillips.asp

47. See *Express & Echo*, Exeter, 2 January 1964. '75 years old ... This phonograph still works at an Exmouth carpenter's home'.

48. Rutgers University, Thomas A Edison Papers: Document File Series 1894: (D-94-28) Motion Pictures – Maguire & Baucus [D9428AAL; TAEM 135:408]. Courtesy of Thomas Edison National Historical Park.

49. Letter from Richard Brown to Ray Phillips, 18 December 1992. Private collection.

50. 1901 Census record. The 1911 Census records Berrington working in the same occupation.

51. See *The Exmouth Journal* (15 June 1963). 'Local Man's Unusual Hobby'. George Berrington lived from 1909 to 1976. His son sold the kinetoscope and phonograph.

52. Letter from John Huntley to G. E. Berrington, 24 July 1963. Private collection.

53. Letter to 'Jerry', surname unknown, 21 October 1992. Private collection.

54. Letter from Ray Phillips to John Barnes, 12 November 1992. Private collection.

55. This project can be seen at http://www.theracetocinema.com/cameras/

Appendix 1

Kinetoscope Exhibitions in the UK, 1894–1895

T he following information has been compiled largely through searches of the British Newspaper Archive, a rapidly expanding digital resource not available to earlier historians of British film such as Rachael Low and John Barnes. It is, of necessity, incomplete, and the authors would welcome any updates or further information.

1894

October

18 October: Continental Commerce Company give first public kinetoscope exhibition at 70 Oxford Street, London. Films shown included: *Annabelle Serpentine Dance*; *Bertoldi, Bar Room Scene*, *Barber Shop Scene*, *Blacksmith Shop*, *Carmencita*, *Cock Fight*, *Wrestling Match*.

30 October: The Royal Aquarium, London. By December there were at least four machines owned by A. S. Martens, of New York. Kinetoscopes were still on display in January 1895.

October: A kinetoscope reported at The Grapes Commercial Hotel, Salford, Lancashire.

November

Wednesday, 7–19 November: National Schools Bazaar, Preston, Lancashire.

Friday, 9 November: Continental Commerce Company open their second London parlour at 432 Strand. By this time CCC report that three rival establishments were operating in London.

Early November: kinetoscope demonstrated by Alfred Lomax at Blackpool, Lancashire.

December

Monday, 10 – Saturday, 29 December: A. H. Rigg's Art Gallery, Market Street, Bradford, West Yorkshire. Frederick Dalton exhibiting three kinetoscopes. Films shown included *Annabelle Serpentine Dance*, *Bar Room Scene*, *Boxing Cats*, *Caicedo*, *Carmencita*, *Cock Fight*, *Indian War Council*, *Mexican Knife Duel*, *Sandow*.

Monday, 17 December: three kinetoscopes owned by A. S. Martens exhibited at the Panopticon, Cardiff, Wales (for two weeks). Films shown included *Annabelle Serpentine Dance*, *Barber Shop Scene*, *Bertoldi*, *Blacksmith's Shop*, *Caicedo*, *Carmencita*, *Carnival Dance from 'The Gaiety Girl'*, *Highland Dance*, *Sandow*.

Saturday, 22 December: Grand Christmas Carnival, St James's Hall, Manchester. Reportedly, the first kinetoscope shown in Manchester.

Friday, 21 December: Herr Samuels [Samuel Stott] demonstrates kinetoscope to reporter from *Dundee Evening Telegraph*.

Friday, 21 December: H. E. Moss, assisted by R. F. Swayze gives private demonstration of two kinetoscopes at Waverley Market, Edinburgh, Scotland.

Monday, 24 December 1894 – 12 January 1895: Edinburgh Christmas Carnival at Waverley Market. Films shown included *Blacksmith's Shop*, *Annabelle Serpentine Dance*, 'Three Female Dancers'.

Saturday, 29 December: kinetoscope being exhibited at 204 High Street, Perth, Scotland. Admission 3d. Exhibition continued into January.

1895

January

Tuesday, 1 January: 72 Briggate, Leeds, West Yorkshire. Kinetoscope exhibited by Frederick Dalton. Films shown included *Annabelle Serpentine Dance*, *Indian War Council*, *Sandow*.

Saturday, 5 January: 2 Park Street, Bristol. Price 2d each scene. Films shown included *Bertoldi*, *Buffalo Bill*, *Highland Dance*, *Mexican Knife Duel*. Continued throughout January.

Monday, 7 January: 57 Overgate, Dundee, Scotland. Admission 3d. Mrs Duncan proprietor. Continued for a second week.

Monday, 7 January: 73 St Mary Street, Cardiff, Wales. Three kinetoscopes on show.

Thursday, 10 January: Conversazione at Leigh Technical College, Lancashire.

Friday, 18 January: Mrs Duncan takes shop, 38 Union Street, Dundee, Scotland. Continues for second week.

Saturday, 19 January – Saturday, 9 February: kinetoscope being exhibited at World's Fair, Islington, London (probably there for the entire Christmas season).

Tuesday, 22 January: *Fun* magazine refers to eight London kinetoscope parlours; Bond Street, Holborn, Piccadilly, Regent Street and two located both in Oxford Street and the Strand.

Wednesday, 23 January 1895: Five kinetoscopes on exhibition at Mawson, Swan and Morgan's store, Grainger Street, Newcastle, Tyne and Wear. Open 10 am – 8 pm. Admission one shilling. Advertised as the largest show outside London. Films shown included *Annabelle Butterfly Dance*, *Barber Shop Scene*, *Blacksmith's Shop*, *Highland Dance*, *Sandow*, 'Boxing Contest' and 'A Fight in the Backwoods of California'.

Wednesday, 23 January: Olympia, Northumberland Street, Newcastle, Tyne and Wear. Twice daily 3 and 7.30 pm. Last week of the Christmas Carnival.

Thursday 24 January: 46 New Street, Birmingham, West Midlands. Films shown included *Annabelle Butterfly Dance*, *Cock Fight*, *Blacksmith Shop*, *Sandow*, 'Prize Fight'.

Friday, 25 January: 41 Robertson Street, Hastings, Kent. Films shown included *Bar Room Scene*, *Sandow*, *Annabelle Butterfly Dance*.

Saturday, 26 January: London Scottish Rifles 'At Home', James Street, Buckingham Gate, London.

Thursday, 31 January: H. J. Marshall demonstrates kinetoscope to press representatives in Liverpool, Merseyside. Films shown included *Annabelle Serpentine Dance*, *Boxing Cats*, *Caicedo*, *Fairies' Dance*, 'Plantation Dance'.

Thursday, 31 January: 92 Fishergate, Preston, Lancashire. Opening hours 10 am - 11 pm. Films changed daily. 2d per scene. Exhibited with phonograph which provided 'local skits'

February

Saturday, 2 February: 37 Eastgate Street, Chester, Cheshire.

Saturday, 2 February: Student's Union Soiree at University College, Liverpool, Merseyside.

Wednesday, 6 – Monday, 11 February: three kinetoscopes being exhibited at 26 Alexandra Arcade, High Street, Swansea, Wales.

Thursday, 7 February: kinetoscope exhibited by Herr Samuels at East of Scotland Union of Naturalists Societies Conversazione, University College, Dundee, Scotland.

Saturday, 9 February: 'One Day Only'. 27 Crichton Street, Dundee, Scotland (Herr Samuels). Admission 3d.

Monday, 11 February: Lecture on 'What Edison has done for Electricity' delivered to St-Anne's on sea Congregational Literary and Debating Society by J. H. Taylor at his residence. Alfred Lomax demonstrated kinetoscope and phonograph.

Tuesday, 12 – Thursday, 14 February: Holy Land Bazaar, Town Hall, Chester, Cheshire.

Tuesday, 12 February: three kinetoscopes transfer from Alexandra Arcade to Oxford Street, Swansea, Wales. Films shown included *Barber Shop Scene*, *Bertoldi*, *Mexican Knife Duel*, *Sandow*, 'Prize Fight', 'Skirt Dancers' (three kinetoscopes offered for sale in *The Era*, 6 April 1895 (address of seller, 16 Arcade, Swansea); *Western Daily Press*, 15 July 1895 and *South Wales Daily Post*, 31 August 1895).

Tuesday 12 February – Thursday, 14 February: The British Workman, Gray Street, Broughty Ferry, Scotland. 4 pm to 10 pm. Admission 2d.

Wednesday, 13 February: Leeds Naturalists' Club Annual Conversazione. Philosophical Hall, Park Row, Leeds, West Yorkshire.

Wednesday, 13 February: 8 Market Street, Halifax, West Yorkshire. J. D. Walker and wife exhibiting two kinetoscopes, 2d admission.

Wednesday, 13 February-Friday, 15 February: kinetoscope at Cruft's Dog Show, Royal Agricultural Hall, Islington, London.

Saturday, 16 February: kinetoscope being exhibited at 38 George Street, Aberdeen, Scotland. Admission adults 3d, children half price.

Tuesday, 19 – Friday, Friday, 22 February: Catholic Bazaar, St George's Hall, Liverpool, Merseyside.

Wednesday, 20 February: several kinetoscopes on view at 14 Sheffield-moor, Sheffield, South Yorkshire, films shown included *Annabelle Butterfly Dance*, *Caicedo*, 'a ballet'.

Wednesday, 20 February: introduction of kinetoscope to Ireland. Advertised as being at 22 Royal Avenue, Grand Central Buildings, Belfast, Northern Ireland. 10 am to 10 pm for a few weeks and then to be moved to the Art and Industry Exhibition at Linen Hall Building when opened. Introduced to Ireland by John R. Quain, electrician, Manager of the Edison-Kinetoscope Exhibition Company of London and Liverpool. Local agent Thomas Tate, 18 & 20 Rosemary Street. Films shown included *Bertoldi*, *Bucking Broncho*, *Lady Fencers*, 'Boxing', 'Three Dancers'.

Friday, 22 February: short season at 24 Kings Road, Southsea, Hampshire. Films shown included *Bar Room Scene*, *Cock Fight*, *Highland Dance*, 'Skirt Dancer'. 2d per scene.

Monday, 25 February: 'Today and for a few days', 30 Market Street, York, Yorkshire.

Monday, 25 February: Young Men's Christian Association Annual Conversazione, Leeds, West Yorkshire.

Tuesday, 26 February: Durham City Camera Club Exhibition and Conversazione, Shakespeare Hall, Durham.

Thursday, 28 February: Herr Samuels kinetoscope exhibited at Foresters' Conversazione at the Victoria Galleries, Dundee, Scotland.

February: kinetoscope being exhibited in a shop at Long Row, Nottingham, Nottinghamshire.

March

Friday, 1 March: private view of *Leonard-Cushing Fight* at the Exhibition Room, 175 Piccadilly, London.

Friday, 1 March: kinetoscope exhibited for 'a short time' at W. Wilkinson's, Photographer, 81 North Street, Durham. 10 a.m. to 10 p.m. Admission 3d.

Saturday, 9 March: St. Andrew's Hall, Plymouth, Devon.

Monday, 11 March: Charlesworth's Auction Rooms, Lowgate, Hull, East Riding of Yorkshire.

Tuesday, 12 March: reception for the City of Belfast Young Men's Christian Association.

Kinetoscope in the entrance hall of the Ulster Hall, Belfast, exhibited by S. T. Bitmead [probably New Yorker Samuel Thomas Bitmead, b. 1872 in London].

Tuesday, 12 March – Thursday, 14 March: YMCA 'Venice in Sheffield' Bazaar, Albert Hall, Sheffield, South Yorkshire.

Wednesday, 13 March: kinetoscope at Social Gathering, Sion School, Burnley, Lancashire.

Thursday, 14 March: Frederick Dalton demonstrates kinetoscope at Sheffield Literary and Philosophical Society Annual Conversazione, Cutler's Hall, Sheffield, South Yorkshire.

Thursday, 14 March: 3 Sussex Street, Middlesbrough, North Yorkshire.

Saturday, 16 March: West Pier, Brighton, East Sussex.

Tuesday, 19 March: Exhibition Hall, Monument Bridge, Hull, East Yorkshire.

Thursday, 21 March – Wednesday, 10 April: kinescope and phonograph at Trade, Industrial and Art Exhibition at Borough Hall, Stockton, Durham. Exhibited by Messrs. Rosenberg and Co., of Newcastle.

Thursday, 21 March: Annual Conversazione of Queen's College, Belfast, Northern Ireland.

Thursday, 21 March: 122 Octagon, Plymouth, Devon. Still on exhibition 1 April.

Saturday, 23 March: Burnley and District Teachers' Association Bazaar, Burnley, Lancashire.

Friday, 29 March: five kinetoscopes at McCormack's Cycling Agency, 197 Union Street, Plymouth, Devon. Exhibited by L. E. Faithful, agent for the Kinetoscope Exhibition Company. Films shown included *Annabelle Serpentine Dance*, *Bar Room Scene*, *Fire Rescue Scene*, 'Acrobatic performance'. A separate exhibition to that at 122 Octagon.

April

Wednesday, 3 April: Homeopathic Hospital Grand Bazaar, Guildhall, Plymouth, Devon.

Thursday, 4 April: 68 Dame Street, Dublin, Republic of Ireland, showing 10 am to 10 pm. Exhibited by The Kinetoscope Company.

Friday, 5 April: several kinetoscopes on show at Central Lecture Hall, Westmoreland Street, Dublin, Republic of Ireland. Exhibited by the Edison Kinetoscope Exhibition Company supervised by Percy Willis (Percy Willis (b. 1867) was an early exhibitor of the phonograph and later acted as sales manager for J. E. Hough).

Saturday, 6 April: The Aquarium, Brighton, East Sussex.

Saturday, 6 April: Mr T. Edens Osborne's Cycle Depot, Overland House, Donegal/Waring Streets, Belfast, Northern Ireland. Films shown included *Cock Fight*, *Sioux Ghost Dance, Walton and Slavin*. Three machines, 2d per scene.

Saturday, 6 April: The Arcade, Wrexham, Wales. Films shown included *Boxing Cats*, *Cock Fight*.

Thursday, 11 April: kinetoscopes exhibited at the Belfast Exhibition of Art and Industry: 'Near the main entrance will be found the latest invention of that genius, Edison – the Kinetoscope. The stand occupies a space of 20 x 7, and is well decorated, portraits of Edison, the United States flags, and an arrangement of electric lamps reflecting the name "Edison" being the chief features. The stand is in the charge of Mr. S. T. Bitmead, of New York.' *Belfast Newsletter* (12 April 1895). Kinetoscope continued to be exhibited at the exhibition throughout the summer.

Thursday, 11 – Saturday 13 April: United Methodist Free Chapel Bazaar, Lecture Hall, Dunning Road, Middlesbrough, North Yorkshire (from the Trades Exhibition, Stockton).

Friday, 12 April: Continental Commerce Company showing *Leonard-Cushing Fight* at 70 Oxford Street, London.

Friday, 12 – Monday, 15 April: Bron Hall, Abbey Road, Llangollen, Wales.

Monday, 15 April: Henry G. Groves' kinetoscope exhibited at the Pump Room, Tunbridge Wells, Kent.

Monday, 15 April: kinetoscope being exhibited at 12 Westmoreland Street, Dublin, Republic of Ireland.

Monday, 15 – Tuesday 16 April: Beverley Photographic and Sketching Society Grand Exhibition, Assembly Rooms, Beverley, East Yorkshire.

Tuesday, 16 April: Kinetoscope exhibited at Henry G. Groves' Fine Art Gallery, the Pantiles, Tunbridge Wells. Admission 6d. Change of programme daily. Exhibition continued into June.

Thursday, 18 – Saturday 20 April: Grand Masonic Bazaar, New Public Hall, Arbroath, Scotland (from the Trades Exhibition at Stockton).

Friday, 19 – Saturday, 20 April: 7 Morledge, Derby, Derbyshire.

Tuesday, 23 April: Lincolnshire Pleasure Fair. Kinetoscopes and phonographs belonging to Mr P. Bernstein, of London, at John Cooke and Son's Show Room, opposite Fair Ground, Lincoln.

Tuesday, 23 April: kinetoscope being exhibited at Lord Street, Liverpool, Merseyside.

Wednesday, 24 April: British Art Gallery, Bridge Street, Bradford, West Yorkshire. Films shown included: *Alciede Capitaine*, *Barber Shop Scene*; *Carnival Dance from 'The Gaiety Girl'*, *Finale of 1st Act*, *Hoyt's 'Milk White Flag'*, *Fire Rescue Scene*, *Japanese Dance*, *May Lucas*, *The Rixfords*.

Wednesday, 24 April – Thursday, 25 April: Sale of Work at St Mark's Church, Harrogate, North Yorkshire, under direction of H. D. Clark.

Friday, 26 – Saturday, 27 April: Sale of Work, Thistle Harriers Club, YMCA Rooms, Constitution Road, Dundee, Scotland.

May

Wednesday, 1 May: Fete in Aid of the Dublin Orthopaedic Hospital, Rotunda, Dublin, Republic of Ireland.

Friday, 3 May: Boston May Fair, Lincolnshire. Several machines noted. An exhibition of kinetoscopes and a phonograph continued at 26 Straight Bargate, Boston, until 15 May.

Thursday, 2 May – Saturday, 4 May: North Finchley Baptist Church Bazaar, Dale Grove Hall, Finchley, North London.

Monday, 6 May – late June: kinetoscope being exhibited at Portobello Pier, Edinburgh, Scotland.

Friday, 10 May: Home Arts and Industries Exhibition, Public Hall, Sutton, Surrey.

Wednesday, 15 May: R. W. Paul's kinetoscopes exhibited by 'Viscount Hinton' at 39a Leather Lane, Holborn, London.

Wednesday, 15 May: Edison Kinetoscope Exhibition Company at the Belfast Exhibition. Films shown included *Barber Shop Scene*, *Bar Room Scene*, *Carnival Dance from 'The Gaiety Girl'*, *James Grundy*.

Tuesday, 21 May: kinetoscope being exhibited at 84 North Street, Leeds, West Yorkshire. Entrance reduced to 1d.

Tuesday, 21 May – Tuesday, 28 May 1895: five kinetoscope at Grand Bazaar and Fare in Aid of Sir Patrick Dun's Hospital, Royal Dublin Society, Ballsbridge, Dublin, Republic of Ireland. Under superintendence of Mr Wyndham (two Kinetoscopes were despatched by Edison to H. Wyndham, 7 November 1894)).

Wednesday, 22 May: Gas and Trades Exhibition, Tunbridge Wells, Kent.

Saturday, 25 May: kinetoscope being exhibited at 64 High Street, Winchester, Hampshire.

Tuesday, 28 – Wednesday, 29 May: Myopale Bazaar, Assembly Rooms, Queen's Hotel, Queenstown, Republic of Ireland.

Wednesday, 29 May: Fete and Grand Bazaar in aid of Hainault Forest School, Gidea Hall Park, Romford, Essex.

Wednesday, 29 May – Thursday, 30 May: Christ Church Grand Bazaar, Orange Hall, Lisburn, Northern Ireland.

June

Saturday, 1 June – end of July: kinetoscopes on display at Derby Castle, Isle of Man. Films shown included *Armand D'Ary*, *Bertoldi*, *Blacksmith Shop*, *Buffalo Bill*, *Carmencita*, *Cock Fight*, *Highland Dance*, *Sandow*, *Wrestling Match*, 'Prize Fight', 'Tumblers'.

Monday, 3 June: several kinetoscope sideshows at Bank Holiday celebrations on Hampstead Heath, London.

Monday, 3 June: Palace, New Brighton, Merseyside (on show throughout June).

Thursday, 13 – Friday, 14 June: St Paul's Church Bazaar, Public Hall, Colwyn Bay, Wales. Exhibited by Charles Heaton of Blackpool.

Monday, 17 June: Bazaar in aid of Christchurch Parochial Charities, Pump Room, Tunbridge Wells, Kent. H. G. Groves provided kinetoscope from the exhibition at his Fine Art Gallery, the Pantiles.

Thursday, 20 – Saturday, 22 June: North East Agricultural Show, Belfast, Northern Ireland.

July

Thursday, 4 July: Sale of Work, the Rectory, Barnet, North London. Barnet. *The Barnet Press* (6 July) refers to *The Arrest of a Pickpocket*, *The Boxing Kangaroo*, *Comic Shoeblack* and *The Derby* – the only known contemporary account of British films being exhibited.

Tuesday, 9 – Thursday, 11 July: three kinetoscopes at Grand Rainbow Fancy Fair, Central Hall, St Peter's Church, Redcar, North Yorkshire.

Tuesday, 9 July – late August: Palace, Douglas, Isle of Man. Films shown included *Barber Shop Scene*, *Buffalo Bill*, *Fire Rescue Scene*, *Japanese Dance*, *Ladies Fencing*, 'Boxing Match'.

Tuesday, 23 July: 25 Crichton Street, Dundee, Scotland, for one week.

Thursday, 25 July: Wragby Flower Show, Lincolnshire.

Thursday 25 July – Friday, 26 July: Larne Methodist Church Sale of Work, M'Garel Town Hall, Larne, Scotland.

August

Thursday, 1 August: Bakewell Horticulture and Industrial Society Annual Exhibition, Bath Gardens and Town Hall, Bakewell, Derbyshire.

Thursday, 1 August – Saturday, 3 August: Whiteabbey Independent Church Sale of Work, Belfast, Northern Ireland.

Thursday, 8 – Saturday, 10 August: Bazaar in aid of Rattray Parish Church, Public Hall, Blairgowrie, Scotland.

Wednesday, 14 August: kinetoscopes, kinetophones and electrophone at Unionist Victory Reception in the General Elections, Queen's Hall, Westminster, London.

Thursday, 22 – Saturday, 24 August: phonograph, kinetoscope and kinetophone at Grand Fancy Bazaar, St Andrew's University, Dundee, Scotland.

September

Tuesday, 3 September: 20 King Street, South Shields, Tyneside, 10 am till 10 pm.

Tuesday, 3 September: kinetoscope and phonograph exhibited by Thomas James of Cheadle at Warwickshire Agricultural Society Annual Show, Rugby, Warwickshire.

Thursday, 5 – Friday, 6 September: kinetophone at Grand Bazaar in aid of St James's Chapel of Ease, Hillsborough Castle, Belfast, Northern Ireland.

Wednesday, 11 – Friday, 13 September: The Artillery Bazaar, Market Hall and Music Hall, Inverness, Scotland

Thursday, 12 – Saturday, 14 September: Bazaar and Fancy Fair, Dundela Presbyterian Church, Knock, Republic of Ireland.

198

Friday, 13 September: brief season at the Royal Stock Rooms, 11 Library Place, Jersey. 10-10. Films shown included *Alciede Capitaine*, *Annie Oakley*, *Dental Scene*.

Wednesday, 18 September – Saturday, 21 September: Grand Bazaar in aid of the Moriah Calvinistic Chapel at the Pavilion, Caerndrfon, [Carnarvon] Wales. Poster in Gwynedd Council Archives XD9/385.

Tuesday, 24 September – Wednesday, 25 September: Grand Bazaar, Victoria Hall, Wimborne, Dorset.

Thursday, 26 September: two double Edison kinetoscopes being exhibited on Clarence Pier, Southsea, Hampshire.

Saturday, 28 September: kinetophone at the Manchester Social Clubs opening night. Lower Mosely Street, Manchester.

Monday, 30 September – Friday, 4 October: kinetoscopes at Exhibition of Handcrafts, Drill Hall, Park Street, Bristol.

October

Thursday, 3 October – Saturday, 5 October: Nottingham Goose Fair, Nottinghamshire. Two shops in King Street, each with three kinetoscopes.

Friday, 4 October: Forfar Choral Union Bazaar, Scotland.

Saturday, 5 October: kinetophone at the Manchester Social Clubs (Hulme branch) opening night. Greenhill Street, Manchester.

Monday, 7 October: kinetoscope (supervised by Messrrs. Dalton and Co., Matlock Baths, Derby) at exhibition to accompany the opening of the Municipal Electricity Works, Tunbridge Wells, Kent.

Tuesday, 8 October: Sale of Work of the Thimble League, Public Hall, Belper, Derbyshire. 'Edison's Kinetoscope was on view and did a lucrative business under Mr F. Dalton, of Matlock Bath, the district manager', *Derby Daily Telegraph* (10 October 1895).

Thursday, 10 October – Friday, 11 October: kinetophone at Grand Bazaar and Fancy Fair, Home Industries Hall, Strabane, Northern Island.

Saturday, 12 October: 25 Crichton Street, Dundee, Scotland.

Monday, 14 October: kinetoscope being exhibited at 23 Spurriergate, York, North Yorkshire. Manager H. S. Williams.

Tuesday, 15 October – Friday, 18 October: Grand Confetti Fete, Peacock Lane, Cork, Republic of Ireland. kinetoscope, kinetophone and phonograph supplied by the Kinetoscope Company, Matlock.

Friday, 25 October: Lichfield Floral and Horticultural Society Chrysanthemum and Produce Show, St James's Hall, Litchfield, Lincolnshire.

Tuesday, 29 October: Ice Carnival, Corn Exchange, Northampton, Northamptonshire.

Wednesday 30 October: two kinetoscopes at Mayor and Mayoress' At Home, Guildhall, Worcester, Worcestershire.

Thursday, 31 October: kinetophone at Annual Exhibition of Scientific and Natural Objects at Albert Institute, Windsor, Berkshire.

November

Wednesday, 6 – Saturday, 9 November: kinetoscope and kinetophone at Grand Metropolitan Bazaar, Ulster Hall, Belfast, Northern Ireland.

Thursday, 14 November: kinetoscope and kinetophone at 'Paris en Fete in 1600' Bazaar in Aid of Night Home for Girls, St James's Hall, Manchester.

Friday, 15 November: kinetophone at Crisp and Co, Ltd. Grand 'Xmas Bazaar, Seven Sisters Road, Holloway, North London.

Saturday, 16 November: kinetoscope and phonograph at 11 Yarm Lane, Stockton, Durham.

Tuesday, 19 – Friday, 22 November: kinetoscope and kinetophone at Cambridge Trades Exhibition, Corn Exchange, Cambridge, Cambridgeshire.

Wednesday, 20 – Saturday, 23 November: three kinetoscopes at Grand Educational Bazaar, Drill Hall, Lincoln, Lincolnshire, under the supervision of A. H. Vidler.

Saturday, 23 November: Fraternity Fair, Music Hall Buildings, Aberdeen, Scotland. Kinetoscope in the charge of 'Mr Leith, New Market', i.e. Alex. Leith, New Market Gallery, Aberdeen.

Saturday, 23 November: kinetoscope and kinetophone at the Christmas Bazaar, Bon Marche Ltd, Brixton Road, South East London.

Tuesday, 26 November: Thimble and Cotton Society Annual Tea and Sale of Work, South Banbury, Oxfordshire.

Thursday, 28 November – Friday, 29 November: YMCA Nautical Bazaar, Alexandra Hall, Newton, Devon.

Saturday, 30 November: Peter Robinson's Christmas Bazaar, Oxford Street, London.

Saturday, 30 November: Barony Ter-Centenary Grand Bazaar, St Andrew's Halls, Glasgow, Scotland.

December

Wednesday, 4 – Thursday, 5 December: St James's Church Restoration Fund Bazaar, Town Hall, Teignmouth, Devon.

Friday, 6 December: Free Holburn Church Bazaar. The Music Hall, Aberdeen, Scotland. Mr Leith's kinetoscope and phonograph.

Wednesday, 11 – Saturday, 14 December: kinetoscopes and kinetophones at Grand National Bazaar on behalf of the National Society for the Protection of Children from Cruelty, St James's Hall, Manchester.

Wednesday, 11 – Thursday, 12 December: Wesleyan Bazaar, Townhall, Stonehouse, Devon.

Thursday, 12 – Saturday, 14 December: kinetophone, phonograph and kinetophone at School Wynd Church Bazaar, Kinnaird Hall, Dundee, Scotland.

Wednesday, 18 December: Wesleyan Bazaar, Mutley, Devon.

Saturday, 21 December 1895 – Saturday, 4 January 1896: World Fair, Rosebery Hall, Cardiff, Wales.

Monday, 23 December: kinetophone at Christmas Carnival, Waverley Market, Edinburgh, Scotland. Films shown, *Highland Dance*, 'Trilby Burlesque Dance'.

Tuesday, 24 December: kinetophone at Christmas Carnival, Crystal Palace, South East London.

Films recorded at exhibitions.

Thirty-seven different subjects have been identified as being exhibited in Britain, all but four of them made by Edison. Full descriptions of the following films can be found in Charles Musser, *Edison Motion Pictures., 1890–1900. An Annotated Filmography*. Musser filmography number given in brackets.

Alciede Capitaine (87); *Annabelle Butterfly Dance* (48); *Annabelle Serpentine Dance* (49); *Annie Oakley* (86); *Armand D'Ary* (38); *Barber Shop Scene* (18 or 111); *Bar Room Scene* (37); *Bertoldi* (30); *Blacksmith Shop* (112); *Boxing Cats* (41); *Bucking Broncho* (79); *Buffalo Bill* (61); *Caicedo* (46); *Carmencita* (28); *Carnival Dance from 'The Gaiety Girl'* (90); *Cock Fight* (27 or 53) *Dental Scene* (113); *Fairies' Dance* (51); *Finale of 1st Act, Hoyt's 'Milk White Flag'* (101); *Fire Rescue Scene* (106); *Highland Dance* (33); *Indian War Council* [with Buffalo Bill] (63); *James Grundy* [*Buck and Wing* or *Cakewalk Dance*] (120 or 121); *Japanese Dance* (91); *Lady Fencers* (66 or 67); *Leonard-Cushing Fight* (40); *May Lucas* (89); *Mexican Knife Duel* (72); *The Rixfords* (94); *Sandow* (26); *Sioux Ghost Dance* (62); *Walton and Slavin* (70); *Wrestling Match* (29).

Appendix 2

Paul/Acres and Acres Films of 1895

As no Acres/Paul Kinetoscope film catalogues exist, titles often have several variants. Many films are recorded in the handwritten list of the British Toy and Novelty Company compiled in December 1896 (transcribed in John Barnes, *The Beginnings of the Cinema in England 1894–1901, Volume Five: 1900*, 280–281) and the Romaine Talbot advertisement published in *Der Komet*, 23 January 1897.

1. INCIDENT OUTSIDE CLOVELLY COTTAGE, BARNET
March 1895. London.
(Although not surviving in its entirety, a number of frames from the film are held by the National Media Museum; the Thomas Edison Historical National Park; and the University of Leeds (E. Kilburn Scott Papers). Five complete frames are illustrated in Talbot, *Moving Pictures*).

2. A GIRL JUMPING IN PARK ROAD, BARNET
c. March 1895. London.
Ref: *Hendon and Finchley Times*, 8 October 1915.

3. OXFORD AND CAMBRIDGE BOAT RACE
29 March 1895. London.
Refs: *English Mechanic*, 19 April 1895; Talbot 10526.

4. ARREST OF A PICKPOCKET/A STREET SCENE, SHOWING THE ARREST OF A PICKPOCKET
April 1895. London.
'In which the man is pursued by a constable, runs right across the picture, they struggle together and the policeman's helmet is knocked off, then the pickpocket, by slipping out of his jacket, manages to escape, but runs full tilt into the arms of a sailor, with whose assistance he is finally secured, handcuffed, and marched off to justice'. Programme, Queen's Hall, People's Palace, London, 15 August 1896.
Refs: *The Era*, 20 April 1895; Tester stock list no. 10; Romaine Talbot no. 1058; *Dundee Advertiser*, 21 April 1896; Undated Kineopticon programme, Stollwerck.
Copy: BFI National Archive.

5. BOXING KANGAROO
c. April 1895. London.
Refs: *English Mechanic*, 14 June 1895; Tester stock list 336.
Copy: BFI National Archive.

6. COMIC SHOEBLACK
April 1895. London.
Refs: *The Era*, 20 April 1895; *English Mechanic*, 14 June 1895; Tester stock list 43.
(Fifteen frames illustrated in *Black and White*, 10 July 1895).

7. RAILWAY STATION SCENE
April 1895.
Possibly the same as Highgate Tunnel described in the Barnet Times, 30 October 1896, as 'View of Highgate Tunnel, on the GNR, and while the audience watched it, smoke issued from the opening and a luggage train rushed along the platform on which Mr Birt Acres was observed walking up and down'.
Ref: *The Era*, 20 April 1895.

8. BOXING MATCH OR GLOVE CONTEST
c. April–May 1895.
'Having an interval introduced, during which the contestants sit down for a brief rest, and are vigorously fanned by two attendants, concluding in the last round with one of the boxers being floored'.
Programme, Queen's Hall, People's Palace, London, 15 August 1896.
Refs: *Amateur Photographer*, 14 January 1896 (review of Acres' exhibition); *Dundee Advertiser*, 21 April 1896.

9. CARPENTER'S SHOP/BEER TIME IN A CARPENTER'S SHOP
c. April–May 1895.
Refs: *English Mechanic*, 14 June 1895; Tester stock list 16; Talbot 10524; *Reynold's News*, 29 March 1896.

10. COMIC SINGER (?)
c. April-May 1895.
Shown by R. W. Paul in March 1896. Given that Paul did not start making his own films until late April 1896, it is reasonable to suppose that subjects shown by him before that date and not made by Edison date to his partnership with Acres.
Ref: *Daily Chronicle*, 23 March 1896 (advertisement for R. W. Paul exhibition).

11. DANCING DOGS/TRAINED DOGS/SKIPPING DOGS
c. April–May 1895.
Refs: Talbot 10537; Undated Kineopticon programme, Stollwerck Archive.
Copy: BFI National Archive.

12. PERFORMING BEARS/DANCING BEARS
c. April–May 1895.
Refs: *English Mechanic*, 14 June 1895; Talbot 10536.

13. ROUGH SEA AT DOVER
c. April–May 1895. Dover, Kent.
'The waves roll up in a most realistic manner, breaking against the Admiralty Pier, each wave as it breaks throwing up a great cloud of spray'. Programme, Queen's Hall, People's Palace, London, 15 August 1896.
Refs: *Amateur Photographer,* 24 January 1896; *Dundee Advertiser*, 21 April 1896; Talbot 10523.
Copy: BFI National Archive.

14. SHIP LEAVING HARBOUR WITH PEOPLE WAVING GOODBYE
April–May 1895.
Ref: *The Morning*, 29 February 1895 (review of R. W. Paul exhibition).

15. TOM MERRY, LIGHTNING CARTOONIST, SKETCHING BISMARCK
April–May 1895.
Refs: *The Era*, 28 March 1896; Talbot 10551.

16. TOM MERRY, LIGHTNING CARTOONIST, SKETCHING KAISER WILHELM
April-May 1895.
Ref: Talbot 10550
Copy: BFI National Archive.

17. TOM MERRY – GLADSTONE
April-May 1895.
Refs: Tester stock list 12; Talbot 10549.

18. TOM MERRY – SALISBURY
April-May 1895.
Refs: Tester stock list 13; Talbot 10548.

19. THE DERBY, 1895
29 May 1895. Epsom, Surrey.
'The Derby-day is the most successful, and shows the clearing of the course, the race, with Lord Rosebery's Sir Visto forcing his way to the front, and, finally, the crowd surging in after the last horse'.
London Evening Standard, 21 April 1896.
Refs: *English Mechanic*, 14 June 1895; *Dundee Advertiser*, 21 April 1896: Tester stock list 36; Talbot 1036.
Copy: BFI National Archive.

20. RECEPTION OF THE EMPEROR AT THE DAMMTHOR RAIL STATION BY MAYOR LEHMANN
19 June 1895. Germany.
Ref: *Hamburger Fremdenblatt*, 24 August 1895.

21. THE GERMAN EMPEROR REVIEWING HIS TROOPS/REVIEW OF THE GUARD OF HONOUR ACCOMPANIED BY THE PRINCES/GERMAN EMPEROR AT HAMBURG
19 June 1895. Germany.
'A wonderful picture of an inspection by Emperor William, who is seen, accompanied by his young sons and the Burgomaster of Hamburg, saluting his Guard of Honour'. Undated Kineopticon programme, Stollwerck Archive.
Refs: *Hamburger Fremdenblatt*, 24 August 1895; Talbot 1031.

22. MOUNTING THE CEREMONIAL CARRIAGE AND ITS DEPARTURE
19 June 1895. Germany.
Ref: *Hamburger Fremdenblatt*, 24 August 1895.

23. VIEW OF THE KIEL CANAL/OPENING OF THE KIEL CANAL
19 or 20 June 1895? Germany.
(Apparently, a test shot depicting the entrance of the canal with small boy in foreground)
Copy: BFI National Archive.

24. THE KAISER ON THE BRIDGE OF THE HOHENZOLLERN
20 or 21 June 1895. Germany.
Lange-Fuchs, *Birt Acres*, 122.

25. LANDING OF THE GRAND PLEASURE STEAMER, RETURNING FROM THE HOLTENAU CEREMONIES/PLEASURE STEAMER IN KIEL BAY?
20 or 21 June 1895. Germany.
Refs: *Hamburger Fremdenblatt*, 24 August 1895; Talbot 1052.

26. OPENING OF THE KIEL CANAL
20 or 21 June 1895. Germany.
Ref: Talbot 1053.

27. PASSAGE OF THE FIRST STEAMER THROUGH THE HOLTENAU LOCKS (STEAMER 'SUEVIER' FROM THE HAMBURG-AMERICA LINE/SUEVIER ENTERING THE BALTIC CANAL, HAMBURG, 1895
20 or 21 June 1895. Germany.
Refs: *Hamburger Fremdenblatt*, 24 August 1895; Undated Kineopticon programme, Stollwerck Archive.
(Emil Kobrow mentions two harbour scenes being filmed with warships in background).

28. PASSAGE OF THE RHOEDIA THROUGH THE LOCKS OF THE CANAL
20 or 21 June 1895. Germany.
Ref: Letter from Emil Kobrow to Ludwig Stollwerck, dated 22 June 1895. Stollwerck Archive.

29. LAYING OF THE FOUNDATION STONE OF THE KAISER WILHELM I MONUMENT
21 June 1895. Germany.
Ref: Loiperdinger, *A Foreign Affair*, 86; Lange-Fuchs, *Der Kaiser, der Kanal und die Kinemotographie*, 67.

30. ITALY IN HAMBURG. THE RIALTO BRIDGE. GONDOLA TRIP/VENICE. THE RIALTO BRIDGE
23 June 1895. Germany.
Refs: *Hamburger Fremdenblatt*, 24 August 1895; Talbot 10513
(Deac Rossell speculates that this was possibly two views).

31. PROCESSION HEADED BY THE KAISER ON HORSEBACK THROUGH THE STREETS OF BERLIN/IMPERIAL PARADE AT THE TEMPELHOF FIELD
2 September 1895. Germany.
Refs: Talbot 1055; Lange-Fuchs, *Birt Acres*, 121.

32. CHARGE OF THE UHLAN LANCERS ON THE TEMPELHOF FELDT AT BERLIN
2 September 1895. Germany.
Ref: Lange-Fuchs, *Birt Acres*, 54 and 59 (quoting Acres' son Sidney Birt Acres).

33. AMERICAN SOLDIERS ON PARADE AT SEDAN DAY IN BERLIN/PARADE OF VETERANS OF THE FRANCO-GERMAN WAR?
2 September 1895. Germany.
Refs: *Hamburger Fremdenblatt*, 6 October 1895; Talbot 1054.

34. JULIAN, BUTTERFLY DANCE/DREIFACHER TANZ DER "JULIANS" FROM THE COLOGNE REICHSHALLEN THEATRE/THE SKIRT DANCERS
1895. Germany.
Refs: *Barnet Times*, 10 January 1896; Tester stock list 28; Talbot 10511; Undated Kineopticon programme, Stollwerck Archive.

35. FEEDING A TIGER AT THE ZOO/STUDIES OF ANIMAL LIFE AT THE ZOOLOGICAL GARDENS
1895.
Refs: *British Journal of Photography*, 27 March 1896; Talbot 10512; Tester stock list; Undated Kineopticon programme, Stollwerck Archive.

36. CRUDE SET DRAMA
1895?
Comedy scene attributed by BFI to Acres.
Copy: BFI National Archive.

Appendix 3

'Outcasts of London' and the first portrayal of movie-making on stage

The 'sensational drama' 'Outcasts of London' was presented at a number of theatres during the summer of 1895. It was written by a young actor-manager Edward Mervyn (1874–1939) who also featured in the touring production. The attention of the *Shields Daily Gazette* reviewer appears to have wavered during the third and fourth acts, but, given the ultimately optimistic nature of Victorian melodrama, it can be safely assumed that Mr Temple's daughter and Vivian Bernard were eventually joined in marriage, that the dastardly Percy d'alton met a suitably unpleasant fate and that Joseph Perrydale was reunited with his remarkable kinetoscope.

THEATRE ROYAL, NORTH SHIELDS. – The most successful four-act drama, "Outcasts of London", as produced by Mr Edward Mervyn and his No. 1 Company, supported by the London actress, Miss Dot Selby, is "Billed" for the present week at the Theatre Royal, North Shields. The piece throughout is of a very interesting character, and was watched keenly by the large audience assembled last night. Mr Temple (the bankrupt builder), is impersonated by Mr W. S. Stevenson. In the midst of his troubles more misery is brought upon him by his nephew, Percy d'Alton, in the form of Mr Edward Mervyn, who, to prevent the marriage of Mr Temple's daughter with Vivian Bernard, an Australian gold digger, chops off the right hand of Mr Temple. The birth certificate not being signed, the marriage cannot be solemnised. However, Joseph Perrydale (J. McElroy) travelling with a kinetoscope, takes a view of Percy d'Alton in the act of chopping off the hand. He, however, loses his kinetoscope and Percy d'Alton is liberated. A good illustration of the hardships of the gold diggers is given in the second act, where three diggers are struck down with sun fever, and the last drop

of water being drunk they determine to set the bush on fire, but ultimately are saved. The remaining part of the programme is developed with much spirit, the attention of the audience being sustained throughout. The various roles were satisfactorily portrayed.

Shields Daily Gazette (30 July 1895): 3.

Appendix 4

British Dealers in Kinetoscopes

London

Trade Name	Address	Owner/s	Nature of Business
Continental Commerce Company	70 Oxford Street and 435 Strand, WC	F. Z. Maguire/ J. D. Baucus	European Agents for Edison's Kinetoscopes
R. W. Paul	44 Hatton Garden	R. W. Paul	Electrical Instrument Maker
The Kinetoscope and Film Company	69 Fore Street, Moorgate, EC	J. L. Young	Dealer in Phonographs
Exhibition Novelty Company	272 Gloucester Terrace, Bayswater and 104 High Holborn	F. W. Duval	Dealer in Kinetoscopes and Films
London Phonograph Company	3 Broad Street Buildings, Liverpool Street, EC	J. E. Hough	Dealer in Phonographs and Kinetoscopes
Philip Bernstein	1 Houndsditch and 99 Bishopsgate Street	P. Bernstein	Dealers in Phonographs and Kinetoscopes
The International Agency	16 East Road, City Road	H. J. Heinze	Phonograph and General Dealer
Northcote and Company	381 New Cross Road, SE	–	Camera Dealers in Novelties
Automatic/Interchangeable Syndicate	Tower House, St John's Road, Holloway	J. Barron	Dealer in Automatic Coin-Feed Machines
Anglo-American Phonograph Company	365 Coldharbour Lane, SE	–	General Dealers
Walter Naylor	173 Tower Road, Rotherhithe, Kent	W. Naylor	Electrician and Consulting Engineer
American Kinetoscope Company	95 Queen Street and 3 Broad Street Buildings, Liverpool Street, EC	D. A. Georgiades/ G. Tragidis	Kinetoscope Dealers and Exhibitors
Sandle and Nebel	5 St Peter Street, Islington Green	Sandle and Nebel	Exporters of Kinetoscopes to Germany
Victor Taylor	Wornington Road, North Kensington	V. Taylor	Phonograph Dealer
Alfred Jones	17 Enkel Street, Holloway	A. Jones	Dealer in Electric Novelties
Paquet	15 Upper Bedford Place, Russell Square	–	Dealer in Kinetoscopes

Provincial

Trade Name	Address	Owner/s	Nature of Business
The Kinetoscope Manufacturing Co.	6 Cornwall Terrace, Bradford, West Yorkshire	C. Wray	Electrical Engineer and Dealer in Kinetoscopes
John Henry Rigg	43 Skinner Lane and 28 Cross Stamford Street, Leeds, West Yorkshire	J. H. Rigg	Electrical Engineer and Manufacturer of Kinetoscopes
Kinetoscope Manufacturing Company	5 Railway Street, Cleckheaton, West Yorkshire	H. Pitt	Electrical Engineer and Cycle Dealer
Roberts Brothers	The Observatory, Liversidge, West Yorkshire	S. and W. Roberts	Dealers in Phonographs and Kinetoscopes
John Hamer	Horton Street, Halifax, West Yorkshire	J. Hamer	Electrician and Mechanical Engineer
William Routledge	Low Friar Street, Newcastle-on-Tyne	W. Routledge	Electrician
Edison Phonograph and Kinetoscope Co.	28 Caunce Street, Blackpool, Lancashire	A. Lomax	Phonograph and Kinetoscope Dealer
The Phonograph Company	20 Railway Street, Darwen, Lancashire	–	General Dealers
Simpson Brothers	3 Hammerton Street, Burnley, Lancashire	W. and J. Simpson	Electrical Contractors and Kinetoscope Dealers

Appendix 5

The Kinetoscope Legal Action

The legal document which follows is both the earliest and by far the most substantive (at nearly 10,000 words) nineteenth century 'official' record related to British film history.[1] The legal definition of 'Passing-Off', the common law statute under which the Continental Commerce Company and Thomas Edison action was brought, has been discussed in Chapter Four. The various depositions included in the document have been transcribed verbatim and therefore include errors and deletions present in the original. It is a positive feature that, due to the 'Question and Answer' structure adopted in the cross-examination of witnesses, a high degree of immediacy is created. It is also notable that the dates of events and conversations recalled by witnesses are very recent. This is of course no guarantee that what they said was truthful, but it is at least unlikely that anyone had problems in recalling the incidents they were being questioned about. On an examination of the evidence, it is evident that an integral part of this particular scheme of deception and misrepresentation involved the forgery of Edison nameplates. The level of criminality involved was therefore substantially more than simply design-based. Considering its historical value to early film history, it is remarkable that not only the document, but even the existence of the case, remained completely unknown to scholarship until 2012.[2]

The hearing, to decide whether the temporary or interim injunction should be replaced by a permanent one, was heard in Chambers by two judges of the High Court, Alfred Wills and Robert Samuel Wright. It was defended by the Greeks and Hough.[3] To succeed in obtaining an injunction against the use of Edison's name in relation to the plagiarism of his property, Franck Maguire required corroborative evidence that Georgiades, Tragidis (named as Tragedis in the court records) and Hough had, by commission or omission used – or implied the use of – Edison's name in connection with the sale or the promotion of their own machines. To gather this evidence, Maguire made use of at least two customer-informants, later admitting that he 'may also' have additionally sent some of his employees to the Greeks' shop to obtain information. The probable sequence of events can be reconstructed from deposition evidence which, in some cases, is augmented by reference to details included in the now 'lost' affidavits.

Sometime in October 1894, Ebenezer Tonkin, unhappy in his job as an engineer with the Daimler motor syndicate and looking for an alternative source of income, began to consider establishing himself as a kinetoscope exhibitor in London. He paid a visit in November to the show in Oxford Street and obtained some initial details about the cost of the machine. Continuing his information-gathering tour of kinetoscope exhibitions in London, he 'quite by chance' visited the Greeks' exhibition in New Broad Street where he was quoted a price for the machine that was almost half that of the 'official' level. Whether Georgiades, who was the partner Tonkin saw, mentioned that the machines on offer were of English make is not clear, but Tonkin returned to Oxford Street, no doubt seeking an explanation, and probably with the intention of negotiating a better price for himself from Maguire.

What Franck Maguire suggested was that Tonkin should return to the Greeks' shop on 14 January posing as a potential customer. During this second visit he was quoted £45 for a single kinetoscope complete with a film and was told that the unit price would be reduced to £40 if he was prepared to buy two machines. Tonkin asked that their offer should be put in writing, and tried to get the Greeks to admit that they were selling English-made machines as genuine Edison models by saying several times "I want machines of Edison's make", but this attempt at entrapment failed. A third visit was therefore arranged, with Tonkin this time accompanied by his father as a witness. A new approach – again no doubt a pre-arranged tactic agreed with Maguire – was now tried, with the Tonkin's offering to buy one of the English machines, but only on condition that it came with an Edison plate to identify and 'authenticate' it as a 'genuine' Edison machine. According to Tragidis:

> I said that I wd. not give him an Edison plate as it was not Edison's machine and would be criminal. He [Tonkin's father] then said "Give me the plate, I will put it in my pocket & will place it on the machine myself when I take it away" ... Tonkin asked me to take off one from an Edison machine & argued with me for ten minutes, but I positively refused.

Not surprisingly, Tonkin's recollection of the same conversation was rather different. He claimed that the Greeks were indeed prepared to supply a forged name plate, and had said 'that we could attach the plates ourselves if we liked, or leave them off'.

While Maguire was making use of the Tonkins in an attempt to secure evidence against the Greeks, he was simultaneously trying to gain information against James Hough by using the services of Max Rosenthal a recently retired cigar merchant whom he had first met in November 1894. At Maguire's request, Rosenthal subsequently visited Hough on 14 January, but Hough's suspicions were aroused after Rosenthal had volunteered the information that he was not a spy! He told Rosenthal that he must know more about him before he would be prepared to do any kinetoscope business. Failing in this direct approach to entrap Hough, Maguire next contacted the leading phonograph dealer Jonathan Lewis

Young who, as a fellow phonograph infringer knew Hough well. It was suggested in Court that Maguire had attempted to 'coach' Young, and had said:

> I want you to go right away and make an affidt. that Hough offered to sell you Edison's Kinetoscopes & that he offered to supply you with Edison plates & that he had plenty of them & that it was the same thing to him whether he supplied Edison's plates or any others.

Young, who was not called as a witness, allegedly replied that Hough had not done these things, and that Maguire was asking him to commit perjury – a statement that Maguire in his response dismissed as 'absolutely manufactured'. Maguire's belief that one British phonograph infringer would be prepared to inform on another was perhaps unrealistic, and Young's answer ended his second attempt to obtain incriminating evidence against Hough.

In Court the Greeks were alleged by various witnesses to have made a number of incriminatory remarks. Tragidis was supposed to have said that 'no one could tell the difference between Edison's and English-made machines', while Georgiades was supposed to have remarked 'Who is to know the difference?' when Tonkin asked whether an English machine could be exhibited as a genuine model. Considering what Maguire was attempting to prove, it was also surely unwise of Georgiades to allegedly remark 'When people come to us to look through machines we do not say anything as to whether they are Edison's or English unless the people ask'.

Also counting heavily against the Greeks and Hough was that they could not produce any evidence that nameplates, bearing their own or Robert Paul's name had been attached to the facsimile machines before the 18th of January when Maguire entered his action. How then were customers to know the difference? George Tragidis attempted to answer this question, but Ebenezer Tonkin was positive:

> I believe the words English manufacture were not used, and I am quite sure that the words English manufacture were not used at that stage in connection with machines offered at £40 ... They [The Greeks] did not say that they would fix a plate bearing the name of the place of manufacture namely England.

Even James Hough agreed that 'No manufacturers name [was] used in connection with British machines'. After further evidence mainly concerned with the price charged for the 'bogus' machines in comparison with that asked for the genuine Edison models, the Judges decided in favour of the plaintiffs and a permanent injunction was issued on 14 June.

The existence of this document enables the 'traditional' narrative of this part of early British film history to be challenged in various respects for the first time. Perhaps most significantly the decision of the Court provides irrefutable proof that Robert Paul had been engaged in criminal activity, and that the 'white-washed' version of events given later by both himself and Frederick Talbot - and adopted without question by film historians from Ramsaye (1926) to Barnes (1998) – was merely a disingenuous and exculpatory excuse intended to divert

A section of George Tragidis' deposition evidence, in which he describes the differences between American and English kinetoscopes and confirms that it was he who commissioned Paul to produce copies of the Edison machine.

attention from his involvement in proven plagiarism. This was why it was necessary for Paul to suppress any mention of this case in his later accounts, but by doing so the inevitable result was that he compromised the historical record for many years.

Of more general importance to early film history than Paul's later deceptions, is

The signatures of the protagonists in the court case.

that this case directs attention to the close relationship that always existed between legal and business development. Common law practice provided the framework within which any commercial sector – especially a new one – was obliged to develop. Commercial law in late Victorian Britain was comprehensive and covered a wide range of corporate activity from birth (joint-stock registration) to death (bankruptcy procedure). And, as this case indicates, this included the restraint of fraudulent activity. The existence of the kinetoscope case, situated as it is at the very beginning of film development, also provides additional proof to controvert the impression (much favoured by film 'pioneers' in their later accounts), that the early film business emerged into a disorganised, or *laissez-faire* commercial environment. That this was not so, even at the beginning, has been shown by the information presented in this study of the relative maturity existing in 1895 in widely different aspects of British kinetoscope history, from intellectual property legislation, to the various marketing functions dealers and exhibitors engaged in.

Notes

1. The deposition document is the sole survivor of what originally consisted of a comprehensive range of papers related to this case. For a reason which it has not proved possible to explain, documents such as the 'pleadings', the 'affidavits' and the judges 'reports' were not, contrary to usual practice, filed after the permanent injunction had been given. The possibility that they were held back for further examination, pending an appeal against the verdict, has been investigated without result. The 'judgement books' which would have given the full conditions of the injunction, were destroyed in 1958 under authority of section six of the Public Record Act of that year.

2. First announced in June 2012 at the 12th International Domitor conference held in Brighton.

3. Hearing noted in *The Law Times* (15 June 1895): 176, as 'Opposed motion. For argument.'

NATIONAL ARCHIVES
J. 17/314. X/L 08146
1895 [Case] C.201. [Stamp]

'Supreme Court of Judicature.
Central Office.
Filing and Record 18 Feb 1895'
In the High Court of Justice.
Queens Bench Division.
Between
The Continental Commerce Company
and Thomas Alva Edison – Plts.
and D.A. Georgiades George Tragides
& J E Hough – Defts.
Depositions of witness [sic] examined before me
Edward Hume (Special Examiner) at 10 Old Square
Lincolns Inn, under order dated the 24th of Jan
1895

Sworn Jan 30 1895

Max Rosenthal of 49 Bronsbury Villas Kilburn retired merchant cross –exd. by Mr Scott on his affidt. sworn the 18th of Jany .1895. saith as follows

I gave up my business as cigar merchant at 435 Strand about a month ago. – in the early part of Jany. about the 2nd or 3rd of Jany. I disposed of it to a person named Hard. I do not know how he spells his name. I gave possession of the shop to him in the early part of Jany. He bought the business from me and agreed to give me £135 partly in cash & partly in promissory notes. I first thought about giving up my business about two months ago. I remember about the beginning of Nov.1894 going to ~~see the Greek named Mr Tragides at 95 Queen Street~~ I saw two or three Greeks there. One was thin with a fair moustache. After some discussion I received from ~~Mr Tragides~~ the latter a written agreement. I have not got it here – it has been destroyed. That was not an agreement for the sale to me of 5 English made Kinetoscopes. I took away the agreement – I did not say I wanted to show it to my solicitor. I did not mention a solicitor. I had no solicitor at this time. I did not call at Queen street afterwards & say that I did not want any agreement but wd. buy 5 machines as soon as they were manufactured. I only called once at Queen street between the date of my getting the agreement & the Greeks removing to No.3. Broad Street buildings – but the Greek I have mentioned called several times at my shop. ~~The Greek I have refused~~ He is the gentleman who has just come into the room.

[NB. this was the deft. Tragides. EH.] ~~Before going~~ On the 14 Jany. I went to 3 Broad street buildings, but before going there I ~~went on the same day~~ had been to 140 Cheapside at an earlier date. Referring to par 3 of my affidt. I say that I went to 140 Cheapside before ~~the 14 Jany.~~ my visit to 3 Broad street buildings. I do not know the name of the gentleman ~~who spoke~~ mentioned in par 3 as speaking to me, but he gave me his card which I believe I left with Mr Hough if

I did not destroy it. I may have given it to Mr. Maguire. The gentleman who spoke to me did not appear to belong to the shop, but seemed to be a stranger like myself. I will not swear I gave the card to Mr Hough. When I saw Mr Hough on the 14 Jany. he asked me who I was ~~& what my name was~~ - I did not say my name was Rosenthal ~~nor that I had been in the~~ I do not remember that I said I had been in the Cigar business & that I wanted to buy six Kinetoscopes. I did not say "I have come here to do business I am no spy" Mr Hough asked me whether I was not a spy – I swear that he asked me that.

Q. Did Mr Hough say that his price was £45?

A. Nothing was said about business before we went to 62 New Broad street. Before going to New Broad street I did not say "I have had the machines offered me for £40" ~~Before going there Mr Hough did~~ Hough did just say at 3 Broad street buildings that he did not believe I cd buy them for £40. As we walked to New Broad street I told him that they had been offered to me for £40. He said before he would do anything as to business he must know who I was. ~~I de~~

Q. Before going to New Broad street did not Mr Hough say that he wd. go there with you ~~to New Broad street~~ to see whether they had offered the machines to you at £40?

A. No. No one was present at the interview between me & Hough before we went to New Broad street except ourselves. There was a young man in the office when I first called who went away to look for Mr. Hough & he came back with him but I do not remember whether he remained or not. We left at once for New Broad street- I saw nobody but Mr Hough & the young man. There was a lady in the next office. ~~She was not in the [?] when~~

Q. When you got to New Broad street did Mr Hough ask Mr Tragides whether they had offered machines to you at £40?

A. He asked Tragides who I was.

Question repeated **A**. I did not hear ~~it~~ him.

Q. Did Mr Tragides say he had offered the machines to you at £45 with the film?

A. Tragides said he had offered me three machines with the film and the shop at £45 for each machine. I swear that the shop was included in this sum – ~~It was~~ The above statement was not made on the 14 Jany. by Tragides to Hough. We afterwards went back to 3 Broad Street buildings and had some conversation. The young lady was not present. There was a man present I believe – He did not remain there during the whole of my conversation with Hough. He was in & out but I did not take particular notice – I do not believe I asked Hough whether he wd. take less than £45 for one of the machines. I saw 2 machines at 3 Broad street buildings – I saw no others. ~~Kinetoscopes~~ I think the two ~~machines~~ I have ment'd had no Edison plates on them – I am positive they had not. I have seen Edison Kinetoscopes in other places -They have all had on them a plate with Edison's name upon it. I believe Hough said he wd take £250 for six machines cash down.

Q. Did you not say you wd. not give more than £40 apiece?

A. I do not remember what the transaction was.

Q. Did you further say to Hough that it wd pay you better to give £30 more for each machine to Maguire in order to have Edison's make and Edison's name?

A. I did not say so to Hough.

Q. Did you say so to any one at 3 Broad street Buildings on that day, the 14 Jan?

A. No.

Q. Did you say that Maguire had offered you six Edison Kinetoscopes for £60 apiece?

A. Nothing was said about Edison's Kinetoscopes at all – I presumed they were all Edison's

Q. Did not Hough say he could not believe that Maguire had made such an offer as he had never heard of him offering at less than £72 apiece?

A. No.

At the interview on the 14 Hough opened the top of one of the Kinetoscopes -and perhaps a side as well. He opened the top to let me see the machine. He did not say that although they were English ~~eons~~ manufacture they were exactly the same as ~~the~~ American manufacture. He ~~did~~ said nothing about English manufacture. The lowest price Mr. Maguire ever asked me for an Edison machine was about £60 – I mean £60 & some further expense for delivery here instead of New York. – I did not think the Plt Co had the monopoly of supplying Edison's machines in this country. At the interview on 14 Jany. Hough did not say he cd. deliver to me six English machines in a week's time. Nothing was said about English manufacture – He did not offer to deliver me any machines in a weeks time I think I did say more than once that I was in no hurry, & that three weeks time wd. be soon enough or something to that effect. I do not remember telling Hough that I wd. pay £40 apiece cash down on delivery – I did say something of that kind – I don't know whether he refused to reduce his price. I did not ask Hough whether he cd. get films for machines. ~~He~~ I believe he said he would supply me with films but nothing was said about the manufacture or the place of manufacture England or America – I told Hough I had been in San Francisco about 25 years – I told him I knew roughly the cost of producing cabinet work in America, & that the cases of the machines would not cost more than about two dollars each – I did not tell Hough that he cd. make more profit out of machines made here, or "those machines" pointing to the two machines in the shop at £40 than Maguire wd. out of Edison's made in America at £70 – Mr. Hough told me machines cost so much in America. I said I knew better. That was in reference to the cases. I did not say it would pay me better to pay Maguire £30 more for Edison's make of machine with Edison's name on than to buy his (Hough's) machines. ~~I believe~~ I did not say that to anybody at the interview – I did say something about Maguire having offered the machines at £60 apiece. ~~Hough~~

Q. Did Mr Hough say he had never heard of Maguire or anybody else offering the machines manufactured in America for less than £70?

A. Nothing was said about the place of manufacture.

Q. Did he tell you that he had never heard of Maguire offering machines for less than £70?

A. I do not know whether he meant Maguire but he said if you go to buy them you have to pay £70. He did not tell me that I had better get my machines from Maguire – I don't remember saying as I went away that I wd. return in a day or two. The part of our conversation which took place in the office took place in the outer office-Most of the conversation was on our walk. The distance we had to walk was 3 or 4 hundred feet. I have bought some machines – I bought them from the Plts.

[Signed] M. Rosenthal.

Sworn Feb. 8 1895.

Franck Zeveley Maguire of 70 Oxford Street cross- exd. on his affidt. sworn the 19th of Jany. 1895 saith as follows.

I know Rosenthal. I first came to know him about November 1894. My Co. have sold machines to Maguire [sic] We first sold him three. That was 3 or 4 weeks ago. I can give you the exact dates by reference to our books. I know J. Louis Young – I have known him for about the same time as I have known Rosenthal. I don't think I asked Young to help me against Hough – I wrote to Young or telegraphed to him about a fortnight ago asking him to come see me & he came. I don't think I said to him "I guess you are in the same interest as we are & I want you to help us against Hough" I cannot be positive. I cannot remember. I think Young said "What can I do for you" or something of that kind. I did not say ~~that~~ "I want you to go right away and make an affidt that Hough offered to sell you Edison's Kinetoscopes & that he offered to supply you with Edison plates ~~I did not ask him to make an affidts~~ & that he had plenty of them & that it was the same thing to him whether he supplied Edison's plates or any others" or words to that effect – I did not ask him to make an affidt as to anything – Young did not refuse saying that I wanted him to commit perjury -I am positive he did not say that – that is absolutely manufactured. – There was another gentleman in the room. I have at my own instance offered to pay Rosenthal the expenses of his attendance as a witness here. Neither I nor my Co. ~~never~~ ever offered him anything for making his affidt. or in respect of the matters mentioned in it. He came to us entirely voluntarily. We employ a Miss Rosenthal as cashier, but I am sure she is no relation to the Rosenthal who came to us & made the affidt. I did not suggest nor did anyone in my Co. as far as I know suggest to Rosenthal or anyone else to go to Hough's premises. I did suggest after Tonkin had come to me that he shd. go to 62 Broad street – I may also have sent some employee there – but Tonkin before I suggested sending him had been to Broad street and voluntarily brought to me many of the facts stated in his affid together with the fact that they were exhibiting bogus machines as Edison's Kinetoscopes. The Agreement of the 27 October is in America. It is on its way here.

<u>Re-examined</u> The conversation which I had with Young was to the following

effect – I said, "Mr.Young I have brought you here to know whether you are with or against us. I have been very much pleased with the fact that you have dealt satisfactorily up to date, & I would like to ask you" (of course I said this after an assurance from him that he was in harmony with us) 'if Mr Hough offered to sell you any genuine Edison Kinetoscopes or if he was willing to supply bogus Kinetoscopes with an Edison name plate thereon' He said that Mr Hough had not offered to sell him genuine Edison Kinetoscopes nor the plates. I think that afterwards he asked me some questions about films & other machines. Rosenthal had sold out everything & was starting for Germany when he agreed to give evidence in this case. I entirely of my own accord offered to pay the expense of his remaining though he was quite willing to give his evidence without my doing that.

[Signed] F.Z.Maguire.

Sworn Feb. 13 1895.

Ebenezer William Tonkin of 49 Leadenhall street E.C. cross-exd. on his affidt. sworn the 18 Jan 1895 saith as follows.

I am engineer for the Daimler Motor Syndicate. I do not carry on any business on my own account.

Q. What is your salary per week?

A. I refuse to answer that question.

~~I was~~ I believe it was in Sept or October 1894, that I was first introduced to Mr Maguire. At that time I was thinking of leaving the Daimler Syndicate. I was seeking a better appointment. I had no business in view then which I intended to carry on on my own account. It was about a month after I first saw Kinetoscopes at Oxford Street that I thought of starting an exhibition of them. I did not get information as to Kinetoscopes from Mr. Maguire but I did so from one of his officials – After talking to that official I did not abandon the idea of starting the exhibition – It was quite by chance that I called at 62 New Broad street ~~where~~ On my first visit there I spoke about buying a phonograph – though that was not my first question – I did not speak about phonographs before speaking about Kinetoscopes. Very little was said about Kinetoscopes ~~about~~ on this first visit – except that they told me the prices and important details – I did not say I would call again next day or shortly with a capitalist – I did say that I would mention the prices & details given me to those ~~that~~ who were interested with me in the exhibition – I called again on the 14 of Jany – I then said I wanted to buy some Kinetoscopes. I saw two gentlemen there -To the best of my knowledge & belief they did not make an offer to me of an English made machine at £45 – I believe the words English manufacture were not used, and I am quite sure that the words English manufacture were used at that stage in connection with machines offered at £40. I asked them to put the offer they made into writing. [Exhibit marked] EWT.2. is the offer they made. I read it after I received it & I thereupon said "I want machines of Edison's make" I had said that also before EWT.2. was written – Neither of the gentlemen said to me that the English machines were as

good as Edison's – Nothing had been said about English machines – I got EWT.3. at the same interview as I got EWT.2. At the time when I received EWT.3. I did not understand that these gentlemen could supply me with machines other than machines made by Edison – I did not understand from EWT.3. that the machines were not Edison's make although they might be the same. I paid three visits to New Broad street. My father was with me on the 3rd. visit – I believe it was the 3rd – I will not swear I did not go there 4 times, but I believe it was only 3 times. On my 3rd visit I ask when I was there with my father I asked the price of Edison machines – I had done so on each of the previous occasions – I did not know before my 3rd. visit that there were machines besides those made by Edison. It was on the occasion referred to in par 4 of my affidt. that I first knew that there were machines other than Edison's. I did not on my 3rd visit ask to have I cannot say on which visit it was that I offered asked to have the offer of for an Edison machine put into writing. But I believe it was on the 2nd. visit. Looking at EWT.4. I say it was on the 2nd. visit (the 14 of Jany.) On the occasion when I was at New Broad St. with my father neither of us said that we wanted to buy a £40 machine with an Edison name plate.

Q. Did not one of the two gentlemen say that they could not supply a £40 machine with an Edison plate as it was not an Edison machine?

A. He did not say so in those words. – He said he would supply us with a machine or machines & plates the same as the other machines had & that we could attach the plates ourselves if we liked or leave them off. I did not myself ask for a plate & say I would put it on myself – My father suggested that – but on one condition namely that as we had been assured that they were Edison machines we shd. have an invoice stating that & on the authority of that invoice we should be willing to attach any plates which might be given us – Those machines were quoted to us at £40 each – At the interview when my father was present the gentlemen refused to give us any Edison plate. They did not say that they would fix a plate bearing the name of the place of manufacture namely England. As far as I remember I only saw Maguire or was at any of the Plts. places of business once between the 12 & 18 of Jany. I saw both Maguire & his accountant. I believe I saw no one else connected with the Plt Co. between those dates. The occasion on which I saw Maguire & his accountant was after either the 1st or 2nd visit to New Broad Street – I am not sure which.

[Signed] E.W.Tonkin.

Sworn Feb. 2 1895.

The deft. **James Edward Hough** cross-ex'd by Mr Terzle on his afft. sworn the 23 of Jany. 1895 saith as follows:

I sell Kinetoscopes but I do not import them from America nor do I get them manufactured for me. I do not manufacture them myself. I purchase them in England. I purchase them from both of the other defendts. in this action – I sell them to anyone who likes to buy, to sell again & do what they like with. They are not of Edison's manufacture – I am speaking of the machines as a whole. Some

of the parts I believe are made by Edison. The motor is made by him. I do not know how defts. obtain the motor. I only know it bears Edison's plate. The film I believe is provided by Edison also but it is no part of the machine. I am well acquainted with Edison's machines from having seen them but I have not had them myself. I am also well acquainted with the machines that I sell.

Q. Except for the name plate what striking differences in appearance are there between the machines that you sell & Edison's?

A. There are none. An expert might distinguish them but generally speaking there are none. I have frequently been to the shop in Broad Street where the other defendants exhibit machines – & have seen & examined them. ~~At the~~ On the 18th Jan^y. 1895, there were 5 machines there – three I believe were Edison's & the other two were I believe of English manufacture such as I sell. Edison's name plate is of nickel- about 2½ inches by 3¼ or 3½ . It was placed right on the top of the 3 machines. There was no plate at all on the other two. I have seen at 62 Broad Street last night & on some days prior to that other name plates besides those of Edison. They was made of brass-lacquered – slightly larger I think than Edison's and undoubtedly much thicker – The writing on them is I believe engraved though I had some difficulty in discovering that. Edison's plates are stamped or impressed in a different kind of lettering. On the 18 Jan 1895 there was nothing except the absence of name plates to inform the public that the two machines were not Edison's. [Photographs put in & marked JEH 1 & JEH 2] The photog. JEH 1. correctly represents the ~~exterior~~ interior front view ~~of the shop in~~ 62, Broad street – JEH 2 represents the exterior side view. I have ~~seen~~ never seen any British manufactured machines on exhibition except the two at 62 Broad street which I have referred to. I ~~ha~~ must have had conversations with the other defts. before the 18th Jan^y. as to their exhibition of machines at 62 Broad street – I never had any conversations with them ~~in connection with~~ as to the use of Edison's name in connection with the British manufactured machines – No manufacturer's name was used in connection with the two British manufactured machines. Edison's name was outside the shop – I have seen a card there with Edison's ~~photograph~~ portrait ~~name~~ on it but I have never read it. [Card put in & marked JEH 3.] This card is something like what I saw. I will not swear that Edison's name was not on the one I saw. [Exhibit EWT 1. handed to witness] I have seen cards like EWT 1. issued by the defts. when at 95 Queen street but I do not remember seeing it at Broad street – I knew of the existence of the Plt. company – I did not know that the Plt Co. ~~were~~ had the sole right to sell Edison's machines but I had heard it. I do not know who told me. It was general rumour. I know other people have sold Edison's machines & are doing so today so I did not believe the rumour. I decline to say who ~~they~~ these other people are but I can buy some today.

Q. Is it a secret who they are.?

A. So far as I am concerned it is.

Q. Is it a secret from whom they get the machines ~~from~~?

A. I shall not divulge my knowledge in reference to it here. I have known all along that genuine Edison machines want [sic] to be obtained in England elsewhere than from the Plt Co. – I have never bought one in my life. I know people who have bought them otherwise than through the Plt. Company. I will swear that I do not know whether ~~the~~ persons who have so bought have also bought machines of British make – I have never been told that they have. I know nothing about any machines except those I have sold myself – I ~~am~~ will sell Mr Maguire ~~machines made by Edison~~ genuine Edison machines at £50 apiece if he likes. I will sell him five such – I decline to say when those were brought into England or where they are now. They are reported to me as new & not second hand. I do not consider it of the slightest importance to me that this matter shd. be kept secret – I think it is of importance to the persons selling and also of importance to them that Mr Maguire shd. not know – I have never had any conversation with the other defts. about the Edison machines. ~~On Jan^y.14th~~ Prior to Jan 14 I could have bought Edison's machines and have resold them at about £65 to make a profit. I believe ~~they~~ that the Plt Co's price then was about £72 odd but I never dealt with them. I had heard of such a thing as Maguire selling for less than £72 in a wholesale way but not so far as I know to a retail buyer. ~~On the~~ I had no conversation with Rosenthal on the 14 Jan^y. as to the advantage of Edison's name ~~being~~ being on the machine. He made an ejaculation to me – He said "it wd. pay me to give £30 ~~more~~ a machine more to have Edison's name & Edison's make" At that time I had already offered him British machines at rather less than £45 for a quantity – for six – I did not offer Rosenthal Edison's machines because I ~~refuse~~ have always declined to deal in ~~Edison's machines because~~ them as I consider the price outrageous. When Rosenthal ~~first~~ came to see me on the 14 Jan I at first thought he was a bona fide purchaser – I had some doubts during our interview but even at its close I thought he might return – He told me he was not a spy. A guilty-conscience made him say that – I think he was a spy and a put-up spy. I first came to that conclusion when I saw his affidavit. ~~Rosenthal~~ He & I went to 62 Broad Street together – I don't know whether he knew Georgiades before – When we got to Broad street the shop was full of people. Tragides was the man I spoke to. I think he was in the office – the office is an open desk in the ~~office~~ shop. Rosenthal went up to the desk with me. I think Georgiades was attending to the customers in the shop but I am not quite sure. The first thing I said ~~was~~ to Tragides was "Have you offered this gentleman machines at £40" Rosenthal was close to me. He had told me that the machines had been offered at this price by Tragides – It was to ascertain the truth of that that I went there & Rosenthal who had made this statement went with me. Tragides replied "I offered him machines at £45 including the film but as you are now dealing with him he cannot buy a machine from me at any price he must finish his business with you" Rosenthal did not say a word – & we left the shop. Neither of us spoke to Georgiades. I did not ask ~~not~~ Tragides whether he had known Rosenthal before – but I cd. see he must have done so from his nature as to the offer. I told Rosenthal that day that the British machines were the same as Edison's – the same in principle and everything- I told him this.

Q. How did he come to say to you that he would rather give £30 more for Edison's?

A. It was at the end of the interview – He had offered me £40. I said he cd. have six for £250 – He said he wd. not give more than £40 & that it wd. pay him better to give £30 more to Maguire for Edison' s name & make – That was the first time Edison's name was ment'd. between us – except that as I have already ~~told~~ said, I had told him that ~~Edison's was the same~~ the British machines were the same in principle as Edison's – Not a word was said to me about Edison's name plate at any time. He told me Maguire would sell him an Edison machine for £60. I told him I could scarcely credit it or words to that effect – I did not tell him that Georgiades was working with my capital – If I had it wd. have been a lie. There is no business connection between me & the other defts. except that I buy machines from them ~~I deny the truth~~ As far as I know no films are made in England.

Re-examined. Films as I sell them ~~as~~ and as I believe others sell them are not part of the machines – though they are essential for the use of them & are sold separately. They vary in price from £2. 15 – to £5. & I consider Tragides answer as to price verified what Rosenthal had told me – The name of Edison on the motor wd. not be visible to a person inspecting a machine in the shop – A motor is a regular stock article of commerce & is used for giving motion to other machines besides Kinetoscopes such as fans for ventilation. I have not the slightest interest in the business of the persons from whom I said in my cross exam. that I could purchase Edison machines or who offered them to me.

[Signed] James E Hough

Sworn Feb. 2. 1895.

John Magnall Kelly cross-exd on his affidt. sworn the 28 of Jany 1895 saith as follows:

At the interview of the 14th Jany. I think Hough offered to supply Rosenthal with films ~~& told~~ & told him they were of American manufacture but I do not remember the name of Edison being used – I think Rosenthal asked whether they wd. be genuine films – Hough said in reply to that they wd. come from America. I came over from America about 11 years ago. I am a merchant in London. I do not deal in Kinetoscopes or phonographs or anything of that sort. I am a general merchant trading with China & Japan & other countries & have been so since 1867. I have known Mr Hough for several years – I saw Hough open the machine & show it to Rosenthal – I heard Hough say, "You see, they are the same" They had just been talking about Edison's machines – I understood him to ~~say~~ mean that they were English made machines ~~but~~ the same as Edison's & Rosenthal said I see they are – Hough & Rosenthal when they went to Broad Street were absent about ~~10 to~~ five or at most 10 minutes. ~~He~~ Rosenthal said he cd. make more money out of machines with Edison's name on them than out of those without the name – Hough said "That is my price if you want Maguire's machines you must go to him"

Q. That meant Edison's?

A. Yes – I do not remember anything being said about the advantage of Edison's name except that Rosenthal said it wd. be worth £30 more to him. Mr. Hough did not say a word about supplying Edison machines only about supplying the films. I do not remember anything being said about name plates – I will not swear one way or the other – but if it had been ment'd I think I shd. remember it.

Re- examined. Hough said the films would come from America.

[Signed] John M Kelly.

Sworn Feb 8 1895.

The deft **George Tragides** cross-ex'd. on his affidt. sworn 23 of Jany. 1895, saith as follows:

I know a man of the name of Quain – I have had conversations with him with regard to ~~my~~ Kinetoscopes & our exhibition of them. I did not tell him that I & my partner Georgiades intended to start a parlour show of machines – not that I remember. I never told him that I intended to place one Edison machine before other machines – I told him nothing of the kind – I did not tell him that I & my partner intended to work under the title of "Edison's Marvellous Kinetoscope" At ~~that~~ the time I knew Quain we had that title on our window in Queen Street. I have seen him since at Broad Street when he asked me to lend him 6/-. He told me he was Maguire's manager. That was the last I saw of him. I do not remember telling him that I had no difficulty whatever in securing films. I did not tell him that no one could tell the difference between Edison's & English made machines. If I had told him so it wd. have been a lie.

Q. Describe ~~the~~ differences which the public can see between the Edison machines & the English machines exhibited at your show at Broad Street.?

A. ~~Mr. Hough~~ The difference between them is this – the Edison machines are slot machines & the English are not- that is a great difference – Edison's are nickel in the slot – nickel being a ~~five~~ coin – a five cent piece – They are automatic slots. In our exhibition the ~~mach~~ public do not start either of the machines with coins. An attendant starts all the machines for the purpose of showing them – The English machines have English locks on each side – the American machines have Yale or American locks which can be seen from the outside. The English are made of English oak which is lighter in colour than the American machines – and they now bear a plate of different colour to Edison's larger & thicker stating that they are manufactured by the American Kinetoscope Company 62 Broad Street London. – They did not bear those plates before the 18 Jany as the maker ~~of the~~ had not them ready. We had ordered them before that date. It was part of the agreement with the maker, (R.W. Paul of 44 Hatton Garden) to deliver machines to us complete with plates – That was the agreement before any had been made for us. Paul is the only man who has made machines for us – ~~We have~~ Our agreement with him is in writing – The suggestion that he shd. make the machines came from me not from him. I gave him an Edison machine to copy from. I have not got the agreement with me – I am willing to produce it. My solicitor shall give you a copy of it, provided the price is left out. I am well

223

acquainted with Hough. He has bought machines from me – machines made by Paul. All that Paul has made are of the same pattern. I remember Rosenthal calling at my office with Hough – but I do not remember the date – Hough came to ask whether I had offered machines to Rosenthal for £40 – that was part of the conversation – I said ~~No then I~~"No – besides I wd. not sell him any machines – if he wants any he must buy them from you" or words to that effect. I don't remember whether ~~thereupon~~ – Hough then said anything to Rosenthal – Hough just nodded but I do not remember that he said anything – I do not mean to say that I have never sold machines for £40 – I offered to sell them at that price to Tonkin. I have seen Tonkin. Referring to par. 4. of Tonkin's affid[t]. I was present when he called on the occasion there referred to – EWT 2, EWT 3 & EWT 4 are all in my handwriting – except that EWT 3 & EWT 4 are signed by my partner. Tonkin did not on that occasion (the 14 Jan[y].) ask me the price of Edison Kinetoscopes – He did ask me the price of English Kinetoscopes – I told him that the machines I offered at £40 were not Edison's.

Q. Did he on that day say anything about Edison's machines?

A. Yes.

Q. ~~What did he say?~~

He said that the English machines were much cheaper but that he wanted to be sure that they would be as good. I told him that they were as good as Edison's. He explained that he wished to see one worked & we showed him. He seemed perfectly satisfied. He asked me to sell him an Edison machine also but not on the same day – not on the 14 Jan[y]. when EWT 2 & EWT 3 were written – not as far as I can remember. On that day I thought he was going to buy three of my machines but I did not think he was going to buy an Edison as well. There was not a conversation between us on that day as to his buying three of ~~ours~~ mine & one Edison. There was such a conversation the last time I saw him their [sic] but I am sure there was not on the 14 of Jan[y].when exhibits EWT 2 & EWT 3 were signed – I never intentionally misdate a document. [Note: EWT 4 shown to this witness] I see now that I am mistaken as to dates. I thought it was on the next occasion that I spoke about Edison's machines. I see now that it was on the 14 Jan[y] – I say that EWT 4 was not written on the same day as EWT 2 & EWT 3 – the date of EWT 4 must be wrong – I do not remember any conversation with Tonkin as to the way in which the Kinetoscopes should be shown to the public – I will swear that neither I nor my partner nor Tonkin said that as long as he (Tonkin) had one Edison machine it was all right and he could use Edison's name in connection with the show. My partner did not say "Who is to know the difference" nor anything of the kind – Tonkin changed his mind & wanted to buy one machine only – That was on the 2nd or 3rd interview. I cannot remember dates – He said "You must give me an Edison plate with it" He meant with a £40 machine – I said that I wd. not give him an Edison plate as it was not Edison's machine and would be criminal. He then said, "Give me the plate I will put it in my pocket & will place it on the machine myself when I take it away" I told him that I would not give him an Edison plate under any circumstances but that I

would fix a plate bearing the name of our firm & the place of manufacture that is England – We have never had any spare plates of Edison. ~~He~~ Tonkin asked me to take off one from an Edison machine & argued with me for ten minutes but I positively refused.- ~~That was~~ On that occasion ~~whe~~ the Tonkin's both father & son were present – It was Tonkin the father who asked me to do this as to the plate. There was no talk at all about the value of Edison's name. ~~My partner~~ At ~~the first~~ one of the interviews my partner ~~told~~ showed Tonkin the Edison machines & the English machines & told him the difference in price – £65 being the price of Edison's – We should not lose by selling at that price but shd. make money £15 – We did not buy these Edison machines from Hough we bought them from Edison – We bought them from him more than three months before Maguire's company was formed – four months before Maguire came to England. We bought them before June 1894 – See exhibit A to my affidt. We bought three from Edison. ~~One of these was~~ It was one of those three that I was going to sell to Tonkin for £65.

Re-examined. On the occasion when Hough called with Rosenthal I do not remember that I told Hough that I had offered machines to Rosenthal at any price at all.

Note I had spoken to Rosenthal on a former occasion. I knew nothing about prices.- I mean I knew nothing about prices before I began making machines. When I had spoken to Rosenthal before I told him that the price would be about £45 & that is all I told him about price – I saw Tonkin (the son) three times I think at Broad St – My partner was present on all those occasions. On the 1st occasion he spoke to my partner about buying a phonograph. Then he changed the subject & said he wd. like to buy Kinetoscopes also. My partner told him that we would sell him some & he then said he would call next day with his capitalist – I took no part in this conversation – I remember his coming on the 2d occasion. My partner & I were present. He told my partner that he would like to buy three Kinetoscopes & asked him if we were agents for Kinetoscopes. My partner said; We make them ourselves" A price was mentioned. My partner asked him £45 for one machine only – he exclaimed that he wanted to buy more than one so I told him that if he bought more than one I would make it £40 – He had said he wanted to buy a good many. I think I must have made a mistake in the dates of EWT 2 & EWT 3 – At this ~~3rd inter~~ last interview we had with Tonkin (the son) he came alone & wanted to know if I wd. sell him an Edison Kinetoscope. I told him I would for £65. ~~That~~ It was on that occasion that EWT 4 was written – We had three Edison machines in our shop and two of English manufacture. The Edison machines all had ~~each had~~ his plate on them – I never in any of the interviews with Tonkin suggested to him that the English made machines were Edison's.

[Signed] G. Tragides.

Sworn on same day.

The Deft. **Demetrius Anastas Georgiades** cross –exd. on his joint affidt. sworn the 23 of Jan. 1895 saith as follows.

My firm have had altogether three Edison machines in our Broad Street shop – that is all we have had. My firm consists of myself & Tragides & is called "The American Kinetoscope Co" Except the three Edison machines I have referred to we only offer for sale English made machines. We offered one of the three Edison's to Tonkin. We offered him also English made machines – all those we offered him except the one Edison were English machines. My partner Tragides has just brought me here. We had no conversation on this matter. He only told me that his examination was over & that it was my turn. He said nothing to me about the 3 letters to Tonkin – EWT 2 EWT 3 & EWT 4. Two of them EWT 3 & EWT 4 are signed by me. They purport to be dated on the same day but I say there must be a mistake as to the date of one of them because I know the one stating £65 as the price of an Edison was not written on the same day as the ~~one~~ other letter. EWT 4 was ~~written~~ given on a different day not on the same day as ~~when~~ EWT 3 was given – When people come to us to ~~buy~~ look through machines we do not say anything as to whether they are Edison's or English unless the people ask – If anyone comes wanting to buy a machine we tell him that English machines cost £45 and that if he wants an Edison he will have to buy it elsewhere and give £73 for it. We tell ~~intending purchasers~~ enquirers that the English & Edisons' machines work on the same principle – I have read Tonkin's affidt. ~~Tonkin~~ He came to us to buy a machine. He did not ask for an Edison machine. He came to us for English made machines and asked for those – I did not tell him that there was no difference between the English & the Edison machines – He knew the difference – Tragides was present. I ~~did~~ never sold any machines to anyone at Birmingham. I did not tell Tonkin that I knew a professor in Paris who could make films – I do not know any such person in Paris – We ~~could~~ buy our films from America – Edison films.

Re-examined We purchased the three Edison machines in June 1894 in America and directly from Mr. Edison – and we have his authority to exhibit them. Exhibit A to my affidt.is that authority. We had it put in the window of the shop in Broad Street together with other advertisements relating to Edison's machines.
[Signed] D.A. Georgiades.

The evidence contd. on this & the 21 preceeding sheets of paper was taken down by me and afterwards read over to the respective witnesses & signed by them in the presence of the parties attending.
Edward Hume.

Bibliography

Books

Abel, Richard (ed.), *Encyclopedia of Early Cinema* (London and New York, Routledge, 2005)

Acres, Alan Birt, *From Frontiersman to Film-maker: The Biography of Film Pioneer Birt Acres, FRPS, FRMetS 1854–1918* (Hastings: The Projection Box, 2006): CD-ROM

Andrews, Frank, *Edison Phonograph: The British Connection* (Rugby: City of London Phonograph and Gramophone Society, 1986)

Barnes, John, *The Beginnings of the Cinema in England 1894–1901 Volume One: 1894–1896 (revised and enlarged edition)* (Exeter: University of Exeter Press, 1998)

Brown, Richard and Anthony, Barry, *A Victorian Film Enterprise. The History of the British Mutoscope and Biograph Company, 1897–1915* (Trowbridge: Flicks Books, 1999)

Continental Commerce Company, *Thomas A. Edison's Kinetoscope* [1894]

——, *Thomas A. Edison's kinetoscope: Edison's Masterpiece* [1894]

——, *Thomas A. Edison's Latest and Most Remarkable Invention: The Kinetoscope* [1894]

Cornish, W. A. and Clark, G de N., *Law and Society in England, 1750–1950* (London: Sweet and Maxwell, 1989)

Davenport, Neil, *The United Kingdom Patent System* (Havant: Kenneth Mason, 1979)

Dutton, Henry, *The British Patent System* (Manchester: Manchester University Press, 1984)

Edmunds, Lewis, *The Law of Copyright and Design* (London: Sweet and Maxwell, 1895)

Fulton, David, *The Law and Practice relating to patents, trade marks, and Design* (London: Jordan's, 1902)

Hendricks, Gordon, *The Edison Motion Picture Myth* (Los Angeles: University of California Press, 1961)

——, *The Kinetoscope. America's First Commercially Successful Motion Picture Exhibitor* (New York: self-published, 1966)

Herbert, Stephen and McKernan, Luke (eds.), *Who's Who of Victorian Cinema* (London: BFI Publishing, 1996)

Hopwood, Henry V., *Living Pictures: Their History, Photo-Production and Practical Working* (London: Optician and Photographic Trades Review, 1899). Republished New York: Arno Press and New York Times, 1970. Second edition (London: The Hatton Press, 1915). Accessible online at http://archive.org/details/hopwoodslivingpi00hopwrich

Israel, Paul, *Edison: A Life of Inventions* (New York: John Wiley, 1998)

Lange-Fuchs, Hauke, *Birt Acres* (Kiel: Walter G. Mühlau, 1987)

——, *Der Kaiser, der Kanal und die Kinematographie* (Schleswig: Landesarchiv Schleswig-Holstein, 1995)

Loiperdinger, Martin, *Film & Schokolade: Stollwercks Gesshäfte mit lebenden Bildern* (Frankfurt am Main: Stroemfeld, 1999)

Mannoni, Laurent, *Le Mouvement Continué. Catalogue illustré de la collection des appareils de la Cinémathèque française* (Paris: Cinémathèque française/Musee du Cinema, 1997). The catalogue and that of le Centre national du cinema are accessible online at http://cinematheque.fr/fr/catalogues/appareils/collection.htm

Mannoni, Laurent, *The Great Art of Light and Shadow. Archaeology of the Cinema.* Translated by Richard Crangle (Exeter: University of Exeter Press, 2000)

Mannoni, Laurent; Donata Pesenti Campagnoni; David Robinson, *Light and Movement: Incunabula of the Motion Picture. 1420–1896* (Pordenone: Le Giornate del Cinema Muto: 1995).

Martin, William, *The English Patent System* (London: Dent, 1904)

Mees, C. E. Kenneth, *From Dry Plates to Ektachrome Film: A Story of Photographic Research* (New York; Ziff-Davis Publications, 1961)

Millard, André, *Edison and the business of Innovation* (Baltimore, MD: Johns Hopkins University Press, 1990)

Morris, Peter J. T. (ed.), *Science for the Nation: Perspectives on the History of the Science Museum* (Basingstoke: Palgrave Macmillan, 2010)

Musser, Charles, *The Emergence of Cinema: the American Screen to 1907* (New York: Charles Scribner's Sons, 1990)

——, *Before the Nickelodeon: Edwin S. Porter and the Edison Manufacturing Company* (Berkeley: University of California Press, 1991)

——*Thomas A. Edison and his Kinetographic Motion Pictures* (New Brunswick: Rutgers University Press, 1995)

——, *Edison Motion Pictures, 1890–1900: An Annotated Filmography* (Washington: Smithsonian Institution, 1997)

Phillips, Ray, *Edison's Kinetoscope and Its Films: A History to 1896* (Trowbridge: Flicks Books, 1997)

Race, Sydney, *The Journals of Sydney Race 1892–1900* (London: Society for Theatre Research, 2007)

Ramsaye, Terry, *A Million and One Nights: A History of the Motion Picture* (New York: Simon and Schuster, 1926)

Robinson, David, *From Peep Show to Palace. The Birth of American Film* (New York: Columbia University Press, 1996)

Rossell, Deac, *Ottomar Anschütz and his Electrical Wonder* (Hastings: The Projection Box. 1997)

——, *Living Pictures. The Origins of the Movies* (New York: State University of New York Press, 1998)

——, *Faszination der Bewegung: Ottomar Anschütz zwischen Photographie und Photographie* (Frankfurt am Main: Stroemfeld, 2001)

Sherman, Brad and Bently, Lionel, *The Making of Modern Intellectual Property Law: The English Experience 1760–1911* (Cambridge: Cambridge University Press, 1999)

Spehr, Paul C., *The Man Who Made Movies: W. K. L. Dickson* (New Barnet: John Libbey Publishing Ltd., 2008)

Talbot, Frederick A., *Moving Pictures: How They are Made and Worked* (London: Heinemann, 1912). Entirely revised edition (London: Heinemann, 1923) Accessible online at https://archive.org/details/movingpicturesho00talb

Charles Urban (Edited by Luke McKernan), *A Yank in Britain. The Lost Memoirs of Charles Urban* (Hastings: The Projection Box, 1999)

Wachhorst, Wyn, *Thomas Alva Edison: An American Myth* (Cambridge, MA: MIT Press, 1981

Wadlow, Christopher, *The Law of Passing Off. Unfair Competition by Misrepresentation* (London: Sweet and Maxwell, 2004)

The Will Day Historical Collection of Cinematograph & Moving Picture Equipment, (London: Harris & Gillow, 21 January 1930)

Williams, Keith, *H. G. Wells, Modernity and the Movies* (Liverpool: Liverpool University Press, 2007)

Articles

Andrews, Frank, 'Out-takes 1', *Hillandale News*, No. 163 (August 1988): 64-66; 'Out-takes 2', No. 164 (October 1988): 100–103; 'Out-takes 3', No. 170 (October 1989): 267–269.

Anthony, Barry, 'Music Hall and the Birth of Records and Films', *Music Hall Studies,* No. 9 (Summer 2012): 372–378.

Bostwick, Arthur E. (ed.), 'Mechanism of the Kineto-phonograph', *The Literary Digest*, Vol. X, No. 4 (November 1894):15.

Brown, Richard, 'The British Film Copyright Archive', in Colin Harding and Simon Popple (eds.), *The Kingdom of Shadows: A Companion to Early Cinema* (London: Cygnus Arts, 1996): 240–245.

——'"England is not big enough…" American Rivalry in the early English film business', *Film History*, Vol.10, No.1 (1998): 21–34.

——, 'The Kinetoscope in Yorkshire. Exploitation and Innovation', in Simon Popple and Vanessa Toulmin (eds.), *Visual Delights: Essays on the Popular and Projected Image in the Nineteenth Century* (Trowbridge: Flicks Books, 2000): 105–115.

——, 'Films and Postcards', *Visual Delights Two. Exhibition and Reception* (Eastleigh: John Libbey Publishing Ltd, 2005): 236–252.

——, 'A new look at old history – the Kinetoscope: Fraud and market development in Britain in 1895', *Early Popular Visual Culture*, Vol. 10, No. 4 (November 2012): 407–439.

'A Chat with Mr Paul', *The Era* (25 April 1896): 17.

Christie, Ian, '"What is a Picture?" Film as Defined in British Law Before 1910', in Marta Braun et al (eds.), *Beyond the Screen: Institutions, Networks and Publics of Early Cinema* (London: John Libbey Publishing Ltd, 2012): 78–84.

——, 'Moving-picture Media and Modernity: Taking Intermediate and Ephemeral Forms Seriously', in Jeffrey Geiger and Karin Littau (eds.), *Cinematicity in Media History* (Edinburgh: Edinburgh University Press, 2013): 46–64.

Coe, Brian, 'William Friese-Greene and the Origins of Kinematography', *Photographic Journal* (March/April 1962): 92–104 and 121–126.

Convents, Guido, 'Edison's Kinetoscope in Belgium, or, Scientists. Admirers, Businessmen, Industrialists and Crooks', in Claire Duprié la Tour, André Gaudreault and Roberta Pearson (eds.), *Cinema at the Turn of the Century* (Lausanne: Payot, 1999): 249–258.

Cook, Malcolm, 'The lightning cartoon: Animation from music hall to cinema', *Early Popular Visual Culture*, Vol. 11, No. 3 (2013): 237–254.

Costa, Nicholas, 'The Barrons of Yarmouth – the first hundred years', *Coin Slot* (12 September 1981): 32.

Crabtree, J. I. 'The Motion Picture Laboratory' in Fielding, Raymond (ed*), A Technological History of Motion Pictures and Television* (Oakland: University of California Press, 1983): 150–171.

Dickson, Antonia and Dickson, W. K. L., 'Edison's Invention of the Kineto-Phonograph', *The Century Magazine* (June 1894): 206–214.

Dickson, W. K. L., 'Brief History of the Kinetograph', *Journal of the Society of Motion Picture Engineers* (December 1931): 435–455.

'Edison's Very Latest. A Chat with the Kinetoscope Man', [London] *Evening News and Post* (24 October 1894): 4.

F.D. [Frederick Dalton?], 'Edison's Kinetoscope', *The English Mechanic and World of Science and Art*, Vol. LXI, No. 1575 (31 May 1895): 313.

Harrison, A. E., 'Joint Stock Company Flotations in the Cycle, Motor-Vehicle, and Related Industries 1882–1914', *Business History*, Vol. 23, No.2 (July 1981): 165–190.

'The House of Walker and its wonderful development', *The Kinematograph and Lantern Weekly* (28 December 1916): 61.

'Kinetscope (sic) in Blackpool: The Agent Interviewed', *The Blackpool Gazette* (16 November 1894): 2.

Loiperdinger, Martin, 'Ludwig Stollwerck, Birt Acres, and the Distribution of the Cinématographe Lumière in Germany', in Roland Cosandey and François Albera, *Images Across Borders, 1896–1918. Internationalism in World Cinema* (Lausanne: Payot, 1995): 167–177.

——,'A Foreign Affair. Birt Acres and Ludwig Stollwerck', *Early Popular Visual Culture*, Vol. 3, No. 1 (May 2005): 77–94.

Lomax, A., 'Kinetoscope and Lantern', *The Optical Magic Lantern Journal* (August 1896): 132–134.

Paul, Robert W., 'Kinematographic Experiences', *Journal of the Society of Motion Picture Engineers* Vol. 27, Issue 5 (November 1936): 495–512. Reproduced in Raymond Fielding (ed.), *A Technological History of Motion Pictures and Television* (Berkeley: University of California Press, 1967): 42–48.

'The Photographic Revolution: Interview with Mr T. H. Blair', *Black and White* (20 July 1895): 79.

Popple, Simon, 'Cinema Wasn't Invented, It Growed. Technological Film Historiography before 1913', in John Fullerton (ed.), *Celebrating 1895. The Centenary of Cinema* (Sydney: John Libbey, 1998): 19–26.

'Prominent Men in the Lantern World. No. VII. – Mr. Birt Acres', *The Optical Magic Lantern Journal* (May 1897): 80–81.

Rossell, Deac, 'A Chronology of Cinema, 1889–1896', *Film History* 7, No. 2 (1995): 115–239.

——, 'Serpentine Dance. International Connections in Early Cinema' (London: Goldsmith's College, 1999).

——, 'Rough Sea at Dover: a genealogy', *Early Popular Visual Culture*. Vol. 15, Issue 1, (February 2017): 59–82.

——, 'Second Thoughts: A Fresh Look at Birt Acres in the Light of New Discoveries'. Unpublished paper, accessible online at www.acadenia.edu

Spehr, Paul C., 'Unaltered to Date: Developing 35mm film', in John Fullerton & Astrid Soderbergh Widding (eds.), *Moving Images. From Edison to the Webcam* (Bloomington: Indiana University Press, 2016): 3–28.

'Then and Now. Pictures in '97 and in '09', *The Kinematograph and Lantern Weekly* (26 November 1908): 729.

Tissandier, Gaston, 'Le Kinétoscope d'Edison', *La Nature* (20 October 1894): 323–326.

Walker, J. D., 'The Early Days of Cinematography', *The Bioscope* (12 December 1912): 811–813.

'What Edison's Living Pictures are like. Exhibition of the Kinetoscope', *The Westminster Budget* (26 October 1894): 754.

Index

Biographies of the Authors

Barry Anthony is a historian who has written extensively about the social history of the late Victorian period. He has contributed to the *Who's Who of Victorian Cinema* (1996); the *Encyclopaedia of Early Cinema* (2005); and *Directors in British and Irish Cinema: a Reference Companion* (2006). Full length works include *The Kinora; Motion Pictures for the Home, 1896–1914* (1996), *The King's Jester: the life of Dan Leno, Victorian Comic Genius* (2010); *Chaplin's Music Hall: the Chaplins and Their Circle in the Limelight* (2012); *Murder, Mayhem and Music Hall* (2015); and *A Victorian Film Enterprise* (with Richard Brown).

Dr Richard Brown is particularly interested in the economic characteristics and commercial structure of the early British film business. He is co-author (with Barry Anthony) of *A Victorian Film Enterprise: The History of the British Mutoscope and Biograph Company*, and has provided an introduction to the facsimile edition of W. K-L. Dickson's memoir of filming the Anglo-Boer War, *The Biograph on Battle* (1901). He has contributed to the *Encyclopedia of Early Film*, *Who's Who of Victorian Cinema* and *The Lost World of Mitchell and Kenyon*, and his research papers have been published in *Historical Journal of Film, Radio and Television*, *Film History* and *Early Popular Visual Culture*.

Michael Harvey was formerly Curator of Cinematography at the National Media Museum where he was responsible for developing the cinematography collection and curating the Animation Gallery. He originated and curated several exhibitions including *Magic Behind the Screen: 100 years of British Cinema* (1996); *Bond, James Bond* (2002), which toured to major venues in the USA and Canada; *Myths and Visions: The Art of Ray Harryhausen* (2006); *Live by the Lens, Die by the Lens: Film Stars and Photographers* (2008) and *Drawings that Move: The Art of Joanna Quinn* (2009). In 2012, his work on researching and realising the first colour moving images (dating from 1901–1902) from the original negatives by Edward Raymond Turner in the National Media Museum collection attracted worldwide media attention.